SELECTED WORKS

Snite Museum of Art
University of Notre Dame

Published in commemoration of the
25th anniversary of the opening of
the Snite Museum of Art building.

Dedicated to

Rev. Anthony J. Lauck, C.S.C.,

and Dean A. Porter

Second Edition
ISBN 978-0-9753984-1-8

CONTENTS

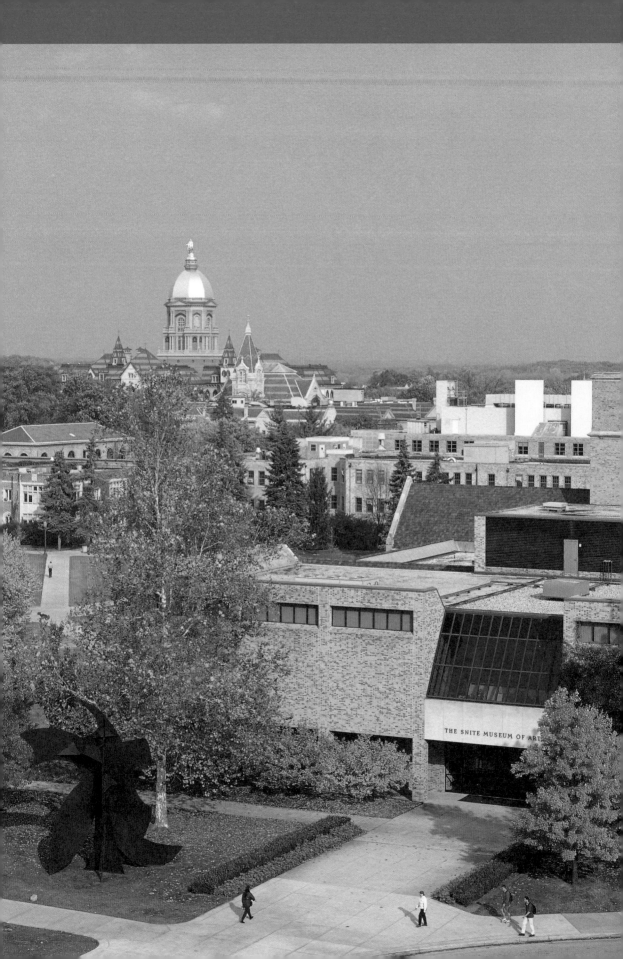

FOREWORD

From its earliest years, the University of Notre Dame has understood the importance of the visual arts to the academy. In 1874 Notre Dame's founder, Rev. Edward Sorin, C.S.C., brought Vatican artist Luigi Gregori to campus. For the next seventeen years, Gregori beautified the school's interiors—painting scenes on the interior of the Golden Dome and the Columbus murals within the Main Building, as well as creating murals and the Stations of the Cross for the Basilica of the Sacred Heart. In 1875 the Bishops Gallery and the Museum of Indian Antiquities opened in the Main Building. The Bishops Gallery featured sixty portraits of bishops painted by Gregori. In 1899 Rev. Edward W. J. Lindesmith, C.S.C., gave the collection of Native American art he had amassed while a chaplain at Fort Keogh, Montana, to the Museum of Indian Antiquities.

In 1917 Rev. John W. Cavanaugh, C.S.C., acquired over 100 paintings for Notre Dame, and these were complemented by a 1924 gift of 108 paintings from Charles A. Wightman. The growing art collection was exhibited in 1924 within the Charles A. Wightman Memorial Art Gallery, located in what was then the University's library (now Bond Hall).

In 1952, at the request of Rev. Theodore M. Hesburgh, C.S.C., Ignatius A. O'Shaughnessy funded construction of the liberal arts building, O'Shaughnessy Hall. It included the O'Shaughnessy Art Gallery, which opened in 1953 and remains today an integral part of the Snite Museum of Art.

In 1955 Father Hesburgh invited Croatian sculptor Ivan Meštrović to teach and work at Notre Dame, and the Meštrović Sculpture Studio was constructed for the "maestro." During the last seven years of his life, Meštrović created public artworks for the campus, including sculptures installed in 1984 within the *Shaheen-Meštrović Memorial*, which illustrates the story of Jesus and the Samaritan woman at the well. Meštrović's masterpiece, his *Pieta*, is located in the Basilica of the Sacred Heart. The Meštrović initiative was followed in 1964 by Fathers Hesburgh and Edmund P. Joyce commissioning nationally recognized artist Millard Sheets to create the *Word of Life*, a granite-mosaic mural on the exterior of the Hesburgh Library.

 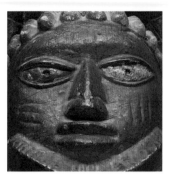

In 1975 the Fred B. Snite family donated funds to construct the Snite Museum of Art. The new building opened in 1980 and bridged the O'Shaughnessy Art Gallery with the Meštrović Sculpture Studio, which was converted into a gallery. In this expanded space, the Museum was able to exhibit its rapidly developing collections of art and to interpret them with extensive art education programs directed by two curators of education.

Therefore, the Snite Museum of Art, University of Notre Dame, is honored to publish this updated *Selected Works* collection handbook on the twenty-fifth anniversary of the construction of the Snite Museum building in 1980. The first edition, published seven years after the Museum opened, is no longer representative of the breadth and richness of the collection, because—thankfully so—many fine works of art have been acquired since then. It is note-worthy that certain sections of the handbook have grown dramatically since 1987, in particular Mesoamerican art, old-master drawings, and photography.

I thank the Fred B. Snite family for funding the construction of the building, which was the catalyst for the collection's dramatic growth over the past twenty-five years. I also acknowledge the benefactors listed on page 8, who have made this second edition necessary. These individuals, families, endowments, and foundations have made gifts of art or have provided funds for the purchase of objects for the permanent collection—the soul of the Museum. Many of these benefactors are alumni, members of the Snite Museum of Art Advisory Council, and Friends members. Special thanks are also offered to the curators and directors who guided the development of the collections in concert with these benefactors.

In 1975 the Fred B. Snite family donated funds to construct the Snite Museum of Art. The new building opened in 1980 and bridged the O'Shaughnessy Art Gallery with the Meštrović Sculpture Studio, which was converted into a gallery.

I am especially grateful to Dr. R. Stephen and Maureen Lehman for their generous gift, which has made printing this handbook possible. Stephen is chair of the advisory council, and, in observance of our celebration, he has produced a video that describes the staff and council's vision for the next twenty-five years.

Curator of Photography Stephen R. Moriarty, with Allyson Klutenkamper, April Wilkins, and Katie Yenglin, prepared the handsome photographs that illustrate this publication. The authors, who are listed on page 11, wrote interpretive essays that provide useful insights into each art object. I thank them for their fine writing and for their discipline in meeting both the production deadline and my strict word limit for essays. Anne Taaffe Mills and Sarah McGaughey Tremblay skillfully edited the essays, and Assistant Professor Robert Sedlack tastefully combined images with text.

Thanks are also given to Curator of Native American Art Joanne M. Mack for information shared earlier in this foreword regarding the Bishops Gallery and the Museum of Indian Antiquities. (This Museum history is intentionally brief, in anticipation of the more complete history that Director Emeritus Dean A. Porter is writing.)

In short, I am deeply indebted to the many individuals who have made this publication possible with their gifts of art, funds, talents, and time.

It is indeed long overdue. May it soon become obsolete.

Charles R. Loving
Director and Curator of Sculpture

BENEFACTORS

PRINTING OF SELECTED WORKS
Dr. and Mrs. R. Stephen Lehman

BENEFACTORS OF WORKS OF ART FEATURED IN SELECTED WORKS

Mr. Lester S. Abelson

Mr. and Mrs. Julian Aberbach

Mr. and Mrs. Edward Abrams

Mr. and Mrs. James W. Alsdorf

Marilynn B. Alsdorf

Alsdorf Foundation

Mr. Ernst Anspach

Mr. and Mrs. Ignacio Aranguren and Sons

Mr. Emil Arnold

Mr. and Mrs. Russell G. Ashbaugh, Jr.

Dr. R. Austgen

William and Leslie Banks

Dr. and Mrs. Douglas Barton

Walter R. Beardsley Endowment for
 Modern and Contemporary Art

Mr. and Mrs. Richard Beech

Mr. and Mrs. Edwin A Bergman

Mr. and Mrs. Richard E. Berlin

Kennett B. Block Family

Dr. and Mrs. Leslie Bodnar

Mrs. J. C. Bowes

Raymond E. Britt Family

Theodora Winterbotham Brown

Mr. and Mrs. Michael G. Browning

Dr. M. L. Busch Purchase Fund

Mr. and Mrs. Noah L. Butkin

The Butkin Foundation

Mr. L. Russell Cartwright

Mr. James A. Chism

Mr. Harold L. Cooke

Mrs. Thomas Cusack

Arthur J. Decio Purchase Fund

Mr. and Mrs. Arthur J. Decio

Mr. B. Nelson Deranian

Mr. and Mrs. Joseph Dillon

Mr. and Mrs. Terrence J. Dillon

Mr. and Mrs. Terrence J. Dillon Endowment

Dr. Tom Dooley Art Purchase Fund

Mr. and Mrs. Gary Doran

Mr. and Mrs. William J. Doran

Mr. and Mrs. Robin Douglass

Mr. Charles K. Driscoll

Mr. and Mrs. Randy Dukes

Ms. Mary Dunbar

Mr. and Mrs. James H. Dunfee, Sr.

Mr. Robert Dunfee

Dr. and Mrs. R. Charles Eades

Mr. and Mrs. Harrison Eiteljorg

Mr. and Mrs. William N. Farabaugh

Mr. and Mrs. Jack Feddersen

Mr. and Mrs. Harry Fein Purchase Fund

Mrs. Fred J. Fisher

Fotsch Foundation

Mr. Edward Fowles

Lawrence and Alfred Fox Foundation

Mrs. Lorraine Gallagher Freimann
 Purchase Fund

Friends of the Snite Museum of Art

Betty Gallagher and John Snider

Mr. and Mrs. J. W. Gillon

Mrs. Dorothy Griffin

Mrs. James M. Hall

Mr. and Mrs. Robert L. Hamilton, Sr.,
 Purchase Fund

Ms. Carolyn Hammerschmidt

Mr. and Mrs. Jerry Hammes

Mr. Kevin Healy

Mrs. Frank E. Hering

Mr. and Mrs. John T. Higgins

Laura Holt

Mr. Richard J. Huether

Humana Foundation Endowment for
 American Art

Mr. and Mrs. Thomas Johnson

Mr. Charles Jones

Mr. Peter David Joralemon

Rev. Edmund P. Joyce, C.S.C.

Fritz and Milly Kaeser Endowment for
 Liturgical Art

Milly Kaeser

Mr. and Mrs. Douglas Kahn

Mr. and Mrs. Michael Kiefer

Walter and William Klauer Purchase Fund

Family of William Klauer

Lee Krasner

Samuel H. Kress Foundation

Lake Family Endowment

Mr. and Mrs. Walter H. Lake, Jr.

Mrs. Walter Lake

Mr. and Mrs. Louis Lapierre

Rev. Anthony J. Lauck, C.S.C.,
 Sculpture Endowment

Dr. and Mrs. R. Stephen Lehman

Mr. and Mrs. Judd Leighton

Rev. Edward W. J. Lindesmith, C.S.C.

Ms. Carol Lipis

Mr. and Mrs. Stephen Lobdell

Dr. and Mrs. P. B. Lockhart

Ms. Elsie Manby

Mr. Paul Manheim

Mr. and Mrs. Paul B. Markovits

Mr. Cedric Marks

Mr. and Mrs. John S. Marten

Virginia Marten

Mrs. Robert B. Mayer

Mary R. and Helen C. McDevitt

Mr. and Mrs. J. Moore McDonough
 Endowment for Art of the Americas

Mr. and Mrs. William C. Meehan

Mr. and Mrs. Herbert A. Mendelson

Mr. Joseph Mendelson

Mrs. Janette Burkhart Miller

Mr. Thomas P. Moore II

Mr. and Mrs. Al Nathe

Mr. and Mrs. William B. O'Boyle

Mr. and Mrs. Don Oedekerk

Mr. and Mrs. Robert E. O'Grady

Mr. and Mrs. Robert Oswald

Mrs. Robert Parkes

Mr. and Mrs. James G. Perkins

Dr. G. Pippenger

Mr. and Mrs. Robert Raclin

Ms. Peggy G. Ray

Mr. John D. Reilly

Mr. Peter C. Reilly

Beatrice Riese

Mr. and Mrs. Allan J. Riley

Dr. C. Rosenbaum

Rev. George N. Ross Bequest

Mr. John C. Rudolf

Lewis J. Ruskin Purchase Fund

Mr. Peter J. Ruskin

Sansom Foundation

Mr. Janos Scholz

Janos Scholz Family

Mr. and Mrs. Joseph Shapiro

Rue Winterbotham Shaw

Mr. Joseph R. Skelton

Mr. C. R. Smith

Mr. Fred B. Snite

Snite Foundation

Snite Museum of Art Advisory Council

Mr. Thomas T. Solley

Mr. William A. Sullivan

Anthony Tassone Memorial Art Fund

William L. and Erma M. Travis Memorial
 Endowment for Decorative Arts

Miss Alice Tully

University of Notre Dame Purchase Fund

Mr. and Mrs. Anthony J. Unruh

Mr. Ferdinand Vogel

Mr. John Walker

Miss May E. Walter

Mr. Arthur Weisenberger

Ms. Carolyn Welch

Mrs. Frederick Wickett

Mr. Lester Wolfe

Mr. E. Leroy Yoder

AUTHORS

MA Michael Auping, Chief Curator, Modern Art Museum of Fort Worth

DEB Douglas E. Bradley, Curator of the Arts of the Americas, Africa, and Oceania

GC Gina Costa, Marketing and Public Relations Specialist

AMK Ann M. Knoll, Associate Director

CRL Charles R. Loving, Director and Curator of Sculpture

JMM Joanne M. Mack, Curator of Native American Art

DCJM Diana C. J. Matthias, Curator of Education, Academic Programs

STM Shannon T. Masterson, Head, Educational Programs, The Cleveland Museum of Art

SRM Stephen R. Moriarty, Milly and Fritz Kaeser Curator of Photography

DAP Dean A. Porter, Director Emeritus

SBS Stephen B. Spiro, John D. Reilly Curator of Western Arts

EPS Erika Pistorius Stamper, Research Curator

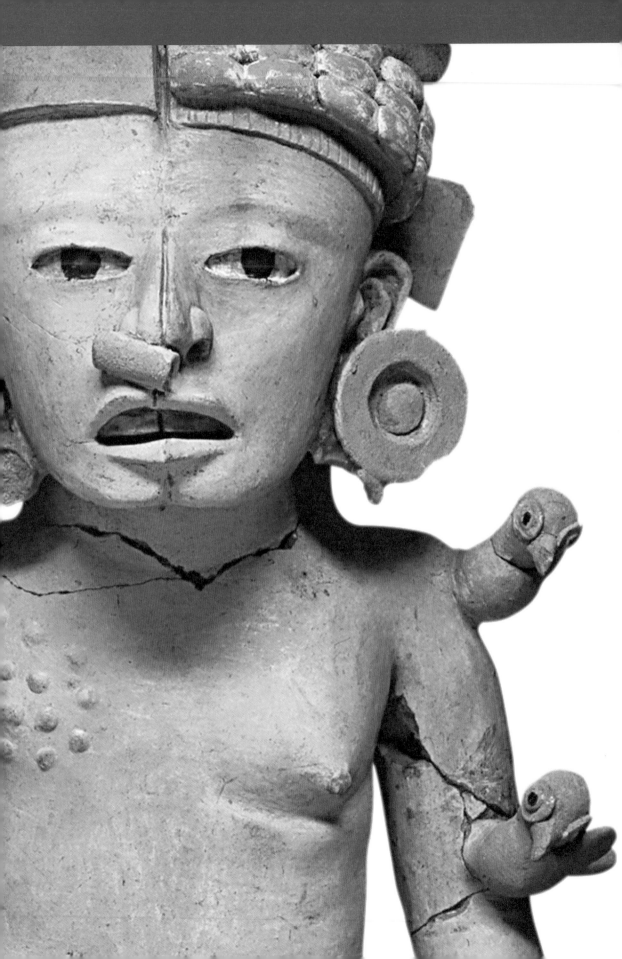

PRE-COLUMBIAN AND SPANISH COLONIAL ART

The University of Notre Dame's first purchase of Pre-Columbian art, or art created by the original inhabitants of the Americas before the arrival of Columbus, was made in 1918. The dealer was Father Urban de Hasque, a Peruvian priest who sold the University a group of Chimu culture blackware ceramic vessels from ancient Peru, as well as other South American pieces. Also included in the sale were "Aztec-style" blackware vessels from Mexico, which are now used to teach students the differences between authentic and fraudulent works of art.

Forty-five years later, Rev. Anthony J. Lauck, C.S.C., director of Notre Dame's new O'Shaughnessy Art Gallery, began to purchase and accept as gifts Pre-Columbian sculpture. A sculptor and Art Department faculty member, Father Tony had a keen eye for form that was reinforced by an annual pilgrimage to New York City, where he visited the galleries and museums that were selling and showing Pre-Columbian art. His favorite dealer was another artist, Frances Pratt, who owned Teochita, Inc., a primitive art gallery in Greenwich Village. Never a shy person, Father Tony used his contacts with dealers to meet important New York collectors such as Cedric Marks, Beatrice Riese, Arthur Seiff, and Lester Wolfe. They began to give works of art in response to his enthusiastic appreciation of their collections and his requests for donations. By 1968 Father Tony had compiled a representative group of Pre-Columbian art.

These were the days of "The Jaguar's Children: Pre-Classic Central Mexico," a 1965 exhibition of 208 pieces held at the Museum of Primitive Art, and "Ancient Art of Latin America from the Collection of Jay C. Leff," a 557-piece Brooklyn Museum of Art exhibition that opened in 1966. Little did Father Tony suspect that forty years later his gallery would become a full-fledged museum owning many pieces that had been shown in those landmark exhibitions. Not content to view Pre-Columbian art in large numbers only in New York, in 1966 Father Tony brought a collection to the O'Shaughnessy Art Gallery as the exhibition "Pre-Columbian Sculpture and Pottery: Collection of Arthur N. Seiff."

Perhaps the most far-reaching impact of Father Tony's early collection development efforts was the 1968 cultivation of two important Chicago art collectors who became members of the gallery's Advisory Council, James W. and

Marilynn Alsdorf. They played important roles in the enrichment of the Snite Museum's collection in general and in the spectacular growth of the Pre-Columbian area in particular, from 1980 to 2005.

Upon my arrival in November 1979, I realized there was an opportunity to reinforce the University faculty's numerous pedagogical, intellectual, and service-oriented interests in Latin America by expanding the Pre-Columbian collections. Although Notre Dame boasts alumni from every nation in Latin America, the level of faculty involvement in the history, politics, commerce, and language of Mexico indicated that increasing the collection of ancient, historic, and modern Mexican arts would serve the faculty and students particularly well. Ancient Mexico was the largest part of a culture area known today as Mesoamerica—a region that also includes modern-day Guatemala, Belize, and parts of El Salvador and Honduras—and so my first priority evolved into assembling the best possible collection of Mesoamerican art.

It seemed logical to begin at the beginning by acquiring works from the Olmec civilization, the mother culture of Mesoamerica. By 1500 B.C. the Olmec had established a trading empire that spread their cultural template throughout Mesoamerica. The Teotihuacan, Toltec, and Aztec civilizations, as well as the Veracruz, Maya, and other cultures, evolved their own cultural traditions based upon the Olmec model until the Spanish conquest of Mexico in A.D. 1521. The location of the Museum directly across the street from the football stadium suggested that a strong emphasis on the art of the ancient religious athletic event known as the ritual ballgame—both the figurines and the stone sculptures used as equipment and ritual paraphernalia—from all periods of Mesoamerican history would

By 1500 B.C. the Olmec had established a trading empire that spread their cultural template throughout Mesoamerica. The Teotihuacan, Toltec, and Aztec civilizations, as well as the Veracruz, Maya, and other cultures, evolved their own cultural traditions based upon the Olmec model until the Spanish conquest of Mexico in A.D. 1521.

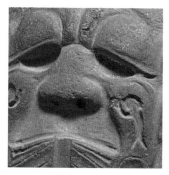 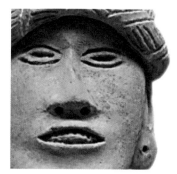

be appropriate. After all, the roots of every European kickball game and American football lie in the bouncing ball and the concept of playing as a team that were introduced to European sports by Aztec ballplayers competing in exhibition games in Spain in 1528.

Finally, it occurred to me that most scholars, students, and visitors are primarily interested in things they can relate to, and that a superb collection of ceramic figurines—images of men, women, and gods—would help visitors identify with the artists and cultures in the collection. Because the Olmec initiated the use of figurines in Mesoamerica, and because figurines of Olmec rulers dressed as ballplayers are among the earliest examples of Mesoamerican art, the various concepts became unified in an irresistible way.

This unified-field theory of collecting, combined with repeated opportunities to purchase carefully selected groups of objects from some of the finest private collections in the country, in addition to generous donations of pieces from them and from other important collectors, has increased our holdings with large numbers of superb pieces, reinforced our strengths, and provided a firm foundation for research in Olmec art, figurines, and the ritual ballgame. The establishment of the Rev.

Edmund P. Joyce, C.S.C., Collection of Ritual Ballgame Sculpture in 1987, to honor Father Ned Joyce upon his retirement, was another powerful force in collection development. Father Ned, a Mesoamerican born in Honduras in 1917, served as executive vice president of the University of Notre Dame and chair of the Faculty Committee in Charge of Athletics from 1952 to 1987.

Recent additions such as the 192-piece Aztlán collection and 97 Preclassic figurines from the Jay Leff collection have ensured that the Museum holds the finest grouping of Olmec art in the United States, as well as the finest exhibition of figurines. Over time, collection development has expanded beyond Mesoamerica, producing the only exhibit of Argentine Pre-Columbian art in the United States, new collections of Colonial and Independence-period painting and sculpture, and a 160-piece collection of nineteenth- and twentieth-century Bolivian textiles. These works join small but fine collections of Pre-Columbian Central and South American art and twentieth-century Latin American art begun by Father Tony. My twenty-six years of collecting have built upon his solid foundation and have provided me with the most gratifying aesthetic and intellectual experiences of my life. DEB

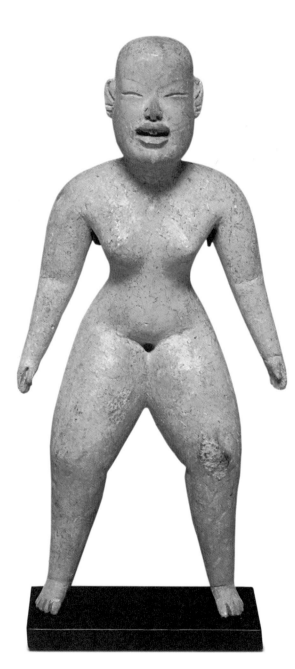

STANDING FEMALE BALLPLAYER FIGURINE, Early Preclassic period, first phase, 1500–1300 B.C.

This ballplayer figurine is a true masterpiece, the finest known standing female in the Olmec solid figurine tradition. Like most masterpieces, it breaks many of the stylistic conventions of its time. The curves and tapered volumes of the arms, legs, and torso combine with a forward-thrusting head to give the figure a sense of restrained energy, negating its static frontal pose. Visual balance among the body elements—the broad flat head, the torso and thighs, and the negative space between the legs—creates an impression of monumentality.

Some Olmec aesthetic conventions are maintained in the figurine, including a high female waist located immediately below the ribcage, slightly flexed knees, and a superbly executed face. The up-turned upper lip, slightly down-turned mouth, and gracefully incised eye curves are all classic Olmec features. A T-shaped arrangement of teeth links this elite woman to the Sun God, who is characterized by a similar dentition.

The figurine's excellent state of preservation is remarkable. Deep cavities in both the groin and sacroiliac allowed moisture in the thickest portions of the clay to escape, preventing it from exploding during firing. Nonetheless, trapped moisture appears to have caused small areas to flake off both thighs. The face and ears are completely intact and the body is unbroken, although the toes have been restored.

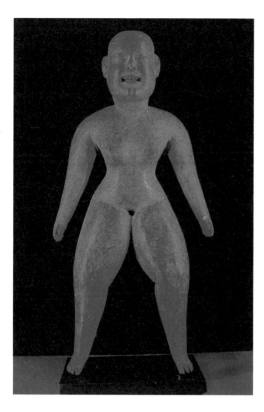 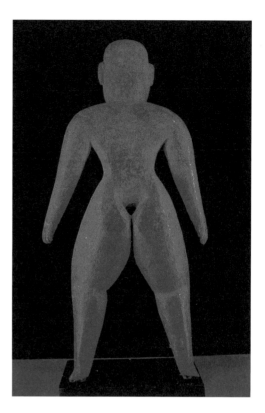

Ultraviolet light reflective photography reveals faded soul paint on the figurine. Soul paint is organic juice that was painted on the fronts and backs of all Mesoamerican human figurines and figures from Olmec to Aztec times—a period of three thousand years. After so many centuries in the ground, it is no longer visible to the naked eye. Research at the Snite Museum has determined that the pattern on the front of the figure mimics the circulatory system, symbolizing life and the body-warmth aspect of the Mesoamerican soul. The design also represents the body of the Great Goddess, the Mesoamerican deity who was the mother of all humans and who gave them their souls before birth. On the back, another pattern resembles a stylized butterfly or bird, a Mesoamerican

symbol for the soul of a deceased person. A life/death duality such as this was created on every figurine, perhaps to activate it for a specific purpose.

Also visible with ultraviolet light are a faded ritual ballgame buttocks belt, or loincloth, and faded padding running down the left thigh, which would have protected the leg used to hit the ball. Red pigment remains in varying degrees on the body's action points, as well—eyes, ears, nose, mouth, back and top of head, neck, limb joints, and groin. DEB

Olmec culture
Las Bocas, Puebla, Mexico
slipped and painted earthenware
7 x 3.5 x 1.5 inches (17.8 x 8.9 x 3.8 cm)
Acquired with funds provided by Mrs. Dorothy Griffin
2001.037

SEATED MALE FIGURINE
Early Preclassic period, 1500–1300 B.C.

This seated male figurine is among the most refined and elegant Olmec ceramic sculptures. Its appearance in the 1966 Jay Leff exhibition at the Brooklyn Museum made it important in the introduction of Pre-Columbian art to the U.S. public. Its cream slip, caplike hair, and delicate facial features—especially the slit and punched ovoid eye orbits and pursed lips—are hallmarks of the Las Bocas style. The animation of the pose is common in ceramic depictions of seated Olmec rulers and may refer to typical arm gestures they used while communicating with the spirit world in drug-induced states. The stylized attenuation of the hands and feet and the use of red paint on them and on other body parts that move are also characteristic features.

Las Bocas (the Mouths) comprised a group of ancient Olmec and Tlatilco trade centers situated near the junctures of the mouths of several valleys in west central Puebla. The area straddles the headwaters of the Balsas River, an important Olmec trade avenue to Guerrero and the south coast of Mexico. Las Bocas was uncovered in the late 1950s when Mexico was expanding its interstate highway system. DEB

Olmec culture
Las Bocas, Puebla, Mexico
slipped and painted earthenware
2.75 x 2.25 x 1.38 inches (7 x 5.7 x 3.5 cm)
Acquired with funds provided by
　Mrs. Dorothy Griffin
2005.001.001

Olmec culture (opposite page)
Las Bocas, Puebla, Mexico
slipped and painted earthenware
2.13 x 4.75 x 2 inches (5.4 x 12.1 x 5.1 cm)
Acquired with funds provided by
　Mrs. Dorothy Griffin
2005.001.002

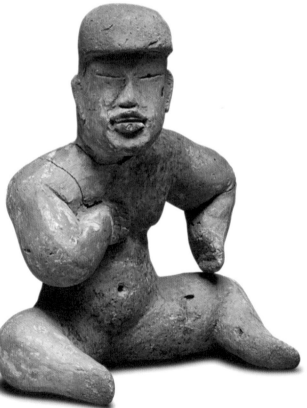

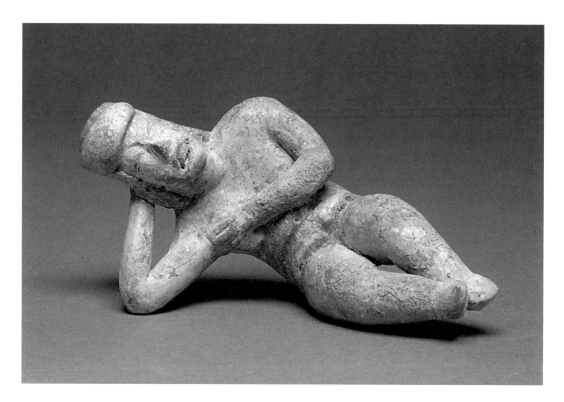

RECLINING FEMALE FIGURINE, Early Preclassic period, 1500–1300 B.C.

Reclining female figurines in ceramic and stone from the Preclassic period are rare, and they never occur after its end in A.D. 250. Nonetheless, the vast majority of those that exist are readily identifiable as one aspect of the Great Goddess as an aged mother. This interpretation is reinforced here by the folds of skin that laterally crease the stomach and the central crease that extends vertically above the groin, indicating stretch marks due to repeated childbearing.

Although broken and restored, this figurine's quality has ensured its prominence among all the examples of its type. The diagonal posture of the body elevates the head and pushes the face forward, offsetting the legs. In addition, the repetitive arcs of the left shoulder and the thighs balance the negative space created by the right side of the torso and right arm, giving the body an undulating, almost serpentine effect. This position would be uncomfortable to maintain for any length of time, but it serves the sculptor's intent to depict a languid pose. The inclusion of this piece in the 1965 "Jaguar's Children" exhibition was one of the rare instances in which Jay Leff lent to exhibitions involving other collectors. DEB

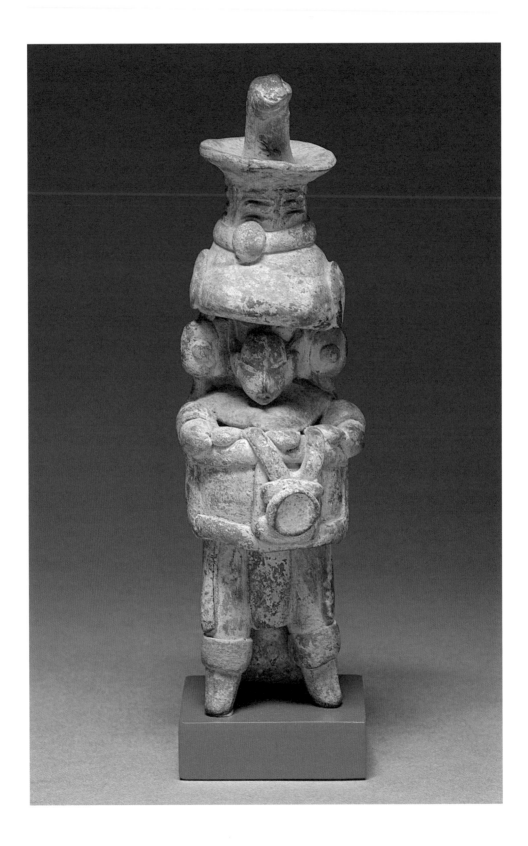

RULER BALLPLAYER WEARING CORN GOD DUALITY MASK, PILLI TYPE
Early Preclassic period, Ayotla phase, 1500–1300 B.C.

Among the earliest Olmec ceramic figurines are Chicharrus phase ruler ballplayers dressed as Corn God priests, from San Lorenzo, Veracruz, Mexico, and this Pilli type, from Tlapacoya, Valley of Mexico. The religious athletic event in which a solid rubber ball was volleyed between two sides was already ancient at the beginning of Olmec times. Ritual ballgame equipment defined the royal person in these first images of kings; it symbolized the king's participation in a ballgame in which he defeated the gods of death and drought in order to deliver fertility to his people. The sculptural quality of this masked figurine, its size, and its state of preservation declare it the finest of truly excellent surviving examples.

Corn was the Olmec symbol of fertility and was usually depicted in three parts: a seed kernel with two sprouting leaves or a seed with a single sprout and an encircling band. This ruler ballplayer's complex fertility role is emphasized through the constant repetition of corn seed symbols in groups of three elements down the entire length of the figurine. Sets of three large and small roundels circling the lower brim of the headdress represent corn seeds. A triangular breast-covering hangs over the padded ballgame belt, the belt itself is divided into three sections on the front, and a three-element loincloth hangs down to the figure's knees. Also, his very stance is a tripod.

Even the red and cream duality mask covering the lower face and the ear spools that flank it are symbolic corn seeds. Duality—the depiction of opposing states of existence in one image—is basic to Olmec religion, because it expresses the poles of human experience: life/death, youth/age, human/deity. The mask and the mirror hanging over the belt also signify rulership, and the mirror's flashing brilliance links the ruler directly to the Sun God. The red register near the top of the headdress repeats the hand/paw/wing design of the Earth Dragon, the Olmec supreme deity of earth and sky, and symbolizes fertility. A silk tassel from a mature ear of corn tops the sculpture. Identical corn and political symbolism is found on major stone monuments from Veracruz and Tabasco, the Olmec homeland, demonstrating that the meaning of this iconography was the same everywhere in the Olmec world and was passed down to later peoples as part of the Olmec cultural template.

The ritual ballgame padded belt, armbands, and leg bands are similar to the belts and yokes worn by ballplayers of succeeding cultures, and the tripartite loincloth is a basic costume feature of Maya kings two thousand years later. Although these figurines of priests and kings bear the most important Olmec symbols of religious and political power, they are always found deliberately broken, usually in trash heaps. This suggests that they served specific functions connected to fertility, during which their power was ritually consumed, and afterward they were discarded. DEB

Olmec culture
Tlapacoya, Mexico, Mexico
slipped and painted earthenware
8.25 x 2.13 x 2.13 inches (21 x 5.4 x 5.4 cm)
General Endowment in honor of Rev. Edmund P. Joyce, C.S.C.
1987.006

RULER/SERPENT TRANSFORMATION FIGURE
WITH SERPENT TONGUE ON CHIN
Early–Middle Preclassic periods, 1500–300 B.C.

This elegant figure displays the Olmec penchant for intricate facial detail and bilateral symmetry. The open mouth reveals a human tongue, but a forked serpent tongue extends down the chin. This links the figure with four other known portable stone sculptures that illustrate the transformation of a human into the serpent deity who would be known to the Aztecs as Quetzalcoatl—the Feathered Serpent or Precious Twin, god of war, fertility, and the planet Venus. The diamond-shaped pose of the figure's legs refers to the four-point star, a symbol of the serpent aspect of the Olmec Earth Dragon, a caiman/harpy-eagle composite being who is the supreme lord of earth and sky. The posture of the arms recalls another transformation pose, in which the ruler prepares to transform himself into a jaguar to communicate with the spirit world. A royal ballplayer's helmet of jade beads laced together is identical to those found on Olmec colossal heads from Veracruz and Tabasco, and the hands display an important gesture of Olmec rulership—right hand palm up and left hand palm down—found on monumental stone figures of rulers. DEB

Olmec culture
Veracruz(?), Mexico
serpentine, with traces of pigment
3.63 x 2.63 x 2.63 inches (9.2 x 6.6 x 6.6 cm)
Museum purchase by exchange, Mr. and Mrs.
 William J. Doran, Mr. and Mrs. J. Moore
 McDonough Endowment for Art of the
 Americas, Rev. Anthony J. Lauck, C.S.C.,
 Sculpture Endowment, Mr. and Mrs. J. W.
 Gillon, Mr. and Mrs. Richard Beech, Mr.
 and Mrs. Douglas Kahn
1998.029

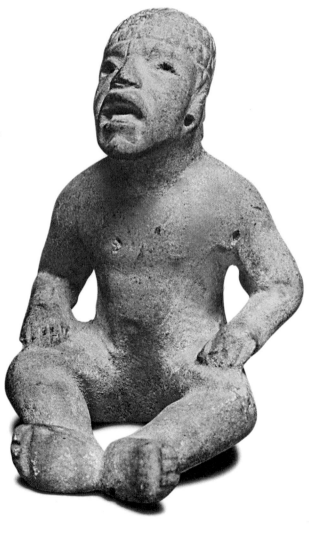

STANDING FIGURE OF A RULER
Middle Preclassic period, 1000–600 B.C.

Olmec figural sculpture conveys the impression of monumentality even in small works by combining complete technical mastery of hard green stones with frontal presentation and bilateral symmetry. Almond-shaped eyes, an up-turned upper lip, and a down-turned mouth create a classic Olmec face on this figure. Yet the shape and other details of the face emphasize the ruler's individuality. The extended-arms gesture is an Olmec pose of rulership.

Serpentine is almost as hard as steel and is fitting for the image of a ruler who is the link between his people and the gods. Additionally, green is the symbolic color of fertility, a ruler's major earthly concern. This straight-grained stone is equally dense throughout the figure, and the lines of grain were carefully worked to create bilateral symmetry. The equal density of the grain allowed the artist to locate the center of gravity and carve the figure so that it stands balanced on its own two feet, even though the feet are rounded. This perfect balance illustrates the artist's virtuosity. Although the inlays that originally animated the eyes, ears, nose, and mouth are lost, figures as complete as this one are rare. DEB

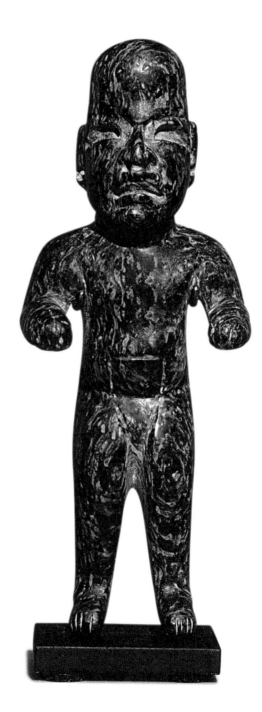

Olmec culture
Veracruz, Mexico
serpentine, with traces of pigment
5 x 2 x 1 inches (12.7 x 5.1 x 2.5 cm)
Acquired with funds provided by the Mr. and Mrs. J. Moore
 McDonough Endowment for Art of the Americas
1992.018

BOTTLE WITH INCISED EARTH DRAGON EYE AND FLAME EYEBROW
Early Preclassic period, first phase, 1500–1300 B.C.

This bottle combines an elegant form with two of the preeminent features of Olmec ceramics: superb control of firing and precisely incised decoration. The slightly flaring neck balances the lower container and is shaded from rich gunmetal black to the light gray of the ceramic slip. This coloring was achieved by applying a wax or resin resist to the upper quarter of the neck and a diluted resist solution to the second quarter, then firing the vessel in a reduction atmosphere that produced a black surface.

Beginning in Olmec times, Mesoamerican cultures traditionally represented the supreme deity of both earth and sky as a dragon whose eye was modeled on the plumage of the harpy eagle, symbol of the sun. Mountains and valley were the dragon's scales, and caves were its many mouths leading to the underworld.

Olmec culture
Las Bocas, Puebla, Mexico
slipped and painted earthenware
8 x 5.63 inches (20 x 14.3 cm)
Acquired with funds provided by the
 Mr. and Mrs. J. Moore McDonough
 Endowment for Art of the Americas
1999.019.010

Olmec culture (opposite page)
San Lorenzo, Veracruz, Mexico; found in
 Puebla, Mexico
Calzadas Carved slipped earthenware
2.13 x 5.5 inches (5.4 x 13.97 cm)
Acquired with funds provided by the
 Alsdorf Foundation
1993.060.006

The Earth Dragon was often represented on sculptures and ceramics by its flame eyebrow and eye. Incised bottles are rare in the Olmec ceramic inventory, and this profile of the deity's eyebrow and eye is unusual because it combines thick incised lines often seen on vessels from Mexico's central highlands with cross-hatching and a pendant line below the eye, which are features of early vessels from the Olmec heartland, Veracruz and Tabasco. DEB

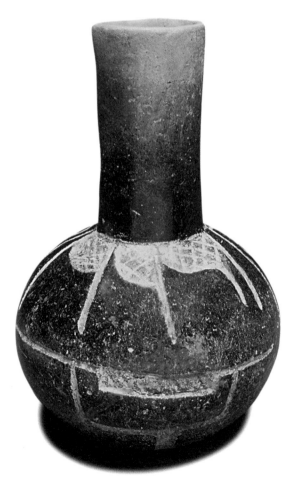

BOWL WITH EARTH DRAGON FLAME EYEBROW AND EYE MOTIF
Early Preclassic period, first phase, 1500–1300 B.C.

Recent research has revealed that certain types of ceramics were made in the earliest known Olmec city, San Lorenzo, Veracruz, and traded throughout Mesoamerica, where they became highly prized for their prestige value. In Olmec Veracruz they are found in household refuse and trash heaps, as one would expect of typical wares put to daily use, but in the rest of Mesoamerica they are found in elite burials or as offerings to deities. Among these types is Calzadas Carved, a polished, quartz-tempered earthenware that was fired to buff, brown-gray, and black colors. It is characterized by broad channeling used to carve motifs of classic Olmec iconography in the sides of vessels before firing.

This bowl, with its lustrous, gunmetal black surface, is a rare example of the beauty of Olmec blackware ceramics. Probably all Olmec blackwares were intended to look like this one, but most surfaces are clouded, eroded, or destroyed by the action of groundwater. The Earth Dragon's flame eyebrow and eye, symbols of his dominance of the sun and sky, are flanked here by two equal-armed crosses, references to his dominion over the earth. The eyebrow elements increase in size from the back of the eye to the front, a typical profile view. DEB

BOWL IN THE FORM OF A HALVED CALABASH
Early Preclassic period, 1500–1000 B.C.

Calabash gourds cut in half have served as bowls or dippers in Mesoamerica for thousands of years, well before the advent of ceramics. Cultivation of the gourds is part of the shared behavior that defines Mesoamerica as a homogenous culture area. Binding them or exerting sustained pressure on them when they are green and still growing produces a variety of shapes useful in cooking and in other household tasks.

This elegant vessel is one of the finest surviving examples of a ceramic bowl in the form of a calabash. It even exhibits the half star that would have remained from a stem's attachment in the center of an actual gourd. Half stars also symbolize the presence of the Serpent God, an aspect of the Earth Dragon who was patron of the planet Venus, war, and fertility and who would be known to the Aztecs as Quetzalcoatl. Crossed bands in each half star found on the sides of this vessel reveal the presence of the Earth Dragon himself. A dimple in the underside is an extremely unusual feature of Olmec ceramics. One end of the bowl is pierced twice to hold a string loop for hanging and draining the bowl. DEB

BOWL WITH BOUND CODEX AND OTHER OBJECTS
Early Preclassic period, 1500–1000 B.C.

P*illi* is a Nahuatl word that means noble, and it perfectly fits the beautiful, rich white surfaces of some of the ceramic wares produced at the Olmec trade outpost of Tlapacoya, located on an island in Lake Chalco in the southeast corner of the Valley of Mexico. For several decades, the small group of locally made vessels that comprise the Pilli White inventory has been known for its high-quality depictions of classic Olmec iconographic themes typically found on hard greenstone sculptures, not on ceramics.

The motif incised on one side of this vessel—plain and crosshatched layers bound together with a strap—is the earliest depiction of a book in Mesoamerican art. The image represents a codex, a bark-paper or deerskin book whose pages were plastered and then written or painted upon. The artist divided the bowl's exterior into three decorative zones with bundles that may represent leaves of the maguay, or century plant. Depicted in the other two zones are a netted bag with a ritual enema symbol below it, and a bone bound to a netted form with a netted strap. Both bear a strong resemblance to Maya glyphs used two thousand years later. DEB

Olmec culture
Tlapacoya, Mexico, Mexico
Pilli White slipped earthenware
4.5 x 5.25 inches (11.4 x 13.3 cm)
Acquired with funds provided by the Alsdorf Foundation
1993.060.007

Olmec culture (opposite page)
Puebla, Mexico
slipped earthenware
3.63 x 8.38 x 5 inches (9.2 x 21.3 x 12.7 cm)
Acquired with funds provided by the Alsdorf Foundation
1993.060.008

SELLO WITH EARTH DRAGON FLAME EYEBROW, BLOOD GLYPH, AND 3-BRACKETS DEITY GUM/MOUTH

SELLO DEPICTING THE GREAT GODDESS GIVING BIRTH TO HERSELF
Early Preclassic period, first phase, 1500–1300 B.C.

Sello is the Spanish word for a printing stamp, either cylindrical or flat. Dating from as early as 1500 B.C., *sellos* provide evidence that the Olmec combined two forms of technology—rotary printing and papermaking—to produce roller-printed images for the first time in human history. Most *sellos* are ceramic and have one or more design motifs, which were cut into them before firing. When the *sellos* are inked and rolled over a padded flat surface of paper, cloth, or skin, the designs can be printed once or repeatedly.

Paper is traditionally made in Mesoamerica today by pounding the inner bark of the fig or mulberry tree with a stone or wooden mallet. As the hard object hits the bark, the thickness is reduced and the surface area expands. Direct evidence for papermaking in the Early Preclassic period is scant, but one stone mallet has been excavated from the beginning of the Middle Preclassic period, 1000 B.C. The shortage of earlier evidence is probably due to insufficient archeological excavation.

One of these *sellos* is carved with the Earth Dragon's flame eyebrow and eye, a blood glyph, and 3-shaped brackets. The structure of the design perfectly parallels a month sign and a year sign inscribed as an anniversary date on the earliest dated monument in Mesoamerican art with a written text, *La Mojarra Stela 1*, dated A.D. 162. Combined with many other examples, this presents strong evidence that the Olmec had invented writing and used *sellos* to print it by 1500 B.C. A padded rod or stick would have been passed through the center of this *sello* to roll it during printing.

The second *sello* has handles on the side and would have been rolled like a rolling pin. It depicts the Great Goddess giving birth to herself, a potent image of fertility. A stylized version of this image of the goddess was painted on the front of every figurine made in Mesoamerica for over three thousand years. Mesoamericans believed that the Great Goddess was the mother of all humans and that she and her consort, the Old Fire God, kindled the body-warmth aspect of the soul in the breast of every fetus two weeks before delivery. Thus, her image is a logical representation of that aspect of the soul. DEB

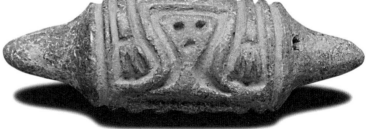

Olmec culture
Las Bocas, Puebla, Mexico
earthenware, with traces of pigment
.002: 2.38 x 1.63 inches (6 x 4.1 cm);
 .001: 6.38 x 2 inches (16.2 x 5.1 cm)
Acquired with funds provided by the
 Mr. and Mrs. J. Moore McDonough
 Endowment for Art of the Americas
 and the Fotsch Foundation
1999.006.002 and 1999.006.001

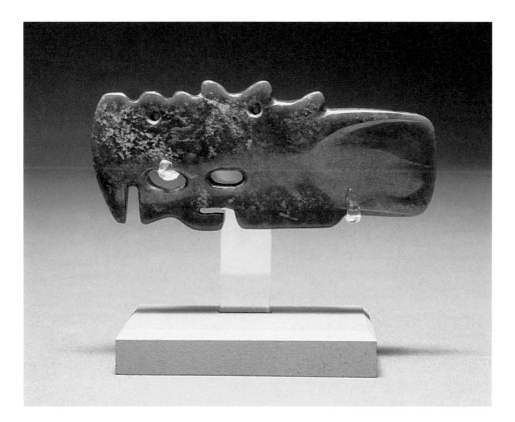

SUN GOD EFFIGY RITUAL BLOODLETTER HANDLE
Middle Preclassic period, 1000–600 B.C.

Olmec rulers used ritual bloodletters to perforate their penises and other soft body tissues to make personal blood sacrifices. Their offerings contained portions of their own souls, which fed the gods and thereby sustained the course of the universe. Personal bloodletting was a reciprocal relationship that nourished the gods who had given their own lives to create the world. Blood from the most fertile part of the ruler's body contained the most potent part of his soul.

This bloodletter handle is formed in the profile of a harpy eagle, a sacred image of the Sun God, an aspect of the Earth Dragon. It is a wonderful example of Olmec jadeite sculpture that refers directly to the generation and maintenance of fertility through its blue-green color. The recurved beak and string-sawn open mouth of the raptorial bird emerge on the left; the upper edge reveals creases in the beak, as well as nostril and eye perforations. Behind these perforations is the harpy eagle's erect head plumage, the symbolic flame eyebrow of the Sun God. A sharp point that protruded from the right side of the handle was broken off in ancient times, and the break was reworked. DEB

CORN GOD EFFIGY YUGUITO
Early–Middle Preclassic periods, 1500–300 B.C.

This superb *yuguito*, carved in the effigy of the Corn God, is a stone model of a ritual ballplayer's kneepad. It may be a trophy, since it is too narrow to fit a knee and has no means of attachment. The *yuguito*, or "little yoke," is a rare form confined to Olmec times.

The Corn God is identified by a corn kernel in the center of his forehead and two corn dots flanking his mouth. The dots have forked roots, and slender shoots grow up beside them. They are the clearest images of sprouting and rooting corn in Olmec art. Gods, like rulers, offered personal blood sacrifices, and the central trough below this god's down-turned mouth symbolizes the mutilation of his tongue to feed his fellow deities with his own soul in the blood. Stylized blood scrolls flank the wound.

On the back of the head is a T-shaped emblem similar to that found on many stone portraits of rulers. The crossbar contains an image of a deity wearing a sprouting-corn headdress and giving the extended-arms gesture of rulership; the upright contains the crossed bands of the Earth Dragon and, across the bottom, a fan of feathers. The original inlays and paint are now missing. DEB

Gods, like rulers, offered personal blood sacrifices, and the central trough below this god's down-turned mouth symbolizes the mutilation of his tongue to feed his fellow deities with his own soul in the blood.

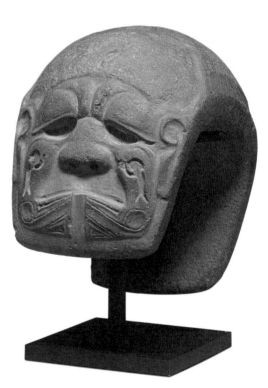

Olmec culture (opposite page)
Guerrero, Mexico
blue-green jadeite
1.5 x 4.5 x .25 inches (3.8 x 10.8 x .6 cm)
Gift of Mr. and Mrs. William B. O'Boyle
1991.063.004

Olmec culture
Pacific slope of Mexico/Guatemala
basalt
6 x 6 x 6 inches (15.2 x 15.2 x 15.2 cm)
Acquired with funds provided by Mr.
 Michael G. Browning (Class of 1968)
1988.014

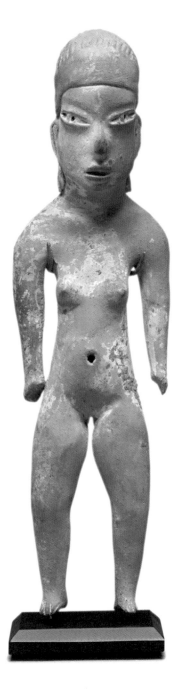

STANDING FEMALE FIGURINE
Early Preclassic period, second phase,
1300–1000 B.C.

One of the most elegant and haunting human images from Tlatilco culture is this standing female figurine. The stylized naturalism of the face and elongated head combines with a broad neck, sloping shoulders, and hanging arms to create a foil for the slender hourglass torso, swelling hips, and tapering legs. Attenuation was not an aesthetic ideal at Tlatilco—solid, plump bodies were much preferred—and it probably was not on the artist's mind when this piece was being created. However, wide variations existed in the Tlatilco style, and attenuation seems to have emerged occasionally in an artist's work as one of many possible ways to treat a subject.

Sometimes when an artist breaks the rules and goes against aesthetic conventions, as this artist did, the result is a tremendous contribution to the world of art, even if the breakthrough is never repeated. Jay Leff's inclusion of this sculpture in the 1965 "Jaguar's Children" and 1966–67 Brooklyn Museum of Art exhibitions of his collection ensured that it would become a defining image of Tlatilco culture. DEB

Tlatilco culture
Mexico, D.F., Mexico
slipped and painted earthenware
5.38 x 1.63 x .88 inches (13.7 x 4.1 x 2.2 cm)
Acquired with funds provided by Mrs. Dorothy Griffin
2005.001.014

Tlatilco culture (opposite page)
San Luis Tlatilco, Mexico, D.F., Mexico
slipped and painted earthenware
5.25 x 2 x 1.25 inches (13.3 x 5.1 x 3.1 inches)
Acquired with funds provided by the Lake Family
 Endowment
2000.017.001

STANDING FEMALE FIGURINE WITH BLACK-AND-WHITE DUALITY BODY PAINT, TYPE D4
Early Preclassic period, 1300–1000 B.C.

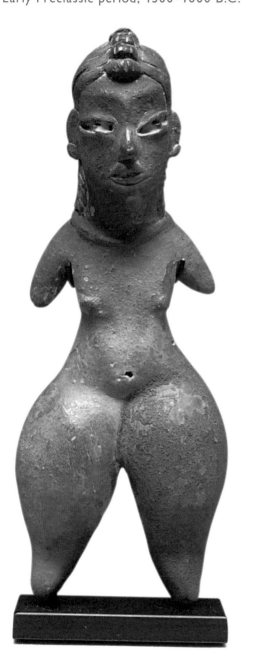

Tlatilco culture was a regional religious expression of the Valley of Mexico and the central Mexican highlands named after a site in the northwest corner of Mexico City. The area was an Olmec port of trade on a route that extended across the Valley of Mexico. Its inhabitants made Olmec-influenced figurines and ceramic vessels that included imagery of the Great Goddess. They buried these objects with their dead under the floors of their homes and compounds.

This finely modeled figurine's duality body paint is unusually well preserved. Fingerprints indicate that all the paint was applied at one sitting, without time to dry. The limbs and body are quartered just above the navel (right leg, left chest, and left arm are cream; left leg, right chest, and right arm are black). The artist covered the entire face with red, then painted black and white on the right and left sides. Double-wedged eyes with central punch marks distinguish Type D4, an archaeological classification, from the rest of the D group figurines.

In 1966 Arthur N. Seiff lent a large exhibition of Mesoamerican art, including this piece, to Father Anthony Lauck's O'Shaughnessy Art Gallery at Notre Dame. This figurine returned to campus as a purchase in 2000. DEB

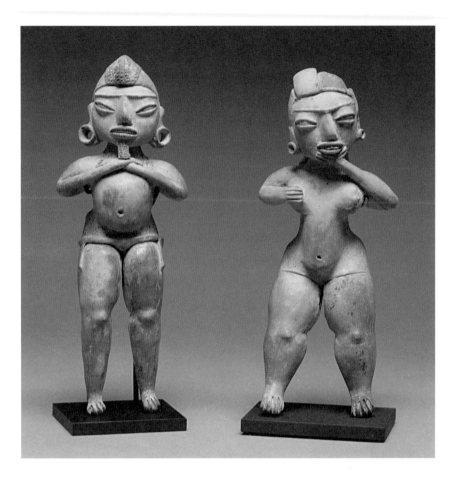

PAIR OF STANDING OLD GOD BALLPLAYER AND FEMALE FIGURINES
Early Preclassic period, 1300–1200 B.C.

This pair of figurines likely represents a transitional style. The massing and balancing of each figure's body parts create a dynamic plasticity found only in the first phase (1500–1300 B.C.) of the Early Preclassic period. However, the style of the figures is characteristic of Tlatilco culture from the state of Puebla in the second phase (1300–1000 B.C.). Exaggeration of the front and back of the torsos thrusts the features out toward the viewer, yet all the forms are held together under tautly stretched skins. The result is the finest known examples of this local Puebla style.

The Old God, or Old Fire God, is the quintessential Mesoamerican ballplayer. He is defined by his crest of hair, beard, wrinkles, and humpback. His ballplayer status is indicated by the buttocks belt cinched around him to ease the sting of the ball's impact. No known traits identify the female as the Great Goddess, but she would be the Old God's logical companion. The slit between her legs and the lines flanking her groin may have held cloth costume elements. The meanings of each figurine's hand gestures are unknown, but the female's motion toward her breast suggests a fertility connotation. DEB

STANDING HOLLOW FEMALE WITH DISPLAYED DEITY BODY PAINT AND INCISION ON HEAD
Early Preclassic period, 1300–1000 B.C.

Folded over the headdress of this figure are the incised torso and limbs of the Displayed Deity, an aspect of the Great Goddess first identified at the Snite Museum in 1990. The narrow red torso of the deity ends on the forehead in a triangle pierced by a firing vent, which represents a kernel of *teocinte*, a triangular symbol of fertility linked to the Olmec concept of the threeness of corn. The goddess's arms extend over the figure's brow to the sides and join the legs over the ears; red *teocinte* hands and feet are detached from the limbs and flank the deity's torso at both front and back. The arms and the central *teocinte* kernel form a headband for the figurine, whose face may be read as the head of the deity turned upward. On the back, the torso ends in a cleft, indicating that the deity is female.

Red-slipped brownware characterizes Tlatilco large, hollow figurines and vessels. This sculpture defines the aesthetic ideals of the style. The careful swelling of the legs from the feet to the rounded groin, the tapering of the torso, and the mastery of the triangular head show complete command of the medium. DEB

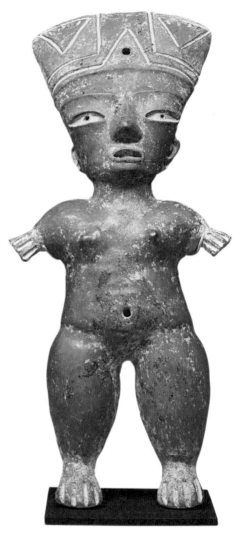

Tlatilco culture (opposite page)
Puebla, Mexico
slipped and painted earthenware
.022: 6.88 x 2.5 x 1.5 inches (17.5 x 6.3 x 3.8 cm);
 .023: 6.5 x 2.88 x 2.13 inches (16.5 x 7.3 x 5.4 cm)
Acquired with funds provided by Mr. and Mrs. Judd
 Leighton
1990.012.022 and 1990.012.023

Tlatilco culture
Morelos, Mexico
slipped and painted earthenware
15.75 x 7.38 x 4 inches (40 x 18.7 x 10.1 cm)
Acquired with funds provided by Mr. and Mrs. Judd
 Leighton
1990.012.030

SEATED GREAT GODDESS FIGURINE WITH MISSING MOVABLE ARMS
Middle–Late Preclassic periods, 500–200 B.C.

The southern coastal zones of Chiapas, Mexico, and Guatemala were crisscrossed by active Olmec trade routes from the earliest times, and by 900 B.C. Kaminaljuyú was one of the most important trade centers in the region. Important features of Proto-Maya culture evolved there in the Las Charcas and Provedencia cultures before expanding northward over the Guatemalan highlands and into the Peten and Yucatán Maya areas.

This delicate seated figurine is a prime image of the Great Goddess as mother of all humanity—a stoop-shouldered, aged woman whose belly is stretched and rounded by numerous childbirths and whose breasts have shrunken and fallen. She is the Earth Mother who ignited the fire of body warmth in the soul of every

Mesoamerican and whose image is painted on every Mesoamerican figurine, including this one, in organic paint that has now faded to invisibility. This piece is very similar to a more famous figurine of the Great Goddess in the National Museum of Guatemala, *La Muñeca Kidder*, which is three times larger in size. The movable arms on both are missing, but the survival of movable limbs on figurines or stone figures is an extremely rare feature in Mesoamerican art. DEB

This seated figurine is the Earth Mother who ignited the fire of body warmth in the soul of every Mesoamerican and whose image is painted on every Mesoamerican figurine, including this one, in organic paint that has now faded to invisibility.

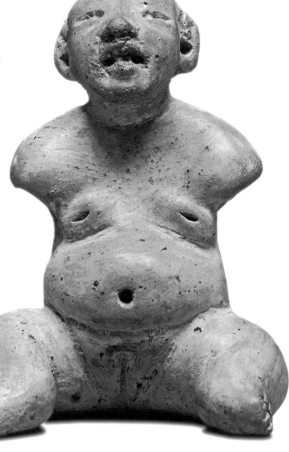

SEATED SUN GOD
Protoclassic period, 300 B.C.–A.D. 250

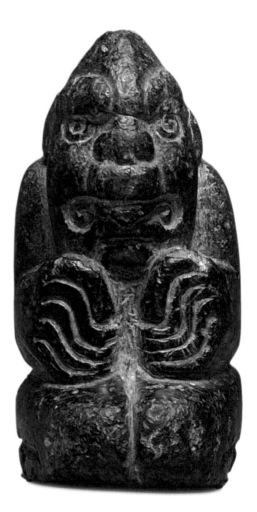

Izapa culture was a transition between the
Olmec civilization and later cultures that
developed in the Gulf coast lowlands, the
Isthmus of Tehuantepec, and the Pacific slope
of Mexico and Guatemala. The use of a black
stone to represent the Sun God is a typical
Olmec and Mesoamerican visual pun or joke.

The elegantly curved hands of this compact
sculpture hark back to representations of the
Olmec hand/paw/wing motif, representing
the Earth Dragon, and the precisely carved face
and head recall Olmec solar iconography in the
flame eyebrows and T-shaped teeth found on
gods and rulers. This figure's flame eyebrows
are elaborated into a classic Olmec depiction
of duality: the right one is subrectangular and
the left one is scalloped, suggesting two differ-
ent aspects of the solar deity. The Izapa used
the scroll descending from the top of the eye to
identify the Sun God during the day, and that
became the standard Maya convention. DEB

Provedencia culture (opposite page)
Kaminaljuyú, Guatemala
slipped and painted earthenware
3 x 2.25 x 1.75 inches (7.6 x 5.7 x 4.4 cm)
Acquired with funds provided by
 Mr. and Mrs. Judd Leighton
1990.012.007

Izapa culture
Mexico/Guatemala
painted steatite
3.25 x 1.75 x 2.5 inches (8.2 x 4.4 x 6.3 cm)
Acquired with funds provided by the Rev. Anthony J.
 Lauck, C.S.C., Sculpture Endowment and the Mr.
 and Mrs. J. Moore McDonough Endowment for
 Art of the Americas
1997.067

STANDING FEMALE FIGURINE WITH LONG INCISED SKIRT
Terminal Preclassic period, 250 B.C.–A.D. 250

Most human figural sculpture from the West Mexican cultures of Jalisco, Colima, and Nayarit is not solid but hollow, and not flattened but voluminous. The stylization and flattening of this figurine have created an atypical image that is very sympathetic to modern aesthetic sensibilities yet retains core elements of Jalisco style.

A head constricted at the temples is a typical feature of Jalisco figural sculpture. However, the expansion of this cranium into a fan shape, as well as the elongation of the lower face, exaggerate that trait and create a perfect counterpoint to the squared and flattened upper torso. The sash that diagonally divides the torso pushes out the breasts and, along with the head, creates a powerful asymmetry that draws the viewer's eyes all over the sculpture.

The swelling tummy emphasizes the upper edge of the skirt, which is decorated by zigzag punctations and incised lines. Much West Mexican figural sculpture is painted after firing, but the punched and incised textures of this skirt balance the projection of the head and torso in a way that paint could not. The result is a small but powerful sculpture that gives the impression of monumentality. DEB

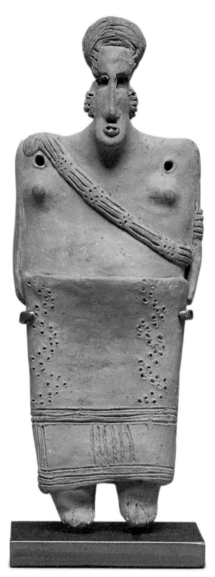

Jalisco culture
Jalisco, Mexico
slipped earthenware
5.25 x 2 x .75 inches (13.3 x 5.1 x 1.9 cm)
Acquired with funds provided by Mr. and
 Mrs. Anthony J. Unruh
2004.014.018

STANDING FEMALE BALLPLAYER FIGURINE WITH INCISED THIGHS
Terminal Preclassic period, 300 B.C.–A.D. 250

Colima, a West Mexican culture, has a rich and varied tradition of solid ceramic figurines that exhibit a variety of shapes and styles. The Autlán style has a distinctive almond-shaped eye form with a central slit, as well as elaborate and refined body incising that suggests tattooing but has not been interpreted. Often, hair and costume elements are also ornately carved, shedding light on personal attire and adornment in a more precise manner than when they are depicted with paint.

This particularly fine example of the Autlán style depicts a standing female with intricately incised patterns of interlaced bands on her thighs and a zigzag band across her abdomen. The double pendant, upper armbands, short skirt, and double sash all suggest that she is a hip game ballplayer. The hip version is one of several variations of the ritual ballgame that were played throughout Mesoamerica, each using different body parts to hit the ball. These clothing features are found on female ballplayers from the entire Terminal Preclassic period from West Mexico to Veracruz, especially in cultures that produced great numbers of figurines during that time, such as those in the modern states of Michoacán and Guerrero. DEB

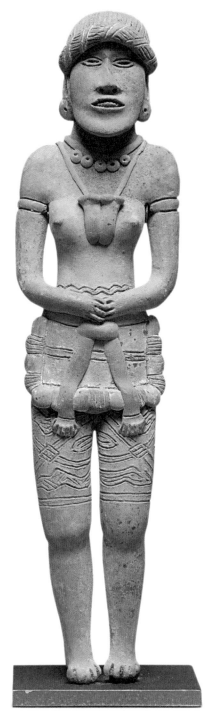

Autlán Colima culture
Autlán, Colima, Mexico
slipped and painted earthenware
10.38 x 2.63 x 1.5 inches (26.3 x 6.6 x 3.8 cm)
Acquired with funds provided by Mr. and Mrs.
 Anthony J. Unruh
2004.014.015

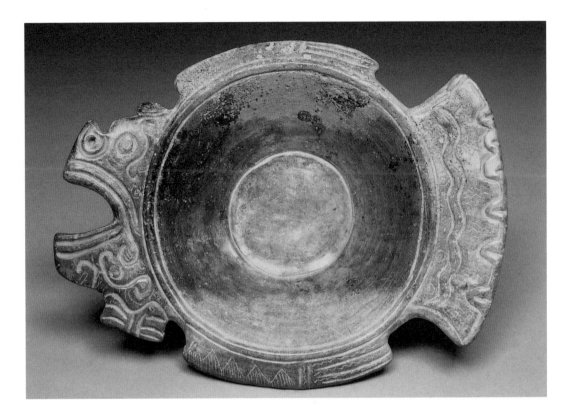

BAT/FISH DUALITY EFFIGY BOWL
Middle Preclassic period, Monte Albán IA, 500–300 B.C.

This Zapotec duality effigy bowl shaped in the form of a bat head and fish body combines the two most widely used Mesoamerican animal symbols of the underworld and death. Throughout Mesoamerica, bats live in large caves that are the symbolic mouths of the Earth Dragon and direct routes to the underworld realm of the dead, and fish inhabitant the water, another symbol of the underworld and death. Bats fly and cannot swim, and fish swim but cannot breathe air. Here, these oppositions are united in a rare program of death duality on a vessel form typical of Middle Preclassic Zapotec culture. Death references naturally suggest a connection with ritual blood sacrifice, and an appendage below the bat's head could be interpreted as an Olmec knotted symbol of personal bloodletting. Thin, delicate walls contrast with the more robust flanges that represent the head, tail, and fins. A circular foot supports the bowl underneath.

This former Leff Collection effigy bowl is one of the most well-known Zapotec works of art in the United States. It was first exhibited at the Carnegie Institute in Pittsburgh, Pennsylvania, in 1959. DEB

RESTING OLD FIRE GOD/HUMAN DUALITY BALLPLAYER EFFIGY VESSEL
Protoclassic period, Monte Albán II, 200 B.C.–A.D. 200

The Old Fire God, the archetypal Mesoamerican ballplayer, is depicted in works of art from Olmec to Aztec times. Deep wrinkles and a sunken cheek mark the god on this effigy, while a smooth face defines the human portion. There are only six known Monte Albán II period Zapotec effigy vessels with finely modeled ballplayer figurines attached, and this is the only Old Fire God/ human duality image among them. Around their waists, all of these ballplayer effigies wear a U-shaped yoke, a protective stone sculpture used to hit the ball in the hip version of the ballgame. Knotted cords that secured the yoke around the waist are sometimes depicted. Both arms on this figure are wrapped to protect the player's forearms from abrasion. The wrappings strongly resemble straps used in the wrapped-arm ballgame, which employs a smaller ball than the hip version.

Vessels such as this may have held food or drink offerings for the dead when they were buried. Direct influence from the great city of Teotihuacan, in the northeast corner of the Valley of Mexico, is evident in the use of mold technology to form the ballplayer's body parts applied to the side of the vessel. DEB

Zapotec culture (opposite page)
Oaxaca, Mexico
slipped and painted earthenware
2.63 x 12 x 9.25 inches (6.6 x 30.5 x 23.5 cm)
Acquired with funds provided by Mr. and
 Mrs. Anthony J. Unruh
2004.014.040

Zapotec culture
Monte Albán, Oaxaca, Mexico
slipped and painted earthenware
4.88 x 7.63 x 4.5 inches (12.4 x 19.3 x 11.4 cm)
Acquired with funds provided by the Dr. Tom
 Dooley Art Purchase Fund in honor of
 Rev. Anthony J. Lauck, C.S.C.
2000.011

TWO-PART EFFIGY VESSEL OF A SEATED PERSON HOLDING AN OLLA
Early Classic period, A.D. 200–400

Teotihuacan civilization succeeded the Olmec as the pan-Mesoamerican cultural and commercial force between 150 B.C. and A.D. 700. Its influence created the conditions for the rise of the Zapotec, Veracruz, and Maya cultures. The Teotihuacan figural aesthetic clearly prized frontal presentation and bilateral symmetry, but this vessel's maker broke all the rules to create one of the most important human images known from that culture. The crossed legs create a substantial base that is cast into shadow by the olla, or jar, which is casually tilted toward the viewer. This is not an accident of firing but the deliberate positioning of a key visual element to break the horizontal and vertical planes in a daring and audacious manner. The cock of the upturned head and the symmetry of its features provide a counterpoint to every movement going on below, resulting in a dynamic visual tension rarely achieved in any aesthetic tradition.

The figure separates at the waist to form the upper and lower portions of the vessel. Holes in the sides of the lower portion and the shoulders of the upper one suggest the effigy could have been suspended on a cord or worn on a necklace. Slits in the head originally held feathers, painted paper, or cloth. DEB

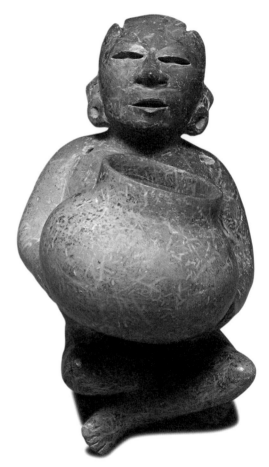

Teotihuacan culture
Teotihuacan, Mexico, Mexico
slipped and painted earthenware
4.5 x 3.13 x 4.25 inches (11.4 x 8.2 x 10.8 cm)
Acquired with funds provided by Mr. and Mrs.
 Anthony J. Unruh
2004.014.023

LIFE/DEATH DUALITY MALE EFFIGY VESSEL WEARING A HEADDRESS
Early–Middle Classic periods, A.D. 250–700

Effigy vessels of seated males form a rare and important sub-style of Thin Orange–ware containers. These effigies often depict seated individuals with arms and legs in different positions, but this composition has the frontal presentation and symmetry of a solid Teotihuacan ceramic figurine. The rigid bilateral symmetry of the body is especially unusual in light of the asymmetric facial treatment and bird headdress. Although asymmetry in the facial expression of an effigy is not uncommon, the duality expressed here may be unique.

The face combines an aged half on the right, indicated by the heavy wrinkle line originating at the nose and extending across the cheek, and a diseased or decayed half on the left, denoted by punctures and incised lines that represent corrupt skin. The waterbird is another death-related motif. A triangle above the left eye probably symbolizes the Displayed Deity aspect of the Great Goddess, which was first depicted in the neighboring Tlatilco culture fifteen hundred years earlier.

As the name implies, the walls of Thin Orange containers are thin, but they are very strong. The vessels were traded throughout Mesoamerica because of their high quality and prestige value. DEB

Teotihuacan culture
Teotihuacan, Mexico, Mexico
Thin Orange earthenware
6 x 3.75 x 4.38 inches (15.2 x 9.5 x 11.1 cm)
Gift of Peter David Joralemon
2004.054.004

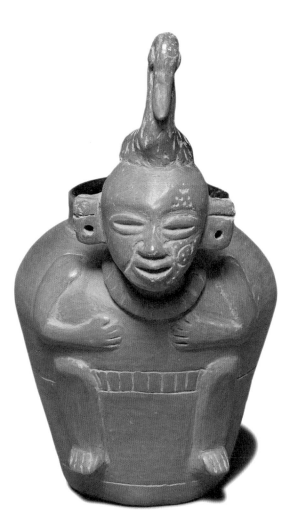

OLD FIRE GOD/HUMAN DUALITY BALLPLAYER
Early Classic period, A.D. 250–400

This powerful and evocative piece of sculpture depicts two major themes of ancient Mesoamerican art—duality and the ritual ballgame. The bent shoulder and wrinkled face of the Old Fire God on the left side contrast sharply with the erect shoulder and smooth face of the youthful human on the right. Dualities such as this reflected the fundamental dichotomies of existence—life and death, youth and age, supernatural and mortal—for Mesoamericans. Both sides are united here as a quintessential Early Classic period ritual ballplayer wearing an almost complete inventory of equipment: a U-shaped yoke around the waist, with a team emblem known as an *hacha* (or axe) mounted on its side; a mitt on the right hand; tape on the left arm; and ankle bands.

The youth/age duality is maximized in an economical manner, but the choices made by the sculptor to articulate it were difficult ones to execute. By creating the contrast between the erect right shoulder and the stooped left one, the artist ran the risk of making the whole sculpture look misshapen. Its success is a testament to the artist's courage and mastery of the medium and technique. Other motifs indicative of advanced age include a bushy eyebrow above the left eye orbit, a semicircular plane depicting skin hardened by age underneath the orbit, a single curved line incised in the hollow of the left cheek to convey a wrinkled face, and sunken fingernails on the left hand. The thin stone *hacha* carries the duality theme as well, depicting a youthful dog on the right and an ancient dog with a sunken eye orbit and receding gum line on the left.

Even the figure's ears are formed differently, but this disparity does not seem to be age related. The human right ear is roughly triangular and has two parallel lines incised down its length, whereas the deity's left ear is shaped like a shallow *b*. Broken lower loops on both sides suggest that they held attachments or ear spools. A knot above the device resembling a sun visor on the deity's forehead may be a Classic period emblem of the Old Fire God. The gesture of the right hand slipped under a rope that encircles the neck and is knotted at the back may refer to the partial strangulation of sacrificial victims of the Old Fire God to render them unconscious before heart extraction or decapitation.

The transverse mounting base on the bottom of the sculpture is similar to those on post-Olmec monuments of corpulent males seated cross-legged that were made on the Pacific coast of Mexico and Guatemala in the Late Preclassic or Protoclassic period, 300 B.C.–A.D. 250. In addition, the ballplayer's yoke tapers at the ends, suggesting a similar date. DEB

Classic Veracruz culture
Veracruz, Mexico
basalt
12.13 x 6.75 x 7.75 inches (30.8 x 17.1 x 19.2 cm)
Rev. Edmund P. Joyce, C.S.C., Collection of
 Ritual Ballgame Sculpture
Acquired with funds provided by Mr. and Mrs.
 John S. Marten and Mr. and Mrs. Al Nathe
1989.012

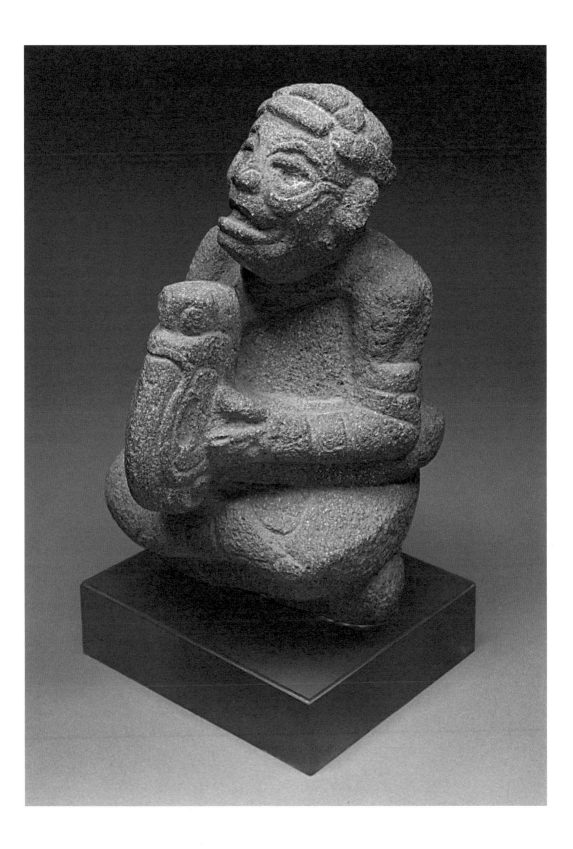

GREAT GODDESS/MALE DUALITY FIGURE
Early Classic period, A.D. 200–500

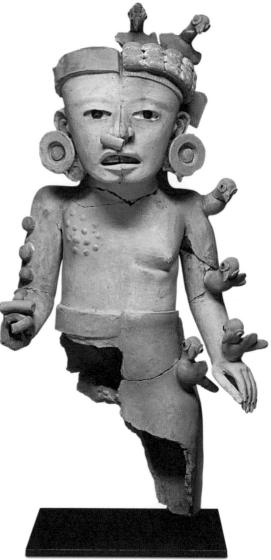

Although there are numerous duality images of life/death, youth/age, deity/human, and human/monster, this is the only male/female duality image identified in Pre-Columbian Mesoamerican art. The logical assumption is that it represents the duality that would be known to the Aztecs as Ometeotl, aspects of the Great Goddess and her consort, the Old Fire God. They inhabited the thirteenth heaven of blue duality and kindled the fire of the body-warmth aspect of the human soul in the breast of every fetus.

The left side indeed displays Mesoamerican fertility symbols that identify the Great Goddess, such as birds and their eggs, a large left breast, and a woman's flanged skirt. The right arm and breast exhibit male ritual scarification, but there are no direct references to the Old Fire God. Other distinctions between the two sides are clearly made: the iris of the right eye is unpainted and the right chest has a ruddy flesh tone, whereas the left iris is painted white and the left chest is cream color. The exact function of Classic period (A.D. 200–900) monumental ceramic figures from central Veracruz remains in doubt because so few have been excavated in situ by archaeologists. DEB

Upper Remojadas I culture
Veracruz, Mexico
slipped earthenware and bitumen
27.5 x 15.25 x 7.63 inches (69.9 x 38.7 x 19.3 cm)
Gift of Mr. and Mrs. Gary Doran (Class of 1970)
1982.092

RITUAL BALLGAME PALMA DEPICTING DEATH AS A BALLPLAYER HOLDING A KNIFE AND A SEVERED HEAD
Late Classic period, A.D. 700–900

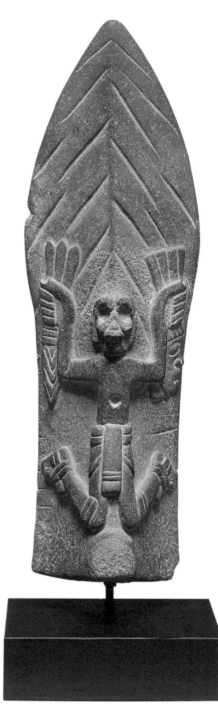

The *palma* is the rarest form of Classic Veracruz ritual ballgame sculpture actually worn by ballplayers. When secured on top of the front arm of the yoke worn around a player's waist, the palm-leaf-shaped sculpture covered the player's solar plexus. This example depicts living Death stretched across a sacrificial knife blade. Death's skull and torso are projected forward, and his bent, low-relief limbs animate the sides. Short diagonal lines add to the dynamism of the expressive, confrontational subject matter—jubilant Death holding the severed head of his most recent offering in one hand and a knife identical to the one upon which he is displayed in the other. Three feathers on the knife handle's end echo the hanks of hair on the severed head.

Death wears the knee bands, feet protectors, and triangular loincloth with a broad front panel commonly found on ritual ballplayers from 1300 B.C. onward. The cavity in his chest shows that his own heart has been removed. The whole sculpture was painted, and the face, heart wound, thumbnails, and big toenails were inlaid. Wear on the protrusion of the roughly triangular base demonstrates that straps were passed over it to fasten it onto a yoke. DEB

Classic Veracruz culture
Veracruz, Mexico
basalt
18.13 x 6.5 x 3.88 inches (46.1 x 16.5 x 9.8 cm)
Rev. Edmund P. Joyce, C.S.C., Collection of
 Ritual Ballgame Sculpture
Museum purchase by exchange, Mr. and Mrs.
 James W. Alsdorf
1996.044

FROG ON LILY PAD EFFIGY VESSEL WITH SPOUT
Protoclassic period, 300 B.C.–A.D. 250

Preclassic and Protoclassic Maya ceramics are rare in American collections, but the design and execution of this Usulután-ware frog effigy mark it as one of the finest Proto-Maya vessels of any type. The frog's body and the water-lily pad blend into one functional form: the frog's four legs form the vessel's feet, and the eight lily leaves expand to give volume to the vessel and the frog's body. The head is impossibly small in relation to the body, but in combination with the three tubular hanging straps, it subtly enhances the domed structure of the upper body. Because it could be hung, the vessel is an ideal design for pouring and aerating liquid chocolate from a short height into drinking vessels to raise thick bubbly foam.

Usulután ware is a type of resist-fired earthenware produced in the southern Maya highlands and Pacific coastal plain in Guatemala. A comb-like tool was dipped in resin and dragged in a wavy pattern over the vessel's surface. After drying, the vessel was fired in a smoky reduction atmosphere, leaving patterns of light lines protected by wax against unprotected blackened ones. Burial in the ground, human touch, and light have faded the wavy design. DEB

Las Charcas(?) culture
Pacific coast or southern highlands of
 Guatemala
slipped and resisted Usulután earthenware
6.38 x 7 x 7.5 inches (16.2 x 17.8 x 19 cm)
Acquired with funds provided by the Lake
 Family Endowment
2000.017.018

Maya culture (opposite page)
Guatemala/Mexico
slipped earthenware
2.38 x 10.88 inches (6 x 27.6 cm)
Acquired with funds provided by the
 Lake Family Endowment
2000.017.023

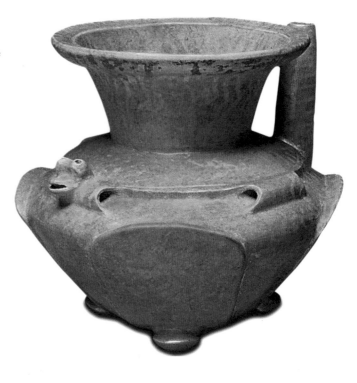

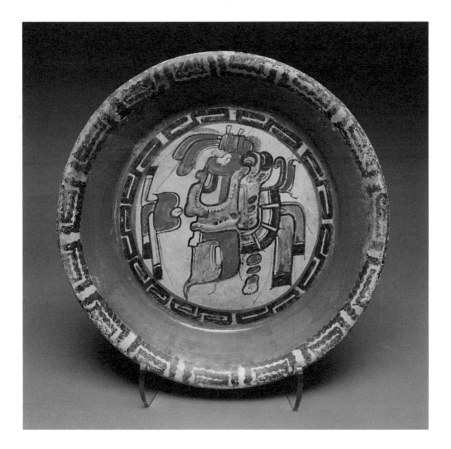

BLOOD-OFFERING PLATE WITH PERFORATOR GOD PROFILE
Late Classic period, A.D. 700–900

Mesoamerican humans and deities were united by a bond of mutual exchange of portions of their souls in order to create and sustain life and fertility on the earth. The gods created the world by sacrificing their lives and the indestructible life forces of their souls, and humans sustained the gods by returning the soul essence contained in blood offerings back to them. On high ritual occasions, humans were sacrificed in order to make profuse offerings of soul essence to the gods.

A royal sacrificer passed paper or rope through his or her wounds to soak up blood, dropped them onto a plate such as this one, and carried them to a brazier in which they were burned and consumed by the gods. This plate is decorated with an elegant depiction of the Perforator God, the deity of personal blood sacrifice, who is identified by his knotted hair and the knife blade protruding from the position of his missing lower jaw. The facial contour was made with a single controlled line that demonstrates mastery of the paintbrush. Drilling the hole in the center of the plate ritually killed the vessel, allowing it to accompany its deceased owner to the underworld. DEB

GOD L STANDING ON HIS BACKPACK WHILE SMOKING A CIGAR
Terminal Classic period, A.D. 850–950

The Maya deity known as God L is a prominent Classic period (A.D. 250–900) supernatural who is the patron of trade and commerce and reigns as the principal lord of the underworld, Xibalba. His name derives from a nineteenth-century work of scholarship in which major Maya deities were given letter designations to eliminate confusion in the literature about their identities. God L's role as the primary underworld deity suggests strong associations with rain, agricultural fertility, and, by extension, wealth and riches.

God L's Classic period identity is clearly expressed by a number of features. His facial wrinkles, sunken cheeks, and toothless mouth embody extreme age. A relatively large, globular eye, with an eye curl that originates on the lower front of the eye orbit, places him firmly in the Maya underworld. Traces of black on his face and extremities provide color associations with rain and with the direction west, where the entrance to the underworld is located. The top of the feathered headdress is missing, but comparisons with several other identical panels from the facade of a building at Dzehkatun, the apparent origin of this panel in the northern Yucatán lowlands, confirm that all of them share Moan owl plumage. This owl is often accompanied by depictions of the Maya death glyph, reflecting its role as an underworld messenger, but it also has important links to rain and corn. The tail of a jaguar, another animal with strong underworld associations, peeks from below the rear of God L's kilt, while the deity puffs contentedly on his signature cigar.

God L is an important Post Classic period (A.D. 900–1521) deity as well, and this relief features his two most important later attributes: a backpack filled with trade goods bound into a bundle covered with a network of ropes, and a spinal-column staff topped by a cadaverous head. The backpack expresses his role as the god of commerce, while the use of a string of clanking, articulated vertebrae as a walking

Father Joyce was a Mesoamerican, born in Honduras in 1917. As executive vice president of the University of Notre Dame, he oversaw its fiscal operations for thirty-five years. He also chaired the Faculty Committee in Charge of Athletics from 1952 to 1987 and was a lifelong cigar smoker.

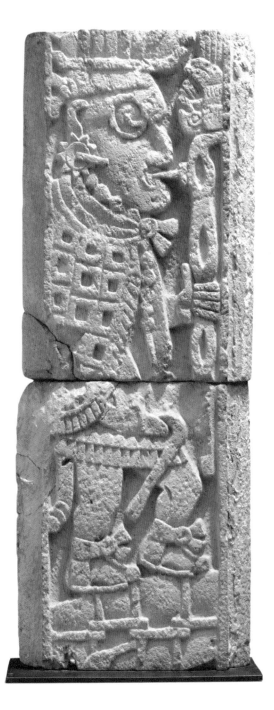

stick confirms his position as Lord of Hell and mimics the *chicahuaztli*, the Post Classic rattle staff that traveling merchants carried to announce their approaches to markets.

The artist gave the old deity's facial profile and costume details, especially the starburst ear flare and elegantly woven cape, physical depth through excellent carving and visual depth by cropping the image within two vertical bands flanked by quarter-round molding. The quality of the composition and execution, especially on such a porous stone, underlines the superior nature of Late Classic sculpture and the great skill of artists using only stone tools.

Father Joyce was a Mesoamerican, born in Honduras in 1917. As executive vice president of the University of Notre Dame, he oversaw its fiscal operations for thirty-five years. He also chaired the Faculty Committee in Charge of Athletics from 1952 to 1987 and was a lifelong cigar smoker. The Museum's large collection of ritual ballgame sculpture was named in his honor in 1987. DEB

Maya culture
Yucatán, Mexico
limestone
43.13 x 16.5 x 3.5–5 (variable) inches
 (109.5 x 42 x 8.9–12.7 cm)
Gift of Marilynn Alsdorf in memory of
 Rev. Edmund P. Joyce, C.S.C.
2004.048

MULTILOBED TRIPOD JAR WITH EHECATL DEITY PROFILES
Late Post Classic period, 1200–1521

Mixteca-Puebla ware is so common in the archaeological remains of the southern and western central Mexican highlands that its precise origin remains undetermined. This lightweight vessel's contrast of texture and form illustrates the finest in western Mixtec ceramic design and fabrication. Incised and painted around the shoulder plane are white bands that frame a series of deities wearing a triangular hat identical to that of Ehecatl, the Late Post Classic Aztec Wind God, an aspect of Quetzalcoatl, the Feathered Serpent. Each hat is framed by two L-shaped devices in the head-dresses or breast ornaments of the deities. The texture of the incised relief gives the composition depth, which is enhanced by the white and light orange painted details and balanced by the smooth volumes of the lobes and legs.

Images of Ehecatl are associated with depictions of the *ihiyotl* aspect of the Mesoamerican soul, expressed as airs or winds. Human breath, other bodily expressions of air, and other movements of air or wind had to be closely monitored to prevent potential harm to the body's owner and his or her neighbors. DEB

Mixtec culture
El Chanal, Colima, Mexico
Mixteca-Puebla slipped and painted
 earthenware
6.75 x 7.38 inches (17.1 x 18.7 cm)
Acquired with funds provided by
 Mr. and Mrs. Anthony J. Unruh
2004.014.048

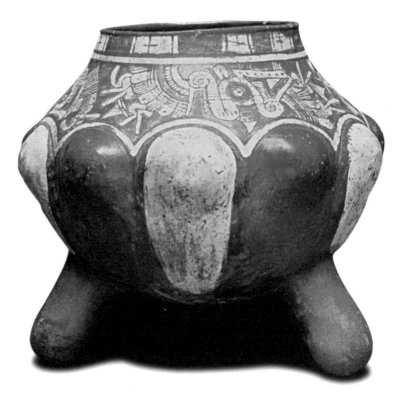

STANDING WERE-JAGUAR PENDANT, 1000–1530

Gold sculptures depicting composite supernatural beings were widely made and distributed as presents between Costa Rican rulers and shamans. The sculptures symbolized supernatural traits or qualities that the human owners wished to appropriate to enhance their power. This powerful and refined were-jaguar holds a small animal in its feline jaws. It is bracketed above and below by polished crescents and flanked at head and feet by dragons. In its outstretched arms are two triangular devices connected by a rope.

The design of the image and the quality of the casting make this an outstanding example of Costa Rican lost-wax casting. The desired shape of the sculpture was exactly modeled in wax and covered with successive layers of charcoal dust and clay until a thick, sturdy mold was formed. The mold was heated in a fire and the wax was poured out through a tube. Then the molten gold-and-copper alloy was poured through the tube into the hot mold. After cooling, the completed sculpture was removed.

Gold sculptures were the first form in which the Spanish found the metal, and the foreigners melted down thousands of pieces before resorting to surface prospecting, panning, and mining. DEB

The design of the image and the quality of the casting make this an outstanding example of Costa Rican lost-wax casting.

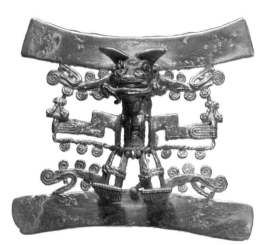

Diquis style
Palmar Sur, Diquis, Costa Rica
gold-and-copper alloy
3.5 x 3.63 x .88 inches (8.5 x 9.3 x 2.2 cm)
Gift of Mrs. Robert Parkes and the Kennett B.
 Block Family in memory of Genevieve Block
 Joyce, mother of Rev. Edmund P. Joyce, C.S.C.
1995.034.001

ANGULAR PIPE
Early Formative period, 650 B.C.–A.D. 500

The clean, bold outline and subtly textured surface of this pipe emphasize the difficulty of carving it from a single piece of very hard stone. Its simple and elegant design is even more astonishing in light of the technical precision that created it: the sculptor drilled ten inches down the bowl and twelve inches down the stem and succeeded in aligning the holes in the correct spot. In addition, the artist utilized two lighter bands of stone to form decorative elements that streak diagonally through both stem and bowl. The pipe, which would command attention in any installation of art from any time or place, is one of only four known examples on display anywhere. The other three are in Argentine museums.

Although many substances could have been smoked in this pipe, the first logical choice would be traditional New World tobacco, *nicotiana rustica*, a highly potent and hallucinogenic substance far removed from its domesticated descendant. At the base of the front wall of the bowl, a small plug of stone was knocked out during fabrication to allow the stem to be cleaned. **DEB**

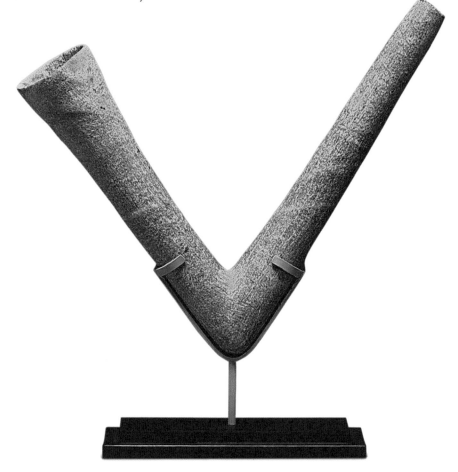

SEATED FEMALE EFFIGY VESSEL
Condorhuasi II period, A.D. 0–600

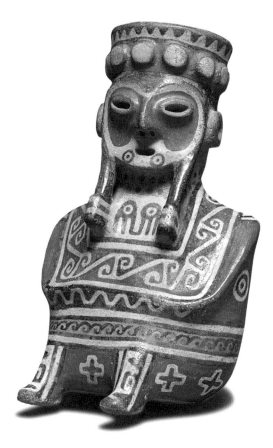

The general form and facial features of this vessel clearly relate to late Condorhuasi (House of the Condor) effigies from the central valleys of northwest Argentina. However, some of the decorative motifs, applied in red-and-black-on-beige slips, point to the nearby Santa Maria culture, which existed from 850 to 1500. The refinement of the construction and decoration marks the vessel as one of the most important objects to emerge from the region.

Condorhuasi effigy vessels vary widely, but this figure's raised oval eyes, beaked nose, recessed mouth, and circular ears are hallmarks of the general style. The facial features are projected forward by a combination of techniques: the red-slipped area covering the upper face is outlined in beige, and the features are enclosed by the protruding roundels in the headdress, the ears, the two lip labrets painted on the jutting chin, and the braids hanging over the breast. The shape of the red-slipped area, widely interpreted by archaeologists as a bird face, was first seen on Condorhuasi sculpture. Directional crosses, opposed spirals bordering the cloak, and opposed bird heads between the braids are motifs found in the Santa Maria inventory, but little is known of their origins. DEB

Condorhuasi culture
Argentina
slipped earthenware
7 x 4.5 x 5.5 inches (17.8 x 11.4 x 14 cm)
Acquired with funds provided by Robert E.
 (Notre Dame, Class of 1963) and Beverly
 (Saint Mary's College, Class of 1963) O'Grady
2005.006

Condorhuasi culture (opposite page)
Argentina
andesite
10.5 x 12.25 x 2 inches (26.6 x 31 x 5.1 cm)
Acquired with funds provided by Robert E.
 (Notre Dame, Class of 1963) and Beverly
 (Saint Mary's College, Class of 1963) O'Grady
2004.047

CIRCULAR PLAQUE WITH FOUR TROPHY HEADS AND SOLAR MEDALLION
Imperial phase, 1480–1535

This exceptional lost-wax cast sculpture is one of about a dozen that appear in the literature from both museum and private collections. Their functions are unknown, but all have loops cast onto their backs to allow them to be attached to shields or other devices. A review of all of the Imperial phase circular plaques reveals that their designs are bilaterally symmetric on one or both axes, are created using the same motifs repeatedly, and are different from earlier plaques in size and complexity of design. This appears to be the only example with a central motif.

The design of four severed heads forming a cross with the sun creates a cosmogram defining the center of the world. This cosmogram is reiterated by four concentric-circle motifs that might represent stars, the moon, other celestial bodies, or some other aspect of physical reality. Whoever holds or displays this plaque demonstrates his control of the center of the world and his ability to rule, multiplied in a timeless cycle as the plaque is rotated.

A section of the proper lower-right portion of the circumference was deliberately removed in ancient times for an unknown reason. The plaque could have been ritually killed to allow its spirit to accompany its owner in death, or the portion may have been removed for someone to retain it as a keepsake or to recast it for some other purpose. The loss is not disfiguring because the careful balancing of the composition causes the whole image to hold together perfectly well. This is the product of good design and a tribute to the artist.

The lost-wax casting technique utilizes a onetime clay mold that is built up in successive layers around a wax sculpture of the desired form. The mold is heated and hardened and the wax is poured out, after which the molten copper alloy is poured in, conforming to the mold. After cooling, the mold is broken and the sculpture is removed. In this case, two different pouring tubes, or sprues, also were fashioned in wax and attached to the sculpture before the mold began to be applied. Either a sufficient amount of metal to complete the casting in one pour could not be heated in one crucible, and metal from two different crucibles had to be poured into the mold, or the breadth of the casting caused the temperature of the molten metal poured into one sprue to fall too quickly, preventing the metal from reaching the bottom of the mold. In any case, a seam was created where the molten metal from the two different pours touched, and the entire front surface was polished to remove the seam and visually unify the composition. Lost-wax casting something so large and flat was a supreme technical accomplishment. It would have been very difficult to prevent the wax model from collapsing of its own weight, much less to build up the mold around it. DEB

Santa Maria culture
Argentina
copper alloy
11.5 x .75 inches (29.21 x 1.91 cm)
Purchase funds provided by Robert E.
 (Notre Dame, Class of 1963) and Beverly
 (Saint Mary's College, Class of 1963) O'Grady
2005.028

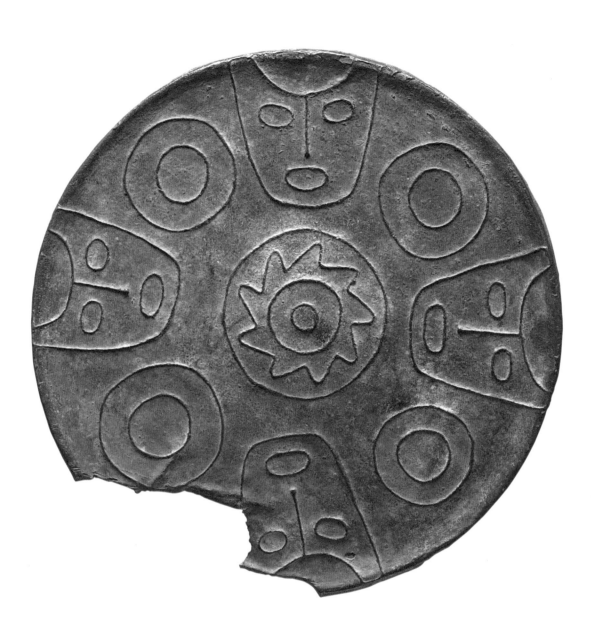

Whoever holds or displays this plaque demonstrates his control of the center of the world and his ability to rule, multiplied in a timeless cycle as the plaque is rotated.

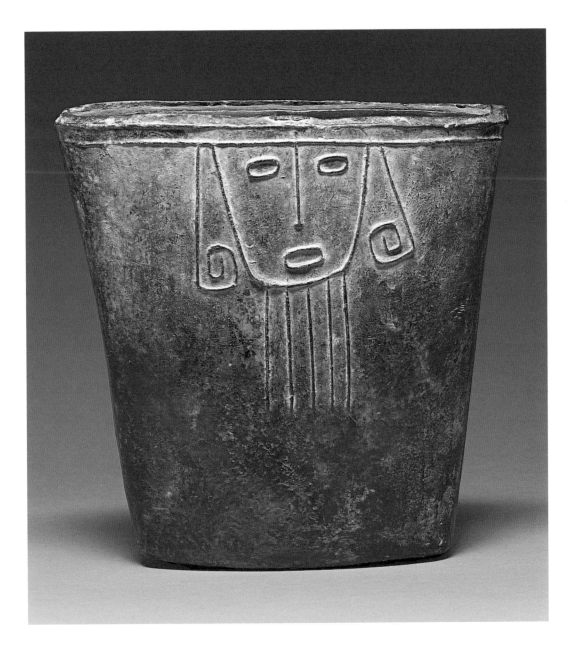

The outline of each face on the bell is essentially the same shape as the instrument, echoing

its outline, but the protruding curls of hair expand the shape of the head from top to bottom

and create visual tension between it and the sides of the bell.

BELL WITH ONE TROPHY HEAD ON EACH SIDE
Imperial phase, 1480–1535

Triangular bells are associated only with the Santa Maria culture of northwestern Argentina, and fewer than a dozen examples are known. This appears to be the only one outside Argentina and the finest of those that appear in the literature. The context in which the bells were used is unknown, and how they were mounted and rung is debated. The leading archaeological authority suggests they were mounted on staffs or posts with their mouths upward by means of perforations in their narrow, enclosed ends—the opposite of how Western bells are hung. Then, the bells could have been sounded by beating them with wooden implements. Virtually identical patterns of pronounced wear that have smoothed the lower sides of all the bells strongly reinforce that theory.

The bell and the Santa Maria plaque (p. 57) use the same trophy-head motif in very different ways to accomplish very different ends, but together they provide a visual tour de force and a sophisticated lesson in design. The plaque employs the trophy-head repetitively, as one element in a symmetrical pattern that covers its frontal surface and is organized around a solar medallion, creating a cosmogram. On each side panel of the bell, a trophy-head design interplays with the shape of the instrument to transform the object into a trophy head itself.

The outline of each face on the bell is essentially the same shape as the instrument, echoing its outline, but the protruding curls of hair expand the shape of the head from top to bottom and create visual tension between it

and the sides of the bell. The slightly asymmetric form of the head and its placement below the strong rim band create the impression that it is hanging from the belt of the victorious warrior who removed it from its owner. A vacant, staring face and lines of blood from the neck wound combine with these other features to accentuate the simplicity, size, and superb placement of the head on the side panel. This effect is enhanced by the strength and quality of the line stretched over the slightly uneven surface.

The bell was cast in as many as four stages using the lost-wax technique. A reinforcing inner rim around the mouth was cast separately first. This was enclosed in the wax sculpture of the rest of the bell and a ceramic mold was built up around the whole. Three casting tubes were added to the roughly flat, enclosed end to allow the wax from the sculpture to be poured out after it was melted, and to accept the molten copper alloy as it was poured into the mold. Each side panel was cast using a separate casting tube, and the enclosed end with two large perforations was cast with a third one. Remnants of each casting tube are visible on the exterior of the enclosed end, and casting seams are visible down the sides and the edges of both ends. DEB

Santa Maria culture
Argentina
copper alloy
9 x 9.25 x 3.63 inches (22.9 x 23.5 x 9.2 cm)
Purchase funds provided by Robert E.
 (Notre Dame, Class of 1963) and Beverly
 (Saint Mary's College, Class of 1963) O'Grady
2005.033

PARROT EFFIGY VESSEL, about 1550

Two completely different worlds meet in this sixteenth-century ceramic effigy vessel, one Mesoamerican and the other Spanish. Its Mexican maker employed traditional stylistic conventions that can be traced back hundreds of years from the time of its manufacture. The forms of the feathers, the manner in which they are incised, the stippling on the remainder of the body, and the shape of the bird's eye are found on ceramics from all over Mesoamerica dating from the beginning of the Early Classic period (A.D. 250), due to the widespread influence of Teotihuacan civilization. The red, yellow, and blue colors suggest a strong link to the central highlands, even the Valley of Mexico.

The shape of the vessel, though, is completely foreign to Mesoamerica and the New World. No Mesoamerican would have put the mouth of the vessel in the center of the back or added a vertical rim to the composition. This is a Spanish or, more accurately, European form based on an Islamic one, an *aquamanile*. Derived from the Latin words for water and hands, this term describes a vessel used to pour water over one's hands to clean them before dining at table or saying Mass. In this case, the water flows through small holes flanking the parrot's head. DEB

Mexica or Mixtec culture
Mexico
slipped and painted earthenware
4.88 x 15 x 6.25 inches (12.4 x 38.1 x 15.8 cm)
Acquired with funds provided by the Rev. Anthony
 J. Lauck, C.S.C., Sculpture Endowment
2001.025

Unidentified artist (opposite page)
Peru
oil on canvas
31.5 x 32.5 inches (80 x 82.55 cm)
Acquired with funds provided by Mr. and Mrs.
 Anthony J. Unruh
2002.004.002

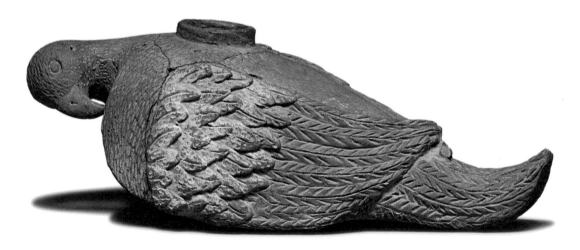

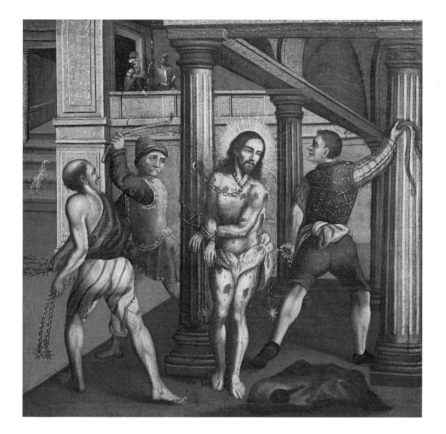

LA FLAGELACIÓN DEL CRISTO
(THE FLAGELLATION OF CHRIST), 1650–1700

This Flagellation depicts three prison guards whipping Christ with leather straps, thorny branches, and metal chains with pointed spurs. A soldier and an elaborately dressed older man, perhaps Pilate, look on from a balcony. The handsome face of Christ is bathed in a heavenly light, but the guards are portrayed as ugly and brutish. Two of them wear clothing made of striped fabric—the cloth of Satan.

The artist deliberately distorted the architecture of the building to focus attention on Christ, who is tied to a column in the center of the composition. There is one column directly behind him, another to his left, and a fourth parallel and behind the third. Together, the columns form a square. The capitals of the central and two rear columns are connected in a straight line—the hypotenuse of a triangle—by an architrave. This framing device visually pushes forward the center of the painting, the poised, static figure of Christ. It has the added benefit of giving the guard in the red pantaloons sufficient space in which to stand. By selectively ignoring laws of perspective in this way, the artist achieved a powerful impact. DEB

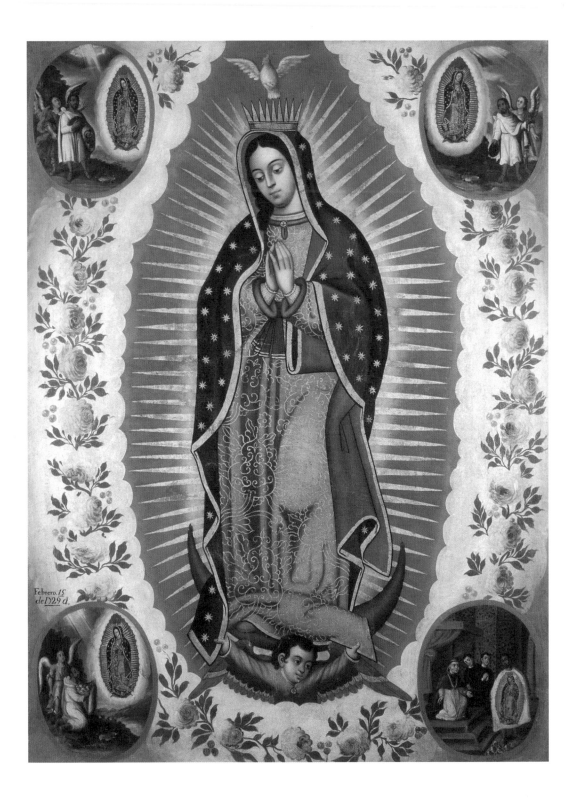

NUESTRA SEÑORA DE GUADALUPE (OUR LADY OF GUADALUPE), February 15, 1729

Nuestra Señora de Guadalupe is the Virgin Mary as she appeared in 1531 to Juan Diego, an Aztec convert to Christianity. The visions occurred at Tepeyac, a hill northeast of Mexico City. The visions are described in the *Nican mopohua* (Here It Is Recounted), an anonymous account written in Nahuatl, the Aztec language, and published in 1649. The earliest painting containing the apparitions is dated 1668.

In the early 1700s, Guadalupan devotion became popular after the Virgin was invoked to halt plagues and droughts in Mexico City. Since then, the Catholic Church in Mexico has taken great pains to preserve the purity of Guadalupan images in order to maintain proper devotion and discourage idolatry. The resulting stylization tends to make the images static, but the accomplished and confident artist who made this painting managed to give the Virgin a touching, lifelike appearance. In the classic pose associated with the story, she wears a crown and stands on a crescent moon supported by an angel. The radiance of the sun surrounds her, and the Holy Spirit hovers overhead as a dove. Castilian roses connecting the corners of the composition and four simple oval frames containing apparitions associated with the narrative are seventeenth-century Baroque features that the artist rendered with ease and facility.

The apparitions read from left to right, top to bottom, and tell a simple story. The first time the Virgin appears to Juan Diego, she instructs him to tell the bishop that she, mother of the true God, wants a chapel built in her honor on Tepeyac. Juan visits Bishop Zumárraga, who rebuffs him and tells him not to return without proof. He attempts to avoid the Virgin, but she stops him and tells him to pick flowers that are blooming on top of Tepeyac. Juan dutifully collects blossoms in his cloak and brings them to the Virgin, who gathers them up in her hands, replaces them in the cloak, and tells Juan to hurry to the bishop's house. When he opens his cloak before the bishop, a miraculous painting of Mary is revealed upon it. The stubborn bishop falls on his knees in awe, and the chapel is built.

Mexicans—Indians, Catholics, Protestants, Jews, and atheists alike—recognize Nuestra Señora de Guadalupe as the emblem of their national identity, *mexicanidad*. The name Guadalupe is derived from a pilgrimage site in Extremadura, Spain, where a miraculous early fourteenth-century apparition of the Virgin took place. The Spanish Virgin of Guadalupe and her chapel expressed Christian resistance to long centuries of Moorish occupation; *Guadalupe* means "river of wolves" and may refer to the Moorish period. Many early conquistadors of the New World came from Extremadura, and it was logical for them to return to her shrine, as well as to bring her veneration to their new home. **DEB**

Unidentified artist
Mexico
oil on canvas
50.88 x 37.63 inches (129.22 x 95.57 cm)
Donated by Mr. Ignacio Aranguren (Class of 1952), his wife Pirri, and their sons Luis (Class of 1984), Ignacio (Class of 1985), and Santiago (Class of 1992)
2002.018

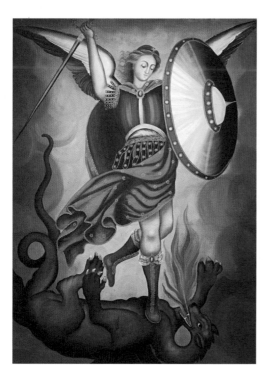

The expulsion of Satan was a common topic in Spanish Colonial art because of its obvious parallels with Christianization efforts to turn Indian populations away from their traditional belief.

SAN MIGUEL EXPELLING SATAN FROM HEAVEN, 1700–1750

The expulsion of Satan was a common topic in Spanish Colonial art because of its obvious parallels with Christianization efforts to turn Indian populations away from their traditional belief that the supreme deity was the earth in the form of a dragon. In this image, San Miguel raises his sword arm to strike another blow at the draconic Satan. Dynamic visual tension is created between the Y shape of the angel's wings and body, and the strong, dark dragon's body. San Miguel's armor and fine costume are thrust forward, but the curved, shiny surface of the shield, turned to one side, combines with circles in the dragon's tail and neck to create an asymmetrical triangle that constantly vies for the viewer's attention.

The swirl of the angel's cloak, the bright gold touches on the costume elements, and the delicate lace are typical features of Spanish Colonial art, rendered here in an accomplished and confident manner. No effort was spared to highlight the importance of San Miguel and the danger posed by the dragon's huge claws, fiery breath, and traditional meaning. DEB

Unidentified artist
Guatemala or Central America
oil on canvas
47 x 35 inches (119.38 x 88.9 cm)
Acquired with funds provided by
 Mr. and Mrs. Anthony J. Unruh
2002.004.001

BLUE AND RED FIESTA PONCHO WITH RED FRINGE, 1882

The loose weave of this beautiful textile not only appears soft but also feels luxurious to the touch. From ancient times, Andean Indian cultures have woven ponchos with large, bold color schemes to convey ethnic identity, as well as to attract attention in crowds during fiestas and market days. Large areas of solid color may symbolize the pampas, or grasslands, of the high elevations bordered by mountains, but here the central blue panel probably refers to the sky or the waters of Lake Titicaca. The red bands, which may suggest hot, dry male portions of the environment, are flanked by green sections probably representing cool, fertile female portions. Another eye-catching feature is the fringe, which likely carries the same color symbolism.

The inscription woven into the narrow white bands reads: ANO 1882 R.P.A 20 EDoINU [and] TEBUR CIOCHAMVILLA. Its meaning is unknown, but it might celebrate an important public event. Also woven into the bands are solar disks and condors with their wings spread. These artists' ancestors were never fully subjugated by the Inca, who maintained an empire until the Spanish conquest. Sustained contact with European culture has resulted in the loss of much traditional knowledge, including the interpretation of these textiles. DEB

Unidentified Aymara-speaking artist
Lake Titicaca area, Bolivia
llama wool
55.5 x 57 inches (141 x 144.8 cm)
Gift of Mr. Kevin Healy (Class of 1962)
2003.046.009

CRUZ DE ANIMAS WITH TWO CARVED KNEELING FIGURES, about 1820

Painted and sculpted *cruces de animas* (crosses of souls) became popular in eighteenth-century Querétaro and Guanajuato, where they were used in personal devotions and to comfort the dying. Their iconography is standardized: God the Father and the Holy Spirit appear above the crucified Christ, who is surrounded by the instruments of the Passion and the sun and moon, with the Virgin of Sorrows and Saint Michael below. The base depicts Adam and Eve, the Blessed Sacrament, Death threatening a bedridden person, and a row of souls suffering in Purgatory. *Cruces* were sometimes made in the workshops of masters and journeymen who emulated European aesthetic standards in order to charge more for their compositions, but in this example the Holy Spirit is depicted as a hummingbird, a truly Mexican concept.

Refined brushwork marks the features on this cross, but the souls reflect a less-experienced hand. The sculpted male and female appear to represent the living, and Death draws his bow to shoot the dying person. In the late nineteenth century, the Catholic Church banned the *cruces* under suspicion that the shrinking figure of Christ and growing instruments of the Passion indicated that *cruces* were being used in witchcraft. DEB

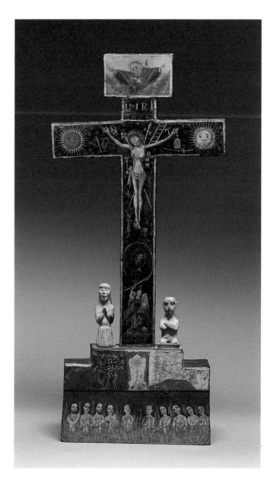

In this example of cruces de animas *(crosses of souls), the Holy Spirit is depicted as a hummingbird, a truly Mexican concept.*

Unidentified artist
Querétaro or Guanajuato, Mexico
oil on wood and canvas
20.88 x 9.75 x 2.5 inches (53.1 x 24.8 x 6.4 cm)
Acquired with funds provided by the Fritz and Milly
 Kaeser Endowment for Liturgical Art
2001.004.004

CRISTO CRUCIFICADO
(CHRIST CRUCIFIED),
about 1835

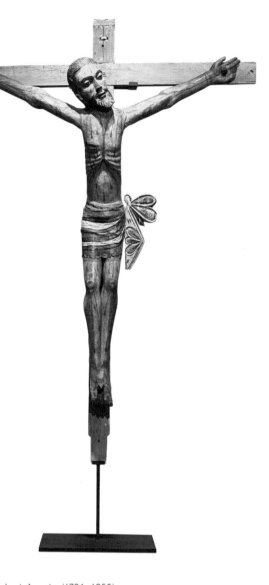

Redoubled efforts at evangelization of the Pueblo Indians and resettlement of Nuevo Mexico (now New Mexico) by Mexicans after the Pueblo Revolt created an acute shortage of religious imagery at the end of the seventeenth century. Mexican-trained priests and laymen living in Nuevo Mexico created a lively local tradition of *santos* (images of God and the saints) in the eighteenth century, but the classic period of *santo* sculpture in Nuevo Mexico was 1800 to 1850, ending with the Mexican American War. After 1850, mass-produced plaster casts and lithographs from the eastern United States quickly began to replace the region's traditional sculpture.

José Aragón was one of the most important *santeros* (saint makers) in northern Nuevo Mexico during the first half of the nineteenth century. For this sculpture, Aragón carved a sinewy *Cristo*, whose muscles have been stretched to their limits, and then covered the body with gesso-coated muslin. The result is a composition animated by the sense of skin stretched over living bone and muscle racked with pain. The raised head is unusual, but its oval shape, delicate features, and almost-smiling mouth are Aragón trademarks. Red, green, and white on the loincloth combine with black detailing to impart a sense of majesty and authority to this tortured figure. DEB

José Aragón (1796–1850)
Nuevo Mexico
wood, gesso, cloth, and paint
53 x 38.5 x 9.75 inches (134.6 x 97.8 x 24.8 cm)
Purchase funds provided by an anonymous benefactor and the Mr. and Mrs. Terrence J. Dillon Endowment
2001.045
In prayerful memory of the Nicholas Scherer and John Austgen families, early settlers of northwest Indiana, whose religious needs were faithfully served by the Holy Cross Religious of Notre Dame, to whom the families are eternally grateful

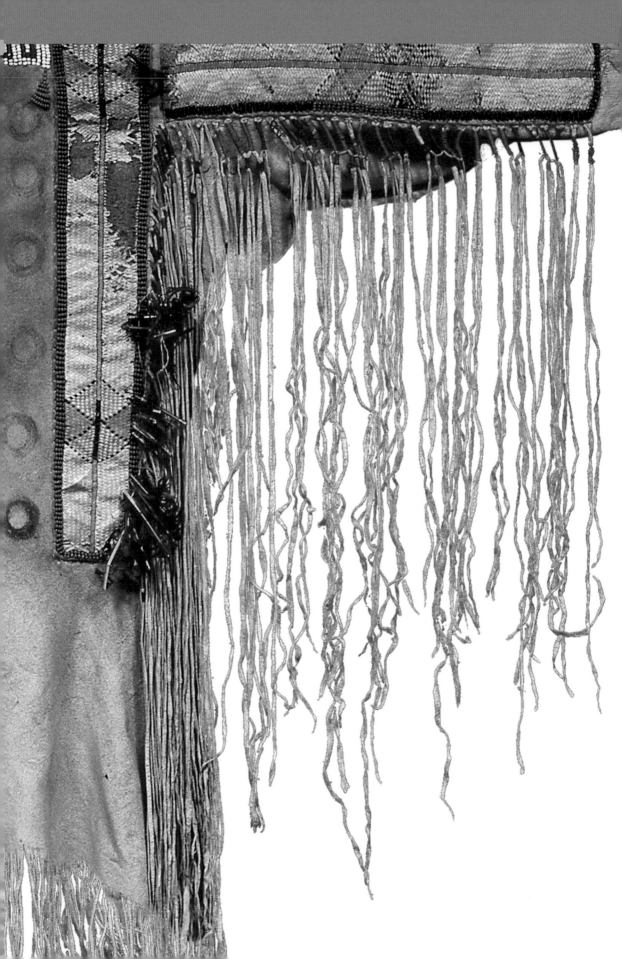

NATIVE NORTH AMERICAN ART

The Native North American art collection includes archaeological, ethnographic, historic, and contemporary objects. Together, these works span a number of centuries, from approximately 2500 B.C. to the present. The archaeological, ethnographic, and historic pieces can most easily be termed decorative arts, and include clothing, basketry, and objects made of ceramic, stone, antler, bone, ivory, and fabric.

There are three areas of strength: clothing from the Great Plains, ceramics from the precontact Southwest, and textiles from the American Southwest. A selection of some of the best pieces from each of these areas is described in the essays that follow. The small contemporary art portion of the collection has been developing only since 1998 and consists primarily of works on paper.

The mission of a university art museum is to teach, as well as to allow patrons to view and appreciate fine art. For the art of Native Americans, this education must include an effort to challenge the typical stereotype associated with their cultures. This stereotype has at least three components: (1) the belief that "real" Native American cultures are only of the past, a characterization for which anthropologists use the term "ethnographic present"; (2) the fallacy that all Native Americans were nomadic hunters and gatherers; and (3) the notion that all Native American cultures were fundamentally the same, with the typical image being the Plains buffalo hunters. Thus the collection at the Snite Museum strives to represent Native American art traditions realistically, focusing on the diversity of these arts in time, space, and cultural practices.

The collection reflects cultural diversity by showing the art of hunters and gatherers as well as that of farmers and fishermen. Also, because Native American art is not timeless but has changed over the ages, the collection includes objects reaching back many centuries to the precontact period, pieces from the late nineteenth and early twentieth centuries, and works by contemporary Native American artists. Native American art of the modern period incorporates past Native American artistic traditions with those from Europe, Asia, Africa, and the Pacific Rim to form a rich, syncretic artistic tradition. *Ceremonial Landscape* and *Big Lotso* are examples of contemporary works that illustrate this syncretism.

The donation of objects accessed into the Native North American art collection began at the University of Notre Dame long before there was an art museum. Initially, a library with an associated museum and a "cabinet of curiosities" displayed works made by Native Americans. These pieces were sent to the university from the 1870s through the early part of the 1900s by priests of the C.S.C. order and others with ties to Notre Dame. The Crow shirt described in this volume is one of the finest examples. The priests were sent by the order to the Western frontier to provide Catholic services to towns in the Dakota, Montana, and Wyoming territories.

One of these early donors stands out because of both the quality and number of the objects he gave. His name was Rev. Edward W. J. Lindesmith, C.S.C., and he was the first Catholic chaplain commissioned into the U.S. Army. He was stationed with the Seventh Calvary at Fort Keogh, in the Montana Territory, between 1880 and 1890. One of his passions was acquiring objects made by the Native Americans he came to know. After his retirement he split his collection, sending approximately half of it to Notre Dame in 1899. Two of the objects described in this catalog, the Lakota girl's dress and the White Swan pictograph, come from his collection.

Friends and faculty continued to give objects to the university throughout the early 1900s. In 1953 the opening of the O'Shaughnessy Art Gallery marked the formal beginning of a more comprehensive university art museum. In 1963, objects that were thought to be Native North American art were accessed into the University's art collection. From that point on,

Because Native American art is not timeless but has changed over the ages, the collection includes objects reaching back many centuries to the precontact period, pieces from the late nineteenth and early twentieth centuries, and works by contemporary artists.

In the future, the contemporary Native American art collection will continue to grow. In addition, diverse textile arts from various cultures throughout North America will be added to the excellent examples from the American Southwest.

various donors have contributed works of Native North American art. Three individuals, Mr. and Mrs. Paul B. Markovits and Mr. Peter David Joralemon, have given many of the Museum's best Southwest ceramic objects, several of which are described in this volume. Their generosity has contributed greatly to the quality of our ceramics collection. William and Leslie Banks have almost single-handedly donated the Southwest textile collection. Again, the individual pieces are of excellent quality, as exemplified by the man's wearing blanket described in the following pages. The recent growth of the Museum's contemporary Native American art collection owes much to the Walter R. Beardsley Endowment for Modern and Contemporary Art and the generosity of Mr. and Mrs. Russell G. Ashbaugh, Jr.

In the future, the contemporary Native American art collection will continue to grow. In addition, diverse textile arts from various cultures throughout North America will be added to the excellent examples from the American Southwest. Fine pieces of ceramics from the Southwest, both pre-1500 and early twentieth-century, will also increase the range of the Southwest ceramic collection. All future acquisitions will continue the effort to present the full diversity of Native American art in time, space, and cultural tradition. JMM

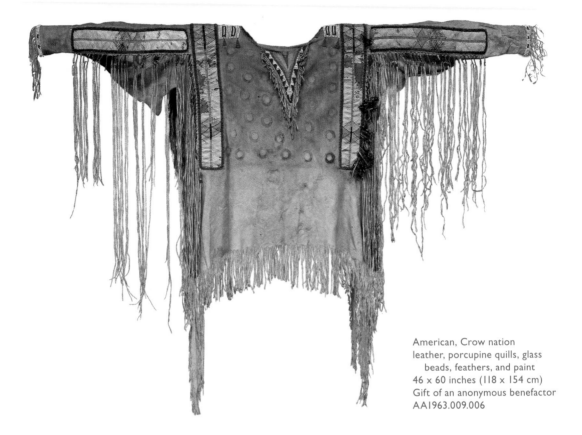

American, Crow nation
leather, porcupine quills, glass
beads, feathers, and paint
46 x 60 inches (118 x 154 cm)
Gift of an anonymous benefactor
AA1963.009.006

CROW MAN'S SHIRT, about 1845

The layout and execution of the plaited quillwork bands, thread-wrapped fringe, beadwork, and paint make this Crow "ceremonial" or "war" shirt a classic example of Upper Missouri River Plains art. During the 1800s, the Crow were renowned for their men's shirts, which they traded to warriors and chiefs from tribes throughout the northern plains and plateau. The detail and fine workmanship of this example illustrate why the shirts were desired by many warriors and chiefs. This shirt's cut and the combination of pony and seed beads suggest it was manufactured before the 1850s, as does the dark bead border, which was typical of Crow men's clothing during the 1840s and 1850s.

The quill strips down the sleeves and over the shoulders are exquisitely sewn in a pattern characteristic of Crow artists, a multiple-quill plaited design joined down the center by a narrow line of quillwork. Two other features common to Crow shirts are the isosceles triangle elements at the shoulders and the design arrangement on the quill strips, which positions the design unit at the elbow, the shoulder, and midway on the front and back strips. The dark blue paint on the shirt indicates its owner successfully counted coup during a battle. JMM

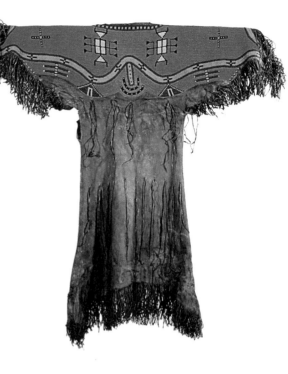

LAKOTA GIRL'S DRESS, about 1880

This beautifully beaded buckskin dress is called *chuwignaka* in Lakota. Its style was common to the Plains, Plateau, some Great Basin, and some Southwest cultures from the mid-1800s into the early 1900s. The aesthetics of those cultures dictated the careful preparation of the skins of elk, deer, or bighorn sheep to a shade of white. For this type of dress, two skins were sewn together, with the hind legs forming the bodice and sleeves. The cut of the sleeves—tapered at the ends and slightly curved along the inner seam—is typical of Lakota dresses. The sleeves and bottom of the dress were fringed, and the beads were sewn onto the bodice using the "lazy stitch" technique. Solid beading of the bodice, as seen here, did not begin until the mid-1870s, when seed beads became readily available. Such beaded dresses were worn for special occasions and dances. This example was purchased in 1883 by Father Lindesmith, a Catholic priest and commissioned chaplain, from the scout Wolf Voice. Both men were assigned to the Seventh Cavalry of the U.S. Army.

The designs on Lakota women's clothing include those of supernatural significance as well as those of personal preference, representing both the seen and unseen worlds. A background of light blue beadwork is common and symbolizes a body of water in which the blue sky is reflected. Narrow bands of beadwork form the border for the blue field and are said by old-time bead workers to indicate the shore. Traditionally, the designs within the blue field signify the reflections of supernatural beings who live in the sky or on the lakeshore; stars and clouds are often depicted. Some Lakota women say the cross denotes the Morning Star, others it is the Four Winds or Directions. Still others have indicated it is only decorative. The U-shaped figure directly in the center of the lower bodice symbolizes Turtle (the U shape stands for Turtle's breast), and the red double crosses represent dragonflies. In Lakota belief, both Turtle and Dragonfly have protective power for women. JMM

American, Lakota nation
buckskin, beads, and sinew
44 x 56 inches (112 x 142 cm)
Gift of Rev. Edward W. J. Lindesmith, C.S.C.
AA1899.002

PICTOGRAPH WAR RECORD, 1880

Plains warriors commonly depicted war records on animal skin and, later, on muslin and paper. The practice was an extension of a long tradition: warriors had pecked or painted historic events and visionary experiences on rock surfaces for centuries. The scenes they illustrated on buffalo hide typically depicted an individual's war exploits or hunting success, both memorializing and validating the accomplishments. Once the reservation period began, warriors had almost no access to buffalo skins and therefore used muslin and paper for their records.

White Swan drew this war record with pencil and ink and then painted it with watercolors on muslin. He was a Crow warrior and a U.S. Army scout from 1876 to 1881, the oldest of six Crow warriors to serve as scouts for General George A. Custer during the Battle of the Little Big Horn. Occasionally, he recorded his feats on buffalo skin, muslin, and paper, which he then sold. This is one of the largest and earliest known examples, depicting nine of his war exploits. In each of the vignettes, White Swan identifies himself with two signature elements: his red, white, and black loincloth and his yellow and red feathered hair ornament. JMM

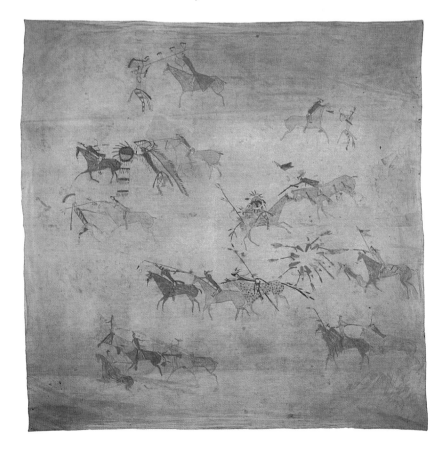

CHILD'S EYE-DAZZLER BLANKET, about 1880

This Navajo blanket is beautifully woven in the Eye-Dazzler style, a term that refers to the sharp color contrasts and zigzag bands. The style was a Navajo innovation between 1870 and 1910, influenced by the Saltillo serape serrated zigzag motif from New Mexico and northern Mexico. Although Eye-Dazzler textiles were very popular with Navajo, many traders considered them too bright and busy.

Navajo weavers used dyed commercial yarns as early as 1850 but more frequently after their internment at Bosque Redondo, in eastern New Mexico, from 1864 to 1868. This blanket is made from Germantown yarn, manufactured in Pennsylvania. The background was originally bright orange-red, with part of the design in forest green. However, aniline dyes fade, and the original bold colors have softened to orange and pea green.

The blanket exhibits typical characteristics of Navajo textile weaving: finished selvage edges, corner tassels, and "lazy lines" woven into the fabric. It is very tightly woven, clearly by a master weaver. The term "child's blanket" is common but misleading, because blankets of this size were also used as saddle blankets, as *hoohgan* door covers, and for sale and trade. Those in almost perfect condition, like this one, likely were made for sale. JMM

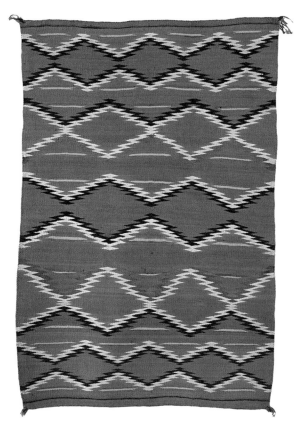

American, Navajo nation
wool textile, with natural and aniline dyes
52 x 35 inches (132.1 x 89.9 cm)
Gift of the Friends of the Snite Museum of Art
 Purchase Fund
1997.060.001

White Swan (opposite page)
American, Crow nation, about 1851–1904
muslin and paint
74 x 78 inches (188.96 x 198.12 cm)
Gift of Rev. Edward W. J. Lindesmith, C.S.C.
AA1963.009.005

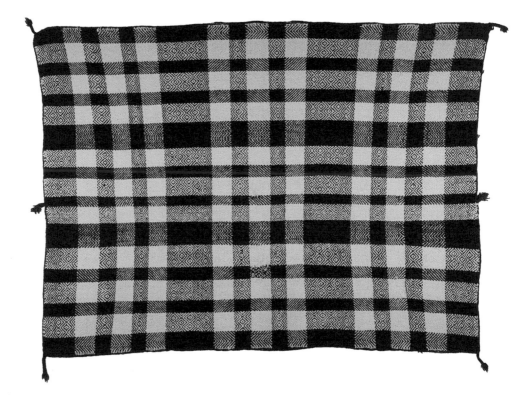

MAN'S WEARING BLANKET, about 1900

This beautifully designed blanket of diagonal twill reinforces the idea of positive and negative design elements, as the tweed or "gray" sections function much like hachuring on black-and-white pottery in the American Southwest. The rectangles of white and black are created in a diamond weave and a herringbone or V-shaped weave. Thus, the rectangular design elements alternate both between black, white, and tweed and between diamond and herringbone weave, resulting in a complex and visually stimulating pattern. The ancestors of the Hopi have woven complicated diamond and herringbone designs for several hundred years.

Black-and-white plaid blankets originally were woven in cotton, but the Hopi adopted wool after the introduction of sheep by the Spanish. Although these plaid blankets were made for men, once American goods became available men no longer wore this style of blanket. Smaller versions continued to be woven for boys. This blanket is almost six by four feet, the size for a man. JMM

American, Hopi nation
wool textile
62 x 45 inches (157.5 x 114.3 cm)
Gift of William and Leslie Banks
1998.068.002

Mimbres Mogollon culture (opposite page)
slipped and painted earthenware
7.5 x 4.5 inches (19 x 11.5 cm)
Gift of Mr. and Mrs. Paul B. Markovits
2003.026

MIMBRES STYLE I FIGURATIVE BOWL, A.D. 750–900

This bowl's small, deep hemispherical shape and in-turned rim are characteristic of the earliest Mimbres Black-on-White bowls. The vessel is an exceptional example of Style I, or Mimbres Boldface Black-on-White pottery, a style once designated Mangus Black-on-White. Other features of the bowl that are characteristic of Style I include the direct and spontaneous manner of the heavy brushwork, the extension of the figures to the rim of the bowl, the use of wavy lines as the filler element in the figures, and the layout of the design in quadrants.

The figurative design is uncommon in this early period. The conventionalized, unrealistic figures appear to be a decorative motif. Although later Mimbres anthropomorphic figures are more realistic, they sometimes resemble stick figures with the head in profile, a design likely influenced by Hohokam-culture potters to the west. These examples are comparable to decorative figures from the Ancestral Northern Pueblo culture, whose people commonly depicted stylized, square anthropomorphic figures. JMM

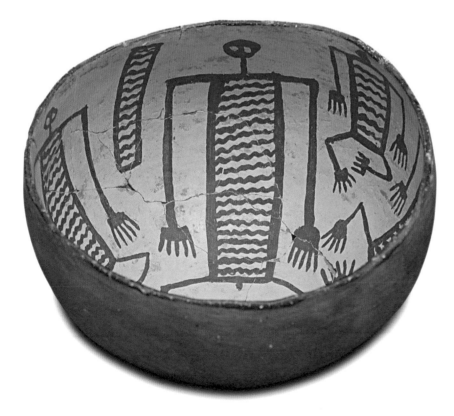

The Mimbres people are famous for their exquisite Black-on-White pottery bowls, which they made over a period of roughly six hundred years.

BOWL WITH CRANE, 1000–1150

Mimbres Mogollon culture
slipped and painted earthenware
3 x 7.5 inches (7.5 x 19 cm)
Gift of Mr. and Mrs. Paul B. Markovits
1993.092.006

The Mogollon culture inhabited southwestern New Mexico and southeastern Arizona for several hundred years, farming the terraces and floodplains of the large streams and small rivers in the area. The Mimbres people, a subculture of Mogollon, were centered upon the Mimbres River and its vicinity in western New Mexico. They are famous for their exquisite Black-on-White pottery bowls, which they made over a period of roughly six hundred years. Both of these examples represent Mimbres Black-on-White Style III, the culmination of Classic Mimbres pottery.

A primary figure is centered on a white background in the bottom of each bowl, and finely drawn framing lines encircle each bowl's rim.

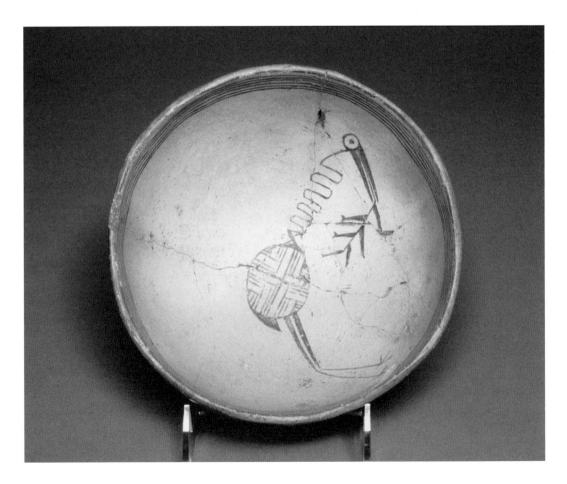

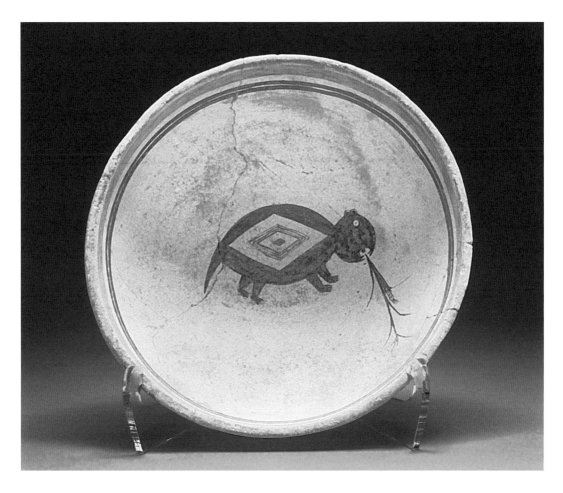

Fish are commonly depicted on Mimbres bowls, occasionally with cranes. On one of these examples, the crane is not eating a single fish but holding several on a line. It is tempting to interpret this as a narrative: the crane has stolen a line of fish from a fisherman. However, the image may instead symbolize the crane's most common food source or the scene from a myth. The gopher on the other bowl may represent a mythical rodent who is allotted corn from the harvest. Or it may be an expression of a frequent concern of Mimbres farmers, a troublesome pest. The depictions of both animals contain common motifs: a quartered design forms the body of the crane, and an eye motif decorates the body of the gopher. JMM

BOWL WITH GOPHER EATING CORN, 1000–1150

Mimbres Mogollon culture
slipped and painted earthenware
4.4 x 8.5 inches (11 x 21.5 cm)
Gift of Mr. Peter David Joralemon
1995.068.001

The ceramic artisan created the fire clouds, a common pattern that appears to have been aesthetically pleasing to the Sinagua people.

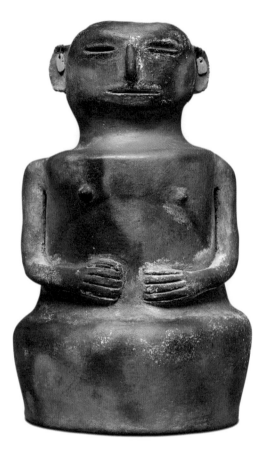

SINAGUA EFFEGY VESSEL, 1150–1300

This unique effigy vessel attributed to the Sinagua people, a prehistoric culture in Arizona, is one of only a few anthropomorphic vessels known from the American Southwest. Dated to the Honanki phase of the Southern Sinagua, it exemplifies the cultural aesthetic and artistry of Sinagua potters.

The vessel is a type of slipped and burnished earthenware known as Sinagua Plain Ware. After 1150, Sinagua artisans specialized in the manufacture of burnished plain-ware ceramic vessels, often with distinctive patterns of fire clouds. This example has the form of a male figure on the front, but the back of the jar shows no indication of the human form except for ears. The jar itself was made using the coil-and-scrape method, and the ears, nose, arms, and nipples were modeled and then applied to the jar after the surface was burnished. The ceramic artisan manipulated the fuel on the surface of the vessel during pit firing to create the fire clouds, a common pattern that appears to have been aesthetically pleasing to the Sinagua people. JMM

Sinagua culture
slipped earthenware and turquoise
8.75 x 4.8 inches (21.8 x 11.75 cm)
Gift of Mr. and Mrs. Paul B. Markovits
2005.007

QUAIL EFFIGY CONTAINER, 1200–1450

Decorated with precise designs in black, white, and red, this quail effigy jar is a beautiful example of ceramic art created by potters of the Paquimé or Casas Grandes culture from the northwestern portion of Chihuahua, Mexico. Though a polychrome jar, it has just three areas of red paint: the tip of the bird's tail and the rings around the eyes and neck. It fits the conventional form of Paquimé bird effigy vessels, with the head extending from one side and the tail from the other. The dotted breast and diamond-shaped eye outline identify the bird as a quail.

Mexican, Paquimé culture
slipped and painted earthenware
8.65 x 4.25 inches (21.5 x 10.7 cm)
Gift of Mr. Peter David Joralemon
2002.068.001

The layout of the design follows the widespread Paquimé practice of creating symmetrical patterns within a decorative field outlined at the top and bottom with black lines. Additionally, many of the painted designs seen on this piece are commonly found on Paquimé-culture painted wares, including the triangles repeated in opposition, separated by a line from the top to the bottom of the jar on each side, and the hook with a rounded end, resembling the letter *p*, within each solid black triangle. The hook, either rounded or squared, is a common element on Southwest ceramics. JMM

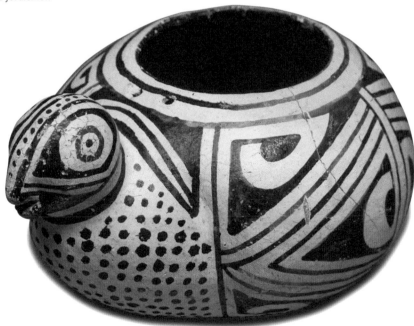

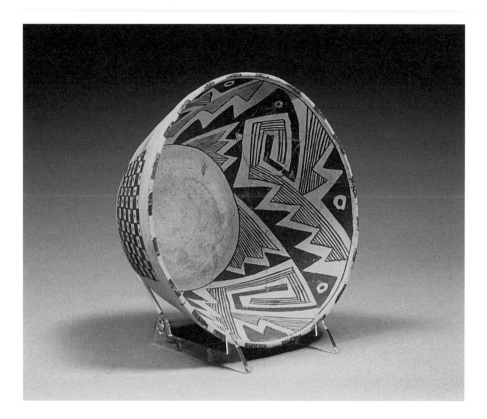

SLANT-WALL BOWL, 1250–1350

The Western Pueblo people of northern Arizona and northwestern New Mexico are the cultural descendants of the Anasazi and Mogollon cultures in the American Southwest. These people lived in farming communities that the Spanish described as "pueblos." They created ceramic pieces well known for their intricate designs and fine artistic technique, as seen in this example of Cibola Whiteware.

The four zoomorphic creatures with long beaks and serrated backs that divide the interior composition are typical of Western Pueblo styles and are often interpreted as symbolizing the horned serpent. Each of the four units has a circle with a dot, usually interpreted as an eye. Longitudinal and diagonal hatching within the composition contrasts with the solid area of the design. Encircling lines frame the composition, one just below the bowl's rim and one at the base of the design, leaving an open, circular area. The rim is flattened and has evenly spaced ticking around it.

On the white-slipped exterior, a checkerboard design appears on two opposite sides of the bowl. This design has several possible interpretations: it could imitate a blanket design, but may symbolize the winter starry war god, Hopi and/or Zuni clowns, or the horned serpent. JMM

Western Pueblo culture
slipped and painted earthenware
8.6 x 5.5 inches (21 x 15 cm)
Acquired with funds provided by the
 Mr. and Mrs. J. Moore McDonough
 Endowment for Art of the
 Americas
1986.041.001

BOWL WITH THUNDERBIRD INTERIOR, 1350–1400

One of the finest examples of its type, this spectacular Four Mile Polychrome bowl depicts a mythological thunderbird in black and white boldly stretching across the red-slipped interior. On the exterior of the bowl, a white motif forms a band framed by wide black lines. The design of the bowl reflects the interaction of several cultural traditions of the American Southwest, which by the fifteenth century would concentrate into communities within northern Arizona and northern New Mexico.

The motifs on the wings and tail occur frequently on Southwest pottery and in textile designs from the last fifteen hundred years. Some are associated with specific pottery styles: the white fine-line outlining and the F-hook motifs link this bowl to Four Mile Polychrome and the Pinedale style. The composition of the bowl is similar to Classic Mimbres Black-on-White

The design of the bowl reflects the interaction of several cultural traditions of the American Southwest.

bowls, which also depict spread-wing birds in their centers. Further, the hourglass form and the head shape with two eyes are reminiscent of early Hopi pottery designs on Jeddito Black-on-Yellow pottery. The stepped and fringed ends of the wings and the triangular ends of the tail feathers, as well as the white squares with dots, are also well-known motifs, dating back to some of the earliest painted pottery in the Southwest. JMM

Western Pueblo culture
earthenware
4.13 x 9.5 inches (10.5 x 24 cm)
Gift of Mr. and Mrs. Paul B. Markovits
1998.016.002

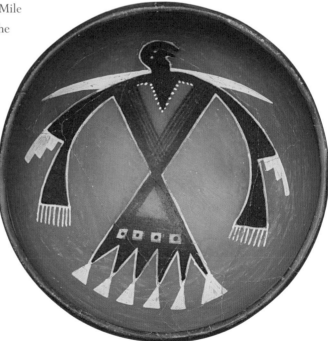

CEREMONIAL LANDSCAPE, 1993

Mario Martinez is a contemporary Native American Abstract Expressionist who uses abstract forms reminiscent of Western modernist art to represent spiritual elements of Yaqui tradition. He was raised in a Yaqui village that became engulfed by the city of Scottsdale, Arizona, and he grew up in the Phoenix area under the influence of three cultures: Yaqui, Anglo, and Mexican American. These multiple cultural influences are reflected in his paintings, particularly Yaqui song, dance, ceremony, and religion, and European modernism. His work has been primarily inspired by Wassily Kandinsky and Pablo Picasso, and his abstract compositions are constructed with layers of meaning.

Ceremonial Landscape synthesizes Western modernist visual traditions and concepts with images inspired by Mario's Yaqui heritage, using bright, compelling colors. As a landscape, it is an abstract expression of Yaqui ceremony and the cultural and physical environment into which ceremonial activities are placed. Those who know something of Yaqui culture will recognize the stick or sword, important in many Yaqui ceremonies. Martinez works primarily in acrylic and oil, using color very effectively. In the early 1990s, he began adding materials other than paint to his canvases. For *Ceremonial Landscape*, he used acrylics and materials common in traditional Yaqui ceremonial regalia. JMM

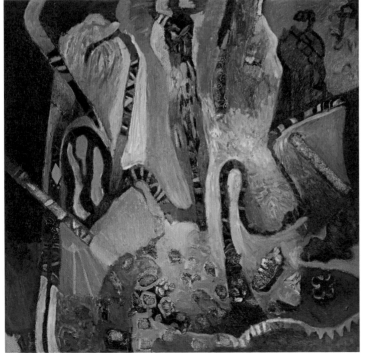

Mario Martinez
American, Yaqui, born 1953
acrylic and mixed media on
 canvas
67 x 70 inches (168 x 175 cm)
Acquired with funds provided
 by the Walter R. Beardsley
 Endowment for Modern and
 Contemporary Art
1999.001

BIG LOTSO, 1999

Rick Bartow
American, Wiyot, born 1946
mixed media on handmade paper
72 x 50 inches (178 x 131 cm)
Acquired with funds provided by the
 Walter R. Beardsley Endowment
 for Modern and Contemporary Art
2004.052.001

Rick Bartow creates brightly colored expressionist drawings by using energetic, yet often delicate, marks and lines, as well as erasures. The marks occasionally hold meaning, but they represent a personal symbolism he has developed from several sources; they need not have meaning for the viewer.

The roots of Bartow's visual symbols and aesthetics are European literature and the oral traditions of his Wiyot tribe, as well as other tribes from the Oregon and California coast, where his family lived for generations. His world travels immersed him in Asian and South Pacific cultures, particularly Maori

and Japanese, which also influenced his art. The mixture of cultural elements in his work reflects a blending of his life experiences.

In *Big Lotso*, drawn with dry pigment and charcoal, Bartow integrated many of his sources of personal strength and aesthetics. Lotso is the name for Green Frog, a being of power in native cultures of northwest coastal California. The large size of Lotso in this drawing, in contrast to the actual small size of the frog, emphasizes its power, which lies in its capability of physical transformation. Symbols and images important to Bartow's life and personal transformation are drawn around the image. JMM

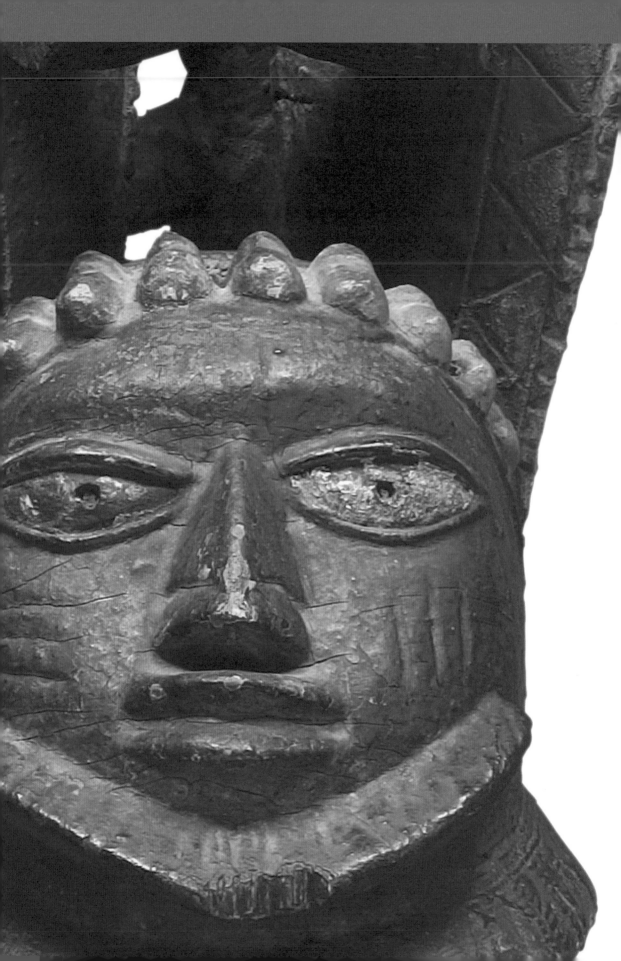

AFRICAN ART

African art typically made its appearance in nineteenth-century American universities, colleges, and museums in the natural history collections of those institutions. That is exactly where necklaces, bracelets, and skirts made from European glass trade beads by the Zulu and Pondo peoples of southeastern Africa were exhibited at Notre Dame by the 1880s, in the Main Building library.

In 1958 Rev. Anthony J. Lauck, C.S.C., director of the O'Shaughnessy Art Gallery, purchased several fourth- to seventh-century Egyptian Coptic Christian religious vestment fragments that depicted human figures amid a variety of African flora and fauna. Collecting textiles produced in the very earliest centuries of the church in Africa must have held great appeal to Father Tony. In addition, appreciation of the formal qualities of traditional African art was becoming widely visible in American museums and popular culture, and they appear to have been irresistible to the Notre Dame gallery director and sculptor.

That year saw another important event in the growth of popularity of African art, the release of the romantic comedy *Bell, Book and Candle*, starring Jimmy Stewart, Kim Novak, Jack Lemmon, and Ernie Kovacs. The film was shot in the most popular "primitive art" sales venue in New York, Julius Carlebach's 1040 Madison Avenue gallery. Father Tony's visits to Carlebach seem to have begun about this time,

and, as with Pre-Columbian art, he approached a number of prominent collectors of the day for donations. By 1962 Father Tony was accepting donations of African art, appraised for income-tax purposes by Carlebach, from New York collectors including Ernst Anspach, Emil Arnold, Martin Goodman, Cedric Marks, Willi and Beatrice Riese, and Lester Wolfe. Realizing that those collectors were expecting him to demonstrate his determination to build a collection on his own, he began buying sculpture from Carlebach and other dealers through the Dr. Tom Dooley Art Purchase Fund.

Of course, African art and design had been popular in New York since the Brooklyn Museum of Art's 1,450-piece exhibition of African objects opened in 1923, curated by Stewart Culin. This exhibition was the first and largest display of African art in any American art museum, and it is credited with having a profound influence on many artists of the Harlem Renaissance. The Museum of Modern Art's landmark 1940 exhibition of African

art and the 1957 opening of the Museum of Primitive Art, with its regularly changing exhibition schedule, offered both New Yorkers and visitors the opportunity to see African sculpture from other art museums and private collections. Some of the collectors began giving to Notre Dame in the following decade.

During my undergraduate career, from 1967 to 1971, Father Tony assembled exhibitions from three of the most important collectors of the time, with catalog commentary from the foremost experts: Ernst Anspach's *Anspach Collection*, with a catalog introduction by the greatest American African art historian, Indiana University's Roy Sieber, exhibited from March 17 to May 12, 1968; Eric de Kolb's *Ashanti Goldweights and Senufo Bronzes*, with a catalog introduction by Warren Robbins, director of the Museum of African Art, Washington, DC, September 6–November 15, 1970; and Mr. and Mrs. J. W. Gillon's *African Sculpture from the Tara Collection*, with a catalog written by the British Museum's curator, William Fagg, the

greatest European African art scholar of his day, March 28–May 23, 1971. All were wonderful inspirations for me, a young anthropology major, and I distinctly remember standing in the Ashanti goldweight show and thinking, "I could do this."

Nine years later, when I returned as curator in 1979, I was given the opportunity. Beginning with a thorough review of the collection, and adding some important objects donated by collectors who shared my interests in African art and who followed me to Notre Dame, we opened the Arts of the Americas, Africa, and Oceania Gallery in 1981 on the lower level of the Snite Museum of Art. The 1980s witnessed rapid growth of the collection in the arts of groups from the arid western Sudan, the rain forest of the west coast, the forests of central Africa, and the grasslands of the southern Savannah, through donations from the Alsdorfs, Ernst Anspach, the Britt Family, and Beatrice Riese, among others. The 1980s were also marked by important in-house and

The Brooklyn Museum of Art's 1,450-piece exhibition of African objects in 1923 was the first and largest display of African art in any American art museum.

A storyteller as well as a student of the spoken text, Erskine was keenly interested in the oral traditions and art of the Yoruba people of southwestern Nigeria.

traveling exhibitions and catalogs from the Britt Family and John and Rita Grunwald. The year 1998 saw *Sculptor's Hand, Viewer's Eye: African and Native American Art from the Beatrice Riese Collection*, and 2002 opened with *Masks and Figures, Form and Style: The Christensen Family Collects African Art*.

It was the untimely death of a colleague and friend, a brilliant African American scholar of Emily Dickinson's poetry, Erskine A. Peters, that offered an intellectual framework for setting a new course in African art collection development. A storyteller as well as a student of the spoken text, Erskine was keenly interested in the oral traditions and art of the Yoruba people of southwestern Nigeria, whose rich and deep oral history and worldview is depicted in the largest body of sculpture of any group in African art.

I had long wanted to develop a collection of superb Yoruba art that would depict their pantheon of gods and illustrate the creation and preservation of their traditional beliefs for visitors. The strong imprint of Yoruba beliefs and aesthetics on African American traditions made the case all the more compelling, especially since Erskine had been director of the African American Studies program at Notre Dame. It became apparent that the occasion of honoring a great teacher and talker offered an opportunity to begin that special collection with an appropriate piece of sculpture—a dance staff of Esu-Elegbara, the mischievous messenger god who carries communications between humans and deities during Ifa divination ceremonies.

Because the earlier portion of the Museum's collection is reasonably well published, and because the quality of the recent Yoruba acquisitions is so high, I have chosen to show only those pieces in this section. Other important African works have been and will be acquired, but a sharp focus on a theme with objects of very high quality is the best way to build any collection. DEB

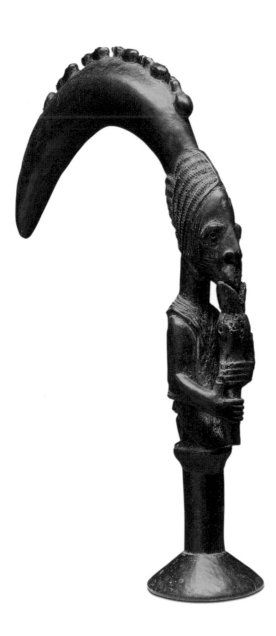

ESU-ELEGBARA DANCE STAFF,
about 1900

This dance staff depicts the Yoruba trickster god Esu-Elegbara. It would have been held with the large, curving projection resting over the performer's shoulder. Mediator between mankind and the gods, Esu-Elegbara carries human divination petitions to Ifa, lord of wisdom, and other deities and delivers replies to mortals. If Esu is not appeased by sacrifices, he may confuse the message in his trickster role. Here, the god plays a flute similar to those used to summon him to divination sessions.

Carved from a single block of wood, the sculpture features an elegant, elongated face that mediates between the grand, sweeping head projection and the more geometrically abstract forms of the torso and kneeling legs. Esu's hairstyle is carefully detailed, as is his costume, which is composed of powerful geometric forms. The rising of *ashe* (the divine power to make things happen) within Esu-Elegbara is depicted as a projection from his head. *Ashe* also is present within seven calabashes of power that line the upper crest of the projection. The sculpture's surface has an aged, leather-like quality with iridescent hints of blue—the remaining traces of indigo applied to flatter Esu and enhance his appearance. DEB

Oyo Yoruba people
Nigeria
wood with indigo and other encrustation
19.25 x 4 x 11.25 inches (48.9 x 10.2 x 28.6 cm)
Acquired with funds provided by an anonymous bene-
 factor, in memory of Professor Erskine A. Peters
1997.048

In typical Yoruba fashion, the crossroads on the front of this

satchel reveals what it once hid: a small divination tray, an ivory

tapper to call Esu to the divination, and other ritual implements.

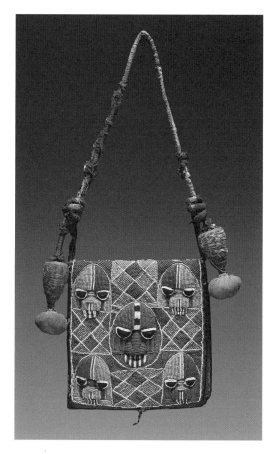

Yoruba people
Nigeria
leather, glass beads, men's-weave cotton cloth,
 and medicinal substances
10.75 x 10.38 x 1.25 inches (27.3 x 26.4 x 3.2 cm)
Acquired with funds provided by the Fritz and
 Milly Kaeser Endowment for Liturgical Art
2005.002.002

IFA DIVINER'S SATCHEL, about 1910

This diviner's equipment bag is emblazoned with four boldly contrasting rectangular panels of blue and orange diamonds, which create an equal-armed cross around the central face of Ifa, the god of wisdom. The cross represents a crossroads defining the center of the world and the four directions. This center of communication is governed by the trickster and messenger of the gods Esu-Elegbara, who is called to a divination, appeased with offerings, and sent to Ifa with the petitioner's request. Four faces of Ifa are depicted in the corners of the bag, reiterating the cosmological structure. In Yoruba divination symbolism, multiples of four motif elements are the basic units used to express divination concepts. The artist used a hot iron stylus to make images of a man and animals, referring to the world's creation, on the leather interior.

An essential first step in any divination session is the drawing of a crossroads in white chalk upon the wooden divination board used in the ceremony. In typical Yoruba fashion, the crossroads on the front of this satchel reveals what it once hid: a small divination tray, an ivory tapper to call Esu to the divination, and other ritual implements. DEB

SHANGO DANCE STAFF OF A STANDING MOTHER CARRYING A CHILD, about 1900

Shango, a sacred Oyo Yoruba king, was a tyrant whose quest for supernatural power ultimately consumed him. As he gained in secret magical knowledge, he became uncontrollable and his opponents forced him to commit suicide by looking into his crown and exposing himself to the raging, violent power emanating from his own head. His followers claim he did not die but became the *orisha*, or deity, who controls the uncontrollable— thunder and lightning, smallpox, and other unruly natural forces. Shango also sends twins, babies that have unusual powers for good or evil. He is quick to anger and forgive and epitomizes the Yoruba duality of hot and cool. At his annual festival, Shango's entranced priests express his capricious nature by alternately swinging their staffs wildly or swaying sedately with them from moment to moment.

This bold, powerful sculpture represents a female devotee of Shango who carries a child on her back and holds a calabash rattle in her right hand. Emerging from the top of her head are opposed triangular forms representing thunderbolts that Shango hurls in his wrath at those who displease him. A large head is one of the most important features of Yoruba human figural sculpture, because the head is the seat of strength and wisdom. In profile, this head is a low, rounded triangle with jutting eyes, nose, and mouth that are offset by the indentations of the gathered hair at the back of the head. The ear is a visual fulcrum upon which the head is balanced, and it echoes the curves of the hair behind it. An enigmatic smile emphasizes the secret power of women in magical and religious contexts, and bulging eyes convey hidden knowledge concealed by hooded lids. The calabash rattle may also refer to *ashe*, the power or knowledge to make things happen that is guarded from the eyes of unbelievers.

Both mother and child are nude except for traditional waist beads and necklaces, a manner of depiction common in ritual objects. Extensive wear on the breasts suggests that the staff was used to promote fertility and resolve issues surrounding twins and childbearing. The additional wear on the lips and nose is typical. Shango staffs sometimes are displayed in his shrines, but large ones such as this are uncommon. Although ritual objects are often washed, the surface of indigo and other materials on this sculpture probably was removed in Europe after the staff was acquired by a collector. DEB

Igbomina or Erin Yoruba people
Nigeria
wood with traces of pigment
25.5 x 8 x 4.75 inches (64.77 x 20.32 x 12 cm)
Acquired with funds provided by Dr. and Mrs.
 R. Stephen Lehman, Marilynn B. Alsdorf by
 exchange, and anonymous benefactors
2002.010

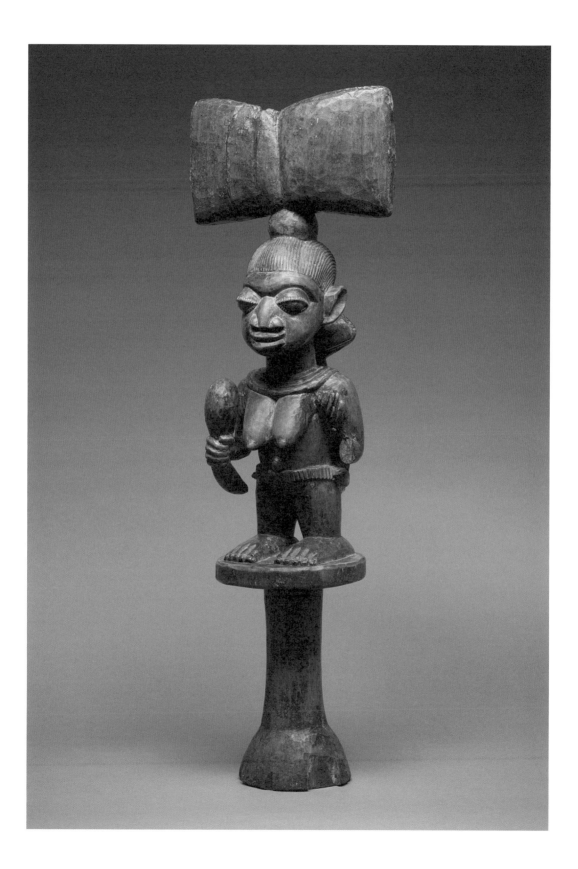

OGUN SOCIETY TITLE STAFF DEPICTING A BLACKSMITH HOLDING A TITLE STAFF, about 1900

Ogun is the god of iron and the patron of blacksmiths, warriors, and hunters. He also holds sovereignty over brass casting. Thus he controls the creation of objects of great beauty in wrought iron and brass, as well as those of death and destruction. The two concepts merge in song cycles devoted to his praise, in which the cut of a blade into soft flesh is described in terms of great beauty. Ogun is a "hot" deity of bloodlust and vengeance who brings power and prestige to his followers working honestly at the forge.

Ogun Society title staffs are very rare. They are never used as weapons, but their symbolic capacity to pierce and penetrate has always created sexual metaphors associated with the power and fertility of the earth. Today, title staffs are held by the chief blacksmiths of towns or regions. In the past, they also belonged to the regalia of war chiefs.

This impressive sculpture cast in the lost-wax method on top of a war sword depicts an Ogun Society titleholder brandishing another type of title staff. He sits armed with a war knife and a calabash filled with *ashe*, the power to make things happen. DEB

Yoruba people
Nigeria
lost-wax cast copper alloy on wrought iron
29.25 x 6.13 x 1.63 inches (74.4 x 15.6 x 4.2 cm)
Acquired with funds provided by the William L. and Erma M. Travis Memorial Endowment for Decorative Arts
2005.005

EGUNGUN HARE AND THE HUNTER OF THE NIGHT MASK, about 1940

Adugbologe family carvers, active since the late nineteenth century, specialize in twin figures and masks worn in Egungun masquerades, a pan-Yoruba tradition honoring ancestors that originated in the city of Oyo. Charged with preserving the memory of wise, deceased community leaders, participants in Egungun had the authority in traditional times to kill witches. The character Hare and the Hunter of the Night punished witches who committed infanticide.

The elongated ears and the vicious-looking hare on the back of this mask refer to its ability to move freely at night when witches are active and most vulnerable. Variation in the directions of the facial scars—horizontal (representing the Oyo Yoruba people) and vertical (symbolizing the Egba Yoruba people)—shows that Egungun membership transcends family ties, since a member may have to punish kinsmen. The forehead is decorated with calabash gourds filled with magical protective *ashe*. A pressure drum, the voice of the ancestors, connects the ears, which are ornamented with magical Islamic-knot protective devices. The yellow paint outlining the ears and the forehead, and the foil on the eyes and ear triangles, would have reflected torchlight at night, when the masks were typically danced. A cloth band tied around the base secured the dancer's costume. DEB

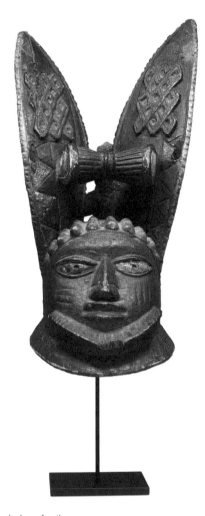

Adugbologe family
Egba Yoruba people
Abeokuta, Nigeria
wood, paint, and tin foil
17.75 x 10.5 x 12.75 inches
 (45.1 x 26.6 x 32.4 cm)
Museum purchase by exchange,
 the Raymond E. Britt Family
1998.036

ELEFON (EPA) MASK OF AN ELDER WOMAN, about 1910

Elefon and *Epa* are two different names for identical masquerades held in the Ekiti and Igbomina areas of northeastern Yorubaland. In Igbomina, both the masks and the festivals are known as Elefon and celebrate Yoruba cultural values. They honor important, idealized human figures—brave warriors and women of superior wisdom and moral character. Different masks are found in every town. In the town of Ila-Orangun, the festivals have ceased and the masks are now used as shrine sculptures to honor important ancestors.

This mask from Ila-Orangun depicts an idealized mother. The children represent the local population for whom she cares. Indigo blue in the hairdos of all of the figures and on the woman's stomach connotes royalty and authority. Although lip labrets passed out of style early in the twentieth century, they continued to be depicted, as here, in sculptures dedicated to important women. The mask was painted repeatedly between performances to refurbish it, and the multiple coats of brick red paint have obscured some of the painted costume details. The rear hair crest and right breast were restored to extend the life of the piece. DEB

Ogundeji (1873–1938?)
Igbomina Yoruba people
Ila-Orangun, Oyo State, Nigeria
wood, paint, and indigo
31.25 x 10.13 x 11.75 inches (79.38 x 25.73 x 29.85 cm)
Acquired with funds provided by Mr. Ernst Anspach, Mr. Emil Arnold, Mr. and Mrs. Harrison Eiteljorg, Mr. J. W. Gillon, Mr. Cedric Marks, Beatrice Riese, Mr. Lester Wolfe
1984.027

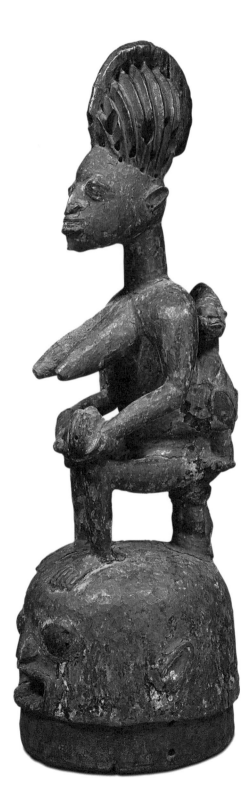

GELEDE SOCIETY MASK DEPICTING A BEAUTIFUL WOMAN, about 1900

In western Yorubaland, Gelede Society masks that often depict the heads of beautiful women are used to calm and placate the anger of the spiritually powerful elderly women known as "our mothers," who exert great influence in Yoruba religious, social, and political life. The women's anger may be justifiable, arising from ritual transgressions committed by members of the community or from breaks in traditional behavior. Nonetheless, because their power may be used for good or ill, it can affect the stability of society. The masks are attached to costumes of expensive prestige cloth like those worn by "our mothers." They hide the identities of the male Gelede masqueraders, who seem to float over the ground, imitating the stately movements of the elderly women.

The series of arcs that unfolds from the coiffure to the chin of this mask creates an elegant profile of one of these aged mothers and is designed to elicit their respect and admiration. The mask was held in such high esteem that it was converted into a shrine object and repeatedly covered with coats of paint, which have softened its details but not its powerful impact. White clay in the mouth refers to the ability of the mothers to speak with truth and purity. DEB

Yoruba people
Nigeria
wood, paint, encrustation, and bamboo
16.13 x 8.75 x 10.5 inches (41 x 22.3 x 26.7 cm)
Gift by exchange, Mr. and Mrs. Russell G. Ashbaugh, Jr., and purchase funds provided by the Fritz and Milly Kaeser Endowment for Liturgical Art
2005.002.001

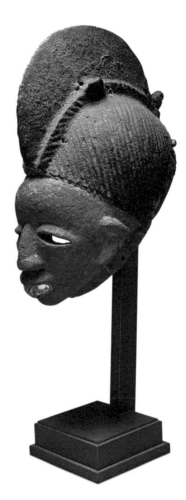

ORO SOCIETY STAFFS, about 1850

These two superb sculptures joined by a chain are mid-nineteenth-century Yoruba staffs of the elite Oro Society. This group of senior male community leaders carried out the judgments of the secret Ogboni Society against those who offended the ancestors with immoral or criminal behavior. Crimes such as murder, adultery, and other heinous acts were punishable by death. Because of the secret nature of Oro and Ogboni, it is difficult to know all of the ways the staffs were used, but sometimes they were placed in the ground outside the home of a person who had been judged, alerting them to their upcoming punishment.

The most typical form of Ogboni Society staffs is that of two sculpted human heads cast onto iron spikes and connected by a chain, but important society members tend to have single male and female figures cast and connected in the same manner. Oro Society staffs depict large figures superimposed over smaller ones of the opposite sex, in addition to more complex symbolism that reflects the greater power and responsibility of its members.

On these examples, the outlines of the top figures are rhythmic and carefully balanced, conveying their dignity and elegance as the founding male and female ancestors of the group, whose honor and sanctity is preserved by the Oro Society. The male figure grasps his right thumb with his left hand, the traditional Ogboni Society gesture of membership. The female figure supporting him makes the same gesture, conveying the importance of women in the fabric of society and the unanimity of Ogboni judgments. The larger female grasping her breasts refers to the wise, aged women called "our mothers," who are capable of wielding great magical power, including the ability to fly at night. Two small rods held by the male who supports her are Ogboni staffs and reflect the structure of judgment and punishment. The chain connecting the conical hats of the ancestors also reflects the male-female cooperation essential to moral and just existence.

These staffs were produced in the workshop of Alatishe Ogundipe, a famous Ijebu Yoruba bronze caster and warrior who brought his characteristic style from his hometown of Ijebu-Ode, Nigeria, to Abeokuta about 1840. After the downfall of the Oyo kingdom in southwestern Nigeria about 1835, four royal courts were established in the new town of Abeokuta. Ogundipe was one of several artists who moved there to provide ritual and ceremonial sculpture to the royal courts, their Ogboni Societies, and many other clients.

Ogundipe's style is recognizable here in the bulging eyeballs with sharp, horizontal centers, the straight nose with flaring nostrils, and the mouth located on the edge of the jaw itself. A choker with a pendant disk around the neck, triangular crosshatched shoulder ornaments, breasts placed high on the chest, beaded waist ornaments, and the depiction of the female pubic hair as netted diamonds are other features common to Ogundipe's style. DEB

Alatishe Ogundipe workshop
Ijebu Yoruba people
Abeokuta, Nigeria
lost-wax cast copper alloy on wrought iron
15.88 inches (40.32 cm) high
Acquired with funds provided by the Lake Family
 Endowment and the Rev. Anthony J. Lauck, C.S.C.,
 Sculpture Endowment
2004.025

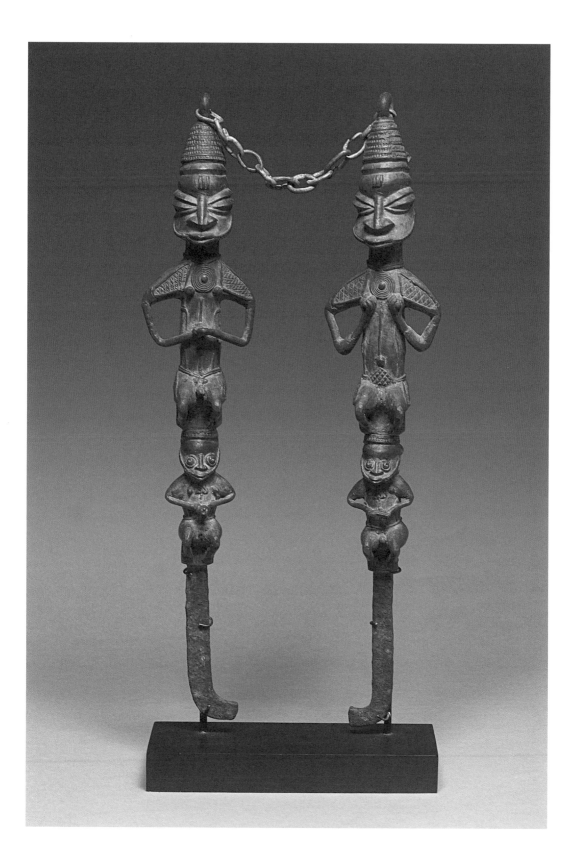

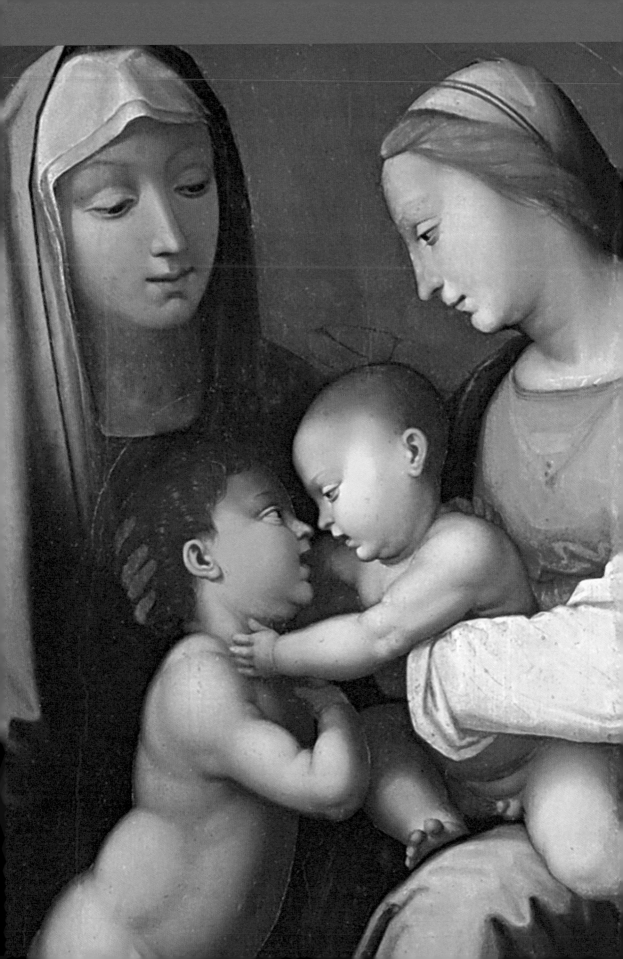

WESTERN ARTS

Although there have been old-master paintings worthy of note at the University of Notre Dame since the early years of the twentieth century, many of the works posed critical problems in terms of both attribution and condition. It was not until the 1950s, when the O'Shaughnessy Art Gallery was founded and several key Renaissance and eighteenth-century works from the collection of Mrs. Fred Fischer were bequeathed, that paintings of individual quality and importance began to delineate the future shape of the collection.

Also during this time period, the Kress Study Collection, with important works by Jacopo de' Barbari, the Master of the Fabriano Altarpiece, Fra Paolino, and Cosimo Rosselli was placed at the art gallery. In the 1960s, it was primarily through gifts from private collectors that several noteworthy works, including Claude Lorrain's *Rest on the Flight into Egypt* and the Master of Miniato's *Madonna and Child*, continued to enter into the gallery's collection.

In light of the ever-escalating costs and increasing scarcity of high-quality old-master works during the past few decades, we feel fortunate to have been able to add Ridolfo Ghirlandaio's impressive *Adoration of the Shepherds* and the captivating devotional image of the Madonna and Child by Girolamo Mazzola Bedoli to our holdings of earlier paintings. Perhaps due to the new interest and scholarship in the field of Baroque art, a considerable number of seventeenth- and eighteenth-century works have come onto the market in recent years. Under

these circumstances, the Museum has been able to acquire some outstanding paintings by artists such as Lubin Baugin, Charles de La Fosse, Jean-François de Troy, and Giambattista Pittoni, as well as several vigorous oil sketches by Gaetano Gandolfi, Francesco Solimena, and Carle Vanloo.

One of the key additions to the Baroque collections came in 1983, when seventy-two etchings by Rembrandt van Rijn from the collection of Mr. and Mrs. Jack Feddersen were donated to the Snite. This private collection contained virtually all of the master's Old and New Testament narrative subjects. Included in the donation were some of Rembrandt's most remarkable images, including *The Hundred Guilder Print*, *The Flight into Egypt* (altered from the plate by Hercules Segers), *Christ Preaching*, and *The Three Crosses*.

In 1985 Mr. John D. Reilly, a Notre Dame graduate in the class of 1963, acquired and placed on loan the old-master and nineteenth-

century drawing collection of the art historian John Minor Wisdom, Jr. He donated the drawings to the Museum in 1992. Although forming a collection of drawings had long been among the Snite's priorities, this gift of sixty-five drawings finally gave the Museum a primary group of works it could build upon. With this single donation, the Snite acquired notable sheets by Edgar Degas, Pierre-Paul Prud'hon, Giulio Romano, Paolo Veronese, and Taddeo Zuccaro.

Over the past twenty years, with the continued support of Mr. Reilly, the drawing collection has grown considerably in numbers, range, and quality. Significant drawings from the Renaissance to the early twentieth century have been added, the majority being by French, Italian, German, and British artists. Exceptional individual sheets by Jean-Baptiste-Camille Corot, Jacques-Louis David, Jean-Baptiste Greuze, Guercino, and Jean-Baptiste Oudry, as well as groups of works by François Boucher, the Carracci family, Eugène Delacroix, Théodore Gericault, and Jean-François Millet, among others, have brought the Museum's drawing collection to a new level of prominence. The nineteenth-century French collection, in particular, has developed to encompass examples by not only most of the major masters but also many of the lesser-known but gifted draftsmen of the period, including Théodore Chassériau, Paul Gavarni, Henri Lehmann, and Pierre Puvis de Chavannes.

Though many of the most illustrious names of the nineteenth century are admittedly missing from the Snite's paintings and sculpture galleries, the Museum nevertheless has a noteworthy collection of nineteenth-century French art. This grouping has grown considerably in the past few decades, due mainly to the remarkable paintings from the collection of Mr. and Mrs. Noah L. Butkin that were placed at the Museum in 1980. From some dozen random works, our collection has grown to include examples that cover most of the important styles of the nineteenth century, from Neoclassicism to Impressionism.

There are paintings in the galleries by such celebrated names as Eugène Boudin, Jean-Baptiste-Camille Corot, Gustave Courbet, and Pierre-Henri de Valenciennes, and there are also superlative works by artists less often encountered in American collections, including Thomas Couture, François-Xavier Fabre, Hippolyte-Jean Flandrin, and Georges Michel. In addition, we own groups of works by the accomplished painters Léon Bonnat, Carolus-Duran, Jean-Léon Gérôme, Horace Vernet,

and others, who were once regarded as major figures in the French school and are currently being reevaluated. The nineteenth-century collection is further enhanced by important sculptures by the artists Jean-Baptiste Carpeaux, Albert-Ernest Carrier-Belleuse, Honoré Daumier, Auguste Rodin, and others.

The collection of decorative arts and design objects is the most recent field of art to be developed at the Museum. In 1985 a decision was made to attempt to build a collection of modern design objects that would specifically complement aspects of the Museum's nineteenth- and twentieth-century collections. As a result, the Snite set out to acquire notable examples from such critical movements as Art Nouveau, Arts and Crafts, Bauhaus, and Wiener Werkstätte and by the famous designers Josef Hoffmann, Archibald Knox, Louis Comfort Tiffany, Henry Van de Velde, and Frank Lloyd Wright, among others. That initial decision has since been reassessed, and the collection has been expanded to include a range of representative examples of earlier decorative arts from such prominent factories as Doccia, Meissen, Sèvres, and Staffordshire.

The Snite's American holdings were for many years defined by a handful of notable paintings by well-known artists such as William Merritt Chase, Thomas Eakins, Charles M. Russell, and Benjamin West. For decades thereafter, the Museum found it possible to access only modest examples of works by Childe Hassam, John Singer Sargent, Elihu Vedder, and the like. More recently, a determined effort has been made to develop the earlier American collections, and the Museum has added distinguished works by William J. Glackens, Gilbert Stuart, Abbott Thayer, and Worthington Whittredge.

In the past few decades, we have steadily added to a core group of post–World War II American paintings by such artists as James Brooks, Adolph Gottlieb, and Georgia O'Keeffe. With support from the Humana Foundation, notable works by Grace Hartigan, Ray Parker, and Sean Scully have provided stimulating new range to the twentieth-century American collection. In 1994, long-time advisory council member Miss May E. Walter donated a group of remarkable paintings and drawings by twentieth-century masters, including Natal'ya Goncharova, Jean Metzinger, Joan Miró, and Joaquín Torres García. The acquisition of a number of significant paintings by Milton Avery, Ralston Crawford, Fairfield Porter, and Joseph Stella has also helped to place some of the later twentieth-century works within a more meaningful context. **ss**

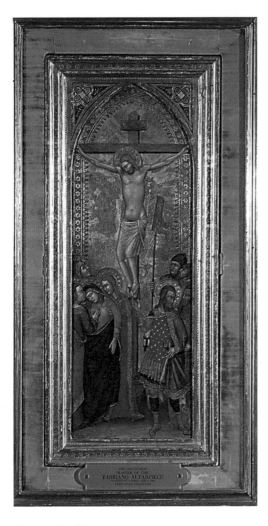

Master of the Fabriano Altarpiece
Italian, active mid-14th century
tempera on wood panel
15.5 x 5.5 inches (39.37 x 13.97 cm)
Gift of the Samuel H. Kress Foundation
1961.047.004

THE CRUCIFIXION, about 1360

This small panel demonstrates the shift in style that occurred in Italian painting during the mid- to late fourteenth century, ushering in the Florentine Renaissance style. Formerly attributed to Andrea da Firenze, it is now recognized to be by the Master of the Fabriano Altarpiece, probably executed late in his career. It was once the right wing of a triptych; the middle panel is now lost, and the left wing, the *Adoration of the Magi*, is in the Worcester Art Museum.

The painting depicts Christ on the cross against a gold background. On the left, Saint John and Mary Magdalene support the swooning Virgin. On the right, a centurion raises his hand toward the cross. A soldier behind him holds a red banner inscribed "S. (P. Q. R.)." The late Byzantine style of the painting—including the use of gold leaf and the flattened, stylized figures—links the artist with Nardo di Cione, Bernardo Daddi, and Andrea Orcagna, important artists working in central Italy. These artists were also part of a growing stylistic trend toward naturalism, and the emotion suggested by the reactions of the Virgin, soldiers, and centurion reflects this new interest. GC

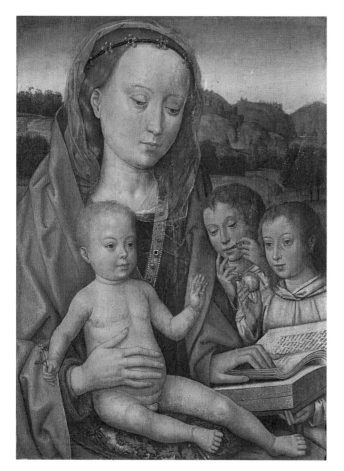

The figures display the typical Flemish elongation and softness of form, lacking the mass and rotundity characteristic of contemporary Italian painting.

MADONNA AND CHILD WITH TWO ANGELS, about 1460–65

Hans Memling
German, 1433–1494
oil on panel
13.5 x 9.75 inches (34.29 x 27.77 cm)
Bequest of Mr. Edward Fowles
1971.018.001

Hans Memling was one of the most popular Netherlandish painters of his time. Although born in Germany, he worked in Bruges for most of his career. His patrons included rich burghers of the city as well as important Italian merchants, for whom he primarily painted portraits and devotional images such as this one. Probably trained by the Flemish artist Rogier van der Weyden, Memling was a more conservative painter and developed a softer, sweeter version of his master's style.

This panel exemplifies the type of devotional art that enjoyed unparalleled popularity at the end of the fifteenth century in Europe. The intimate work depicts the Madonna holding the Christ Child—who clutches a daisy, symbolic of innocence and purity—flanked by two music-making angels. The figures display the typical Flemish elongation and softness of form, lacking the mass and rotundity characteristic of contemporary Italian painting. Memling focused attention on the shimmering quality of the Madonna's neck and her hair ornament, as well as the pattern of the cushion on which the Child sits. Similarly, he rendered the countryside in the background in minute detail. This emphasis on jewel-like surfaces and floral and landscape details is typical of Northern European painting. GC

THE TRINITY, 15th century

British
alabaster with polychrome and gilding
22.5 x 10.13 inches (57.15 x 25.73 cm)
Acquired with funds provided by Mr. and
 Mrs. Robert Raclin
1989.010

From the fourteenth to the sixteenth centuries, alabaster relief panels carved in Nottingham were in demand for churches throughout England and Europe. Alabaster is a soft stone that can be carved easily and broken easily, and most of the medieval alabaster panels that survive today contain breakages. Because the artists depicted characters from biblical stories in ordinary medieval dress, the panels give an immediate impression of the look of everyday life in late medieval England.

Alabaster carvers usually produced the panels as a set of relief sculptures to be assembled as a horizontal altarpiece in a church. Often the panels told a story, such as the Passion, reading from left to right. Whereas in the making of medieval books the various tasks of illustrating, writing, and preparing the paper usually were carried out by different specialist workers, the alabaster carver executed all of the jobs himself. These included carving and painting the stone, as well as carpentering and decorating the wooden frames in which the finished panels would be displayed.

In the Snite Museum's *Trinity*, a seated, crowned God the Father raises His hands in blessing over the head of the smaller-scale crucified Son held between His knees. The filled-in dowel hole beneath the Father's beard probably originally held a carving of a white dove representing the Holy Spirit, which has broken off in the course of time. Two angels carrying the chains of censers flank the Father's head, and two smaller angels hold chalices to the bleeding hands of Christ to catch his holy blood. Below

All of the heads turn to look at the Savior, evoking the power of Jesus' personality and the importance of the event.

CHRIST ENTERING JERUSALEM, 15th century

British
alabaster with polychrome
17.25 x 11 inches
　(43.82 x 27.94 cm)
Gift of Laura Holt (MA 1992, PhD 1999)
2001.046

Christ's feet, two more angels collect his blood in a single chalice. Traces of color can be seen inside the folds of robes, in the gold of the Father's crown, and in the green of the lower background, on which small white flowers have been painted.

The other panel, *Christ Entering Jerusalem*, presents a crowded scene in which the Savior begins the inevitable progress of events that will lead to His Crucifixion. The carving conveys the appearance of a medieval street lined with animated, gesticulating people. All of the heads turn to look at the Savior, evoking the power of Jesus' personality and the importance of the event. Although the colors are no longer visible, the hair, the haloes, and the folds of clothing originally would have been painted. Like the *Trinity*, this panel probably was part of a set that told the complete story of the Passion and would have been installed above an altar. DCJM

CORONATION OF THE VIRGIN, about 1460

German and Austrian sculptors frequently illustrated various moments from the life of the Virgin as subjects in grand wooden, winged altarpieces with many ornately carved and painted framed sections. The narrative of the Virgin Mary's life ended with the scene depicted in this sculptural group, her crowning in heaven by the Trinity. It is likely that this Coronation scene was originally part of a multifigured winged altarpiece of the kind carved by German master sculptors such as Tilman Riemanschneider.

Before the Reformation in 1517, numerous artists, including the maker of this Coronation, presented the idea of the unity of the Trinity by giving God the Father and God the Son identical facial features. The Holy Spirit, usually present in the form of a white dove hovering above the Virgin's head, has been lost from this version of the subject. Even though the Father (on the viewer's right) and the Son have identical features, their positions, their gazes, and the objects they hold allow a viewer with knowledge of scripture and the creed to understand which is which. DCJM

YOUNG MAN, HALF-LENGTH, IN A TONDO, about 1485

An inventive and energetic draftsman, Filippino Lippi produced a body of work so large that among his fifteenth-century contemporaries only Leonardo da Vinci surpassed it. Initially trained by his father, the friar Filippo Lippi, Filippino entered the studio of Sandro Botticelli in 1472. This stimulating environment nourished his innate talents, and he developed a unique style that combined the sweetness and charm of his father's work with the attenuated grace that was Botticelli's hallmark.

The Snite's *Young Man* is representative of the works Filippino created in the 1480s, a period marked by an increase in skill and assurance that won him a number of prestigious commissions in Florence and Rome. Drawings from this decade demonstrate the artist's mastery of his various media. Here, Filippino's confident use of metalpoint (his forte) and a painterly deployment of white highlights result in a highly effective economy of means. These characteristics, together with the elegance and expressiveness of the figure itself, have led scholars to date the work to the mid-1480s. The drawing is believed to be a study for the artist's *Vision of Saint Bernard*, a painting executed between 1485 and 1490 under commission from Piero del Pugliese for his chapel in the monastery of Le Campora, Marignolle.

Filippino Lippi
Italian, about 1457–1504
silverpoint, brush, and white heightening
 on rose prepared paper
2.81 inches (7.2 cm) in diameter
Gift of Mr. John D. Reilly (Class of 1963)
1992.038.019

German (opposite page)
carved wood with gilt and polychrome
43 x 34 x 15 inches
 (109.22 x 86.36 x 38.1 cm)
Gift of Mrs. Frederick Wickett
1934.007.001

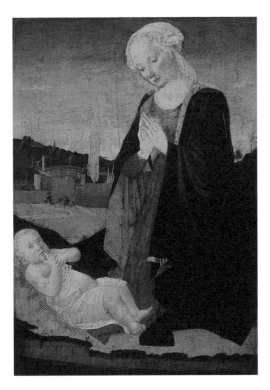

MADONNA AND CHILD,
second half of 15th century

Master of Miniato
Italian, second half of 15th century
oil on wood panel
22 x 15.75 inches (55.88 x 40 cm)
Gift of Mr. John Walker
1974.011

Fra Paolino (opposite page)
Italian, 1472–1517
oil on panel
46.5 x 41.75 inches (118.11 x 106.05 cm)
Gift of the Samuel H. Kress Foundation
1961.047.007

Intimate scenes of the Madonna and Child were a devotional art form that enjoyed an unparalleled popularity during the last two decades of the fifteenth century in Florence. These works were intended primarily for devotional purposes in private family shrines in bedrooms or gardens, or occasionally on the outer front wall of the home. Since the demand for them was great, workshops set up a system by which they could be mass-produced.

This example epitomizes the favorite type at the time, depicting the Virgin as a contemplative, human mother. She is no longer enthroned as the Queen of Heaven in a formal setting; instead she has become the Madonna of Humility. Also popular in Florence during this period were depictions that showed the Virgin as the Madonna of Witness and the Madonna of Love.

The fragile yet firm outline of the figures, their sense of weight and mass, and the rounded, pale face of the Virgin are characteristically Florentine features. However, the light, clear, bowled background and the delicate imaginary city indicate that the artist was also influenced by northern Italian painting. The placing of the infant on a parapet in the immediate foreground is also a typical northern element. GC

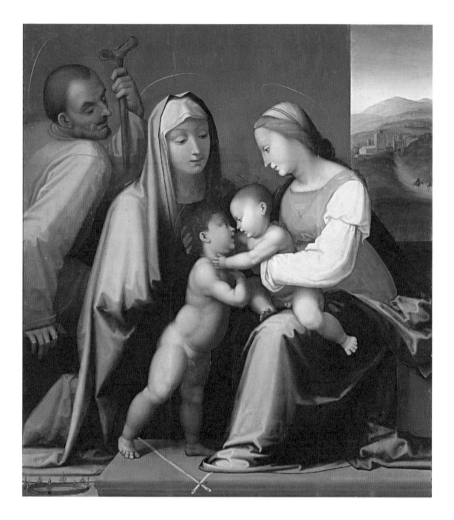

THE HOLY FAMILY WITH SAINTS, late 15th–early 16th century

Images of the Holy Family with saints in attendance were popular in sixteenth-century Italy. This work depicts the Madonna holding the Christ Child, who leans forward to embrace the infant Saint John. Saint Catherine kneels behind them, wearing a greenish blue mantle, and Saint Joseph looks on over his shoulder. On the right, a window shows a view of a walled town and a winding road, where the Flight into Egypt is depicted. The High Renaissance style is epitomized in the pyramidal arrangement of the main figures and the overall attention to balance and symmetry.

Fra Paolino's early work demonstrates a dependence on the drawings and compositions invented by his teacher, Fra Bartolommeo. In fact, this painting was once attributed to Fra Bartolommeo, owing to the similarity between its compositional details and his works. During these years, Fra Paolino must have worked as an assistant to Fra Bartolommeo, but his precise contributions remain difficult to isolate. He was obviously closely tied to his master; on Fra Bartolommeo's death in 1517, his drawings were consigned to Fra Paolino. GC

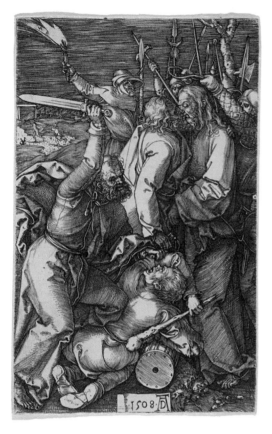

THE BETRAYAL OF CHRIST BY JUDAS, 1508

Engraved Passion
Albrecht Dürer
German, 1471–1528
engraving
4.5 x 2.7 inches (11.43 x 6.85 cm)
1963 University of Notre Dame Purchase Fund
1963.051

Throughout his life, Albrecht Dürer closely identified with Jesus Christ and strived to use his God-given gifts for ennobling ends. His desire to emulate Christ partially explains why he created six different cycles depicting the Passion, the litany of torments Jesus endured between the Last Supper and the Crucifixion. The Snite's *Betrayal* depicts the moment when Judas Iscariot, one of Christ's erstwhile disciples, betrayed his master. The sheet belongs to the so-called *Engraved Passion*, sixteen engravings prepared between 1507 and 1513 that are considered Dürer's most refined and psychologically complex treatment of the subject.

The image skillfully communicates Christ's acceptance of God's will. Jesus allows Judas to identify him for the centurions with a kiss, quietly proffering his hands for binding and letting a guard slip a rope over his head. His composure is heightened by the tumult surrounding him: the apostle Peter attacks a terrified Malchus, servant of the high priest, and a harrowing forest of halberds, pikes, and spears looms behind Christ. The year of the print's execution (proclaimed on the monogrammed scroll) was marked by Dürer's introduction of the remarkable gray tonalities that lend the engraving its tremendous softness and technical sophistication.

*The Madonna Lactan's popularity may correspond to periods of food shortages that
created famines over large areas, as well as waves of the plague, in western Europe.*

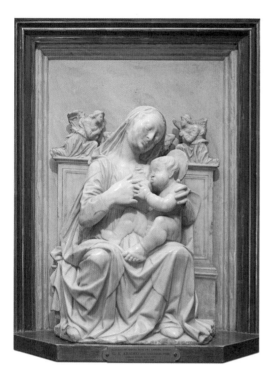

ENTHRONED MADONNA NURSING CHRIST CHILD ADORED BY TWO ANGELS, early 16th century

Giovanni Antonio Amadeo and collaborators
Italian, 1447–1522
marble
19.75 x 14 x 6.5 inches (50.17 x 35.56 x 16.51 cm)
Gift of the Samuel H. Kress Foundation
1961.047.001

The evolution of Mary's role and significance in Roman Catholic theology is documented visually in the artistic depiction of her relationship to Christ through the centuries. This private devotional wall sculpture carved by Giovanni Antonio Amadeo and his workshop illustrates the dependant, loving relationship between the infant Christ and the mother who provided his human form with sustenance by nursing him.

The sacred representation can be related to a number of long-standing theological concepts, as well as some that were contemporary to the piece's creation. The Madonna Lactans—shown either offering an exposed breast to the Christ Child or in the act of nursing him—was a popular Italian image from the fourteenth to the seventeenth centuries. Its popularity may correspond to periods of food shortages that created famines over large areas, as well as waves of the plague, in western Europe.

Per Rona Goffen, common belief during this time equated a child's physical appearance and personality characteristics with those of his or her milk source. Thus childcare manuals and church sermons objected to the popular practice of using wet nurses, instructing mothers of all social classes to nurse their own children, following the example of Mary. AMK

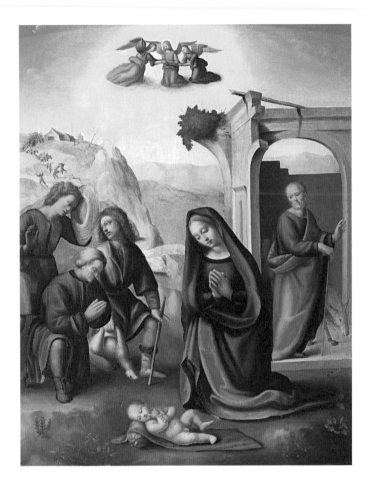

THE ADORATION OF THE SHEPHERDS, about 1520

Ridolfo Ghirlandaio
Italian, 1483–1561
oil on panel
23 x 18.25 inches (58.42 x 46.36 cm)
Acquired with funds provided by Mr.
 and Mrs. Walter H. Lake, Jr.
1988.053

Ridolfo Ghirlandaio, the son of well-known Florentine painter Domenico Ghirlandaio, studied with his father and with Fra Bartolommeo. However, much of his style was influenced by Raphael, who worked in Florence from 1504 to 1508 and befriended him. The sixteenth-century artist and biographer Giorgio Vasari wrote that Ridolfo completed the Virgin's blue robe in Raphael's famous *La Belle Jardinière* (The Beautiful Gardener), now in the Louvre. Many of Ridolfo's portraits reveal Raphael's influence.

The Snite's *Adoration of the Shepherds* was probably painted about 1520. Ridolfo depicted the subject at least six times, and this work relates closely to his *Nativity* in the Metropolitan Museum of Art. His style alternated between a conservative, formulaic approach and one of great originality. This painting displays both manners. The arrangement of figures across the composition is uneven: the figures of the Virgin, Child, and Joseph are conservative and rather stiff, whereas the grouping of shepherds at left exhibits a greater liveliness and range of gestures and emotions. The mysterious background demonstrates the artist's great ability to create evocative scenes. This inconsistent quality of his work may have been due to commercial pressure; Ridolfo's studio was very popular, and he often worked on many commissions simultaneously. GC

The commission represented an opportunity for Giulio to realize in a single building his ideas on architecture, pictorial composition, and interior decoration.

SATYR WITH HIS DOG, about 1527

G iulio Romano, an Italian painter, architect, decorator, and student of Raphael, was an immensely gifted draftsman. He served as court painter to Duke Federico Gonzaga in Mantua from 1524 to 1540. The commission by the duke for a summer villa on the outskirts of Mantua represented an opportunity for Giulio to realize in a single building his ideas on architecture, pictorial composition, and interior decoration. Giulio worked on the project, Palazzo del Te, for ten years. His creative imagination and technical skill are most apparent in the elaborate drawings he provided to his assistants working on fresco cycles for this and other projects.

This drawing is from the period when Giulio was working on the interior of Palazzo del Te. It may have been a study for the ceiling fresco in the Sala dei Venti, or Hall of the Winds, where the twelve months of the year are represented in lozenges between the twelve signs of the zodiac. The month of February is symbolized by *A Faun Walking with Two Torches.* Both the faun and the Snite's satyr are pictured as a man with the horns of a goat, wearing a belt with a goat's skull, and carrying fire. EPS

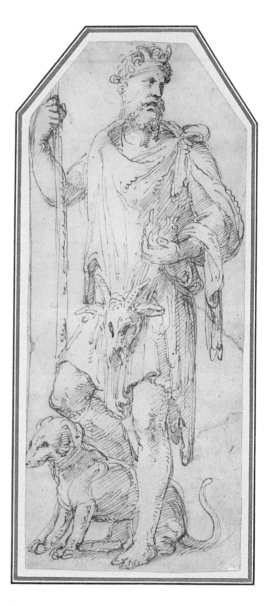

Giulio Romano
Italian, 1499–1546
brown ink on laid paper
9.5 x 4 inches (24 x 10 cm)
Gift of Mr. John D. Reilly (Class of 1963)
1992.038.025

115

In a tender moment between mother and son, the Christ Child reaches for a flower in his mother's hand.

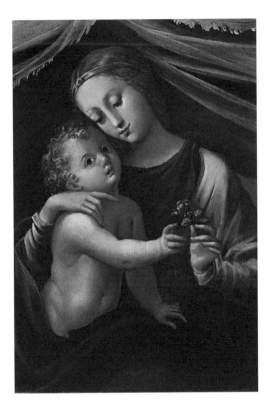

Girolamo Mazzola Bedoli
Italian, about 1505–about 1569/70
oil on panel
14 x 9.5 inches (35.56 x 24.13 cm)
Acquired with funds provided by the Lake Family
 Endowment
2001.016

MADONNA AND CHILD,
about 1530–40

Girolamo Mazzola Bedoli was one of the most talented and sought-after artists of the early sixteenth century. He was born near the northern Italian city of Parma, and he worked extensively for the churches and families of the area. His paintings and drawings have frequently been compared to, and even confused with, works by his teacher, Parmigianino. Although he was influenced by Parmigianino and Correggio, Bedoli developed a style of his own, producing altarpieces, frescoes, portraits, and mythological and religious paintings.

This small panel depicting the Madonna and Child exhibits qualities of the High Renaissance as well as of Parmigianino's classic Mannerism. Bedoli combines elements that are intimate and lively with a style that remains essentially formal and idealized. In a tender moment between mother and son, the Christ Child reaches for a flower in his mother's hand. The daisy represents his innocence and the incarnation. The half-length figures are placed in front of parted curtains that suggest draperies covering an altarpiece or a tabernacle, alluding to the Eucharist and sacrifice.

The size and subject matter of the painting indicate that it was intended for private devotional use. Such images were in great demand throughout Europe, and artists in a sense massproduced panels for their patrons. GC

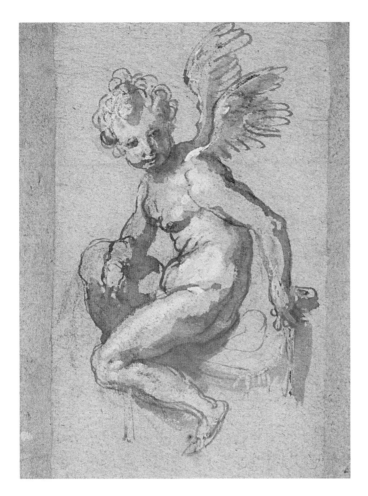

ANGEL SEATED ON A CLOUD, mid-1550s

Taddeo Zuccaro
Italian, 1529–1566
pen, brush, black and brown ink, and
 wash, heightened with white on blue
 paper and mounted on blue-tinted
 paper
6.75 x 4.75 inches (17.15 x 12.07 cm)
Gift of Mr. John D. Reilly (Class of 1963)
1992.038.029

A gifted artist from a small town near Urbino, Taddeo Zuccaro became well known for his façade fresco paintings. He was awarded some of mid-sixteenth-century Italy's most prestigious commissions by popes and wealthy private patrons before his premature death at age thirty-seven. Zuccaro had traveled to Rome in the early 1540s in search of a teacher. The city, however, was still reeling from the Sack of 1527, so he copied the works of masters to cultivate his skill.

The impact of his experiences in Rome is evident in this drawing, which weds one of the most famous antique fragments known during the Renaissance, the Belvedere Torso, with elements from Michelangelo's ceiling frescoes in the Sistine Chapel. The drawing equally reflects contemporary influences on Zuccaro's work, including that of Polidoro da Caravaggio, Perino del Vaga and, to a lesser extent, Correggio and Parmigianino.

An old inscription on the drawing attributes it to Cherubino Alberti. However, the piece is typical of Zuccaro's technique, melding Mannerism's exploitation of grace and elegance with an interest in naturalism, the human form, and the antique typically associated with the High Renaissance. The drawing is not identified with any finished work by Zuccaro, but it is dated on stylistic grounds to the mid-1550s.

TWO SCENES FROM THE LIFE OF SAINT CATHERINE, about 1595–96

Francesco Vanni was a prominent Italian painter who played a leading role in Siena's artistic life during the late sixteenth century. His art, which was strongly influenced by such celebrated masters as Federico Barocci and the Carracci family, is notable for its reaction against some of the excessive aspects of Mannerism and for its new and distinctive style of realism. He was particularly admired as a prolific and accomplished draughtsman.

This deftly finished drawing is a study for a series of prints on the life of the fourteenth-century saint Catherine of Siena. The artist designed eleven plates and a frontispiece, which were engraved by Pieter de Jode and published in 1597. Eight full-size composi-tional drawings for the print series are in the Albertina Museum in Vienna and the Duke of Devonshire's collection at Chatsworth. The Snite's study shows the saint receiving the stig-mata and exorcising a woman. Vanni had earlier painted a fresco of this second subject for the church of San Domenico in Siena, and some of the figures in the drawing appear to derive directly from that fresco. Additional drawings relating to both the fresco and the print are in the Louvre, the Uffizi, and the Fitzwilliam Museum in Cambridge. **ss**

Francesco Vanni
Italian, 1563/65–1610
red chalk and red wash on off-white laid paper
8.25 x 12.13 inches (20.96 x 30.8 cm)
Acquired with funds from the estate of
 Mr. William A. Sullivan
2005.014

Saint Sebastian, identified here by his pose and loincloth, was invoked for protection from the plague and other contagions.

Guercino (Giovanni Francesco Barbieri)
Italian, 1591–1666
pen and brown ink on laid paper
8.56 x 6 inches (21.8 x 15.2 cm)
Gift of Mr. John D. Reilly (Class of 1963)
1994.049.006

AN ANGEL SHEATHING THE FLAMING SWORD, WITH SAINTS ROCH AND SEBASTIAN IN A LANDSCAPE, about 1632

Guercino was one of seventeenth-century Italy's most prolific draftsmen. Among his thousands of drawings are a large number of compositional sketches such as this one, the second of three early studies for an altarpiece commissioned by Conte Antonio Maria Sertorio for the town of Nonantola, in the province of Modena. The finished work, *Madonna and Child with Saints Roch and Sebastian*, is now lost. It was originally housed in a purpose-built oratory constructed by the town members in 1630 as a votive offering in recompense for their salvation from the plague then raging through Northern Italy.

Saint Roch, patron saint of plague victims, was frequently shown displaying a sore on his knee, which may explain the anomalously dark area on his left leg in Guercino's drawing. Saint Sebastian, identified here by his pose and loincloth, was invoked for protection from the plague and other contagions. The angel sheathing its sword, who was replaced by the Madonna and Child in the finished piece, is a symbolic reference to the heavenly banishment of the Black Death. The looping, calligraphic quality of the drawing is typical of Guercino's style from this period.

REST ON THE FLIGHT INTO EGYPT, before 1630

This pastoral scene's unusually vibrant palette, contemporary setting and clothing, and compositional focus on the landscape rather than the biblical figures referenced by the title are characteristic of the Mannerist style of Abraham Bloemaert's landscapes.

In place of the standard iconographic clues of a donkey, desert landscape, palm tree, or pyramid to indicate the biblical locale of Egypt, Bloemaert painted Dutch peasant huts and windmills. Yet we recognize the young woman nursing a child and her older male companion resting in the shade as stand-ins for the Holy Family briefly pausing on their flight from the wrath of King Herod.

Bloemaert was a prolific painter who was accomplished in more than one style and genre. He also designed hundreds of engravings while established in Utrecht. Many important artists of the next generation, in addition to his four sons, studied with him. Bloemaert received commissions for large altarpieces from patrons throughout the Netherlands, and his fame attracted Peter Paul Rubens to visit his studio in 1627. **AMK**

Abraham Bloemaert
Dutch, 1564–1651
oil on panel
13.38 x 23.38 inches (33.99 x 59.39 cm)
Acquired with funds provided by Mrs. Walter Lake
1991.047

Gerrit van Honthorst
Dutch, 1592–1656
oil on canvas
30 x 24.75 inches (76.2 x 62.87 cm)
Acquired with funds provided by Mr.
and Mrs. Richard E. Berlin
1958.047

PORTRAIT OF AN UNKNOWN OFFICER, 1638

After apprenticing with Abraham Bloemaert, Gerrit van Honthorst traveled to Italy, where he was struck by the great naturalism and dynamic light effects used by the painter Caravaggio. Honthorst's incorporation of these elements into his own work led to his inclusion in a group later referred to as the Utrecht Caravaggisti, Dutch followers of the innovative Baroque master. Similarly, his penchant for artificially illuminated night scenes gave rise to his sobriquet "Gherardo delle Notti," or "Gerrit of the Nights." As his popularity grew, he was commissioned to paint a number of portraits for the royal families of England, Bohemia, and the Netherlands.

This work highlights Honthorst's uncanny ability to balance realism with a carefully studied air of nobility. The sitter, whose identity remains a mystery, is portrayed as a middle-aged man with early jowls, heavy-lidded eyes, and soft wrinkles. These humanizing touches are counterbalanced by the anonymous officer's rigid mustache, stiff beard, erect posture, tight lips, and formal costume, all of which work together to preserve his regal bearing and aristocratic demeanor. Also notable is Honthorst's use of light, which dances on the satiny folds of the subject's sash and glints off his steely armor. These remarkable effects point to the artist's early fascination with Caravaggio.

REST ON THE FLIGHT INTO EGYPT, 1639

The brief story of the Flight into Egypt, recorded only in Saint Matthew's Gospel (2:13–18), tells how an angel appeared to Joseph in a dream and warned him to escape into Egypt with Jesus and Mary, because King Herod planned to kill all baby boys in an attempt to remove any threats to his authority. This painting of the subject can be dated to 1639, for Claude Lorrain gave it the number thirty-nine in his *Liber Veritatis*, the sketchbook record of his true paintings. It was bought by Cardinal Giorio, one of seventeenth-century Rome's most famous art patrons.

Surprisingly, this story involving fear and cruelty is often interpreted as Claude presents it to us: as a moment of peace on a summer's day. The foreground figures are sharply silhouetted against the middle ground—a low, horizontal expanse of still water placed in front of the vertical thrust of a medieval castle. A tall tree in the left foreground acts as a dark frame and a contrast to the series of planes on the right, which recede gradually into the misty distance. To create this idealized scene, Claude probably invented a landscape based on his drawings of actual places around Rome. DCJM

Claude Lorrain
French, 1604–1682
oil on canvas
15.75 x 20 inches (40 x 50.8 cm)
Gift of Mr. B. Nelson Deranian
1954.030

PASTORAL LANDSCAPE WITH A FLOCK OF SHEEP AND AN OXCART

Sébastien Bourdon was an eclectic artist, equally successful painting portraits, narratives, landscapes, and *bambocciate*—small scenes of street life, peasants, brigands, and other picturesque subjects. Nicolas Poussin influenced his turn to monumental compositions with sharply defined planes, classicizing figures, and fresh colors.

Remarkable for its breadth of space and structural simplicity, this image is one of Bourdon's purest landscapes and epitomizes his contribution to classical landscape. While the expansive sky and pastoral atmosphere affirm his familiarity with Venetian prototypes, the composition remains firmly rooted in the classicism of Poussin. Bourdon arranged the landscape as an artificial construction of geometric complexity, with layered planes and somewhat unreal, fragmented colors. The sophisticated palette is typical of his later works, in which he employed a range of steel grays and soft, smoky blues. Instead of classical ruins evoking the Roman Campagna, the architecture suggests the outskirts of a French village, dominated by a church's Gothic spire. Bourdon's originality and independence lay in this mixture of the heroic and the real, the classical and the natural. GC

Sébastien Bourdon
French, 1616–1671
oil on canvas
28.13 x 38.25 inches (71.05 x 97.16 cm)
Acquired with funds provided by Mr. and Mrs. Al Nathe
1993.040

THE HOLY FAMILY WITH THE INFANT SAINT JOHN AND TWO ANGELS, about 1650–60

The paintings of Lubin Baugin combine aspects of several important currents in Italian and French art of the sixteenth and seventeenth centuries. Baugin has, in fact, been referred to as "Le Petit Guide," owing to the number of styles and schools his work traverses. He was clearly influenced by the school of Fontainebleau and the Mannerist art of Parmigianino, as well as by Correggio. A trip to Italy in the 1630s brought him into contact with the works of Raphael and Guido Reni.

Recognized mostly for his small devotional religious paintings, often of the Virgin and Child or the Holy Family, Baugin is known to have produced several notable large-scale compositions for the Cathedral of Notre-Dame in Paris. In recent years, he has also been acknowledged as the creator of a series of famous and exceptional still lifes. His work apparently became overlooked once the new seventeenth-century French classicism came into favor, and only in the last few decades have scholars begun to restore his reputation as an important seventeenth-century painter.

The Snite Museum's jewel-like *Holy Family*, probably datable to 1650–60, is a splendid example of the artist's complex mature style. Although the elegantly elongated figures and soft but strangely luminous colors are reminiscent of such earlier masters as Parmigianino and Domenico Beccafumi, the classicizing, static composition and architectural background elements suggest the influence of Raphael and Nicolas Poussin. It is an impressive achievement that Baugin was able to blend these strong, diverse influences and yet create his own distinctive style. A painting of the Holy Family at the Musée Magnin in Dijon seems to be a slightly altered version of the Snite image, and another Holy Family in London's National Gallery shows Baugin's use of many of the same elements to produce yet another notable version of the subject. ss

Lubin Baugin
French, 1612–1663
oil on panel
13 x 10.25 inches (33.02 x 26.03 cm)
Acquired with funds provided by Mr.
 and Mrs. Robert Raclin
1991.027

Recognized mostly for his small devotional religious paintings, often of the Virgin and Child or the Holy Family, Baugin is known to have produced several notable large-scale compositions for the Cathedral of Notre-Dame in Paris.

MEMENTO MORI: DEATH COMES TO THE TABLE

This unsettling scene features four expensively dressed figures seated at a damask-covered, beautifully appointed table, where their enjoyment of music as they eat and drink is interrupted by the appearance of a skeleton holding an hourglass with its sand about to run out. The painting's subject is *vanitas* (Latin for "emptiness"); it censures humankind's pursuit of ephemeral pleasures instead of attention to the inevitability of death. Many *memento mori* (reminder of death) symbols are included, such as the skeleton, hourglass, and insect.

The startled musician at the left raises his hand from the mandolin, as if to ward off the intruder; the woman in black points to the apparition; and the central figure in red shrinks away from the untimely visitor, her hands anxiously clenched. The young man at

the right looks over his shoulder incredulously, grasping the table for support and touching his chest with his right hand; his raised brow and wide eye reflect his surprise and fear at death's touch. In the upper left, another diner looks on in shock.

Giovanni Martinelli worked primarily in Florence, though he came from Arezzo, and concentrated on religious and moralizing scenes such as this. His chiaroscuro style of dramatic light and shadows was based on the work of Caravaggio. GC

Giovanni Martinelli
Italian, 1600/04–1659
oil on canvas
38.5 x 48 inches (97.8 x 121.9 cm)
Gift of an anonymous benefactor; Museum purchase by exchange, Mrs. James W. Alsdorf; and acquired with funds provided by Mr. and Mrs. Robert Raclin, Mr. and Mrs. Russell G. Ashbaugh Jr., and Mr. Joseph R. Skelton
1999.024

CHRIST CRUCIFIED (THE THREE CROSSES), about 1660

Rembrandt van Rijn created some three hundred prints in his lifetime and is regarded as one of the most brilliant and innovative printmakers. *The Three Crosses*, which he printed in five states, is among the greatest masterpieces ever produced in the medium. Remarkably, the large, powerful composition was created entirely in drypoint, a particularly sensitive and problematic technique to control.

The print illustrates the devastating moment when Christ was dying on the cross and chaos ensued. Three early states carefully describe a narrative of many believers, persecutors, and onlookers reacting in utter alarm to the momentous event. The artist returned to the print some years later, dramatically transforming the mood and details in a fourth state.

The resulting expressionistic image presents a dark scene of sweeping desolation. Rembrandt added new figures, scraped out some existing ones, and left others almost as ghosts. Deep, slashing drypoint lines and bold areas of ink cut across the design. The focus is now directly on Christ, who alone is bathed in heavenly light while the panicked crowd is plunged into darkness. The Snite's rare fifth state of the print retains this intense emotional turmoil and includes the publisher's name at the bottom of the design. **ss**

Rembrandt van Rijn
Dutch, 1606–1669
drypoint
15.16 x 17.72 inches (38.5 x 45 cm)
Gift of Mr. and Mrs. Jack Feddersen
1991.025.049

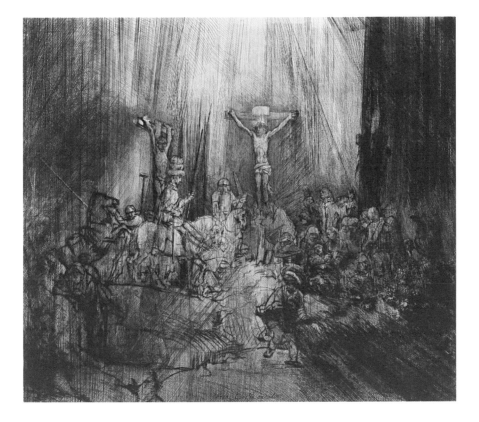

LANDSCAPE WITH FIGURES, 1660s

Jan Wijnants specialized in landscapes such as this one, inspired by the sandy countryside of his native Harlem. He continued painting landscapes even after moving to the bustling city of Amsterdam about 1660. His images approach the eighteenth-century interest in the picturesque. Although he adopted some classical landscape conventions, Wijnants's interests lay primarily in creating comfortable, elegant scenes that recalled an idyllic, pastoral world. He often executed the landscape and had others add the figures.

Landscape with Figures is painted in a muted, earth-toned palette. Alternating bands of light and dark indicate spatial recession. The gnarled trees are the most active elements: their leaves reflect the subdued sunlight, and their strange, thrusting branches reach to the sky, giving vitality to the scene. The gently winding path and tranquil figures represent the rhythmic pulse of country life.

For all of its interest in nature, the painting ultimately raises the issue of man's place within his environment. These rural people seem to live in harmony with their familiar surroundings and feel a strong attachment to the land. Images such as this were popular with the urban elite, as they evoked nostalgia for the simple life in nature that city dwellers felt was slipping away. GC

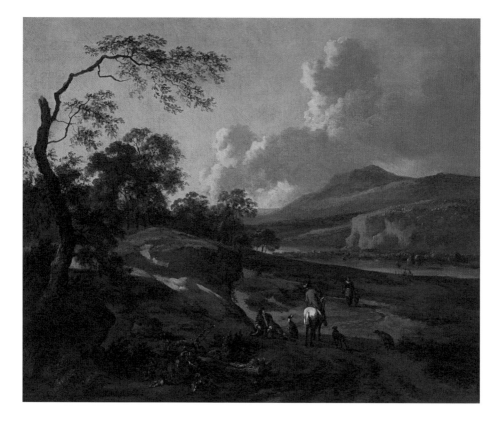

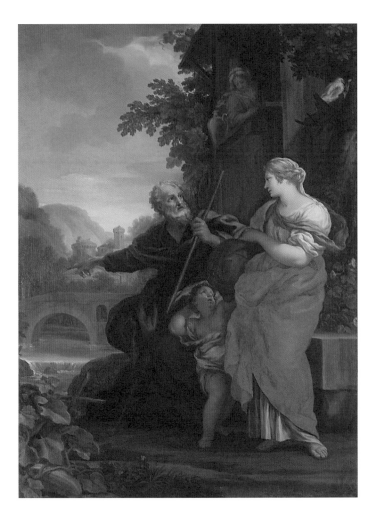

Ciro Ferri
Italian, 1628/34–1689
oil on canvas
53.15 x 40.16 inches (135 x 102 cm)
Museum purchase by exchange, Mr.
 Fred B. Snite and the Snite Foundation
1988.061

Jan Wijnants (opposite page)
Dutch, 1632–1684
oil on canvas
20 x 24.5 inches (50.8 x 62.23 cm)
Gift of Mr. Lester S. Abelson
1952.013.002

THE EXPULSION OF HAGAR, about 1685

This scene, taken from Genesis 21:9–21, depicts Abraham banishing his second wife, Hagar, and their son, Ishmael, from the family home. Sarah, his first wife, watches from a window above. Ciro Ferri set the figures in an idyllic, mountainous landscape instead of a dry desert, which was the original setting for the story. This change in scenery is typical of seventeenth-century Italian painting. The artist added decorative arrangements of foliage as framing devices to highlight the central figures and action. He also invigorated the image by the use of strong diagonal compositional elements that underscore the drama of the story.

Ferri was an important Italian painter, sculptor, architect, and draughtsman. He was the most gifted pupil of Pietro da Cortona, and his style in frescoes, easel paintings, and drawings remained a remarkably true interpretation of Cortona's Roman Baroque. Ferri's art helped spread the decorative style of the Roman Baroque to Florence and other cities. GC

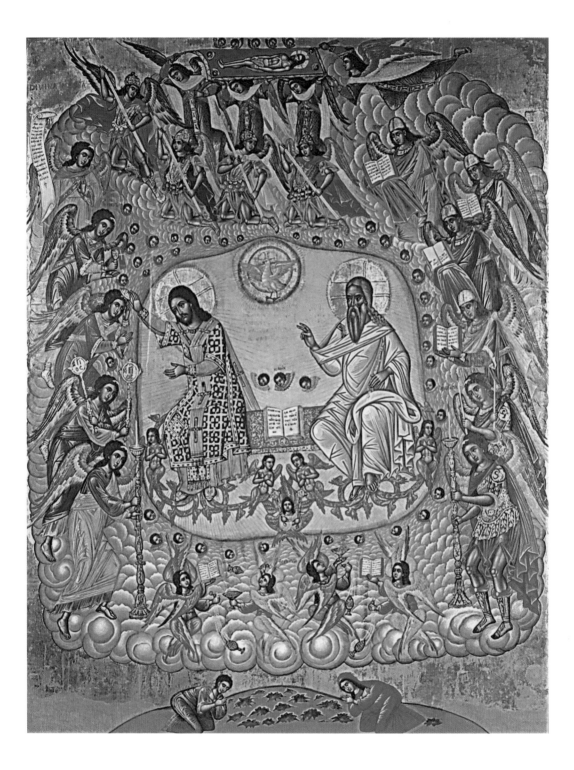

DIVINE LITURGY (AND HOLY TRINITY), second half of the 17th century

This work is significant for its variation of the post-Byzantine iconography of a similar panel attributed to the most important Cretan painter of the second half of the sixteenth century, Michael Damaskinos. Both pieces have a concentric composition with representatives of the nine choirs of angels either supporting the central scene of the Holy Trinity and an altar, or surrounding it in procession with gifts for the Eucharistic rite—a wine chalice in the upper-left corner and a litter bearing the body of the crucified Christ at the top. The male and female kneeling in homage at the bottom of each image are thought to be Adam and Eve. But the works' central panels differ significantly in the depiction of the relationship between the Holy Trinity figures, especially pertaining to the Holy Spirit. The question of whether the Holy Spirit proceeds only from God the Father or from both the Father and the Son has divided Eastern Orthodox theologians (who believe the former) from Roman/Latin Catholic theologians (who believe the latter) since the ninth century.

Scholar Jens Fleischer has interpreted Damaskinos's earlier version as illustrating the compromise to this debate about the constitution of the Holy Trinity offered by the bishop of Kythera, Maximos Margounios. In his *Three Books on the Procession of the Holy Spirit*, published in 1583, Margounios argued that both concepts of the Holy Spirit were correct, since the Orthodox hierarchical definition describes the eternal nature of the Trinity and the Latin characterization of circular or triangular parity expresses its temporal manifestations. Damaskinos's bidirectional representation of the dove illustrates this compromise; its wings are outstretched in flight and its feet are pointed toward the Father, who is seated on the right of the altar in the guise of the Ancient of Days, but its head is turned toward Christ, who is seated on the left of the altar and dressed in a bishop's dalmatic. Also, the halos of all three aspects of the Holy Trinity would touch as a representation of the dual origin of the Holy Spirit, except for the temporal act of Christ leaning forward, as High Priest, to accept the Eucharistic gifts carried to the altar by the procession of angels.

According to Notre Dame professor Charles Barber, the Holy Spirit's ambiguous flight path and the posture of the Father in Damaskinos's icon were altered in the Museum's version to create an Orthodox illustration of the unidirectional procession of the Holy Trinity. The dove's whole body now points left toward Christ and away from the Father. The Father sits with His entire body turned toward His Son, in comparison to His mixed posture with feet facing right but upper body facing left in Damaskinos's panel. The interpretation of the modified scene as an Orthodox iconography is confirmed by the inclusion of a quote from the Orthodox creed beneath the dove: "The Holy Spirit, the Lord the giver of life who proceeds from the Father, who with the Father and Son together is worshipped and glorified." The inscription omits the Latin creed's addition: "who proceeds from the Father *and the Son*." AMK

Unidentified artist
Greek (Cretan)
tempera and gilt on wood
49 x 38.25 inches (124.46 x 97.16 cm)
Gift of Mr. Ferdinand Vogel
1958.020

FINDING OF MOSES, about 1695–1700

Charles de La Fosse, one of the most talented and original seventeenth-century French artists, worked on some of the premier official and private decorative projects of the late Baroque era. He assimilated crucial aspects of the styles of Correggio, Paolo Veronese, and Peter Paul Rubens into his art, and his rich colors and inventive designs in turn influenced the Rococo style.

The biblical story of the finding of Moses seems to have preoccupied La Fosse's imagination in the years surrounding 1700. Louis XIV requested the artist's most important rendering of the subject (now in the Louvre) for the private rooms of his palace at Versailles. The Snite Museum's independent version of the theme, along with several related drawings in private collections, was probably completed before the Louvre painting. These earlier works show the artist experimenting with a variety of poses, gestures, and groupings of figures for the final complex composition. The Snite's canvas of graciously arranged figures set within a luminous landscape is a transitional work that shows a debt to Baroque art and yet also provides some sense of the styles that would follow in the eighteenth century. SS

Noël Coypel
French, 1628–1707
oil on canvas
37 x 29.5 inches (93.98 x 74.93 cm)
Gift of Mrs. J. C. Bowes
1957.062

Charles de La Fosse (opposite page)
French, 1636–1716
oil on canvas
18.5 x 22 inches (46.8 x 55.8 cm)
Acquired with funds provided by
 Mr. Thomas P. Moore II; Sansom
 Foundation; Mr. L. Russell Cartwright;
 Mr. Joseph R. Skelton; Fritz and Milly
 Kaeser Endowment for Liturgical Art;
 Mr. Richard J. Huether; Rev. Anthony J.
 Lauck, C.S.C., Sculpture Endowment;
 Mr. and Mrs. Robin Douglass; Anthony
 Tassone Memorial Art Fund; Mr. James
 A. Chism; Mr. Charles K. Driscoll; Rue
 Winterbotham Shaw and Theodora
 Winterbotham Brown (by exchange);
 Art Purchase Fund
2002.025

RESURRECTION OF CHRIST, about 1700

This painting is probably a *modello*, or small-scale version, of a large Resurrection commissioned for the Dominican Convent in Rennes, France, in 1700. In his interpretation of the story, Noël Coypel referred to Saint Matthew's Gospel (28:1–18). The apostle described how three days after the Crucifixion, during an earthquake, Mary Magdalene and the other Mary arrived at Jesus' tomb, where they found an angel sitting on the stone that had been rolled away from the entrance to the cave. While the Roman guards trembled with fear, the angel told the women that Jesus had risen.

In the painting, the Romans and the women, in the left and right foreground, form the wide base of a triangle that is topped by Jesus' heroically nude figure. Holding the triumphant banner of the Resurrection, Jesus floats toward heaven surrounded by supernatural light. Coypel dramatized the extraordinary quality of this miraculous moment by contrasting the different emotions of his characters through their gestures and expressions, by carefully rendering attributes such as shields, helmets, and robes, by including fabrics of such unusual colors as yellow and pink, and by using extremes of light and dark to suggest the awesome sight of this supernatural event. DCJM

133

THE DAUGHTERS OF CECROPS FIND THE INFANT ERICHTHONIUS,
second half of 17th century

Called "the Dutch Raphael" by his contemporaries in Amsterdam, Gérard de Lairesse arrived in that commercial center in 1665 or 1666. It was an opportune time to create engravings, theatrical sets, paintings, and wall decorations craved by the growing intellectual elite and the recently victorious William III. Lairesse's reliance on subjects from classical literature and on formal and decorative inspirations from Greco-Roman art and architecture placed him in direct opposition to the prevalent realistic landscape, biblical, and genre scenes produced by the city's established artists. His ideas were published as *Principles of Design*, in 1701, and *Great Book of Painters*, in 1707. These two tomes were distributed throughout Europe and contributed to the foundation of the Neoclassical style.

The subject of this painting is one of the obscure, brief stories found in Ovid's *Metamorphoses*. The half-human, half-serpent creature in the basket is Erichthonius. His accidental, chthonic birth occurred when the Greek god Hephaestus's semen fell to earth during his attempted rape of Athena. The goddess charged the three daughters of Athens's King Cecrops (Herse, Aglauros, and Pandrosos) with Erichthonius's safekeeping, with the caveat that they must not open the lid of the basket. Lairesse's painting illustrates their horror at the moment of their disobedience. There are various accounts of the tragic result of their action. The prevailing one in Renaissance translations tells that all three daughters became mad from the frightful shock and committed suicide. AMK

Gérard de Lairesse
Flemish, 1640–1711
oil on canvas
56.25 inches (142.88 cm) in diameter
Gift of Mr. Richard E. Berlin
1958.016.002

Bernard Lens III (opposite page)
British, 1682–1740
pen and gray wash
on off-white laid paper
9.25 x 13 inches (23.5 x 33.02 cm)
Acquired with funds provided by Mr. and Mrs. Allan J. Riley (Class of 1957)
2003.005

FIGURES IN A PARK, about 1720

This extremely finished drawing appears to be an early instance of a favorite genre in British art, the conversation piece. Generally small in scale, conversation pieces are informal group portraits showing figures in either a domestic interior or a garden setting. In this example, Bernard Lens III carefully arranged a group of fashionable people at leisure in an ordered and handsome garden setting. The figures are all drawn with admirable care and stylishness, and the parklike setting is rendered with realism and precision. However, in all likelihood, neither the figures nor the park were intended to be identified with any specificity.

Lens was the most famous member of a distinguished family of artists and served as the official draftsman to Kings George I and II. He produced numerous portrait miniatures, including the earliest dated English miniature painted on ivory. Lens also had a talent for making small-scale copies in gouache or pastel of old-master paintings by such artists as Peter Paul Rubens and Anthony Van Dyck. In the landscape genre, he created both impressive, idealized compositions of nature and strictly topographical landscapes in ink and wash. ss

THE GAME OF HOT COCKLES, 1728

Jean-Baptiste Oudry was an exceptionally versatile artist who produced remarkable paintings of animal subjects, hunting scenes, still lifes, and landscapes. He also served as chief designer of the royal tapestry works at Beauvais and Gobelins. By the late 1720s, Oudry had established his reputation as one of the principal decorative artists at work during the reign of Louis XV.

This signed, dated, and splendidly finished drawing is a study for a set of eight tapestry designs called *Country Amusements* that Oudry completed for the Beauvais Manufactory in 1732. For some reason, this subject was not included in the final tapestries. The imaginative pastoral composition showing elegantly dressed figures engaged in a playful pastime seems related to Antoine Watteau's famous paintings of *fêtes galantes* (courtship parties), in which figures enjoy the pleasures of life and courtship in an idyllic outdoor setting. Oudry skillfully rendered the animated figures, the animals, and the lush garden setting with lively, brisk strokes of black chalk and white heightening. The picturesque landscape, with its varied trees and plants and the suggestion of light and atmosphere, anticipates the sensitive and naturalistic group of about one hundred drawings the artist later created of the park and gardens of the Château d'Arcueil. **ss**

THE RAPE OF PROSERPINE, about 1733

Jean-François de Troy earned a reputation as one of France's finest history painters during the first half of the eighteenth century, and from 1738 to 1751 he held the prestigious position of director of the French Academy in Rome. The popularity of his style was based on his ability to combine the monumentality of Peter Paul Rubens with the careful gesture and expression of Charles Le Brun.

The Greek myth of Proserpine, featuring uncontrollable love, violence, loss, death, and the seasons, has been a European favorite for three thousand years. The details de Troy used suggest that his source was the Latin poet Ovid's version, from his book *The Metamorphoses*. The painting depicts the beginning of the tale, when Cupid aims his arrow of love at Pluto, lord of the underworld. Also illustrated is the middle of the story, when Pluto cannot control his emotions and kidnaps Proserpine, the first woman he sees. She is the daughter of Ceres, goddess of the harvest. De Troy did not include the end of the story, the creation of the cycle of summer and winter, but assumed that viewers would know that Proserpine eventually becomes Pluto's bride for half the year and spends the remaining six months with her mother, on earth. DCJM

Jean-Baptiste Oudry (opposite page)
French, 1686–1755
black chalk with white heightening on faded blue paper
11.22 x 17.01 inches (28.5 x 43.2 cm)
Gift of Mr. John D. Reilly (Class of 1963)
1996.070.013

Jean-François de Troy
French, 1679–1752
oil on canvas
41.5 x 48 inches (105.41 x 121.92 cm)
Acquired with funds provided by Mr. and Mrs. Robert Raclin
1986.017

This image shows a more sedate Bacchus proffering a bowl of wine to Ceres, suggesting the theme of bountiful harvest.

Francesco de Mura
Italian, 1696–1782
oil on canvas
81 x 61 inches (208.28 x 154.94 cm)
Acquired with funds provided by the
 Lewis J. Ruskin Purchase Fund
1972.002

BACCHUS AND CERES, about 1735

Ceres, goddess of cereal grains and harvest, was considered the earth mother and source of agricultural fertility, and often was portrayed with nature's abundance—a crown of corn, a sheaf of grain, a cornucopia of fruits and vegetables, or a sickle. Bacchus, god of the vine, wine, and fertility, was sometimes portrayed as a goat or bull. Scenes depicting him frequently included orgies of animals being torn to pieces and consumed—a symbolic eating of the god himself. This image shows a more sedate Bacchus proffering a bowl of wine to Ceres, suggesting the theme of bountiful harvest.

Francesco de Mura was born in Naples and studied with the highly regarded Neapolitan painter Francesco Solimena. The two artists are regarded as the chief exponents of the Neapolitan Baroque school. Initially, de Mura closely followed his teacher's monumental Baroque style. However, he later developed a more controlled and elegant linear style displaying lighter, more delicate colors. This painting is an example of de Mura's earlier style, perhaps executed in the 1730s. The rich color palette and bold diagonals that enliven and unite the composition are hallmarks of the early Neapolitan Baroque style. GC

MADONNA AND CHILD WITH SAINTS PETER, AMBROSE, AND CHARLES BORROMEO, about 1741–42

Giambattista Pittoni is one of the foremost representatives of the Venetian Rococo. A sophisticated and attractive colorist, Pittoni often evoked an elegant, Arcadian mood close to that of contemporary French painting. Later in his career he embraced a lighter palette and tamer compositions influenced by the general trend towards Neoclassicism.

The Snite grisaille, or monochrome painting, is a preparatory work for the altarpiece in the Church of San Stefano, Bedizzole, in the northern Italian commune of Brescia. Bishop Bartolomeo Averoldi commissioned Pittoni to paint a large canvas of the Virgin and Child attended by his family's patron saints for the chapel in 1741. The artist created a typical Baroque setting for the scene. A strong diagonal compositional arrangement unites the five figures in a theatrical setting, complete with a draped curtain framing the Virgin and Child seated on an elaborate throne. The figures of Saint Ambrose (left) and Charles Borromeo (right) flank the Virgin and Child. Saint Peter kneels before them, proffering the keys to heaven. The dramatic gestures and glances of the figures further unite the composition and highlight the theatrical quality.

Some scholars consider this grisaille study to be superior to the finished altarpiece, because of the greater freshness and inventiveness of the composition. GC

Giambattista Pittoni
Italian, 1687–1767
oil on canvas
22.06 x 14.56 inches (56.03 x 36.98 cm)
Acquired with funds provided by Mr. and
 Mrs. Robert Raclin
1996.039

139

Sebastiano Conca
Italian, 1680–1764
oil on copper
14 x 11 inches (35.56 x 27.94 cm)
Acquired with funds provided by
 Mr. and Mrs. Al Nathe
1990.003

DEATH OF THE MAGDALEN, about 1740

Born in Gaeta, Sebastiano Conca trained briefly in Naples with Francesco Solimena before leaving for Rome about 1707. There, he adjusted his artistic style, tempering his Baroque exuberance by incorporating the classicism of the Roman master Carlo Maratta. A steady stream of important commissions soon followed, both in and outside of Rome.

This painting's small format is suggestive of a preparatory sketch, but the copper ground and the high degree of finish indicate that it was a completed piece. It may have been commissioned by Cardinal Pietro Ottoboni, a great supporter of Conca and a collector of so-called cabinet pictures intended for private viewing and personal pleasure.

The protagonist, a "fallen woman" who accompanied Christ to the cross, is shown at the moment of her own death. The hovering putti and the halo encircling her head suggest that her penance is complete. Her traditional attributes surround her: an alabaster urn filled with spikenard (with which she anointed Christ's feet), a crucifix, and the open Gospels. The skull under her left forearm is a *memento mori* (reminder of death), and the ropes lying on the ledge behind her allude to the Passion of Christ.

THE LAST SUPPER, 1744

Jean Restout was one of the best-known French painters of religious, mythological, and historical subjects during the first half of the eighteenth century. Although painters expected a low fee when they sold a painting to a church, they knew they were virtually guaranteed steady display of their work. Consequently, artists provided first-class pieces of art for churches throughout the eighteenth century. For his church commissions, Restout painted grand, idealized figures based on the classical tradition of Raphael and Nicolas Poussin, animated by vigorous gestures and ardent expressions that produced the sense of deeply felt religious experience clearly visible in this Last Supper.

For this painting, probably commissioned as an altarpiece, Restout composed his scene in a manner comparable to the way a theatrical director would arrange his stage, using a low viewpoint, careful placement of figures, body language, facial expression, lighting, and stage props. The artist made clear reference to the source of his narrative, chapter thirteen of Saint John's Gospel, in the foreground still-life details of the jug and cloth that recall Christ's washing of his disciples' feet, which is described only by Saint John. DCJM

Jean Restout
French, 1692–1768
oil on canvas
96 x 58.75 inches (243.84 x 149.23 cm)
Gift of an anonymous benefactor
1998.052

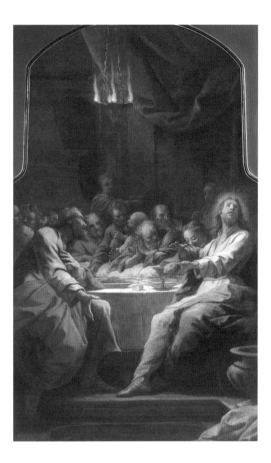

For this painting, probably commissioned as an altarpiece, Restout composed his scene in a manner comparable to the way a theatrical director would arrange his stage.

PRISONERS ON A PROJECTING PLATFORM, about 1745–50

Giovanni Battista Piranesi is celebrated as a gifted printmaker, designer, architect, and archeologist. He is particularly famous for his remarkable series of etchings of topographical views and architectural fantasies. Probably most extraordinary and enduring among these is his series *Carceri d'invenzione* (Imaginary Prisons), which was initially published about 1745. These startling images of prison interiors apparently derived from the artist's imagination, as well as from his knowledge of Baroque stage design.

When the etchings were first issued, there was a certain sense of lightness and delicacy to the fantastic architectural imagery. In a second edition, Piranesi completely reworked the plates, rendering the lines more heavily and creating more emphatic contrasts of light and dark. In addition to the astonishingly vast and perplexing architectural imagery of arches, walkways, and massive stonework, Piranesi included large and small figures, cables, ropes, and instruments of torture. *Prisoners on a Projecting Platform*, plate ten from the second edition, shows the awesome power and haunting content that has made the prints timeless and relevant to succeeding generations. **ss**

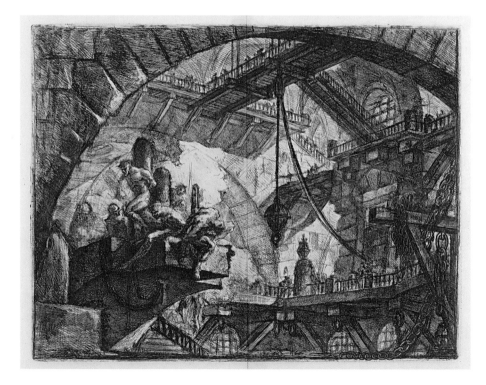

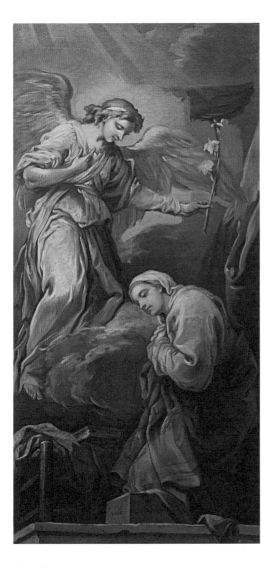

Carle Vanloo
French, 1705–1765
oil on canvas
32.5 x 16 inches (82.55 x 40.64 cm)
Acquired with funds provided by Mr. Joseph Mendelson
 in memory of Mr. and Mrs. Herbert A. Mendelson
1985.058

Giovanni Battista Piranesi (opposite page)
Italian, 1720–1778
etching
16.38 x 21.63 inches (41.6 x 54.94 cm)
1970 University of Notre Dame Purchase Fund
1970.045

THE ANNUNCIATION, about 1746

Carle Vanloo, the most celebrated member of a distinguished family of artists, was enormously successful during his lifetime. His works, though based on classicism and the grand manner, introduced a new Rococo palette of colors and sense of grace. Among his most famous paintings are many large-scale decorative projects.

During the mid-eighteenth century, at the height of his career, Vanloo made a series of paintings of the life of the Virgin for Saint-Sulpice in Paris. The Snite's canvas is a preparatory sketch for his large Annunciation, but it deviates in several ways from the finished composition. The angel, who announces to the Virgin that she is with child, kneels on a cloud holding his right hand to his chest in a less formal gesture than in the final painting. The colors have a light, pearly tone, and the freely flowing draperies are more casually patterned. A chair in the lower-left corner closes off the composition, creating a more compact space. These factors unify the design and connect the angel more closely with the Virgin. Overall, the working sketch shows a liveliness, grace, and intimacy that are missing from the more rigid, formal, and monumental finished work. **ss**

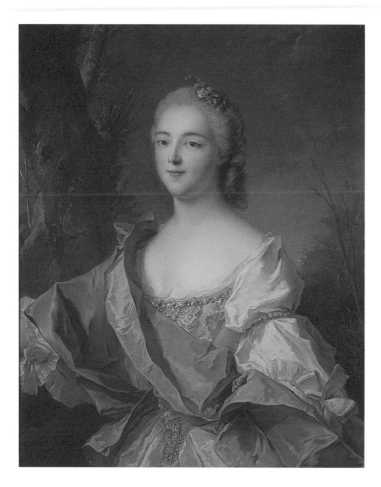

During Nattier's time, some of the philosophes, reform-minded men of the Enlightenment such as Melchior Grimm, complained that cosmetics were harmful to society because they caused people to focus on artificial instead of natural beauty.

PORTRAIT OF THE MARQUISE DE CROISSY, 1749

Jean-Marc Nattier was taught so successfully by his painter father that he won first prize for drawing from the French Royal Academy in 1700. He never traveled to Italy to study, but in Paris he was able to see and copy paintings by famous foreigners, such as those by Peter Paul Rubens in the Luxembourg Palace.

This portrait shows that it was fashionable in the 1740s for even quite young women to powder their hair so it looked gray. The sitter's gleaming white silk dress sewn with jewels illustrates how court society enjoyed displaying its wealth in public. Her bright pink cheeks and pearly white skin indicate the fashion, popular among members of the nobility, for using cosmetics. During Nattier's time, some of the philosophes, reform-minded men of the Enlightenment such as Melchior Grimm, complained that cosmetics were harmful to society because they caused people to focus on artificial instead of natural beauty. These puritanical men extended their critique of women who wore make-up to disapproval of paintings in which highly made-up ladies pretended to be figures taken from mythological stories. DCJM

THE SACRIFICE OF IPHIGENIA, about 1758

A painter of great imagination, Giambattista Tiepolo created in his frescoes an enchanting world of images floating in space, seemingly free from the laws of gravity. Working with extraordinary ease and speed, he covered large spaces with complex scenes that achieved a perfect spatial balance and decorative harmony. He was famous not only for his vast frescoes and numerous altarpieces but also for his graphic work. Tiepolo left an impressive number of drawings—some studies for his large-scale projects, others autonomous, independent artworks.

The Sacrifice of Iphigenia closely follows the Greek myth as related by Ovid in his *Metamorphoses*. Agamemnon and the Greek fleet were wind-bound in the port of Aulis as punishment for offending the goddess Diana by killing a stag in the woods sacred to her. Agamemnon could earn her favor only by immolating his daughter, Iphigenia. But Diana took pity on the innocent victim: wrapped in a cloud, she rescued Iphigenia at the moment of sacrifice and substituted a doe. Tiepolo's rendering of the dramatic scene shows his accomplished draftsmanship and mastery of facial expressions and gestures. Several variants of the myth exist in his graphic work, none intended as preparatory studies for his paintings. EPS

Giambattista Tiepolo
Italian, 1696–1770
black ink and gray wash over graphite on
 paper with watermark "CB"
11.5 x 8.75 inches (29 x 21.5 cm)
Gift of Mr. John D. Reilly (Class of 1963)
1994.049.007

Jean-Marc Nattier (opposite page)
French, 1685–1766
oil on canvas
32 x 25.5 inches (81.28 x 64.77 cm)
Gift of Mrs. Fred J. Fisher
1951.004.005

SALTCELLAR WITH FIGURES OF A TRITON AND A MERMAID, about 1755–57

Founded in 1737 by Marchese Carlo Ginori, the Doccia porcelain factory was one of the most significant creators of fine porcelain in Italy and one of the earliest manufacturers of porcelain in Europe. The factory, located near Florence, produced an extraordinary variety of ambitious and inventive porcelains during much of the eighteenth century. Remarkably, it continued to produce porcelains in the nineteenth and twentieth centuries, creating traditional, Art Nouveau, and more modernist pieces of decorative ceramic art.

The Snite Museum's modestly scaled but imposing saltcellar can be dated to about 1755–57, an especially creative time for Doccia. This small-scale sculpture showing a triton and a mermaid, whose wings support a scallop-shell-shaped dish, was modeled by Gaspare Bruschi, the chief sculptor of the Doccia factory. The very particular facial characteristics of the figures, the compact muscular bodies detailed with stippled tints of flesh color, and the touches of violet and grey are among the distinctive features of works produced by the factory. The vigorous sculptural qualities of this piece, with its exuberantly dynamic curvilinear forms, suggest that it probably derived from a Roman Baroque prototype. **ss**

Doccia factory
Italian, founded 1737
porcelain
6.25 inches (16.5 cm) high
Acquired with funds provided
 by Virginia Marten
2003.019

The very particular facial characteristics of the figures, the compact muscular bodies detailed with stippled tints of flesh color, and the touches of violet and grey are among the distinctive features of works produced by the factory.

François Boucher
French, 1703–1770
black chalk on beige laid paper
13.63 x 11.88 inches
 (34.62 x 30.18 cm)
Gift of Mr. John D. Reilly (Class
 of 1963)
1996.070.020

BOREAS AND OREITHYIA, about 1769

Although at times derided for the frivolous charm of his style, Francois Boucher is still considered one of the most influential eighteenth-century artists. The quintessential Rococo painter created portraits, landscapes, genre scenes, and imaginative depictions of historical and mythological subjects, including stories from Ovid's *Metamorphoses*. Here, Boreas, the wind god, abducts Oreithyia, the beautiful nymph whose love he has been unable to win. Boucher added to the drama by including a group of handmaidens who react with expressive poses and gestures.

Its spontaneity and vigor suggest that the sketch might be *a première pensée* (first idea) for some specific undertaking. Boucher depicted the subject for a number of projects, including a series of tapestries woven at Beauvais, designs for a French edition of *The Metamorphoses*, and decorative paintings for a Paris hotel, which are now in the Kimbell Art Museum, in Fort Worth, Texas. Although scholars previously connected this drawing to the Kimbell composition and the tapestry of the subject, it does not relate definitively to any of these known projects. It may simply be an independent work created while the artist returned to a favorite theme. Comparing its confident and assured manner to other late studies seems to justify dating it to Boucher's mature period. **ss**

François Boucher
French, 1703–1770
oil on canvas
36 x 28 inches (91.44 x 71.12 cm)
Gift of Mrs. Fred J. Fisher
1951.004.002

Hubert Robert (opposite page)
French, 1733–1808
red-brown chalk on laid paper
13 x 17 inches (33.02 x 43.18 cm)
Gift of Mr. John D. Reilly (Class of 1963)
1996.070.008

L'OISEAU ENVOLÉ (THE BIRD HAS FLOWN), 1765

The light-hearted Rococo style was the most popular trend in visual art of the eighteenth century, and François Boucher was its best-loved exponent. He established the appreciation for women of a younger and slimmer type than had been fashionable during the heyday of Peter Paul Rubens in the seventeenth century, and he depicted all social classes, from the royal mistress Madame de Pompadour to lounging goddesses and appealing shepherdesses, in this new manner. Boucher created an artificial world of love and pleasure that delighted Europeans during his lifetime, but by the time of his death in 1770, the severe and moralizing tones of the Enlightenment phi-losophes caused art lovers to turn away from Boucher's spontaneity and pretty pastel colors in favor of a sterner and more didactic historical style and subject matter.

L'Oiseau Envolé is an elegant example of the type of subject for which Boucher is best known, the "amorous pastoral," and perhaps what we are witnessing here is some amorous teasing. The empty birdcage on which the young woman leans is a metaphor for the games and traps of love—a frequently used device in the poetry, drama, and visual imagery of the eighteenth century. DCJM

FOUNTAIN IN AN ITALIAN GARDEN, about 1760–63

Hubert Robert's paintings and drawings of picturesque landscapes with architectural ruins were widely admired by critics and collectors of his day. His endlessly inventive compositions incorporate a vast array of real and imaginary elements borrowed from various sites and recombined to produce attractive new compositions. An eleven-year stay in Italy essentially determined his style and subject matter. There, he came into contact with Giovanni Paolo Panini's distinctive style of view painting and Giovanni Battista Piranesi's prints capturing the grandeur of Rome. He also worked closely with Jean-Honoré Fragonard; at times it is difficult to distinguish the specific hand in the two artists' masterful red chalk drawings.

This informal image of a fountain in a lush Italian garden probably dates from Robert's later years in Italy. The specific details—including the headless antique statue, the niche with the elephant-head fountain, the woman carrying water, the trellis and trailing vines, and the group of potted plants—are all described with assured, quick, and energetic strokes of red chalk. Bathed in light, the scene evokes a timeless and idyllic world where nature and man still exist in some manner of harmony. SS

BUST OF AN UNKNOWN WOMAN, 1750

Jean-Baptiste Lemoyne was one of eigh-
teenth-century France's most successful
sculptors. Over the course of his career, he
produced more than one hundred portrait
busts, at least sixty of them in terra-cotta, or
fired clay. Lemoyne's sitters included courtiers,
the bourgeoisie, aristocrats, and members of
the royal family. He was eventually named the
official portraitist of King Louis XV himself.
His portraits of women were particularly well
received. Their intimacy and charm reflected
a discerning understanding of the work of
the day's popular painters, such as Maurice-
Quentin de La Tour and Noël Coypel.

Those qualities are readily ascertainable in this
bust of a young woman whose identity has
yet to be determined. Lemoyne endowed his
sitter with a coquettish air, capturing a sidelong
glance and an enigmatic half smile. The lifelike
quality of the work is heightened by his skill-
ful incising of the eyes and masterful handling
of the terra-cotta, which seems to tremble
with life. The artist's acute sensitivity toward
society's demands for fashionability is evident
in the sitter's stylish coiffure, an element that—
together with stylistic analysis—dates the work
to approximately 1750.

Jean-Baptiste Lemoyne
French, 1704–1778
terra-cotta on contemporary stand
17.5 x 9 x 7.5 inches (44.45 x 22.86 x 19.05 cm)
Acquired with funds provided by the Walter and
 William Klauer Purchase Fund
1972.001

Louis Lagrenée
French, 1725–1805
oil on copper
16 x 13 inches (40.6 x 33 cm)
Acquired with funds provided by
 Mr. and Mrs. Robert Raclin
1987.026

LOT MADE DRUNK BY HIS DAUGHTERS, 1771

Louis Lagrenée was renowned for his capacity to work in the newly revived classicizing style without neglecting the sheer pictorial beauty so prized by proponents of France's earlier Rococo movement. His balanced approach is manifest in this delightful work, which depicts Lot and his daughters after their flight from the city of Sodom (Genesis 19:30–38). The daughters, in desperation, decided to inebriate and seduce their father, not for lascivious purposes but rather to preserve the lineage of God's chosen people. This episode would have been well received in eighteenth-century France, for it was simultaneously edifying and titillating. The grace and prettiness of the protagonists and the richly saturated palette are vestiges of the French Rococo, whereas the women's classical robes and composure are nods to the more sober style that was quickly gaining ground.

The painting, which was shown at the 1771 Salon, is one of a series of works commissioned by the English collector Sir Henry Hoare of Stourhead. In each painting, Lagrenée used a copper ground cut down to relatively modest dimensions. This allowed his talents to shine, for he excelled at working within a small format.

Benjamin West
American, 1738–1820
oil on canvas
59 x 45.5 inches (149.86 x 115.57 cm)
Acquired with funds provided by
 the Walter and William Klauer
 Purchase Fund
1970.024.003

Louis-Simon Boizot (opposite page)
French, 1743–1809
unglazed porcelain
7.88 x 9 x 6.25 inches
 (20 x 22.86 x 15.87 cm)
Acquired with funds provided by
 Mr. and Mrs. John S. Marten
1998.007

THE COMPASSION OF PHARAOH'S DAUGHTER
FOR THE INFANT MOSES, about 1771

By the time of his death at the age of eighty-one, Benjamin West was considered by many to be the most prominent painter in the English-speaking world. West had traveled to Italy in 1760, spending three years drawing and copying paintings by the old masters and making the European contacts that would ensure his later artistic success. In 1760 he established a studio in London that quickly became a meeting place for three generations of ambitious young American painters.

West executed this painting in the Neoclassical style, drawing static, grand, idealized figures with hard, clear outlines. In order to illustrate the story from Exodus 2:1–10 of how Pharaoh's daughter rescued the infant Moses from the Nile, West used a series of theatrical-style details. These include pyramids in the distance that refer to Egypt, variations in clothing that make clear which figures are Hebrews and which Egyptians, facial expressions that remind the viewer of the story's happy ending, gestures that allude to Moses' sister offering to find their mother to be the baby's wet nurse, and focused lighting on the baby that stresses the idea that he is a forerunner of the divine infant Jesus Christ. DCJM

LA NOURRICE (THE WET NURSE), 1775–80

In 1775 the sculptor Louis-Simon Boizot modeled this family group for the Sèvres royal porcelain factory. Unglazed porcelain, or "biscuit ware," had the appearance of marble and was much appreciated by discerning collectors in the eighteenth century. The Sèvres factory originally produced this group as one piece in a set of three, intended to be table centerpieces. Louis XVI bought one complete set, which is listed in a 1792 inventory of one of his private dining rooms.

Careful examination of the expensive-looking clothes and headgear of the figures reveals that the mother and children belong to the upper class. The simpler clothes and covered hair of the woman holding the cradle indicate that she is a servant. Before 1775 upper- and middle-class mothers usually hired peasant wet nurses for their babies, so it is surprising to see this wealthy mother nursing her own child. Perhaps this table decoration made for the rich and well-educated shows the new fashion for maternal nursing, which Jean-Jacques Rousseau recommended in his bestselling book *Emile*, 1762, as an important way to improve the morality of the French nation. DCJM

THE REJECTION OF CAIN'S OFFERING
AND THE SACRIFICE OF MANOAH, about 1779

This work is a *modello*, or model, for one half of the cupola fresco in Santa Maria della Vita in Bologna, Italy. This portion, which would be visible only to the priests celebrating mass, depicts two Old Testament sacrifices or offerings that anticipate the mass: Cain's offering, which is rejected by God, and Manoah's, which is accepted. Manoah's offering is made in gratitude for the forthcoming birth of his son, Samson, who prefigures Christ.

Gaetano Gandolfi was one of the preeminent painters of Bologna in the last quarter of the eighteenth century. This work was made during the most interesting period of his career, following his long visit to Venice where he absorbed the art of the great Venetian masters, from Paolo Veronese to the Tiepolos. The full impact of this experience is evident in the use of rich color and the dramatic composition. GC

Gaetano Gandolfi
Italian, 1734–1802
oil on canvas
25.59 x 32.68 inches (65 x 83 cm)
Acquired with funds provided by Mr. John D. Reilly
 (Class of 1963) in memory of his mother, Sara Butler
 Reilly
1985.017

A DROVER WITH CATTLE PASSING A WOODED POOL, EVENING, about 1785

Though known to modern audiences principally for his portraits, Thomas Gainsborough was in fact one of eighteenth-century Britain's most talented landscape painters. He was also a prolific draftsman who drew not so much as a preparatory exercise as for the sheer pleasure of the act. Initially entranced by seventeenth-century Dutch landscapists, Gainsborough developed a looser touch as his work matured. His style underwent its most marked transformation in the years after 1759, when he introduced a dramatic play of shadow and light together with a bravado inspired by the paintings of Peter Paul Rubens. These effects are evident in the bold lines and strokes of the Snite's *Drover*. The foliage of the strikingly inclined tree in the middle ground is particularly remarkable; the leaves are described expressively by thick parallel lines.

Although the vignette appears to be a topographical view, it is more likely an idealized pastiche derived from the lengthy study of views (both painted and real) and of the assemblages Gainsborough created in his studio. Like so many of the artist's other rural scenes, this drawing was not simply a hymn to nature but a biting, if subtle, commentary on the erosion of rural lifestyles through the destructive effects of urban migration, dispossession, and enclosure.

Thomas Gainsborough
British, 1727–1788
black chalk and stump on gray wove paper
8 x 11.13 inches (20.32 x 28.26 cm)
Gift of Mr. John D. Reilly (Class of 1963)
2000.074.025

STUDY FOR "THE RECONCILIATION," about 1785

The age of Rococo pictures displaying frivolity and sensuality in the first half of the eighteenth century was followed by a revived interest in classical and moralizing images. Jean-Baptiste Greuze's first painting to be exhibited in the Salon—a picture of a modest, provincial family in private devotion—enjoyed great success in 1755, appealing to those who had tired of Rococo's superficiality. Thereafter, his genre scenes of the daily lives of middle-class families assured him a large audience and financial success.

Greuze's strength and originality lay in the way he showed the bonds of family through both suffering and harmony. Much of his later work became repetitious and melodramatic, lacking honesty. Yet he was still valued for his portraits and drawings, which were often more alive than his finished paintings. He made numerous preparatory studies of figures for his major narrative pictures, often even on the verso of the study sheet, as in this example. This dramatic scene depicting a young son and daughter trying to unite their alienated parents was probably drawn about 1785, when Greuze himself was experiencing marital problems. The friezelike, rapidly drawn composition is similar to sketches he made for several other moralizing genre pictures. EPS

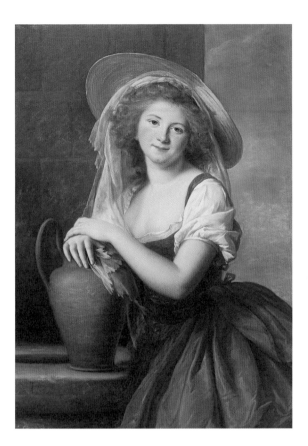

PORTRAIT OF MARGUERITE BAUDARD DE SAINT JAMES, MARQUISE DE PUYSEGUR, 1786

Elisabeth-Louise Vigée Le Brun
French, 1755–1842
oil on panel
41.5 x 29.25 inches (105.41 x 74.3 cm)
Gift of Mrs. Fred J. Fisher
1951.004.015

Jean-Baptiste Greuze (opposite page)
French, 1725–1805
brush and gray washes over black chalk
 on off-white laid paper
9.5 x 13.3 inches (24 x 33.2 cm)
Gift of Mr. John D. Reilly (Class of
 1963)
1996.070.024

In the 1760s, Elisabeth-Louise Vigée Le Brun introduced a new portrait style that pleased her fashionable sitters and made her a popular artist in many European capitals when she became an exile from the French Revolution. This new style focused on the current vogue for "natural manners" by omitting references to mythology or classical architecture and incorporating simplified clothing and relaxed poses. Vigée Le Brun asked female sitters to remove any hair powder or cosmetics and encouraged the women to drape themselves with decorative shawls. Queen Marie Antoinette liked this style so much that she frequently invited the painter to the Palace of Versailles, where the two women became friends. Vigée Le Brun made more than twenty portraits of the queen.

The viewer might wonder why this sitter, clearly labeled as a noblewoman in the title of the painting, is dressed as a peasant. She stands by a well, leaning on a vase, with her skirt tucked up into her belt as if she is ready to walk home along the dirty street. Her dress and pose may, in fact, indicate that she has been involved in the popular games of rustic role-playing led by the queen in the gardens of Versailles. DCJM

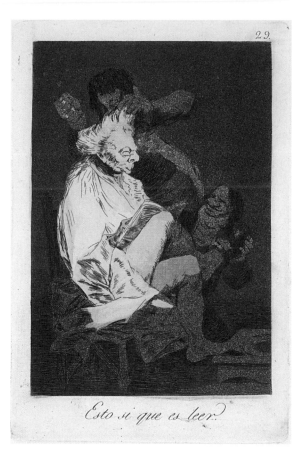

When Goya first published the prints and their accompanying commentaries in 1799, the Spanish authorities considered them an open attack on society. The edition was almost immediately withdrawn from circulation.

Francisco de Goya
Spanish, 1746–1828
etching and aquatint
7 x 5 inches (18 x 12.5 cm)
Acquired with funds provided by the Humana
 Foundation Endowment for American Art
1991.001.002

ESTO SI QUE ES LEER (THEY CALL THIS READING)

The Spanish painter, draftsman, and print-maker Francisco de Goya demonstrated as much creativity in his graphic works as in his paintings. In a series of prints entitled *Los Caprichos*, he depicted Spanish life as he perceived it in the late eighteenth century—riddled with intrigues, lies, bribes, matchmaking, and pandering leading to immorality. When Goya first published the prints and their accompanying commentaries in 1799, the Spanish authorities considered them an open attack on society. The edition was almost immediately withdrawn from circulation.

Goya created the prints using the technique of aquatint etching, which allowed him to accent dramatic qualities through gradation of shading, half-tone effects of glazes, and rich nuances between light and dark. The Snite's plate from the first published edition shows an elderly gentleman, probably a member of the upper class, feigning to read but in fact sleeping while his servants dress him. The commentary to the plate reads: "They comb his hair and pull on his stockings for him, while he sleeps and studies. No one can say that he is not making the most of his time." Through such critical comments on the life of the aristocracy and high bourgeoisie, Goya influenced political satire throughout the nineteenth century. EPS

NAPOLÉON, 1804

This portrait was probably carved by an Italian master stonecarver in Carrara, Italy, using Antoine-Denis Chaudet's original clay version as a model in 1804, the year in which Napoléon Bonaparte crowned himself emperor in the Cathedral of Notre-Dame. The herm bust presents Napoléon in the tradition of portraits of Roman emperors such as Caesar Augustus. He is nude and has short hair, a straight Roman nose, a firm mouth and brow, and blank eyes. The ruler was so pleased with this image that he made it his official state portrait, and over one thousand versions were produced in a variety of sizes and media, including bronze, terra-cotta, plaster, and porcelain. Like Roman emperors, Napoléon and his family gave these sculptures away as gifts, thereby broadcasting his power all over Europe.

Chaudet studied in Rome, where he learned that he could satisfy collectors' wishes for owning a Greek or Roman statue by providing them with a new sculpture carved in the Neoclassical style. The success of this portrait of Napoléon brought Chaudet commissions for more versions. Until his death in 1810, he was considered to be the French sculptor who best interpreted the ideals of Neoclassicism. DCJM

Antoine-Denis Chaudet
French, 1736–1810
marble
21.25 x 13 x 10 inches (53.98 x 33.02 x 25.4 cm)
Acquired with funds provided by Mr. Al Nathe
1998.040.002

The ruler was so pleased with this image that he made it his official state portrait, and over one thousand versions were produced in a variety of sizes and media, including bronze, terra-cotta, plaster, and porcelain.

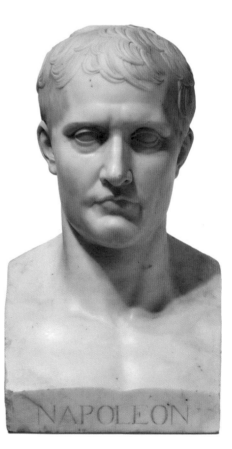

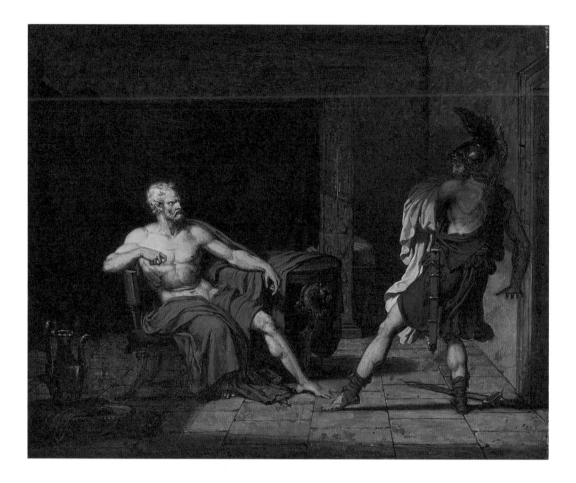

The Roman general Marius confronts a Cimbrian soldier who has been sent by the Senate to kill him. Clearly awed by Marius's courage, the soldier draws back into the shadows and drops his sword, unable to complete his mission.

MARIUS AND THE GAUL, about 1796

François-Xavier Fabre was born in the southern French city of Montpellier and is perhaps still better known for the museum there that bears his name than for his notable body of work as an artist. Entering the studio of Jacques-Louis David in 1783 and quickly assimilating the Neoclassical style of his master, Fabre worked alongside such gifted students as Anne-Louis Girodet and Jean-Germain Drouais. After winning the Prix de Rome in 1787, he set off for Italy, the country where he was to spend the better part of his life and productive career.

Fabre remained at the Academy in Rome for four years. Due to the increasing pace of the French Revolution and his own royalist sympathies, he then left to establish himself in Florence. There, the artist became a prominent member of Florentine society, associating with an international circle of wealthy and influential personalities such as Lord Holland, Lord Bristol, and the poet Vittorio Alfieri.

Best described as both elegant and realistic, Fabre's style of Neoclassicism seems firmly based on the sober and dramatic classicism of Nicolas Poussin and David. The Museum's oil sketch *Marius and the Gaul* is a characteristic, if somewhat freer and livelier, example of his

distinctive style of history painting. The subject was a commission from Lord Holland, and the final painting was completed in 1796.

In this preparatory sketch, the Roman general Marius confronts a Cimbrian soldier who has been sent by the Senate to kill him. The heroic and highlighted general fixes his gaze intently on the soldier. Clearly awed by Marius's courage, the soldier draws back into the shadows and drops his sword, unable to complete his mission. Fabre composed the painting as a frieze, with the protagonists placed on a shallow, stagelike space and few accessories to distract from the interaction of the principal figures. The pictorial devices effectively emphasize the basic narrative, expressive tension, and moral message of the subject. **ss**

François-Xavier Fabre
French, 1766–1837
oil over ink on paper mounted to canvas
12.5 x 15.13 inches (31.75 x 38.43 cm)
On extended loan from Mr. and Mrs. Noah L. Butkin
L1980.027.006

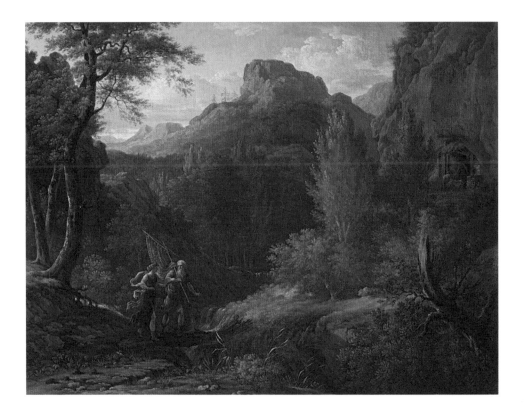

PSYCHE, CHERCHANT L'AMOUR, RENCONTRE LE VIEILLARD QUI LUI AIDE A PASSER LE RAVIN POUR LA CONDUIRE A SA GROTTE
(PSYCHE, LOOKING FOR LOVE, MEETS THE OLD MAN WHO HELPS HER CROSS THE RAVINE AND TAKES HER TO HIS GROTTO), 1796

Pierre-Henri de Valenciennes, who favored the genre of landscape over figure painting, developed a new academic genre called "historic landscape," in which he aimed to teach lessons of virtue through nature. He was so successful in this endeavor that in 1816 a new national prize for historic landscape was established. His treatise on the effects of light in nature became an essential textbook for landscape artists throughout the nineteenth century.

In this painting, Valenciennes interpreted an episode from the long and intricate Greek myth of Psyche and Cupid, written down in the second century by the Latin poet Apuleius. In seventeenth-century France, the writer Jean de La Fontaine wrote a new version, to which he added some scenes of his own creation. Valenciennes's painting refers to La Fontaine's version and depicts a dignified old hermit who leads Psyche to rest in his hilltop retreat after rescuing her from suicide near a river. The painting's original viewers would have known this story, in which Psyche's sufferings parallel those of the human soul, which also must pass through difficult trials before finding heavenly peace and love. DCJM

STUDY OF PAUL-EMILE FOR THE PAINTING "PAUL-EMILE, VAINQUEUR DE PERSÉE (AEMILIUS PAULLUS, CONQUEROR OF PERSEUS)," about 1803

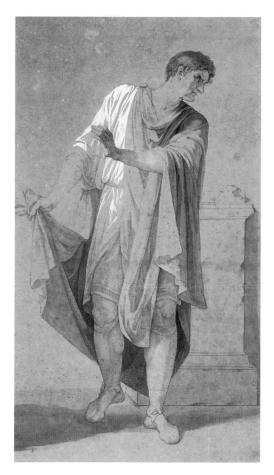

Jean-François-Pierre Peyron
French, 1744–1814
gray ink and wash heightened with white on tan wove
 paper
17.25 x 10.38 inches (43.81 x 26.36 cm)
Gift of Mr. John D. Reilly (Class of 1963)
2000.074.018

Pierre-Henri de Valenciennes (opposite page)
French, 1750–1819
oil on canvas
16 x 22.13 inches (40.64 x 56.21 cm)
Museum purchase by exchange, Mrs. Robert B. Mayer
1986.055

During his lifetime, Peyron was considered the most promising new talent in French painting who was leading away from the Rococo style toward a new form of classicism. He was the chief rival to Jacques-Louis David, and like David, he produced a number of highly successful history paintings.

Although Peyron has been recognized as a remarkable draftsman, relatively few of his drawings are known today. Among the rarest are studies for individual figures in his paintings. This drawing is especially valuable, as it is a study for a painting that was exhibited at the Salon of 1804 and destroyed in 1944. An oil sketch for the composition dated 1802 survives at the Museum of Fine Arts in Budapest, and other related drawings are in French museums.

This study employs the special combination of media—ink and wash heightened with white—that Peyron handled with great facility. The pose and details of the figure, including the intricate folds and patterns of the drapery, are confident and precise. The contours are firmly rendered, and a delicate sense of light and shadow plays over the monumental figure. The drawing seems to coincide closely to the figure as it appeared in the finished painting. ss

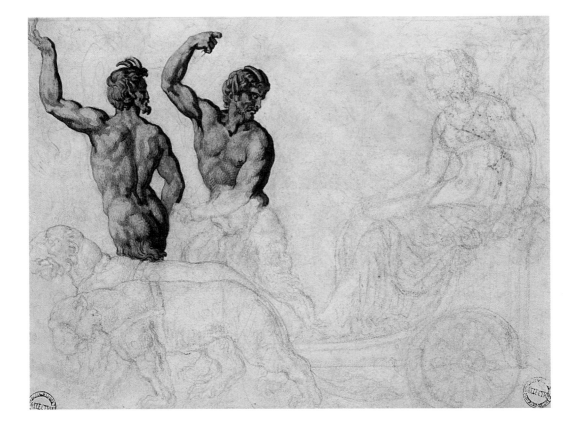

The Museum's double-sided drawing, which can be dated to 1815 (before the artist left for Italy), provides an intriguing insight into the formulation of his art.

THE TRIUMPH OF ARIADNE, 1815

Théodore Géricault is regarded as one of the most important and fascinating artists of the early nineteenth century. Although he trained in the studio of the famous Neoclassical painter Pierre-Narcisse Guérin, where such Romantic artists as Eugène Delacroix and Paul Huet also developed their art, he seemed to learn as much from the numerous masterworks he viewed in the Musée Napoléon and from the Renaissance art he studied on a trip to Italy. He has come to embody the image of the artist as a romantic, passionate, and original genius. In the span of scarcely a dozen working years, he produced a complex, varied, and powerful body of work that brought together elements of Neoclassicism, Romanticism, and Realism with influences from the old masters. Géricault, in turn, was a considerable inspiration for future generations of both Romantic and Realist artists.

The Museum's double-sided drawing, which can be dated to 1815 (before the artist left for Italy), provides an intriguing insight into the formulation of his art. During these early years, Géricault copied and assimilated a vast array of earlier artworks that held a particular interest for him. In these so-called copies, he often transformed the works he was replicating into his own forceful style. *The Triumph of Ariadne* is his reproduction of a print in a book illustrating works from Florentine art collections.

Géricault was clearly attracted to classical subjects; he produced numerous drawings based on them. Several of his other mythological drawings are similar in technique and style to the Snite sheet, which has an underdrawing in chalk and highly finished sculptural qualities rendered in ink and washes. Interestingly, the reverse side of this sheet shows Géricault's bold study after the painting *The Birth of Love*, by one of France's most important seventeenth-century classical artists, Eustache Le Sueur. **ss**

Théodore Géricault
French, 1791–1824
black chalk with brown wash and traces of red chalk on
 off-white wove paper
8.44 x 11.25 inches (21.4 x 28.4 cm)
Gift of Mr. John D. Reilly (Class of 1963)
1996.070.009

STAFFORDSHIRE BULB POT, about 1805–10

This unusual-looking object is an early nineteenth-century bulb pot used to force flowers such as hyacinths, narcissi, and crocuses. Such vessels first became popular in mid-eighteenth-century France, after the famed Sèvres porcelain factory began producing them in 1756. Fashion-conscious England soon followed suit, and before long British porcelain and pottery makers were crafting bulb pots in all manner of shapes, sizes, and media. The most sophisticated pots were made of porcelain, the material that this finely glazed earthenware vessel emulates.

The pot's refined character is reinforced by its graceful half-moon shape, which is echoed in the scalloping that embellishes both its body and the five bulb holders piercing the lid. The vessel's material opulence is further heightened by the three bronze-like feet on which it rests and by the abundant gilding. The central reserve panel, depicting a rocky pastoral scene in which a shepherd tends his flocks, has been attributed to George Robertson, one of the most accomplished porcelain and pottery decorators from Derbyshire, an area known for such work. Though the bulb pot lacks a manufacturer's stamp, it has been related to a rather mysterious group of potted vessels that bear the impress "W(***)," a mark that has yet to be adequately explained.

The central reserve panel, depicting a rocky pastoral scene in which a shepherd tends his flocks, has been attributed to George Robertson.

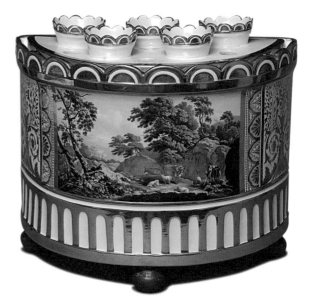

John Wesley Jarvis
American, 1781–1840
oil on canvas
36 x 30.75 inches (91.44 x 78.11 cm)
Acquired with funds provided by the
 Lawrence and Alfred Fox Foundation
 and Mr. and Mrs. Edward Abrams
1998.011

British (opposite page)
glazed earthenware
8.5 x 10.5 inches (21.6 x 26.67 cm)
Acquired in honor of Mr. Robert Dunfee
1994.004

PORTRAIT OF A MAN, about 1815–20

Although born in England, John Wesley Jarvis was raised in Philadelphia, Gilbert Stuart's "Athens of America." There, he was exposed to some of late eighteenth-century America's best painters: Charles Willson Peale, Matthew Pratt, John Turnbull, and Stuart himself. Jarvis trained initially with Edward Savage, a painter and engraver of modest ability. Disappointed by Savage's mediocre skill, the young artist left his tutelage. Because Jarvis was essentially self-taught, his oeuvre lacks a coherent style and quality.

The Snite's *Portrait of a Man* shows the artist at his best. The sitter, with his open chemise and windswept hair, is striking for his bold, romantic air. This impression is heightened by the storm clouds brewing behind him and by his pensive, slightly distracted expression. Though the man's identity has yet to be confirmed, physiognomic similarities with Jarvis suggest that the work may be a self-portrait. The painting's verve and dash support this, as Jarvis had a flamboyant personality and a distinct flair for the dramatic. Together with his artistic gifts, these character traits helped to procure him a number of important portrait commissions during the early nineteenth century.

PORTRAIT OF THE BARONESS JEANIN AND HER DAUGHTER, 1821

Jacques-Louis David was the preeminent Neoclassical history painter. Beginning in the 1780s and continuing throughout the turbulent Napoleonic era, he produced a succession of large, important historical compositions that brought him considerable fame and positioned him as one of the most significant figures in European art. Certain areas of his work, however, have been conspicuously overlooked and ignored. Many of his later paintings and drawings have been disparaged as relatively weak and problematic in conception, and have only recently been reevaluated.

This drawing of Pauline Jeanin and her daughter, done in Brussels in 1821, is an impressive and representative work from David's later years. The frontal poses and close-up view of the sitters are typical of the artist's manner during this period. The portrait displays the particularly tight, finished style of many of David's later drawings, while still showing the masterful precision and facility of his draftsmanship. Although over the years many of David's works have been criticized as cold and polemical, his portraits often show a disarming realism and directness. In this particular case, perhaps because the sitters are his daughter and granddaughter, the image seems especially appealing and unaffected. **ss**

Jacques-Louis David
French, 1748–1825
black chalk on buff paper
5.69 x 7.88 inches (14.4 x 20 cm)
Gift from Mr. John D. Reilly (Class of 1963)
1996.070.004

VUE DU PARC DE SAINT-CLOUD
(VIEW OF THE PARK OF SAINT-CLOUD), 1831

To paint out-of-doors and in complete solitude was the guiding principle of Constant Troyon, a French landscape and animal painter closely associated with the painters of the Barbizon School. These artists, who worked in the small village of Barbizon near the Forest of Fontainebleau, painted directly from nature, capturing its atmospheric effects. Unlike the Impressionists, they finished their canvases in the studio. They did not make the traditional journey to Italy; their inspiration came instead from Dutch Realism and English Romanticism.

Troyon's early works show a poetic colorist of quiet hues aiming to achieve a perfect tonality. *Vue du Parc de Saint-Cloud* belongs to this first period, when he created fine landscapes depicting meadows and riversides on the outskirts of Paris. He executed a number of paintings and watercolors around Sèvres, his birthplace, and Saint-Cloud. In this canvas, Troyon did not attempt to exactly transcribe a concrete motif. He focused rather on interpreting the color and rendering the atmosphere of this particular place in connection with memories of his emotional childhood experiences there. EPS

Constant Troyon
French, 1810–1865
oil on canvas
17.5 x 24.38 inches (44.5 x 62 cm)
Museum purchase by exchange, Mr. Lewis J. Ruskin
1972.021

The image depicts a sweeping panoramic view of a plain with water and plants in the foreground, a hill and building silhouetted on the distant horizon, and dramatic storm clouds hovering in the sky.

LANDSCAPE IN THE ENVIRONS OF PARIS

Georges Michel remains among the most remarkable and yet least well-known French landscapists of the nineteenth century. One of the earliest Romantic artists, Michel also was the most important forerunner to the Realism of the Barbizon School. Even though scholars are beginning to recognize the significance of his art, there is still no essential modern study devoted to him and his work.

Of humble origins, Michel evidently received his initial artistic training by apprenticing with a number of minor painters and by studying and working directly from nature. Although he exhibited at the Paris Salon early in his career, the critics usually ignored his work. Fortunately, he often had the sympathetic backing of highly placed patrons and supporters. The major influences on his developing style were the landscapes of Jacob van Ruisdael, Meindert Hobemma, and Rembrandt, all of which he copied. His exposure to their art was reinforced when Vivant Denon employed him to restore the Dutch and Flemish paintings at the Louvre. Although Michel's style owes a debt to these seventeenth-century masters (he has sometimes been referred to as the Ruisdael of Montmartre), the singular vigor and directness of his art places him among the outstanding original talents of the nineteenth century.

The Snite Museum's large landscape, with its emphatic horizontal format and rich, muted palette, is a splendid and characteristic example of Michel's painting style. The image depicts a sweeping panoramic view of a plain with water and plants in the foreground, a hill and building silhouetted on the distant horizon, and dramatic storm clouds hovering in the sky. Michel never traveled to Italy, or indeed left France, to work. Presumably this painting is one of the artist's many landscapes rendering the environs close to Paris, where he is known to have constantly wandered and found motifs during his later years. The confident, free brushwork, broad strokes, and finesse in handling all suggest that this painting is from his mature period, about 1830 or later. ss

Georges Michel
French, 1763–1843
oil on paper, laid down on canvas
31.6 x 48.4 inches (79 x 121 cm)
Gift of Mr. and Mrs. Robert Raclin
1994.039

ADORATION OF THE MAGI, 1838

Eduard Karl Steinbrück's *Adoration of the Magi* was first purchased by the American ambassador in Düsseldorf, John Godfrey Boker, in the late 1830s. It is speculated that the painting, like the works of many of Steinbrück's colleagues, was sent by Consul Boker to the United States to protect it from revolutionary events shaking Germany in 1848. Certainly, the *Adoration* was in New York City by 1849, when it was presented to the public at Boker's much-acclaimed Düsseldorf Gallery.

As this provenance suggests, the artist was a member of the so-called Düsseldorf School. These painters were characterized by a penchant for saturated colors and carefully articulated forms, fidelity to nature, and minute attention to detail. The Snite's *Adoration*, one of Steinbrück's first attempts to paint on such a large scale, glows with a warmth that is both spiritual and pictorial. The realism of the figures enhances its pathos. Its high degree of finish gives the painting a porcelain-like appearance that augments its timeless, reverent quality. Steinbrück is also frequently associated with the Nazarenes, a nineteenth-century German group of artists who sought to recapture the purity and simplicity they perceived in early Renaissance art and to inject their paintings with a heavy dose of morality.

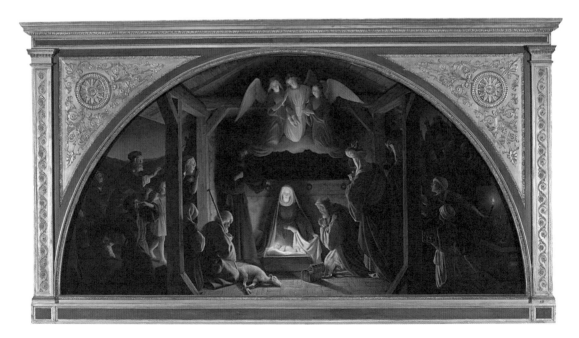

Théodore Caruelle d'Aligny
French, 1798–1871
oil on paper, mounted to canvas
26 x 20 inches (66 x 51 cm)
On extended loan from Mr. and Mrs.
 Noah L. Butkin
L1980.027.019

Eduard Karl Steinbrück (opposite page)
German, 1803–1882
oil on canvas
49 x 96.75 inches (124.46 x 245.75 cm)
Acquired with funds provided by the
 Mr. and Mrs. Robert L. Hamilton, Sr.,
 Purchase Fund
1978.017

A LANDSCAPE IN ITALY, 1834/35

In the early nineteenth century, French landscape painting underwent a dramatic change. No longer merely background for mythological stories or historical episodes, the landscape itself became the subject. Théodore Caruelle d'Aligny was at the forefront of this reform. His aim was to translate onto canvas the beauty and permanence of nature.

On his first sojourn in Italy (1822–27), where he met and befriended Jean-Baptiste-Camille Corot, Aligny filled his sketchbook with drawings and watercolors of the Roman Campagna and Switzerland. After returning to France, he spent most of his time sketching in the Forest of Fontainebleau, where he worked on resolving problems of the spatial organization of form on his canvases.

His second journey to Italy (1834–35) was through the arid countryside around Naples. *A Landscape in Italy* resembles another painting, *Ravins de Sorrente* (now in the Musée Fabre, Montpelier), that Aligny executed in 1834. Both works feature a valley with rushing water amid steep rocks, with mountain peaks in the background. The mood of the landscape is conveyed by a reduced color palette of mostly brown and ochre. Subtle effects of light and shade underline the purplish mountain summits in the distance. EPS

173

STUDIES FOR THE CHAPEL OF SAINT-JOHN, CHURCH OF SAINT-SÉVERIN, PARIS, 1839–41

Under the July Monarchy (1830–1848), religious art was revived in France. Churches that had been dilapidated during the French Revolution were restored, and respected painters were invited to participate in their decoration.

In 1839 Hippolyte Flandrin was commissioned to paint murals in the Chapel of Saint-John at Saint-Séverin, in Paris. He submitted these preliminary studies for the project to the Paris municipal administration for review. The task of painting the murals was difficult given the shape and dimensions of the chapel; its high, narrow walls were not suited to the treatment of groups of figures. To illustrate the life of Saint John, Flandrin devised a scheme of four mural paintings on two opposite walls, each divided into two registers. The east wall depicts *The Last Supper* and *Saint John Writing the Book of Apocalypse on the Island of Patmos*; the west wall represents *The Martyrdom of Saint John* and *The Vocation of Saint John*.

Flandrin used a new encaustic painting technique for the murals that was slow but had the important advantages of producing opaque colors and being resistant to humidity. Unveiled in 1841, the murals established Flandrin's reputation as a religious painter admired for his style and his deep spirituality. EPS

Hippolyte-Jean Flandrin
1809–1864
oil on canvas, mounted to board
23.69 x 9.25 inches (59.8 x 23.2 cm)
On extended loan from Mr. and Mrs.
 Noah L. Butkin
L1980.057 1a–b and L1980.057 2a–b

The task of painting the murals was difficult given the shape and dimensions of the chapel; its high, narrow walls were not suited to the treatment of groups of figures.

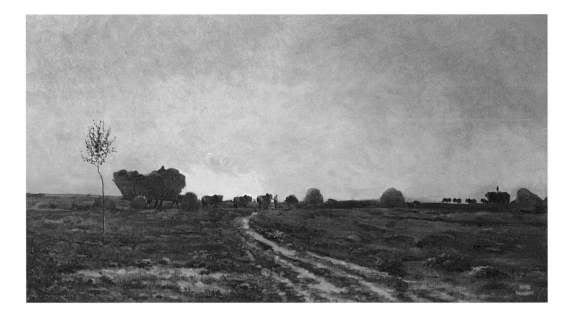

LA MOISSON (THE HARVEST), about 1840

Charles-François Daubigny was an impor-tant French landscape painter of the Barbizon School and one of the earliest expo-nents in France of the practice of painting out-of-doors. *La Moisson* is typical of his landscapes. It reflects the artist's love of the countryside and is notable for its almost Dutch atmospheric effects and uncrowded composition. The work relates to a somewhat later version of the same subject in the Louvre. Both paintings were praised by critics for their luminous colors, fluid atmosphere, and simple motifs.

Daubigny was one of the first landscape paint-ers to take an interest in the changing and fleeting aspects of nature, depicting them with a light and rapid brushstroke—a highly novel technique that disconcerted many critics. He was also an important figure in the devel-opment of naturalistic landscape painting, bridging the gap between Romantic senti-ment and the more objective approach of the Impressionists. His method of working out-doors later influenced Claude Monet. GC

Charles-François Daubigny
French, 1817–1878
oil on canvas
16.5 x 31.5 inches (41.91 x 80.01 cm)
Museum purchase by exchange, Mr. Peter J. Ruskin, Mr.
 Peter C. Reilly, Mr. Arthur Weisenberger, Mr. Paul
 Manheim, and Mr. Fred B. Snite
1994.031

LE RATAPOIL (RATSKIN), modeled about 1850–51, cast 1925

Honoré Daumier is best known for his political caricatures printed in Paris journals during the nineteenth century, when this genre of social commentary came into its own. As a committed republican, Daumier produced anti-monarchist cartoons that landed him in prison in 1832 and in poverty in his old age. Ratapoil, or Ratskin, was a character he created and interpreted in forty prints and in this single sculpted figurine to encapsulate his mockery of Prince Louis-Napoléon, who made himself emperor of France in 1851. Ratapoil's beaked profile, handlebar moustache, and goatee were based on Louis-Napoléon's own features. The aggressive stance and menacing cane refer to the bearing of the thugs he paid to attack republicans in empty city streets.

Daumier modeled sculptures such as this one as small clay figurines. Little known during his lifetime, these figurines reveal him to have been one of the century's most innovative sculptors. He used the clay studies as models for his graphic work and never saw what they looked like as finished sculptures, for they were cast in bronze only after his death. DCJM

Honoré Daumier
French, 1808–1879
bronze
17.13 x 6.5 x 7.13 inches
 (43.51 x 16.51 x 18.11 cm)
Bequest of Miss Alice Tully
1995.056.002

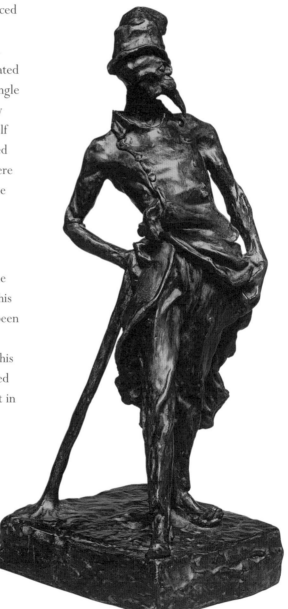

Eugène Delacroix is particularly acclaimed for his exotic Near Eastern images, animal scenes, and heroic subjects from history, in addition to his many works with literary themes deriving from such varied sources as Shakespeare, Goethe, and Byron.

STUDIES FOR "OVID AMONG THE SCYTHIANS," about 1844

As the consummate artist of the nineteenth-century Romantic Movement, Eugène Delacroix is celebrated for the expressive energy, color, and drama of his art, as well as for the diverse, compelling subjects he chose to render. He is particularly acclaimed for his exotic Near Eastern images, animal scenes, and heroic subjects from history, in addition to his many works with literary themes deriving from such varied sources as Shakespeare, Goethe, and Byron. Delacroix is also much admired for the impressive corpus of drawings and watercolors he left behind, many of which relate to his most famous paintings. He is perhaps less appreciated for the important series of decorative commissions he completed throughout his career, even though these ambitious projects have been well documented and studied.

Starting in the 1830s, Delacroix began a program to decorate various rooms of Paris's Bourbon Palace with murals. During the years 1845–47, he decorated the five cupolas of the library with such appropriate subjects as Philosophy, Natural History, Theology, Literature, and Poetry. The Snite's drawing *Ovid among the Scythians* is a study for a pendentive in the ceiling bay devoted to Poetry.

Ovid, the great ancient poet whose works were to provide fundamental source material for generations of artists, was banished by the Emperor Augustus in A.D. 8 to the Black Sea port of Tomis, where he lived the last ten years of his life among the native Scythians. In this vigorous compositional study, Delacroix quickly set down the key narrative elements within the challenging design demands of the architectural space. The poet is depicted seated at the right being offered nourishment, while a mare is shown at the upper left being milked.

Delacroix was obviously still exploring how he might best portray the subject, and related studies in the Louvre and in the library at the Bourbon Palace show him experimenting with several different design solutions. In 1859 the artist painted yet another version of the subject, which today is in the collection of the National Gallery in London. ss

Eugène Delacroix
French, 1789–1863
black chalk on off-white laid paper
10.25 x 15.38 inches (26 x 39 cm)
Gift of Mr. John D. Reilly (Class of 1963)
2004.053.014

LANDSCAPE WITH A STREAM, about 1842

Théodore Rousseau was the leader of the Barbizon School of landscape painters. These romantic naturalists sought to replace the classical notion that a landscape painting had to be idealized, carefully composed, and include some notable narrative content. Their fundamentally naturalistic approach laid the groundwork for Impressionism.

Rousseau's works show his intense regard for such aspects of nature as the individuality of trees, the specific terrain of a site, and even light and weather conditions. He worked on his paintings in a careful, painstaking manner, often over a period of several years. However, his oil sketches and his drawings, frequently made out-of-doors, show a surprising spontaneity and freshness.

The quite-finished drawing *Landscape with a Stream* is characteristic of Rousseau's mature work. Vigorous and straightforward strokes of chalk describe the landscape. A single monumental tree surrounded by water, weeds, rocks, and shrubs dominates the foreground; houses, trees, and the presence of light in the sky are broadly suggested against a low horizon in the distant background. The composition seems remarkably uncomplicated but still intent on capturing the sense of an actual place. **ss**

Pierre Puvis de Chavannes
French, 1824–1898
oil on canvas
24 x 20 inches (60.96 x 50.8 cm)
On extended loan from Mr. and Mrs.
 Noah L. Butkin
L1979.042.001

Théodore Rousseau (opposite page)
French, 1812–1867
black and white chalk
10.38 x 17 inches (26.36 x 43.18 cm)
1976 University of Notre Dame Purchase Fund
1976.040

L'INSPIRATION (INSPIRATION), about 1852

Although Pierre Puvis de Chavannes created many notable easel paintings—primarily portraits and religious or allegorical subjects—it was his decorative painting projects in Paris at the Panthéon, the Sorbonne, and the Hôtel de Ville that secured his fame. The distinctive style and serious subject matter of these works, which bring to mind monumental Renaissance fresco paintings, made him acceptable to both conservative academic factions and more progressive circles of artists such as the Post-Impressionists. Using a limited range of pale colors and simplified contours to define forms, his art seems to evoke a timeless, antique world and is often identified with Symbolism.

The Museum's oil, from Puvis's early period, shows a somewhat atypical subject and style for the artist. It presents the figure of a musician who has stopped playing and seems lost in thought. The realistic style, sensitive modeling, loose handling of paint, and dark earth tones are all uncharacteristic elements not found in Puvis's mature works. Apparently, during this period he was influenced by both the Romanticism of Eugène Delacroix and the Realism of Honoré Daumier. As atypical as this canvas may seem, the theme of music was integral to several other important works by the artist. **ss**

THE LAST ROLL CALL OF THE VICTIMS OF THE TERROR, 1850

In this scene of fear and gloom, Charles-Louis Muller imagined the situation just before the end of the Reign of Terror, a period of the French Revolution characterized by a rash of executions of alleged enemies of the state. The scene takes place in the Conciergerie, the Parisian jail in which the French revolutionaries assembled their prisoners on the night before their execution.

Muller arranged his characters as carefully as a stage director choreographing a crowd scene, drawing the observer's eye to heart-wrenching experiences taking place in different parts of the room. Contrasts of movement and still-ness, and of light and dark, move the viewer's attention from place to place. The bailiff in the center reads the names of the next to die. Seated on a chair, with his companions arranged in a semicircle around him, the poet André Chénier holds paper and pen as he gazes out from his personal agony toward the viewer, freedom, and the future.

By the time this painting was exhibited in Paris in 1850, Chénier had become better known as a victim of the French Revolution than he was at the time of his death. His renown was due to of the publication of his own poems, Alexander Pushkin's and Victor Hugo's poems about him, and Alfred de Vigny's novel *Stello*, which features Chénier.

Muller was a Catholic and a royalist whose artistic training under Baron Antoine-Jean Gros developed his interest in history painting and in the interpretation of suffering during the Romantic period. This presentation of anti-republican sentiments found such favor with Louis-Napoléon, who in 1851 became Emperor Napoléon III, that Muller received orders for eight versions of his painting. The first and largest of these, bought by the French government, is now in the Museum of the French Revolution, Vizille, France. DCJM

PRINCESS MARIE DE SAYN-WITTGENSTEIN, 1855

Although born and trained initially in Holland, Ary Scheffer essentially belonged to the French school. Having taken up residence in France by 1811, Scheffer worked alongside such famous colleagues as Théodore Géricault and Eugène Delacroix in the studio of Pierre-Narcisse Guérin. Today, Scheffer is considered one of the most prominent artists of the Romantic Movement. He often tried to fuse the Neoclassical and the Romantic in his art, in a manner severely criticized by some prominent critics of the day.

Among the artist's large body of works, his portraits remain perhaps the most consistently appealing. This example portrays the daughter of Princess Carolyn Wittengenstein, Marie, who had become the companion of Franz Liszt. Published letters reveal the close relationship the musician and Marie had established. Scheffer's painting shows Marie as a poised and serious young woman at the age of eighteen. It hints at how the artist attempted to combine the styles of Jean-Auguste-Dominique Ingres and Delacroix. Though the pose of the figure and the draperies of the costume are quite consciously composed, the portrait seems less concerned with realistic details and abstract linear patterns than Ingres's works. The rendering offers a warm, soft, and quite intimate image of the sitter. **ss**

Ary Scheffer
French, 1795–1858
oil on canvas
33 x 23.38 inches (83.82 x 59.38 cm)
On extended loan from Mr. and Mrs. Noah L. Butkin
L1980.059.013

Charles-Louis Muller (opposite page)
French, 1815–1892
oil on canvas
51.75 x 95 inches (131.45 x 241.3 cm)
Gift of Mrs. Thomas Cusack
1960.042

Couture apparently decided upon the representation of the Virgin and Child in Glory surrounded by angels, based on famous Renaissance and Baroque prototypes, fairly early.

STUDY FOR "MATER SALVATORIS (MOTHER OF THE SAVED)," SAINT-EUSTACHE, PARIS, about 1851–56

Thomas Couture is probably best known today for one famous history painting, which is still illustrated in numerous art history textbooks, and as the teacher of Edouard Manet. The painting, *Romans of the Decadence*, brought Couture considerable recognition and praise when it was exhibited at the Salon of 1847. An enormous historical composition depicting the moral decline of the ancient Romans within an elaborate architectural setting, it pleased many critics with its moral message and carefully composed design.

Though Couture continued to produce historical paintings with anecdotal or moralizing content, he cannot be categorized as a typical academic artist. He rebelled against many of the strict traditional practices and steered his pupils away from the academic system. Much of his work exhibits a surprisingly independent style and technique, with rich, bright colors and loose, textured brushwork. The wide range of projects he undertook included portraits, religious murals, allegorical scenes, and genre subjects.

In 1851 Couture received one of his most important commissions, the decoration of Saint-Eustache, in Paris. Numerous drawings and oil sketches in museum collections in the United States and Europe show the genesis and importance of this project. The Snite's oil sketch of Mater Salvatoris (Mother of the Saved) is a preparatory study for the central wall of the church's largest chapel. Couture apparently decided upon the representation of the Virgin and Child in Glory surrounded by angels, based on famous Renaissance and Baroque prototypes, fairly early; his quickly sketched poses of the Madonna and Child are remarkably close to the finished mural design. However, the figures at the bottom of the study show a rather different plan for the composition. The church was undergoing major renovation and restoration at the time of Couture's commission, and the artist presumably was experimenting in this early sketch with the idea of showing the Empress Eugenie presenting a model of the building to a religious official of the church.

Although the completed murals created much controversy and debate when the chapel opened to the public in 1856, the Museum's vigorous painting perhaps more effectively reveals the artist's distinctive gifts. Couture's masterful drawing skills, his distinctively rich, grainy, and scumbled paint surface, and the brilliant use of white and color to enliven the design are all clearly apparent. ss

Thomas Couture
French, 1815–1879
oil on canvas
12.5 x 15.75 inches (31.75 x 40 cm)
Museum purchase by exchange, Mr. Fred B. Snite
1988.016

LANDSCAPE AT LIMAY

Jean-Baptiste-Camille Corot is considered the greatest French landscape painter of his time and a crucial figure in the development of the history of landscape painting. First in France and then in Italy, Corot traveled around making sketches from nature. He used these studies as inspiration for the classical, formal landscapes he composed in his studio. Later in his career, the artist's landscapes became more idealized as he developed a type of small easel painting that emphasized a greater sensitivity to the variations of light and atmosphere. He ultimately produced a series of unaffected, clearly lit landscapes that anticipate the Impressionist movement and depict nature conceived as a world apart from man.

Landscape at Limay is an example of this mature style. Here, Corot created an idyllic rural scene that captures a moment of everyday life in the French countryside. The work is painted in a looser, more fluid and spontaneous style than his early, carefully constructed landscapes influenced by the classicism of Nicolas Poussin. It reveals Corot's concern with the momentary effects of nature: the play of light and the changing atmosphere in an idealized and romanticized natural setting. **GC**

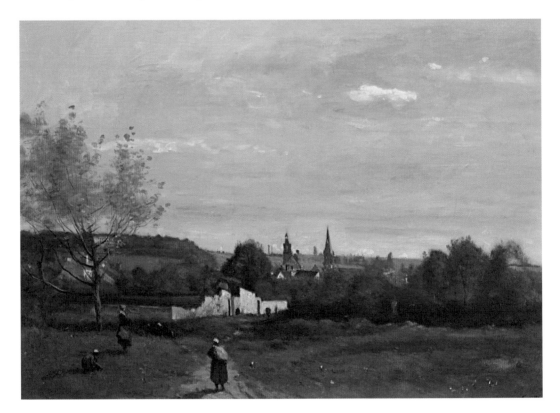

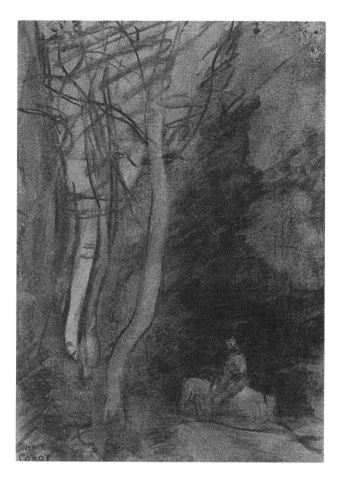

Jean-Baptiste-Camille Corot
French, 1796–1875
charcoal on tan paper
10.5 x 7.38 inches (26.5 x 18.8 cm)
Gift of Mr. John D. Reilly (Class of 1963)
2000.074.008

Jean-Baptiste-Camille Corot (opposite page)
French, 1796–1875
oil on canvas
16 x 24 inches (40.64 x 60.96 cm)
Bequest of Miss Alice Tully
1995.056.001

FOREST SCENE WITH CAVALIER, about 1854

Jean-Baptiste-Camille Corot's early years were spent in some of the most picturesque environs of Paris—in the countryside of Normandy and in Ville-d'Avray, a few miles outside of the city. It was probably in these settings that he first formulated his gentle, idyllic view of nature. He did much of his work outdoors, where he could take in the full effect of the sunlight.

This drawing was likely made sometime after 1850, when Corot began favoring the use of chalk, charcoal, or crayon. These mediums permitted richer effects of light and shade. Corot used charcoal here to create a haze-like atmosphere that appears to envelope the horse and rider in a dimly lit forest. Only the foreground trees serve to identify the space of the composition and the edge of the forest. Corot explored this theme of the rider alone in the forest in several known works, all seeming to date from about 1854–55.

Late in his career, Corot was introduced to the technique of *cliché-verre*, an experimental medium that combined printmaking and photography. He produced a number of *cliché-verre* images that returned to the subject of the horse and rider. EPS

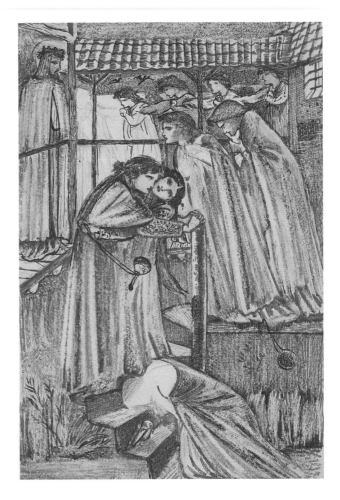

STUDY FOR "THE WISE AND FOOLISH VIRGINS,"
about 1857

Edward Burne-Jones
British, 1833–1898
pen and ink with black wash and graphite
13.5 x 9 inches (34 x 23 cm)
Gift of Mr. John D. Reilly (Class of 1963)
1996.070.019

Auguste Rodin (opposite page)
French, 1840–1917
bronze
11.5 inches (29.21 cm) high
Gift of Mr. and Mrs. Aberbach through
 exchange
1974.035

For the English Pre-Raphaelite painter Edward Burne-Jones, art provided an escape into an imaginary world far from nineteenth-century reality. His refined universe was based on his reading of medieval ballads, classical myths, and the Bible; deep religious beliefs shaped his early works. He was an artist of great sensitivity and imagination who created a dreamlike atmosphere and conveyed spiritual values through line, color, and light.

An admirer of Dante Gabriel Rossetti and a friend of William Morris, for whom he designed tapestries and stained glass, Burne-Jones found meaning in the rediscovered spirit of the Middle Ages. He made four visits to Italy, where he copied Italian masters of the fourteenth and fifteenth centuries. The art of Sandro Botticelli influenced him the most.

This drawing, a study for a painting of the parable of the wise and foolish virgins, marks the beginning of what became Burne-Jones's lifelong fascination with medieval themes. The source of his inspiration for this frieze-like composition was probably the monumental sculpture of French Gothic cathedrals, especially at Poitiers and Chartres, which he knew from his travels in France. The drawing is one of three known versions depicting the idea of the struggle between virtue and the forces of evil. EPS

THE MAN WITH A BROKEN NOSE,
about 1863–64

Auguste Rodin made important contributions to the twentieth-century aesthetic of sculpture by exhibiting partial figures, incorporating accidental breakages, leaving the marks of modeling on the surface of his forms, and never considering a piece to be finished. His interest in mixing and matching heads, limbs, and torsos was misunderstood and ridiculed by most of his contemporaries. Although not widely appreciated in his own time, his sculptures are now found in major collections all over the world.

This bronze portrait of an odd-jobs man named Bibi was made early in Rodin's career. The sculptor was attracted to the man's battered, picturesque face. He submitted the original bust to the Salon of 1864, even though the rear of the head had broken off in his unheated studio. Rodin felt the masklike quality increased its expressiveness. The Salon jury, however, rejected the nontraditional portrait. Nonetheless, Rodin later made several versions of the head, which is now considered to be his earliest mature work. The Snite's sculpture is from a later casting done during Rodin's lifetime. Though less tilted than earlier versions, the head retains the uniqueness of the original and is a frank, sincere representation of a potent personality. GC

Although not widely appreciated in his own time, Rodin's sculptures are now found in major collections all over the world.

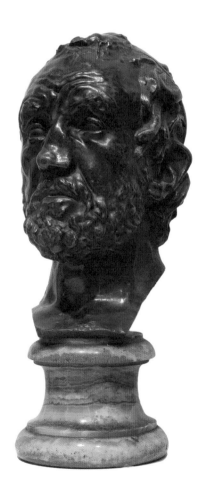

STUDY OF MAN WITH TOP HAT ON HORSE, about 1873

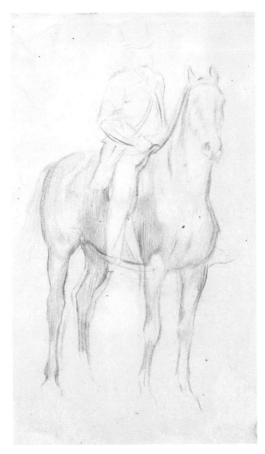

Edgar Degas
French, 1834–1917
black chalk on off-white wove paper
8.9 x 6.9 inches (22.8 x 17.8 cm)
Gift of Mr. John D. Reilly (Class of 1963)
2000.074.027

Edgar Degas grew up at a time when horse races and the hunt were important aspects of French society, as his early sketchbooks attest. This drawing is closely related to another sheet in the Museum Boymans–van Beuningen, in Rotterdam. In both sketches, the horse faces toward the right and is shown in more detail than the rider. The Rotterdam drawing has been dated to the early 1860s, because the rider's stationary pose suggests that it preceded later paintings of horses in motion, after the influence of photography.

An alternate date can be proposed based on a painting Degas made in 1873, *Leaving for the Hunt*, which is his only known hunting scene. According to the scholar J. S. Boggs, Degas may have begun the painting's rural background before taking a trip to England. When he returned, he painted in different riders with their typically English outfits, including top hats. Several notable drawings, such as the Art Institute of Chicago's famous *Gentleman Rider*, have been identified as preparatory studies for this painting. They all express the sartorial elegance of the hunters in a moment of rest. It is plausible that the Snite and Boymans–van Beuningen drawings might be studies for this painting and therefore date to about 1873. EPS

Alphonse Legros (opposite page)
French, 1837–1911
oil on canvas
22 x 28 inches (56 x 71 cm)
Gift of Mr. and Mrs. Noah L. Butkin
1978.025.001

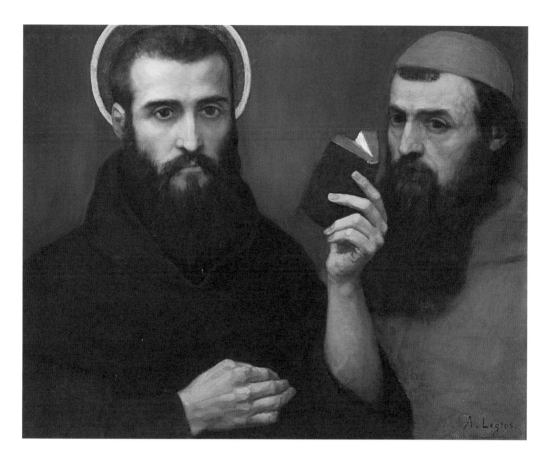

A CARDINAL AND HIS PATRON SAINT, about 1865

The French-born painter, engraver, and sculptor Alphonse Legros received his art education in Paris, where he arrived in the early 1850s. Coming from an impoverished background, Legros identified with the lives of the poor, particularly their religious fervor and archaic culture. His sympathetic studies of peasants and old age were influenced by the Realist painter Gustave Courbet. Although recognized as the most promising artist of his generation and a leading Realist painter, Legros lacked financial security in France. In 1863 he settled in London, where he enjoyed a level of success that had eluded him in Paris.

A Cardinal and His Patron Saint illustrates Legros's Realist style. It may be a modification of an earlier composition, a method he often used; he seems to have added a self-portrait on the left to an already existing figure on the right, perhaps the portrait of his father. The halo and the half-open prayer book (to which neither figure pays attention) also might be later additions. The two half-length figures do not communicate with each other. Instead, each is immersed in his own inner life. EPS

KING BOABDIL'S FAREWELL TO GRANADA, 1869

After completing his studies with Léon Cogniet, a popular French painter of narrative scenes, Alfred Dehodencq continued to emulate his teacher's interest in romantic subjects from Spain and Morocco. He took his style from the Venetian tradition, employing vigorous brushwork and vibrant colors. Dehodencq became a skilled draftsman who frequently composed images by painting directly onto the canvas, without a preparatory sketch.

This picture is an oil sketch for a full-size painting of the same subject that was exhibited in the Paris Salon of 1869. Eight hundred years of Muslim domination in Spain ended in 1492, when the troops of King Ferdinand and Queen Isabella defeated King Boabdil at Granada. In this painting, the vanquished king stops to gaze for the last time upon the city he has lost. His only remaining companion is his African servant, who seems to encourage his master to hurry onward while trying to control his great Spanish warhorse. DCJM

Alfred Dehodencq
French, 1822–1882
oil on canvas
22.88 x 18.63 inches
 (58.12 x 47.32 cm)
On extended loan from
 Mr. and Mrs. Noah L. Butkin
L1980.059.022

Henri Regnault (opposite page)
French, 1843–1871
oil on panel
6.25 x 9.25 inches
 (15.87 x 23.49 cm)
On extended loan from
 Mr. and Mrs. Noah L. Butkin
L1980.027.001

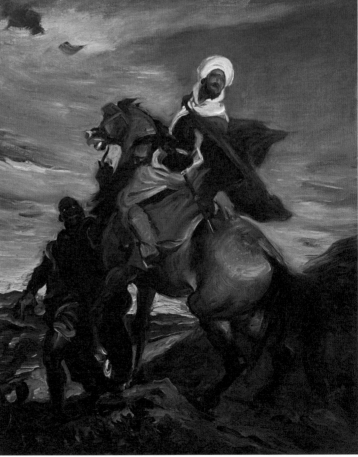

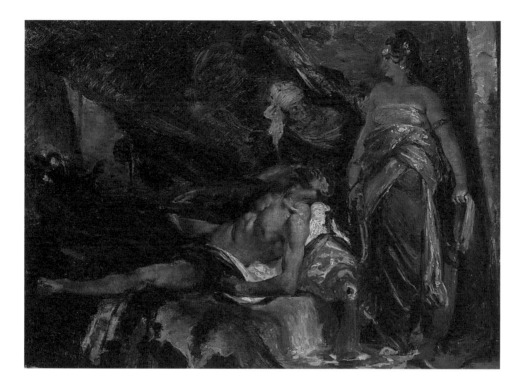

JUDITH AND HOLOFERNES, about 1869

This splendid oil sketch is by an artist who was already famous and immensely admired when he died in the Franco-Prussian War at age twenty-seven. Although trained in the academic tradition, Henri Regnault early seemed drawn to a spirited use of color, light, and loose brushwork. He generally preferred exotic and dramatic subjects, but he also was aware of modern movements such as Impressionism and was fascinated by realistic aspects of contemporary life.

As chief of the Assyrian army, Holofernes was sent on a campaign to control the Jews under the Babylonian Empire. Judith, a beautiful and pious Jewish woman, seduced Holofernes into a drunken state and cut off his head. In the Snite sketch, Holofernes lies prone with his neck thrown back, as Judith holds her sword and contemplates the imminent act. The red tassel of Holofernes's pillow suggests the blood about to flow.

The sketch is related to a large version of the subject that Regnault painted in 1869 (now in the Museum of Fine Arts in Marseilles). Numerous extant oil studies and drawings document the genesis of the work and its importance for the artist. From the vigor and looseness of the Snite work, it is probably among the earliest preparatory studies. ss

FIGURES ON ROCKS AT THE EDGE OF THE SEA, 1867

Jehan-Georges Vibert's love of the theater and his character studies of his fellow man (he specialized in paintings that satirized members of the Roman Catholic clergy) were integral to his creation of dramas for the French stage and of paintings such as this one. The aesthetic and philosophical interest in the Sublime as an emotional response to the power of nature motivated artists like Vibert to take trips to the seashore and other sites of natural phenomenon.

This canvas is a study in contrasts: the towering wave on the left, versus the sheltered calm of the water lapping the sand on the other side of the cliff; and the two intrepid men who sit calmly on the edge of the rocks, in comparison to the tepid group in the middle who cling together under their umbrellas and the two fearful people on the right who clutch the rock. Additionally, the drama of the bright white waves contrasts with the medium light of the central rock face and the dark shadows of the rocks on the far right. Various pieces of red clothing move the viewer's eye from left to right through the group of figures. AMK

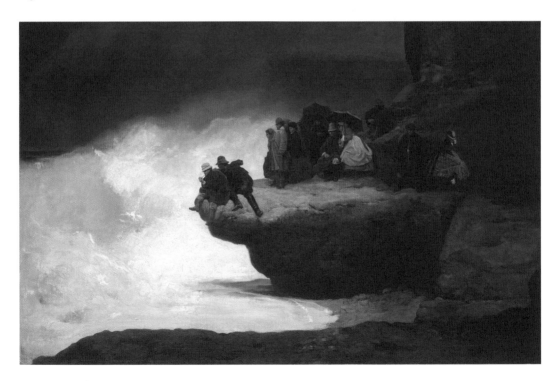

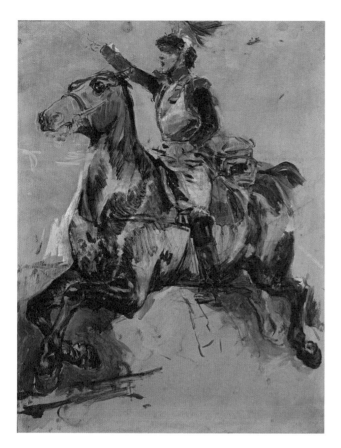

THE CHARGING CUIRASSIER (STUDY FOR "1807, FRIEDLAND"), about 1870

Best known as a painter of Dutch-inspired genre scenes, Ernest Meissonier turned increasingly to history painting after 1859. His *1807, Friedland* (Metropolitan Museum of Art), a work completed in 1875, represents the culmination of the artist's ambitions in this new and challenging field. The Snite's *Charging Cuirassier* is one of more than ninety preparatory studies Meissonier made for that painting.

Remarkable for its dynamism, the sketch is emblematic of the almost compulsive attention to detail Meissonier developed during his years as a painter of punctilious scenes of daily life. The cavalryman's distinctive helmet and uniform, for example, identify him as a member of the Twelfth Regiment of Cuirassiers, while his gestures and open mouth communicate Meissonier's ambition to capture the adoration soldiers felt toward their captain, Napoléon. The work equally reflects the artist's careful study of the movement of horses at full gallop; Meissonier actually constructed a "railway" alongside his private horse track in order to observe the animals racing. In the Museum's piece, the intensity of the charge is made visceral through an incredibly accurate depiction of the horse's stride.

THE FOG CLEARING OFF—AUTUMN ON THE DELAWARE, about 1875

After a somewhat uncertain start to his career as an artist, Worthington Whittredge became a devoted landscapist in the mid-1840s. He fell under the spell of the Hudson River School, which had become America's dominant school of landscape painting and was characterized by carefully detailed panoramic views in which light played a critical role. After traveling to Europe to refine his skills, Whittredge returned to America and ultimately emerged as de facto head of the second generation of Hudson River School painters.

The reasons for his success are evident in *The Fog Clearing Off*, a painting datable to the mid-1870s, when the artist was working in northeastern Pennsylvania's upper Delaware River valley. While its small dimensions and cursory treatment suggest that it was intended as a sketch, the canvas nevertheless reveals Whittredge's confidence with the brush and palette. His masterful strokes precisely evoke a gentle fog settling on a richly colored autumnal landscape, melding color and light to create a living moment. The result is a contemplative image that, like the poetry of William Cullen Bryant, encourages reflection on the beauty and majesty of the American wilderness.

LANDSCAPE WITH MOUNTAINS AND STREAM, about 1874–76

Alexander Helwig Wyant's career demonstrates the change that took place in American landscape painting during the thirty years following the Civil War. His early landscapes were influenced by the Hudson River School and stressed sharp focus and topographically accurate panoramas. His mature works, in contrast, were smaller in size, more intimate, and less detailed, demonstrating the impact of the French Barbizon School. Wyant was particularly impressed by the works of George Inness, an American painter with an affinity for the Barbizon style, and the English painters J. M. W. Turner and John Constable.

The Snite's landscape marks a pivotal point in Wyant's career, visually demonstrating his transition from the tight realism of the Hudson River School to the looser Tonalist painting of George Inness. The shift is evident from left to right across the canvas as a loosening of composition and a lessening of concern with detail. Wyant suffered a stroke in 1873 that partially paralyzed his right side. He began painting with his left hand, hastening his progression to a looser technique with freer brushwork, more implied forms, and less detail. Speculatively dated to about 1874–76, this landscape may demonstrate the difference between painting with his right or left hand. GC

Worthington Whittredge (opposite page)
American, 1820–1910
oil on canvas
12 x 14.25 inches (30.5 x 36.2 cm)
Gift of Mr. and Mrs. Allan J. Riley (Class of 1957)
1996.049

Alexander Helwig Wyant
American, 1836–1892
oil on canvas
42 x 72.5 inches (106.68 x 184.15 cm)
Acquired with funds provided by the Humana
 Foundation Endowment for American Art
1995.014

FLORE ACCROUPIE
(FLORA CROUCHING), about 1874

This terra-cotta, cast in the artist's studio, makes apparent the distinctive liveliness, naturalism, and modern sensibility that have made Carpeaux such an important figure in the history of sculpture.

Jean-Baptiste Carpeaux has long been regarded as one of the leading sculptors working in France during the Second Empire. Although his career lasted barely two decades, Carpeaux produced an extraordinary variety of artworks, including portraits, architectural sculpture, public monuments, historical and allegorical pieces, and genre subjects. The sculptor's markedly expressive style and vigorous modeling of forms, which intentionally creates strong effects of light and shade, anticipated the art of Auguste Rodin.

In 1862 Carpeaux was commissioned to decorate the south side of the Pavillon de Flore wing at the Louvre. One of the completed sculptural reliefs, the *Triumph of Flora*, depicts a conspicuously naturalistic and animated figure of Flora, goddess of flowers, surrounded by dancing putti. About 1870, the artist transformed the memorable central figure of Flora from the relief into a sculpture in the round of a single figure, and produced versions in marble, bronze, and terra-cotta. The Snite Museum's terra-cotta, cast in the artist's studio, makes apparent the distinctive liveliness, naturalism, and modern sensibility that have made Carpeaux such an important figure in the history of sculpture. **ss**

Jean-Baptiste Carpeaux
French, 1827–1875
terra-cotta
18 x 9.5 x 12 inches (45.72 x 24.13 x 30.48 cm)
Gift of Drs. R. Austgen, D. Barton, G. Pippenger,
 C. Rosenbaum
1987.001

STUDY FOR THE PICADOR, 1866–70

Edouard Manet had introduced the French public to scenes of Spanish bullfighting after his visit to Madrid in 1864. Jean-Léon Gérôme may have visited Manet's studio and seen some of his paintings of picadors, in which Manet introduced "modern" stylistic characteristics such as flattened space and vigorous brushwork. Gérôme rejected these innovations, maintaining the precision of his academic, realist style for the portrayal of similar subjects. His interest in carefully painted detail perhaps was influenced by the intricate craft of his father, a goldsmith and watchmaker.

This oil sketch of a picador may have been prepared for a painting that is now lost. Gérôme depicted a moment near the beginning of a bullfight, when the bull, wounded by the picadors, has retaliated by goring both a horse and a man. Although the bull is not in view, the results of his fury are clear: the horse lies dead on the ground, and the picador limps away. The precise and careful style of the sketch masks Gérôme's emotional reaction to the scene. Did he admire the ability of the Spanish to turn cruelty into an art form? Or did he disapprove of the torture of animals and men turned into a public spectacle? DCJM

Jean-Léon Gérôme
French, 1824–1904
oil on canvas
11 x 9.5 inches (27.94 x 24.13 cm)
On extended loan from Mr. and
 Mrs. Noah L. Butkin
L1988.015.004

SOCRATES SEEKING ALCIBIADES IN THE HOUSE OF ASPASIA, about 1861

During the mid-nineteenth century, educated people in Paris enjoyed intellectual conversation about ideas and the arts in literary salons. Knowledge of classical history was essential, so stories about figures such as Socrates and Alcibiades, members of an ancient Greek "salon," were popular and familiar.

Pericles was a statesman in fifth-century Athens. Although he was legally married, he lived with a beautiful and intelligent courtesan, Aspasia, whose salon became a meeting place for intellectuals. One of her regular guests was Alcibiades, a handsome young man whose dissolute lifestyle shocked his contemporaries. Socrates befriended Alcibiades and tried to influence him to change his way of life. In

Gérôme's sketch, the philosopher, who stands on the right, attempts to persuade Alcibiades to leave this house of ill repute. Ironically, Socrates was later tried and condemned to death for his corrupting influence on the youth of Athens.

Gérôme belonged to a group of French painters called the Neo-Greeks, who took their inspiration from the style of Jean-Auguste-Dominique Ingres and the frescoes of Pompeii. Their subjects were genre scenes and sentimental anecdotes. Many of their paintings were so popular that they were reproduced in multiple versions as engravings. DCJM

Jules Bastien-Lepage
French, 1848–1884
oil on canvas
13.75 x 12.25 inches (34.92 x 31.11 cm)
Acquired with funds provided by the
 Butkin Foundation
1981.105

Jean-Léon Gérôme (opposite page)
French, 1824–1904
oil on canvas
9.13 x 14 inches (23.19 x 35.56 cm)
On extended loan from Mr. and Mrs.
 Noah L. Butkin
L1980.027.011

PORTRAIT OF THE ACTOR CONSTANT COQUELIN, about 1881–82

Although his career was cut short at the relatively young age of thirty-six, Jules Bastien-Lepage achieved considerable success with the critics, the public, and the Salon. He studied with the popular academic painter Alexandre Cabanel, from whom he gained a firm grounding in traditional techniques. Bastien-Lepage's style could alternately be loose and sketchy or tight and detailed, leading to comparisons with artists as varied as Edgar Degas, Jean-François Millet, and James McNeill Whistler.

The Snite's surprisingly modern-looking painting portrays Benoît Constant Coquelin, the remarkably successful actor who performed in England, Europe, and the United States with the Comédie Française, France's state theater. In its unfinished condition, the portrait reveals Bastien-Lepage's striking ability to quickly capture an informal pose and such tellingly realistic details as the clasp of the sitter's hands. Coquelin confronts the viewer with a sense of directness and intimacy, casually leaning forward as if about to speak.

Bastien-Lepage was capable of not only rendering a realistic appearance of his subject but also imparting something essential of the sitter's personality and psychology. His portraits of theatrical personalities must have especially engaged him, for he also produced memorable portrayals of Marie Samary, Sarah Bernhardt, and others. ss

PORTRAIT BUST OF A WOMAN, about 1870

Throughout an unusually prolific professional career, Albert-Ernest Carrier-Belleuse produced an impressive variety of decorative objects at such factories as the Minton Pottery in England and, later, Sévres and Christofle in France. In 1884 he was named an officer of the Legion of Honor for his outstanding contributions to the decorative arts. Carrier-Belleuse also established his credentials as a sculptor at an early date, making his debut at the Salon in 1850 and winning a Medal of Honor in 1867. He continued to exhibit at the Salon a remarkable variety of portraits, historical subjects, and models for important public monuments. Among the major commissions he received for architectural sculpture were works for the Tuileries Palace, the Hôtel de Païva, and the Opera in Paris.

In developing his distinctive style, Carrier-Belleuse clearly favored Baroque and Rococo tendencies over earlier classical models. His works exhibit the lively, realistic, and decorative qualities of such eighteenth-century French sculptors as Jean-Antoine Houdon and Clodion. Portrait busts are among his most celebrated pieces. The male subjects include Diego Velázquez, William Shakespeare, John Milton, Wolfgang Amadeus Mozart, and other historical figures, as well as notable contemporaries such as Théophile Gautier, Honoré Daumier, and Emperor Napoléon III.

Perhaps even more memorable are his portrayals of women, in which the appearance of an actual individual has been transformed into an image of fantasy. This large, unique *Portrait Bust of a Woman* presents just such a fascinating subject. The sitter has so far not been identified, but she may have been part of the artistic and café society the sculptor knew so well. Carrier-Belleuse devoted special attention to realistic details, including the lace, ribbons, flower, and flowing, curly hair. In contrast to many of his more fashionable and seductive female portraits, this subject's expression seems singularly pensive, introverted, and enigmatic. **ss**

Albert-Ernest Carrier-Belleuse
French, 1824–1887
terra-cotta and plaster
25.75 x 20 x 14 inches (65.4 x 50.8 x 35.56 cm)
Gift of an anonymous benefactor
1992.020

Perhaps even more memorable are Carrier-Belleuse's portrayals of women, in which the appearance of an actual individual has been transformed into an image of fantasy.

Charles-Emile-Auguste Carolus-Duran
French, 1838–1917
oil on canvas
22 x 18.25 inches (55.88 x 46.35 cm)
On extended loan from Mr. and Mrs.
 Noah L. Butkin
L1980.027.017

Childe Hassam (opposite page)
American, 1859–1935
oil on panel
12.63 x 16.88 inches (27 x 42 cm)
Gift of Mr. and Mrs. Terrence J. Dillon
1976.055.001

PORTRAIT OF THE ARTIST'S SON, PIERRE, 1885

The talented and fashionable French portraitist Carolus-Duran was a Realist painter who developed his style by studying old-master paintings at the Louvre and in Italy and Spain. Although undoubtedly familiar with the contemporaneous work of the Impressionists, Carolus-Duran formulated his own particular manner of vigorous brushwork, frequently employing black along with an array of muted colors.

The Snite's portrait of the artist's young son, Pierre, with its deep red background, lively handling of paint, and dominant use of black in the child's costume, immediately brings to mind the portraits of John Singer Sargent.

In fact, Sargent was one of many artists who studied in the studio of Carolus-Duran and were sympathetic to the master's techniques.

The painting shows both an attractive example of Carolus-Duran's direct and dazzling style and an unusually sensitive and intimate side of his work. Dated to the late 1880s, it was produced at a time when the artist had already achieved considerable fame and prestige in the nineteenth-century art world. By this date, Carolus-Duran had experienced notable success at the Salon, won a commission to paint a ceiling in Paris's Luxembourg Palace, and found popularity with patrons and the public. **ss**

UNDER THE LILACS, about 1889

This work is dated to the three-year span when Childe Hassam and his wife lived in France, where he took art classes at the Julian Academy with Gustave Boulanger and Jules Lefebvre. While there, he familiarized himself with the techniques and aspirations of the French Impressionists. He brightened his palette and began using broken brushstrokes in his paintings, as in this idyllic scene of a woman (perhaps his wife Kathleen) in a hammock enjoying repose in a garden setting.

Like the nine other members of the American Impressionists who began exhibiting together in 1898 in New York, Hassam used paint application techniques that were similar to those of the French Impressionists but chose subjects that were vastly different. Instead of Toulouse-Latrec's gaudy, harsh light of the Parisian nightlife filled with singers, dancers, and prostitutes, Hassam preferred to paint lush, secluded gardens during the day, with a sprinkling of urbane, upper-middle-class children and women. AMK

BRONCO BUSTER, modeled 1895, Casting #15, 1895

The *Bronco Buster*, a technical masterpiece and Frederic Remington's best-loved work, was the artist's first attempt at sculpture. He had already published illustrations of cowboys taming rearing and bucking broncos in *Harper's Weekly*. In 1895 he adapted versions of his earlier two-dimensional work to a small clay or plasticine model for a bronze sculpture.

An easterner with very little academic training, Remington spent four years traveling and sketching in the western states and Indian territories. After returning to the East, he spent the rest of his life interpreting the American West for easterners. In this sculpture, Remington combined the excitement of a moment of struggle between horse and rider with uncertainty about its outcome. Although he chose a subject from the Wild West, his inspiration came from the European tradition of equestrian statues of military leaders and kings. In his Americanization of a European subject, Remington not only presented a cowboy instead of a king but, in doing so, depicted American democratic ideals by showing his admiration for a poor, anonymous man who has learned a skill and practices it with courage and elegance. DCJM

By the Henry-Bonnard Bronze Company, New York
Frederic Remington
American, 1861–1909
bronze
24 x 21 x 12 inches (60.96 x 53.34 x 30.48 cm)
Gift of Mr. Charles Jones
1963.041

WINE JUG, 1893

One of the most versatile and gifted of the Art Nouveau designers, Alexandre Charpentier began his career as a jewelry maker and a sculptor. Later, he produced furniture, posters, medallions, metalwork, and ceramics in an Art Nouveau style. Influenced by Auguste Rodin and Jules Dalou, Charpentier managed to retain an aspect of realism throughout most of his work. He devoted his energy to bringing the fine arts into the everyday world of interior decoration and design. In addition, he was a leading member of some of the most progressive independent art movements formed at the close of the nineteenth century.

This porcelain wine jug, which is signed and dated 1893 beneath the handle, is a particularly impressive and characteristic example of Charpentier's special talents and personal style. The simple form of the jug is decorated with an abundance of lively relief work depicting faces, branches, and vines with grapes. One of the signature elements of the artist's style can be found clinging prominently to the surface of the jug under the spout: an animated and boldly modeled figure of a female nude seen from behind. **ss**

Charpentier devoted his energy to bringing the fine arts into the everyday world of interior decoration and design.

Alexandre Charpentier
French, 1856–1909
glazed porcelain
10 inches (25.4 cm) high
Acquired with funds provided by the William L. and Erma M. Travis Memorial Endowment for Decorative Arts
1996.024

THE THAMES, 1896

James McNeill Whistler
American, 1834–1903
lithotint
10.25 x 7.5 inches (26.04 x 19.05 cm)
Acquired with funds provided by the
 Humana Foundation Endowment for
 American Art
1991.001.099

Louis Comfort Tiffany (opposite page)
American, 1848–1933
Favrile glass
11.25 x 4.75 inches (28.58 x 12.07 cm)
Acquired with funds provided by the
 Snite Museum of Art Advisory
 Council in honor of Dean A. and
 Carol Porter
1999.032

Influenced by the realism of Gustave Courbet and Edouard Manet during his early career in Paris, James McNeill Whistler settled in England by 1859 and became involved in the Aesthetic Movement and its cult of beauty. A newfound interest in Japanese art led him to create works increasingly concerned with art's formal, abstract qualities. Although remembered as a remarkable painter, draftsman, and designer, Whistler is perhaps best known for the many brilliant prints he produced.

The artist's well-known views of the Thames River, which he often referred to as "nocturnes," developed motifs found in nature into compositions essentially concerned with aesthetics.

He considered this lithotint one of his most important achievements; it received a medal at Paris's Universal Exposition in 1900. The lithotint technique was Whistler's variation on a lithograph, in which he diluted ink and painted a diffuse wash landscape on the stone. *The Thames* was the last lithotint he produced, and he allowed only a select number of impressions to be printed. Captured from his rooms at the Savoy Hotel, the river view is a uniquely suggestive image of London at dusk, with buildings, bridges, boats, and the river almost completely lost in an atmospheric haze. **ss**

EGYPTIAN CHAIN VASE, about 1896

Louis Comfort Tiffany worked in more media than almost any other artist. His greatest contributions lay in his innovative glass technology. He and glassmaker Arthur J. Nash invented Favrile glass in the early 1890s. Derived from the Saxon word *fabrile*, meaning "belonging to a craftsman or his craft," the name was purposely selected to emphasize the artistic nature of the pieces, clearly distancing Tiffany's creations from the mass-produced industrial goods then flooding the market. To create such works, artisans repeatedly threaded molten glass with small quantities of additional glass in intricate designs and patterns. The fused glass was exposed to metallic oxides, which provided a characteristic iridescent sheen.

Beyond its virtuosity and sheer beauty, this tomato red vase is remarkable for its unusual color and design. The deep reddish orange of the body shines with a golden purple opalescent finish. Playing against this background are brilliant patches of gold arranged in a so-called Egyptian chain motif around the shoulders of the vase. Brilliant swirls of yet more gold add visual complexity to the design and allude to the peacock-feather pattern so dear to the Art Nouveau movement, of which Tiffany was a leading figure.

Brilliant swirls of yet more gold add visual complexity to the design and allude to the peacock-feather pattern so dear to the Art Nouveau movement, of which Tiffany was a leading figure.

Augustus John
British, 1878–1961
charcoal on buff paper
24.17 x 18.13 inches (61.1 x 46 cm)
Gift of Mr. and Mrs. Allan J. Riley
 (Class of 1957)
1996.072

Paul Cézanne (opposite page)
French, 1839–1906
color lithograph
16.25 x 19.88 inches (41.3 x 49.8 cm)
1961 University of Notre Dame Art
 Purchase Fund
1961.001

ACADEMIC STUDIES, about 1897

Augustus John's lack of consistency, restless spirit, distracted mind, and refusal to conform to Establishment art and society previously encouraged critics to discount his work. Fortunately, more recent scholarship has looked beyond his character flaws and Bohemian lifestyle to focus instead on the uncommon talent palpable in the artist's finest oils and, above all, in his graphic works. John learned the rudiments of drawing from his mother, before moving to London to study at the Slade School of Fine Art. It was only after a serious diving accident and a lengthy convalescence in 1895 that his art began exhibiting the daring touch for which he was later famed.

John's virtuosity is tangible in the drawing *Academic Studies*, in which he radically transformed a traditional life study through his exuberant conception and touch. Bold lines and strokes cohere into a legible whole as if by sheer will alone, lending the work an effect of savage brilliance. The all-over linear mesh that gives the study such remarkable texture and shape is a technique artists have used since at least the time of Albrecht Dürer. John not only studied the old masters during his student days but also returned to their example throughout his career.

THE GREAT BATHERS, 1898

In 1872, under the influence of Camille Pissarro, Paul Cézanne began working outdoors and placing small strokes of pure color next to one another. Unlike the Impressionists, though, who sacrificed solid volumes for the immediate impression of light and atmosphere, Cézanne began to accentuate volume. From 1875 until his death, he produced two primary subjects—bathers and Mont Sainte-Victoire—in a variety of media. The Parisian art dealer Ambroise Vollard commissioned him in 1895 to contribute original prints to Vollard's new series of albums, *Les Peintres-Graveurs* (The Painters-Printmakers). Cézanne composed three lithographs, including *The Great Bathers*, which was intended for the third album but was ultimately not included.

Published in one hundred impressions, *The Great Bathers* is Cézanne's best-known graphic work. It is based on his oil painting *Les Baigneurs au Repos* (Bathers at Rest), now in the Barnes Foundation in Pennsylvania, and is his largest print. Cézanne drew the image on the stone and made a number of prints in black and white. He then hand colored an impression for the poster printer Auguste Clot to follow. Clot strove to create a lithograph that would look like a watercolor. In the luminous result, human figures are united with the landscape, sky, and clouds in quiet harmony. EPS

PORTRAIT OF A YOUNG WOMAN, about 1888

William Merritt Chase
American, 1849–1916
oil on canvas
26 x 21.5 inches (66 x 54.6 cm)
Gift of Mr. Peter C. Reilly
1950.001.002

Although William Merritt Chase's early career was focused on realism, in the 1890s he turned toward Impressionism, which he had learned while studying in Munich during the 1870s. His later style has been compared to that of John Singer Sargent and is noted for the nervous crispness of the brushstrokes, the intensity of color, and the strong contrasts between light and dark. At the same time, the influence of James McNeill Whistler is evident; Chase and Whistler had a brief friendship in the summer of 1885.

For a time, the subject of this portrait was identified as the artist's daughter, Alice. However, it is more likely a portrait of his wife, Alice Gerson, whom he married in 1886, two years before the painting was executed. The sitter is shown in a three-quarter view and wears a white dress and shawl. The painting reflects Chase's belief that a portrait is more than a likeness of the subject and should be elevated to a work of art. He brought the textures of the fabric, the woman's face, and her hair into a harmonious ensemble of artistic beauty. EPS

THE REVEREND PHILIP H. MCDEVITT, 1901

A skilled painter, sculptor, and photographer, Thomas Eakins is best known as a portrait painter who personally selected his sitters and portrayed them in a compelling, but often unflattering, style. Like Rembrandt, he used stark and dramatically focused light to draw out a sitter's inner psychological state, thereby achieving a forceful presence and immediacy.

Eakins was born in Philadelphia, studied drawing in secondary school, and developed a strong interest in anatomy. His travels later took him to Paris and to Spain, where he was inspired by the dramatic chiaroscuro lighting, broad brushwork, and intense, dark color used by the seventeenth-century masters Diego Velázquez and Jusepe de Ribera.

When Eakins returned to Philadelphia in 1870, he combined his studies of art and anatomy, always drawing from live models. This portrait bust is a classic example of his powerful Realist style. It depicts the Reverend Philip McDevitt, who was the superintendent of Parish School in Philadelphia from 1899 to 1916 and the bishop of Harrisburg, Pennsylvania, from 1916 to 1935. Reverend McDevitt was one of the few members of the clergy who remarked on Eakins's later work, providing a small glimpse into the artist's relationship with the many clergymen he painted. GC

Thomas Eakins
American, 1844–1916
oil on canvas
20 x 15.7 inches (50.8 x 39.878 cm)
Gift of Mary R. and Helen C. McDevitt
1954.004

SELF-PORTRAIT,
about 1898

Abbott Handerson Thayer
American, 1849–1921
oil on canvas
30.25 x 25.13 inches
 (76.84 x 63.83 cm)
Acquired with funds provided by
 the Lawrence and Alfred Fox
 Foundation and Mr. and Mrs.
 Edward Abrams
1998.001

Giacomo Balla (opposite page)
Italian, 1871–1958
watercolor on paper
4.5 x 7 inches (10.8 x 17.8 cm)
Bequest of Miss May E. Walter
1994.024.002

Among a generation of skillful American artists whose art matured during the later decades of the nineteenth century, Abbott Handerson Thayer stands out as an especially gifted and original talent. Thayer became noted for his sensitive and evocative portrayals of women, often idealized into images of angels or Madonnas. In later years, the artist produced a series of remarkable landscapes that make evident not only the influence of Impressionism and Japanese prints but also Thayer's own broadly conceived, richly colored, and abstracted view of nature.

There are eight known self-portraits by Thayer in such collections as the Metropolitan Museum of Art, the Corcoran Gallery of Art, and the National Portrait Gallery in Washington. The Snite Museum's painting is closely related to another self-portrait in the collection of the National Academy of Design in New York that Thayer apparently placed there when he applied for membership to the academy. The present version, although clearly an oil sketch and unfinished in appearance, seems to have pleased the artist to the extent that he decided to sign it. With its directly confrontational pose and conspicuous intensity, the painting is a striking example of late nineteenth-century portraiture in the American tradition. **ss**

COMPOSIZIONE (COMPOSITION), about 1911–12

Giacomo Balla, an Italian painter, sculptor, and stage designer, signed the Manifesto of Futurist Painters in February 1910, but he did not immediately participate in the events and exhibitions of the group. Balla shared in the Futurists' cult of energy symbolized by speed and the technology of the machine. However, his approach to their unconditional affirmation of the present and rejection of traditional concepts of art was more subtle. In 1900 he spent a few months in Paris and discovered Divisionism, a technique of applying dots of different unmixed colors directly to the canvas. Consequently, he developed a great interest for problems of light and color.

The Snite Museum's *Composizione*, with its sequence of colored shapes, shows a similarity to the series of *Compenetrazioni Iridescenti* (Iridescent Interpenetrations) that Balla produced during a stay in Düsseldorf in 1912. In these studies, he experimented with the decomposition of light, using chromatic sequences to give the sensation of movement. For Balla, the role of the artist was to present a personal visual experience based on a particular sensitivity to light and color, leading to a synthetic representation of movement that brings the emotional sensation of continual change. EPS

CONDIMENT DISH AND SPOON, about 1903

Archibald Knox was one of England's preeminent designers of Art Nouveau domestic objects during the first two decades of the twentieth century. Trained as an artist and designer at the Douglas School on the Isle of Man, he was strongly influenced by the designer Christopher Dresser, as well as by the artists Aubrey Beardsley and C. R. Ashbee. Knox moved to London in 1897, and in 1901 he began a long association with Arthur Lasenby Liberty, eventually designing more than four hundred objects for Liberty and Co. These included a Celtic-inspired Cymric collection of gold and silver jewelry and hollowware, as well as the 1903 collection of Tudric domestic pewterware to which this condiment dish and spoon belong.

Tudric pewterware was seen as an affordable alternative to more traditional silver objects. Manufactured in Birmingham by W. H. Haseler, it was the most commercially successful of the decorative arts within the English Art Nouveau style. Knox's works were always both functional and beautiful. He envisioned an object's structure and decoration as a unified whole. His designs drew upon the ancient Celtic use of brightly colored enamels, rivets to hold plates and metal together, and interlacing linear patterns. The unique knot motif he created typified the Liberty style. EPS

Archibald Knox
Scottish, 1864–1933
pewter
dish: 1.5 x 7.5 inches (3.8 x 19 cm); spoon: 6.5 inches
 long (16.51 cm)
Acquired with funds provided by the William L. and Erma
 M. Travis Memorial Endowment for Decorative Arts
1995.069a–c

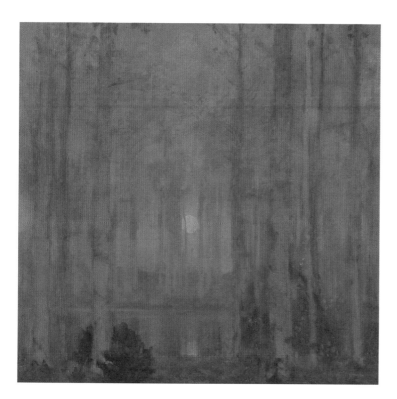

NOCTURNE,
about 1900–1910

Edward J. Steichen
American, 1879–1973
oil on canvas
24 x 25 inches (60.96 x 63.5 cm)
Gift of Mrs. Frank E. Hering
1957.007.009

Edward J. Steichen's oeuvre as a photographer is well known, as is his participation with Alfred Stieglitz and other artists in the pivotal Photo-Secession group, who from 1902 to 1910 exhibited their work in both a New York gallery and the magazine *Camera Work*. The group's goal was to raise the relatively new medium of photography to the same level of respectability as the traditional fine arts. To this end, Steichen's early creative efforts included both paintings and photographs, often of the same subject.

Steichen preferred nocturnal scenes, with their "pictorial" tonal ranges and Symbolist spirituality. He was entranced by the soft,

tonal abstractions of James McNeill Whistler's series of nocturnes, the painting techniques of the Impressionists, and the work of American Symbolist photographers such as Clarence H. White. The square shape of this canvas, its compositional focus on the center section, and the surrounding areas of softly obscured forms echo Steichen's compositional techniques when photographing a landscape.

Steichen ceased painting in 1923 and concentrated his professional and creative efforts on his new job as chief of photography for Condé Nast Publications. From 1947 to 1962, he was the director of the department of photography at the Museum of Modern Art. AMK

HIGH-BACK SPINDLE DINING CHAIR DESIGNED FOR THE WILLIAM E. MARTIN HOUSE, OAK PARK, ILLINOIS, about 1903

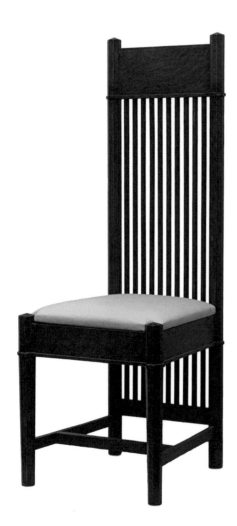

Frank Lloyd Wright is considered the most innovative American architect of his era. He invented at least two new and influential architectural styles—the Prairie style and the Usonian style—and his house designs produced from the 1890s to the 1950s brought him great acclaim. His clients often commissioned him to design furnishings for their houses. The architect typically scaled the furniture to the room it was intended for and often used the same wood as the room's paneling.

Wright designed the William E. Martin House, for which this chair was made, in 1902. One of the best examples of the Prairie style, it was a three-story house with masonry-like plastered walls, horizontal bands of windows, broadly overhanging eaves, and a low, massive chimney. As with the architecture of the house, this chair exhibits an interplay between tall vertical accents and strong horizontal lines. When grouped together around the dining room table, the high-backed chairs balanced the horizontal lines of the architecture, while creating a sense of enclosure and intimacy—a room within a room, where members of the family could experience oneness of purpose in a near religious sense. EPS

Frank Lloyd Wright
American, 1867–1959
oak with fabric seat
46 x 17.5 x 18.25 inches (116.84 x 44.45 x 46.36 cm)
Museum purchase by exchange, Rev. George N. Ross Bequest
1993.068.001

SIDEBOARD #814, about 1904

Gustav Stickley, famed for his leader-ship of the Arts and Crafts Movement in America, was born Gustave Stoeckel in Wisconsin to immigrant German parents. He and his brothers formed the original Stickley Brothers firm in New York State, attempting to counteract the rapid spread of machine-made products by producing man-made furniture and functional objects with structural integrity, simplicity, and style. His later Craftsman line, inspired by the English reformers William Morris and John Ruskin, reflected indigenous American Arts and Crafts philosophy.

Gustav Stickley
American, 1858–1942
quartersawn oak and copper
60 x 22 x 48 inches (152.4 x
 55.88 x 111.76 cm)
Acquired with funds provided by
 the William L. and Erma M.
 Travis Memorial Endowment
 for Decorative Arts
1998.009

Sideboard #814 was one of the Stickleys' most successful pieces and was included in their 1904 catalogue, priced at eighty dollars. Its seventy-inch width enabled it to fit into smaller, bungalow-style homes. The piece is characterized by its dark, fumed, quarter-sawn oak. Its horizontal mass, emphasized by the handwrought hinges and pulls in iron or copper, is regulated by prominent vertical elements. The plate rail accommodated the Stickley Brothers' hand-hammered bronze plates or trays.

Gustav Stickley's zeal to improve the quality of life of ordinary people resulted in his recognition as the Craftsman style's chief advocate—one whose influence is still acknowledged a century later. DAP

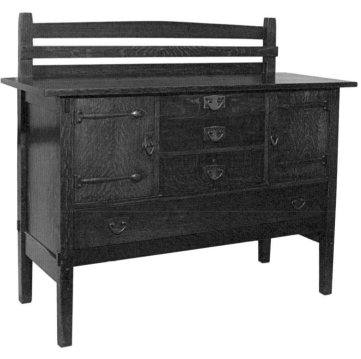

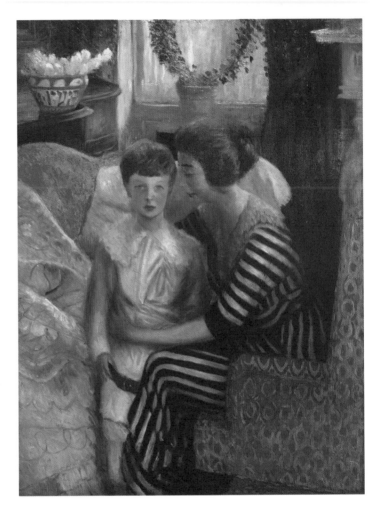

ARTIST'S WIFE AND SON, 1911

William J. Glackens
American, 1870–1938
oil on canvas
48 x 36 inches (121.92 x 91.44 cm)
Gift of the Sansom Foundation
1995.045

William J. Glackens was born in Philadelphia and worked as a newspaper artist for the *Philadelphia Press*, illustrating the events of the day. During this time he became a friend and disciple of Robert Henri, the influential painter, teacher, and leader of the Ashcan School of urban realist painters. In 1894 Henri encouraged Glackens to take up oil painting. The young artist soon became a member of the Ashcan School and of the Eight, a group of progressive figurative painters who opposed the conservatism of the National Academy. Glackens, however, was less concerned with the social realism of the Ashcan School than with representing the carefree life of fashionable members of urban society enjoying the pleasures of a holiday. During a trip to Europe, he was influenced by Auguste Renoir and acquired a life-long interest in the Impressionist style.

This scene depicts an intimate moment between mother and child. Glackens portrays his wife tenderly embracing their son, perhaps whispering something to him. The influence of Auguste Renoir is evident in the use of feathery brushwork and light, delicate color, as well as in Glackens's interest in the transitory effect of light as it plays over the figures' faces. GC

Printemps is one of Goncharova's last works before she completely abandoned easel painting in favor of designing sets and costumes for Ballets Russes.

PRINTEMPS (SPRINGTIME), about 1917

Natal'ya Goncharova's early work reveals the influence of European avant-garde styles. However, she quickly developed a profound interest in Russian peasant art and medieval icon painting. Her art evolved under these influences into a cultivated primitivist style.

Printemps, which means "springtime" in French, is composed of patterns of flat color and floral motifs drawn from the peasant embroideries and popular wood engravings that Goncharova so admired. The three fields of the painting, in which the floral motifs gradually increase, may symbolize the changing of the seasons. The title perhaps also refers to the political climate of the time.

Goncharova's husband was the Russian artist Mikhail Larionov, one of the leading figures of Russian modernism. The couple had a close artistic collaboration. In 1913 they exhibited works made in the Rayist style, a unique Russian combination of Cubism and Futurism. The following year, they began devoting their attention to stage design, and in 1915 they moved to Paris. *Printemps* is one of Goncharova's last works before she completely abandoned easel painting in favor of designing sets and costumes for Serge Diaghelev's ballet and opera company, Ballets Russes. She did not resume painting until 1956. GC

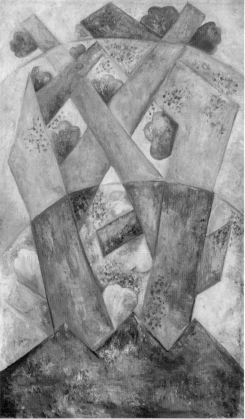

Natal'ya Goncharova
Russian, 1881–1962
oil on canvas
41 x 24.5 inches (104.14 x 62.23 cm)
Bequest of Miss May E. Walter
1994.024.007

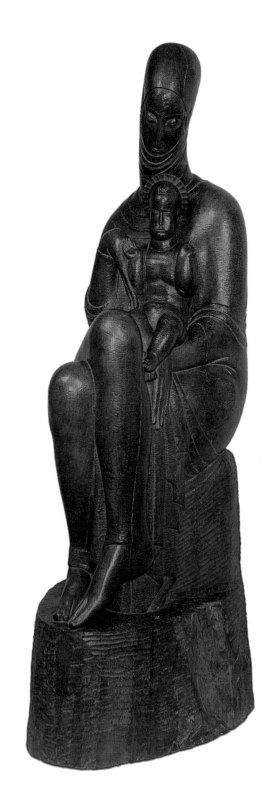

THE ASHBAUGH MADONNA, 1917

The life of Ivan Meštrović, a journey from impoverished peasant beginnings to international fame and recognition, reads like a fairytale. Throughout his career, his sculpture presented his changing attitude toward two of the most difficult issues for human beings to resolve—nationalism and religion. Because Meštrović chose to spend the last years of his life at Notre Dame as sculptor in residence, the University's campus has become a repository for works of art that tell his remarkable story.

When Meštrović was growing up in the mountains near Split, that region of Croatia was still part of the Austro-Hungarian Empire. His father, a stonemason and a Catholic, taught him history through the epic songs composed by fourteenth-century poets to immortalize the defeat of the Serbian Orthodox Christians by the Muslim Turks in 1389 at the Battle of Kosovo. After training as a sculptor at the Academy of Art in Vienna, Meštrović began a project that was so ambitious he could never complete it. He aimed to use sculpture and architecture to show how an artist could promote the idea of a new, independent nation formed by people of different backgrounds who agreed to share a synthetic culture to create a single, national ideal.

Ivan Meštrović
Croatian-American, 1883–1962
walnut
61 x 25.5 inches (154.94 x 64.77 cm)
Gift of Mr. and Mrs. Russell G. Ashbaugh, Jr.
1973.074

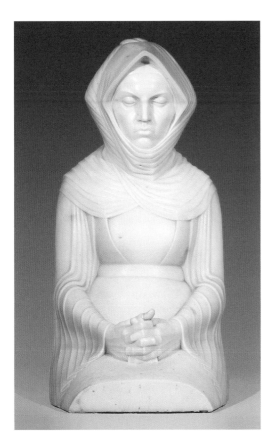

MOTHER, 1926

Ivan Meštrović
Croatian-American, 1883–1962
marble
38 x 23 inches (96.52 x 58.42 cm)
Gift of Mr. and Mrs. Russell G. Ashbaugh, Jr.
1999.056.001

Meštrović may have carved *The Ashbaugh Madonna* while living as an exile in London during World War I. For this rendering of a beloved figure type, he used a single block of wood, as the medieval masters had done. The Madonna presents her child frontally to the people, and the baby raises his hands in the ancient position of prayer. Meštrović combined a medieval subject and sculptural style with the decorative details of his contemporaries, the Vienna Secessionists, rounding off all sharp angles into curvilinear patterns that focus on a serene and otherworldly sense of grandeur.

Mother, dating from 1926, is a version of a portrait Meštrović first made in 1908 or 1909. The figure wears the traditional dress of a nineteenth-century Croatian peasant and sits with hands clasped, perhaps in prayer. The shallow, symmetrical relief carving of drapery on her shoulders and arms is similar to that used in the robes of the Madonna. By dressing her in idealized clothing like the Virgin, Meštrović ingeniously showed his respect for his mother. He simultaneously stressed her humanity through the naturalism of her face and hands. DCJM

Although this combination of sculpture and architecture, called the "Kosovo Temple," was never completed, its partial existence catapulted the artist to European fame, for he exhibited it in art museums across the continent. In 1915 London's Victoria and Albert Museum held a major exhibition of Meštrović's work, which acted as a catalyst for the promotion of the new nation of Yugoslavia. Sadly, Yugoslavia has now ceased to exist as it was originally conceived, but Meštrović's vision, powerfully presented in his sculpture, contributed significantly to its creation in 1918.

223

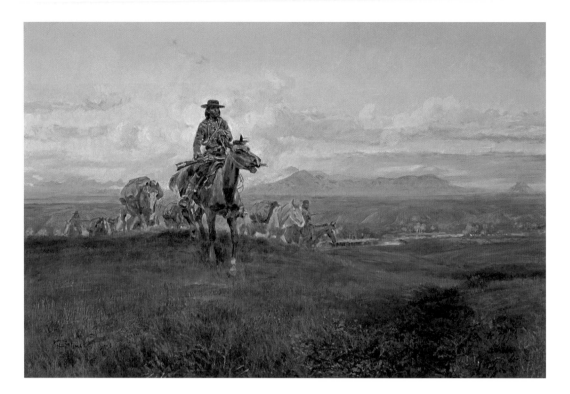

THE ROMANCE MAKERS, 1918

Charles M. Russell's paintings of the rugged lives of cowboys and Indians provided visual images of the romantic myth of the American West, which James Fenimore Cooper had already made popular in his 1826 *Leatherstocking Tales*. In this era before Western movies took over much of the visual depiction of adventures in North America, Russell's paintings and sculpture, together with the work of his fellow artist Frederic Remington, told the stories of heroism and chivalry that established the image of the West as a place where these European chivalric values were part of everyday life.

From 1890 to 1926, Russell explored and interpreted life in the western United States, as the traditional ways of Native Americans broke down before the onslaught of European "civilization." The painter was caught in a paradoxical situation, for the buyers of his scenes of heroism were the very people whose exploitation of the land was destroying the old life he loved. The "romance makers" in the Snite's painting are the mountain men, the first Europeans who opened the West to trade by trapping animals for fur and hunting to supply food for the first cattle ranchers. DCJM

Charles M. Russell
American, 1864–1926
oil on canvas
23.5 x 35.5 inches (59.69 x 90.17 cm)
Gift of Mr. C. R. Smith
1962.020

THE BATTERY, 1918

Walter Ufer was four years old when his family left Germany for America, settling in Louisville, Kentucky. He later trained and worked in Germany before returning to the United States, where he studied and taught in Chicago for some dozen years. His last stay in Germany, from 1911 to 1913, just preceded World War I.

In 1914 Ufer was "discovered" by Chicago's mayor, Carter H. Harrison II, who, along with his syndicate of German American businessmen, sponsored three trips for Ufer to Taos, New Mexico, over the next two years. There, Ufer was immediately successful, particularly at painting Taos Indians. Despite this, his sponsors encouraged him to go to New York, the city "where American reputations are made."

In late 1918, from the apartment window of a friend of another patron, William H. Klauer (who eventually purchased this work), Ufer created a bird's-eye view of the Battery district in lower Manhattan. The sunny, wintry scene of hustle and bustle includes an army recruiting office in one of the buildings. The fiercely patriotic artist crowned his depictions of the buildings with fluttering American flags.

This was the most successful of Ufer's non-New Mexico paintings. He soon returned to Taos, where he remained until his death. DAP

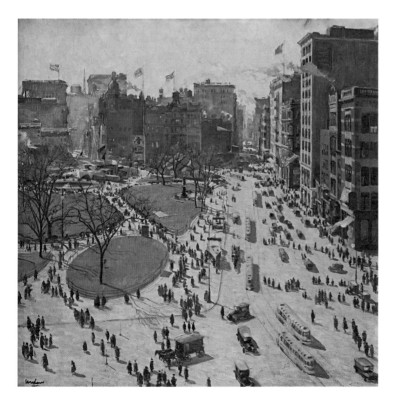

Walter Ufer
German-American, 1876–1936
oil on canvas
30 x 30 inches (76.2 x 76.2 cm)
Gift of the Family of William
 Klauer
1995.008.003

COUPE WITH FLUTED HANDLES, about 1920

The first decade of the twentieth century was a turbulent time in European art, a time of experimentation and searching for new artistic goals. The cosmopolitan city of Vienna, with its atmosphere of refined culture, was at the forefront of promoting new methods of artistic production.

In 1903 the Austrian architect and draftsman Josef Hoffmann and the designer Koloman Moser founded the Wiener Werkstätte (Viennese Workshop). Hoffmann was a great admirer of John Ruskin and William Morris. Consequently, the workshop was influenced by the mid-nineteenth-century English Arts and Crafts Movement. Like Morris, Hoffmann opposed machine production and promoted the revival of artistic craftsmanship. Wiener Werkstätte produced handwoven textiles, hand-printed books, wallpaper, porcelain, ceramics, glass, metalwork, and furniture.

This hammered brass coupe with fluted handles is an excellent example of Hoffmann's innovative variations in beautifully proportioned metal objects. The ribbed half-melon form sits on a flaring, inverted, trumpet-form base and has two looping handles. It shows a stylistic change from the workshop's early geometric, unadorned pieces to the more decorative works that were starting to flourish in Europe after World War I. EPS

Josef Hoffmann
Austrian, 1870–1956
brass
7.13 x 11 inches (19.1 x 28 cm)
Gift of Rev. Edmund P. Joyce, C.S.C.
1989.034

SUNSET, 1922

Max Pechstein played an important role in the development of German Expressionism. After short sojourns in Italy in 1907 and in Paris the following year, he settled in Berlin. His Parisian interlude brought him into contact with the French Fauves and their emotional use of line, form, and vivid colors.

A member of the group Die Brücke (The Bridge), and later one of the founders of the Neue Sezession (New Secession) in 1910, Pechstein was first influenced by Henri Matisse and Paul Gauguin, and later by the Fauves. The Fauve style incorporated strong, often clashing colors, linear distortions, emphasized outlines, wild brushstrokes, and landscapes with patches of color. Pechstein was less experimental; his forms were more representational and his compositions more conventional.

Pechstein was the first German Expressionist to become generally accepted. His themes—bathers on the beach, landscapes, flowers, still lifes, and portraits—were more popular than the more audacious works of his contemporaries. However, *Sunset* shows that he never completely abandoned forceful form and color as his most important means of expression. EPS

Max Pechstein
German, 1881–1955
watercolor on off-white wove paper
19 x 25 inches (48 x 63 cm)
Gift of Mr. and Mrs. Joseph Shapiro
1958.024.002

FAMILY GROUP, 1927

William Zorach
American, born in Lithuania, 1887–1966
brazilian walnut
66.5 x 24.5 x 2.88 inches
 (168.91 x 62.23 x 7.3 cm) each
Acquired with funds provided by Mrs.
 Dorothy Griffin in honor of Rev.
 Theodore M. Hesburgh, C.S.C., Rev.
 Edmund P. Joyce, C.S.C., and Rev.
 Anthony J. Lauck, C.S.C.
1994.042.a–b

Having immigrated to the American Midwest at the age of six, William Zorach began his art career as a commercial lithographer and painting student in Cleveland. He created his first sculpture in 1917 when, engrossed in carving a woodprint, he ultimately sculpted the block into a low relief. This process left an indelible imprint on his later output and that of a generation of American sculptors. Zorach became an advocate of direct carving, allowing the forms and textures to be revealed from the carving process rather than from study models.

The chocolate brown *Family Group* demonstrates Zorach's interests in African, Egyptian, and modern art. The central, life-size figures are presented in frontal poses, but their lower legs and feet are seen in profile—an apparent nod to Egyptian art and to Pablo Picasso. The interlocking legs and feet of these figures, the legs and feet of the children, and the negative shapes between them create flat forms much like puzzle pieces, generating a tension caused by reading the forms as both flat and volumetric. This forceful distortion is most apparent in the boy who is paired with his mother. His face is depicted in a frontal view, but his back is also seen straight on. CRL

CALLA LILIES, about 1928

Marsden Hartley was an American painter whose oeuvre was shaped in response to modernist trends in European art. In 1912 he traveled to Paris, Munich, and Berlin to study. He returned to Europe in 1914, after exhibiting at the Armory Show in New York in 1913. He developed a style based on German Expressionism, which he synthesized into an individual visual vocabulary. Early in his career, Hartley began to paint still lifes influenced by Pablo Picasso and Paul Cézanne; this genre would preoccupy him throughout his career.

Calla Lilies originally belonged to the Kurtz family, friends of the artist who were with him in Europe during the late 1920s and early '30s and who also owned several other works he created during this time. The influence of the Expressionists is evident in this painting. Hartley turns a simple subject—a pot of calla lilies with a broken leaf—into a somewhat sinister plant, its leaves undulating like flames and setting everything into motion, as if on fire. GC

Marsden Hartley
American, 1877–1943
oil on canvas
32 x 25.5 inches
 (81.28 x 64.77 cm)
1965 University of Notre
 Dame Purchase Fund
1965.013

FOUR GENTS, 1928

Guy Pène du Bois
American, 1884–1958
pen and ink and watercolor on
 off-white wove paper
13.56 x 11.44 inches
 (34.5 x 29 cm)
Gift of Mr. John D. Reilly (Class
 of 1963) in honor of Dean A.
 Porter
1996.071

Guy Pène du Bois studied with William Merritt Chase and was clearly influenced by the realism of Robert Henri and Kenneth H. Miller. The artist's early career was mainly occupied by writing and art criticism. Later he helped to plan, and exhibited in, the famous Armory Show of 1913. Pène du Bois's compositions and backgrounds were frequently quite spare and strikingly modern. He often included telling details to define the status, class, and fashions of his figures, but the individuals themselves were usually depicted with simple contours and sophisticated geometric forms.

The signed and dated watercolor *Four Gents* shows a group of fashionably dressed men standing together. The drawing might easily be considered a caricature or an illustration, and yet there is no clear sense of any specific satiric content or anecdote. Also, in contrast to most illustrational drawings, the pen lines and watercolor washes reveal the facility and finesse of not only a professional artist but an exceptional draftsman. Such a contemporary and realistic scene, rendered with the intimation of a social statement or satiric content, is entirely characteristic of the work of Pène du Bois. **ss**

FLOWERS, about 1930

Although born in Italy, Joseph Stella arrived in the United States by 1896 and soon was studying with William Merritt Chase and at the Art Students League. During this early period, he produced work in a variety of realistic styles to which he would return periodically at different times in his career. By 1909 Stella was back in Europe meeting major figures of modernism such as Henri Matisse, Amedeo Modigliani, and Umberto Boccioni. Within a short time, his work began to show the influence of Cubism and Futurism. Some of his most famous works, treating such iconic American subjects as the Brooklyn Bridge and Coney Island, express Stella's romanticism in the fragmented and dynamic imagery that he felt reflected the new American urban life.

Stella was consistently admired as a brilliant draughtsman. One special category of his drawings is the botanical studies, which often seem to be ends in themselves rather than preparatory studies for other projects. At times, the flowers are depicted in a tight, detailed, and realistic style. By contrast, this pastel of flowers, rendered in a fresh, straightforward, and deceptively simple manner with rich colors and freely drawn forms, appears as if it was just quickly captured on paper. ss

Joseph Stella
American, 1877–1946
pastel on off-white laid paper
12 x 18.5 inches (30.48 x 46.99 cm)
Acquired with funds provided by the
 Arthur J. Decio Purchase Fund
1982.002

Joaquín Torres García
Uruguayan, 1874–1949
oil on Masonite
29.5 x 21.5 inches (74.93 x 54.61 cm)
Bequest of Miss May E. Walter
1994.024.006

Joan Miró (opposite page)
Spanish, 1893–1983
oil, sand, and tar on board
53.13 x 39.38 inches (135 x 99.7 cm)
Bequest of Miss May E. Walter
1994.024.015

COMPOSICION UNIVERSAL (UNIVERSAL COMPOSITION), 1933

Joaquín Torres García is known today not only as one of the foremost modernist European artists of the 1930s and '40s but also as a tireless educator who brought modernist art and design to his home country by establishing an art school, a journal, and regular exhibitions in Montevideo. Working primarily in Spain and France, by 1930 he had developed his own distinctive style: a gridlike arrangement of squares and rectangles, each containing naively drawn signs and symbols recalling ancient pictographs and petroglyphs.

Torres García's abstractions were influenced by the Dutch artist Piet Mondrian's severely geometric compositions of squares and rectangles. In his writing and teaching, Torres García explained his belief that the picture writing of ancient peoples could be used by artists of the twentieth century as a vocabulary for "universal constructivism," the name he gave to his style. The creation of this mode was his way of providing people with a glimpse into a shared unconscious world, developed as an alternative to the exploration of dreams and imaginings presented by artists of the Surrealist movement such as Salvador Dalí and Joan Miró. DCJM

SIGNS AND FIGURATIONS, 1936

The Spanish painter, ceramist, and sculptor Joan Miró was among the most prominent Surrealists, but he stood apart from any movement and developed a personal visual imagery. His works changed reality into a universe of signs and symbols that, despite his fascination for the bizarre and monstrous, still point to concrete parallels in the real world.

Miró's desire for innovation led him to many new combinations of materials and techniques. About 1933 he started experimenting with paintings on sandpaper. He restricted his palette to a few elementary colors and used abstracted forms and abbreviated signs for parts of the human body, developing only the head, the foot, and the eye. The Snite's piece from his series *Signs and Figurations* is representative of these works, which Miró referred to as "tarpaper graffiti." It depicts three abstract figures that look half human, half animal.

Miró's early paintings celebrated nature as a source of joy, but as the political situation in Europe worsened, his zest for life gradually changed to thoughts of suffering and death. He was traumatized by the atrocities of the Spanish Civil War and expressed the collective tragedy of Europe through his nightmarish works. EPS

Miró's early paintings celebrated nature as a source of joy, but as the political situation in Europe worsened, his zest for life gradually changed to thoughts of suffering and death.

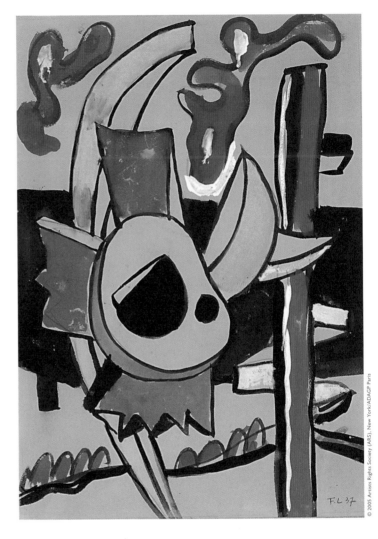

BEACH FORMS, 1937

Fernand Léger
French, 1881–1955
gouache and brush and black ink on
 buff paper laid down on board
14 x 10 inches (36 x 25 cm)
Bequest of Miss May E. Walter
1994.024.011

Fernand Léger, a prominent French painter who worked in many different art media, including filmmaking, once proclaimed that an artist must be in harmony with his own generation. His works show clearly his interest in technology and machinery, which he celebrated in his canvases as the spirit of the modern world. An admirer of industrial life, he typically found his inspiration in big cities, factories, and building sites, and he glorified the beauty of mass-produced everyday objects.

Léger adopted the Cubists' fragmentation of figures created from cones and cylinders, their faces reduced to the geometric structure of a circle or an oval and their general features limited to simple signs. About 1937, the year he executed the gouache *Beach Forms*, the artist painted a number of still lifes, landscapes, and polychrome compositions of objects dispersed in space, delineated with strong black contours. He used flat planes and bold colors—yellow and green on a mostly tan background. EPS

DAME VON EHEDEM
(LADY OF FORMER TIMES), 1939

The Swiss-born painter, draftsman, and teacher Paul Klee was one of the most inventive and prolific modern artists. His complete output is estimated at some nine thousand works, and yet it is not repetitious. Working in a dozen different styles, he combined imagination with the highest technical and formal proficiency. His art deals with the world between dream and reality. The key to that world is line and its expressive possibilities.

Klee spent time making art and teaching in Germany, until the nascent Nazi regime forced him to return to Bern, the city of his childhood. Some art critics consider the works executed during his last period in Bern (1933–49) to be the finest of his whole career. The line was still his primary means of expression, but his compositions were reduced to simple outlined forms, their earlier playfulness gone.

Dame von ehedem demonstrates the tendency toward angularity that his drawings from 1939 to 1940 show. This line drawing of a woman in profile wearing a long pink dress marked with two white triangles is a variant of the drawing *MN 3* (in a private Swiss collection), which preceded the Snite's gouache version. EPS

Paul Klee
Swiss, 1879–1940
gouache and black chalk on bamboo Japan paper, mounted
16 × 10.25 inches (40.5 × 26 cm) with mount
Bequest of Miss May E. Walter
1994.024.009

This line drawing of a woman in profile wearing a long pink dress marked with two white triangles is a variant of the drawing MN 3 (in a private Swiss collection), which preceded the Snite's gouache version.

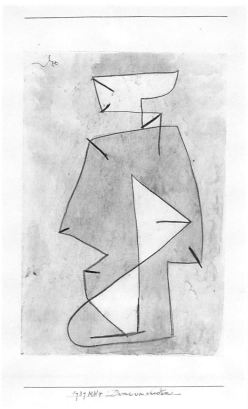

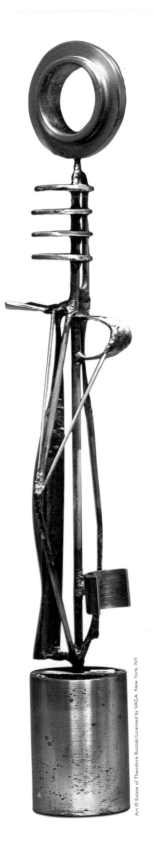

SENTINEL, 1942

Although best remembered as a sculptor, Theodore Roszak was first an accomplished painter. A trip to Europe from 1929 to 1930 introduced him to Surrealism, Cubism, and Constructivism, and he experimented with all three in his paintings. In the late 1930s, he worked with the Bauhaus artist Lázlô Moholy-Nagy at the New York Design Laboratory. Roszak came to believe, as many did prior to World War II, that science and technology would bring a utopian era. He responded by creating nonrepresentational, nonexpressive constructions from industrial materials.

This sculpture is fabricated from sections of commercial steel rods and pipes, as well as machined, cut, and bent steel stock. Created during the war, when Roszak taught airplane mechanics and worked in the Brewster Aircraft Corporation factory, the figure is assembled with his signature cool, architectonic style—his "machine aesthetic." It resembles figures found in contemporaneous paintings by Mark Rothko and Arshile Gorky, evidencing Roszak's awareness of Surrealism and Abstract Expressionism. The title, *Sentinel*, signals his familiarity with Freudian and Jungian psychology. It also foretells the direction his art would take following the devastation of the war: the creation of somber and emotional images meant to stand guard over mankind's darkest impulses. CRL

Theodore Roszak
Polish American, 1907–1981
welded steel
17.5 x 3 x 3 inches (44.45 x 7.62 x 7.62 cm)
Acquired with funds provided by the Walter R. Beardsley Endowment for Modern and Contemporary Art
2002.026

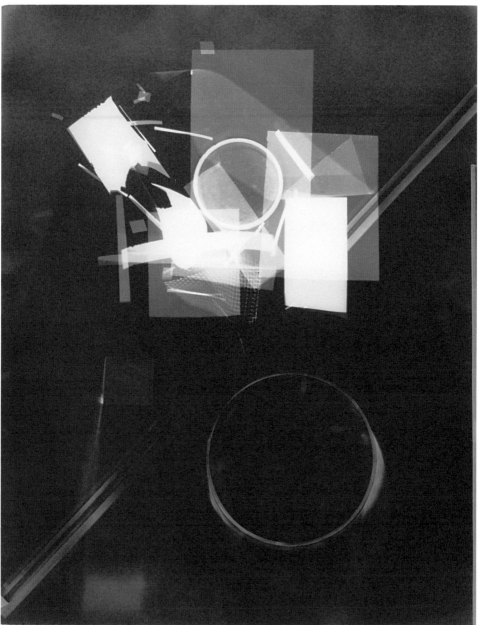

UNTITLED PHOTOGRAM, 1937–41

Theodore Roszak
Polish American, 1907–1981
photogram on silver gelatin paper
10 x 8 inches (25.4 x 20.32 cm)
Aquired with funds provided by the Walter R. Beardsley
 Endowment for Modern and Contemporary Art
2003.040

237

Higgins continued to evolve as an artist, changing his approach from a form of Impressionism to styles reflecting the influence of Paul Cezanne's and John Marin's landscapes.

NEW MEXICO SKIES (AUGUST SKIES), about 1943

William Victor Higgins's *New Mexico Skies (August Skies)* is an iconic painting of the New Mexico landscape: a panoramic desert view, captured from a precarious spot on the north rim of the Rio Grande Gorge, of white blocklike clouds floating in a brilliant blue sky over the Picuris Mountains south of Taos.

Considered the premier painter of New Mexico landscapes, Higgins was born in Shelbyville, Indiana, and in 1899 moved to Chicago, where he attended classes at the Art Institute. He traveled to Europe in 1911, as was the custom of aspiring artists, for further study and practice in various locales. Soon after returning to Chicago, he held two solo exhibitions at the prestigious Palette and Chisel Club, thereby attracting the attention of the very influential mayor, Carter H. Harrison II. The mayor and a few affluent German American businessmen with whom he had formed a syndicate sponsored Higgins's first trip to Taos, New Mexico, in November 1914.

Higgins spent his early years there painting at the famed Taos Pueblo, the virtual center of Pueblo Indian life and culture. He sent many of his works featuring Native Americans in their everyday activities back to his sponsors in Chicago, where they won prizes in the Art Institute's annual juried exhibitions. In 1917 the established members accepted him into the Taos Society of Artists.

During the 1920s and '30s, Higgins was honored with one-man shows in Chicago, New York, Indianapolis, and Washington, DC. He continued to evolve as an artist, changing his approach from a form of Impressionism to styles reflecting the influence of Paul Cezanne's and John Marin's landscapes. During the 1930s, which he considered his era of experimentation, he explored dynamic symmetry in composition. Despite his poor health and Depression-related financial difficulties, Higgins produced important works during this period, including *Gladiolas*, which is also in the Snite Museum's collection.

Following a brief marriage to San Antonio heiress Marion Koogler McNay, an aged Higgins returned to Taos and spent the 1940s painting watercolors, small oils on Masonite (later dubbed "Little Gems" by an inventive dealer), and Impressionistic landscapes. In 1943 he made a final attempt to paint a masterwork, resulting in *New Mexico Skies*. He exhibited the painting at the National Academy in New York before selling it to David F. Broderick. The artist's brother, John Tilson Higgins, purchased it (erroneously titled *Taos Valley*) from the Broderick estate and donated it to his alma mater in 1963. **DAP**

William Victor Higgins
American, 1884–1949
oil on canvas
54 x 56 inches (137.16 x 142.24 cm)
Gift of Mr. and Mrs. John T. Higgins
 (Classes of 1922 and 1924)
1960.018.005

UNTITLED, about 1944–45, printed 1967

During the fall of 1944 and spring of 1945, Jackson Pollock experimented with the technique of engraving, creating eleven copperplates under the tutelage of the artist Reuben Kadish. This was just after his first solo exhibition at Peggy Guggenheim's Art of This Century gallery in November 1943 and the Museum of Modern Art's purchase of his painting *The She-Wolf*, but prior to the creation of his well-known action paintings on canvas.

Editions of the six untitled plates that Pollock kept were pulled posthumously in 1967, with the permission of Pollock's widow, Lee Krasner. She generously gave the Snite Museum a set of these prints. This is the most complex of the six in terms of the biomorphic forms selectively recognized and outlined with cross-hatching and parallel lines of shading within a dense grid of curved lines. It is the third and final state of the print.

The plates were created as part of a process of personal discovery rather than to produce marketable results. The expressive, automatist drawings were made using a Surrealist improvisational technique believed to release the true reality of the artist's thoughts and emotions from the control of the conscious mind. **AMK**

Jackson Pollock
American, 1912–1956
engraving and drypoint
14.5 x 17.75 inches (36.83 x 45.09 cm)
Gift of Lee Krasner in honor of
 Rev. Anthony J. Lauck, C.S.C.
1979.008.002

WATCHING, 1940s

From 1939 to 1945, the years of World War II, a group of European Surrealist painters sought refuge in New York City, where their ideas influenced many artists and writers, including Adolph Gottlieb. In 1951 Gottlieb commented on the paintings that he and fellow artist Arshile Gorky created in the 1940s, writing: "The vital task was a wedding of abstraction and surrealism. Out of these opposites something new would emerge."

Like many of his contemporaries, Gottlieb believed that the writings of psychoanalysts Sigmund Freud and Carl Jung provided a pathway toward a universal language of signs and symbols, which artists like him could make into art. After rejecting the realist style used by many American artists during the Depression, in 1941 Gottlieb began a series of pictograph paintings. *Watching* belongs to this series. The works are based on a geometric grid of straight lines, a form introduced to New York by the Dutch artist Piet Mondrian. They demonstrate Gottlieb's fascination with form and subject matter chosen from nature, the subconscious, myth, and non-European art. The abstracted forms and symbols that he used in the paintings reflect his interest in the early cultures of North America and the ancient Near East. DCJM

Adolph Gottlieb
American, 1903–1974
oil on Masonite
30 x 24 inches (76.2 x 60.96 cm)
Gift of Mr. and Mrs. Joseph
 Shapiro
1954.001.003

THE KING IS DEAD, 1950

Grace Hartigan is often grouped with the second generation of Abstract Expressionists, artists whose works were influenced by psychic automatism and the writings of Sigmund Freud and Carl Jung. Developed in New York City during the late 1940s, Abstract Expressionism was the first truly American style. It stressed the visual representation of the subconscious and personal responses to intellectual and universal ideas. Despite her affiliation with the movement, throughout her career Hartigan tried to evolve an individual style, often alternating abstraction with figuration.

The King is Dead reveals both Hartigan's Abstract Expressionist roots and her search to develop her own style. The work is most directly influenced by Jackson Pollock. Hartigan set down short diagonal brushstrokes in densely interwoven patterns of vibrant reds, whites, blues, and yellows. The balanced, all-over composition seemingly reaches beyond the borders of the canvas and forward into the viewer's space. Unlike Pollock's method of drip painting, though, Hartigan did not relinquish control of the paint; she always maintained contact between the brush and the canvas. The title proclaims her belief in Abstract Expressionism, which she referred to as "the triumph of American painting." King Picasso has been dethroned and Pollock now reigns. GC

OKAME, 1954

Born to a Japanese father and an American mother, sculptor Isamu Noguchi felt he was caught between two worlds. *Okame* illustrates his interest in Japanese culture and natural materials. The cast-iron sculpture, with its rusticated surface texture and golden brown color, takes on the appearance of tree bark or natural stone—perhaps a stone from a Japanese Zen garden.

In a letter written to the Snite Museum's director, Noguchi described the sculpture's meaning:

> Okame *is the mask worn in the "Kyogen" which is a part of the Noh plays. This is the slapstick part of the Noh, and the* Okame *mask itself is that of a rather bumptious countrywoman given to ribald[ry] and repartee. As you can see, I have made my* Okame *all bandaged up with one pathetic eye and no longer humorous. I did it in memory of all the* Okames *that must have had a similar or worse fate, thanks to our kind consideration to end the war.*

This piece, then, whose title *Okame* also means "looking on by an outsider," is Noguchi's response to the use of the atomic bomb in World War II and his attempt to reconcile the roles that his Japanese and American cultures played in that war. STM

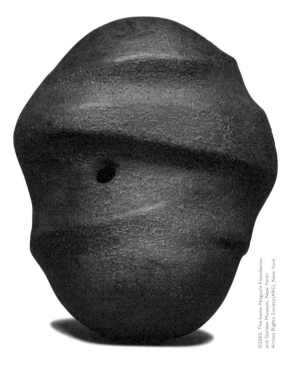

©2005, The Isamu Noguchi Foundation and Garden Museum, New York/ Artists Rights Society (ARS), New York

Grace Hartigan (opposite page)
American, born 1922
oil on canvas
65 x 96.5 inches (165.1 x 245.11 cm)
Acquired with funds provided by Mr. Al Nathe
1995.023

Isamu Noguchi
American, 1904–1988
cast iron
9 x 7.38 x 4.13 inches (22.86 x 18.73 x 10.48 cm)
Gift of Miss May E. Walter
1963.005.002

UNTITLED, 1955

Louise Nevelson was one of the most important American sculptors of the mid-twentieth century. Her wood assemblages are typically painted jet black or, later, white and gold, and they range in size from the small and personal to the large and monumental. Nevelson also made multiples, interpreting her sculptures as lead reliefs and working in various print and drawing media.

Nevelson made two trips to Mexico and Latin America in 1950. She was greatly impressed by the sculptural reliefs on Mayan temples and by the Pre-Columbian imagery and symbols she encountered. This drawing depicts a group of amorphous human, animal, and fishlike forms emerging from a black wash background. These semi-abstract figures and their subtle relationship to one another within the overall composition are influenced by Nevelson's fascination with Pre-Columbian ruins.

This work is noteworthy because it foreshadows Nevelson's move to complete abstraction in her mature work. It also clearly indicates the use of compartmentalization that formed the basis of her sculptural investigations for the remainder of her career. GC

Louise Nevelson
American, 1899–1988
watercolor, wax crayon, and black ink on tan wove
 paper
12 x 17.88 (30.3 x 45.5 cm)
Acquired with funds provided by the Walter
 R. Beardsley Endowment for Modern and
 Contemporary Art
2000.037

FISHING, 1955

An American painter of German origin, Lyonel Feininger spent most of his life in Germany. He worked first as a graphic artist for German satirical magazines, sending some of his cartoons to *The Chicago Tribune* and *Harper's Round Table*. While in Paris from 1907 to 1911, he was influenced by Analytical Cubism and the Futurist movement. Subsequently, he was mainly preoccupied with the structuring of the pictorial surface, the interaction between color fields, and the balance of light and shade.

In 1912 he became a member of and exhibited with the German Expressionist group Die Brücke (The Bridge), and he later joined Der Blaue Reiter (The Blue Rider). Invited by Walter Gropius, he entered the Bauhaus at Weimar and then at Dessau. After a number of his paintings were eliminated from German museums by the Nazis as "degenerate art," Feininger left Germany in 1937 and settled in New York, his birthplace.

Feininger's art is based on the reality of simple things—village dwellings, churches, the sea, the sky, and ships—which he reshapes and relates in color, form, and line. He did not belong to any one school; the power of his imagination played a decisive role in his artistic expression. EPS

Lyonel Feininger
American, 1871–1956
watercolor, black ink, and collage on paper
12.63 x 18.88 inches (32 x 48 cm)
Acquired with funds provided by the Walter
 R. Beardsley Endowment for Modern and
 Contemporary Art, the Humana Foundation
 Endowment for American Art, and Museum Projects
1997.029

UNTITLED, 1957

David Smith was one of the twentieth century's most influential American sculptors. He is best known for the welded and burnished stainless-steel sculptures he created between 1959 and 1965, at the height of his career. He learned the skills for working with steel at the Studebaker plant in South Bend, Indiana, during the summer of 1925.

Smith initially trained as a painter and was influenced by Arshile Gorky, Willem de Kooning, and European modernism. This drawing reveals those influences and that of Julio Gonzalez's and Pablo Picasso's metal-works, as well as Smith's involvement with the Abstract Expressionist movement. Smith maintained that there was no essential difference between painting and sculpture. The vigorous and lively brushwork that characterizes this sketch parallels the forceful and dynamic quality of his large sculptures. Here, the artist used lyrical, rhythmic line over bold, abstract planes to create a work that reveals his mastery of form. GC

David Smith
American, 1906–1965
tempera and watercolor on off-white wove paper
17.37 x 22.37 (44.13 x 56.83 cm)
Gift of Mr. and Mrs. William N. Farabaugh
1986.054.001

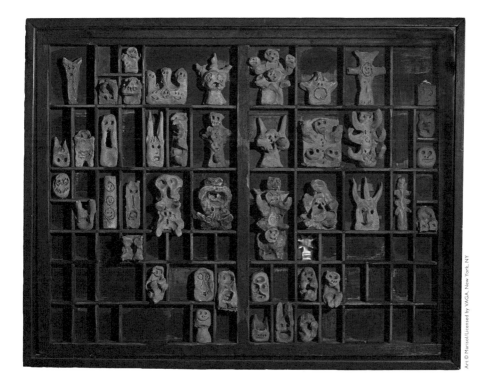

PRINTER'S BOX, 1958

The daughter of wealthy Venezuelan parents who divided their time between Europe, South America, and the United States, Marisol spent much of her childhood in luxurious settings. This set the tone for a life of world travel, during which the quiet, reserved sculptor intersected with principal artists of the twentieth century: she was a student of Hans Hoffman; befriended the Abstract Expressionists, becoming especially close to Willem de Kooning; and participated in two Andy Warhol movies.

Printer's Box is an early work created when Marisol was twenty-eight. It illustrates her interest in found objects, Pre-Columbian ceramic figurines, American folk art, and religion. As a teenager, Marisol was deeply interested in Catholic mysticism's saints and martyrs, and she imposed severe penitential acts on herself. This personal history may provide clues to reading the sculpture as a primitive folk altar. The hand-formed anthropomorphic figures might be modeled after Pre-Columbian ceramic figurines, or they might be totemic figures inspired by those created early in the careers of the Abstract Expressionists. The found object, a printer's type box, possibly references Surrealism, with the figures an array of subconscious memories.

Anchored by the concepts of modern art, enigmatic, and quietly provocative, the sculpture is quintessential Marisol. CRL

Marisol
American, born in France, 1930
wood and ceramic
17.44 x 22.44 x 3 inches (44.29 x 57 x 7.62 cm)
Gift of Mr. and Mrs. Edwin A. Bergman
1978.005

Georgia O'Keeffe
American, 1887–1986
oil on canvas
30.13 x 26.13 inches
 (76.53 x 66.37 cm)
Gift of Mr. Walter R. Beardsley
1978.073.001

Joseph Cornell (opposite page)
American, 1903–1972
mixed media
6.75 x 10.5 x 2.75 inches
 (17.15 x 26.67 x 6.99 cm)
Gift of Miss May E. Walter
1963.005.001

BLUE I, 1958

Georgia O'Keeffe was among the first internationally known American artists to train exclusively in the United States and to find her subjects at home. By 1915 she was developing a working method based on magnifying and simplifying details to create abstract compositions from the lines, forms, and tonal values found in nature. In 1916 Alfred Stieglitz, a well-known New York gallery owner, photographer, and modernist, offered O'Keeffe her first exhibition in his gallery 291. After they were married in 1924, Stieglitz publicized O'Keeffe's work in twenty-two one-person exhibitions that established her as an important American modernist.

Blue 1 belongs to a series of paintings that relate to O'Keeffe's visual memories of her extensive international air travel between 1957 and 1979. The experience of looking down on the world from an airplane gave her new ways of seeing two familiar aspects of nature—rivers and the sky. In her modernist process of gradually abstracting colors and shapes from nature, she may in this case have combined the forms of rivers, seen from above as deep blue stripes, with the shapes of horizontal layers of cloud, crossed by a diagonal wisp of jet stream or smoke. DCJM

VIDEO ERGO SUM (I SEE THEREFORE I AM)

While tending his chronically ill brother, Joseph Cornell wandered Manhattan collecting objects for his art at souvenir, used-book, and junk shops. The handmade, glazed shadow boxes he assembled from these found objects are suggestive of Surrealism, particularly the collages of Max Ernst. However, Cornell transcended the Surrealist aesthetic of chance through his keen eye for design and his poetic juxtapositions of objects.

This construction, *Video Ergo Sum*, utilizes classic Cornell vocabulary: a circle, a ball, driftwood, and a butterfly placed within a heavily painted white box, papered on the exterior with a mathematical chart. The rolling ball evokes a child's toy or pinball machine. Since Cornell's oeuvre features the sun, moon, and solar system, the box may depict an eclipse. The driftwood probably refers to the natural world, specifically the sea, and the mathematical diagram might be a tide chart.

Cornell's boxes record the passage of time and his longings. His diaries are filled with descriptions of women he observed and desired. The subjects of his infatuation were ballerinas, divas, and starlets; this interest inspired the Pop artists, who featured multiple images of popular icons—objects of desire—as subjects of their artworks. CRL

He called the works "simple paintings," but although they may at first appear simple, they are actually complex, sophisticated, and rather daring in their unique devotion to exploring a set of purely formal problems.

UNTITLED, 1959

In the arena of American abstract art after World War II, Ray Parker developed a style that was exceptionally personal and innovative. Parker's single-minded attention to a refined and distinctive use of color can be traced back to Henri Matisse and American painters such as Patrick Henry Bruce and Stuart Davis. Although his paintings may at times resemble the more famous works of Mark Rothko, Ellsworth Kelly, or Morris Louis, Parker's goals and particular use of colors, brushwork, and forms set his work apart from both Abstract Expressionism and Color Field painting.

By 1951 Parker had become acquainted with the New York Abstract Expressionist group and had resettled in New York City. Even at this early date, his work was compelling enough to be included in important exhibitions at the Museum of Modern Art, the Metropolitan Museum of Art, and the Whitney Museum of American Art. In reaction to Abstract Expressionism, during the late 1950s Parker began to develop a style in which he allowed a few discrete painterly forms to coalesce on the surface of the canvas.

Ray Parker
American (1922–1990)
oil on canvas
71 x 82 inches (180.3 x 208.3 cm)
Acquired with funds provided by the Humana
　Foundation Endowment for American Art
1997.031

From 1958 to 1965 he created a group of paintings that are among the most beautiful and accomplished of the period. He called the works "simple paintings," but although they may at first appear simple, they are actually complex, sophisticated, and rather daring in their unique devotion to exploring a set of purely formal problems. In a varied range of dark and bright hues on a neutral background, the simply ordered, cloudlike forms seem alternately to float, hang, rest heavily, bump, or touch one another.

The Snite Museum's untitled composition, dated to 1959, is an early and archetypal example of the artist's directly painted color abstractions. A large rectangular area of taupe dominates the lower section of the canvas, and three somewhat square areas of muted lavender and terra-cotta hover above, nudging one another. In two critical articles that appeared in a 1958 publication called *It Is*, Parker discussed his ideas about artists who prepare mentally before allowing the image to be realized and those who intuitively let the image evolve in the process of painting. Interestingly, he inscribed on the back of the Museum's painting, "For Denise because of It Is." **ss**

BOATS AND PARKED CARS, about 1960

Fairfield Porter occupies an exceptional and somewhat perplexing position in American art. Although he studied with Thomas Hart Benton and his art is generally discussed in terms of American Realism, his work is also compared to that of the French Impressionists and the late nineteenth-century Nabis. Porter frequently depicted landscapes and intimate interior scenes, yet his steadfast attention to purely formal and abstract matters is more characteristic of modernist, nonrepresentational artists.

Though some of Porter's many drawings directly relate to paintings, others simply show the artist's interest in capturing images that he might utilize at some later date. This example does not appear to be a study for a specific painting, but the subject is one to which Porter frequently returned in his paintings, drawings, and watercolors. The informal landscape composed of a parking lot with cars, boats in a harbor, and houses, is reminiscent of Edward Hopper's carefully arranged realist compositions. Porter's quick, energetic chalk strokes capture the basic elements of the scene and create an intriguing composition of light and shade, shapes, and volumes. While attempting to spontaneously render the specifics of a particular place, Porter clearly also is concerned with its more purely abstract values. **ss**

Fairfield Porter
American, 1907–1975
charcoal
11.94 x 17.94 inches (30.33 x 45.56 cm)
Acquired with funds provided by the Humana
 Foundation Endowment for American Art
1998.030.001

TWO FEMALE NUDES ON YELLOW DRAPE, 1964

Philip Pearlstein has consistently explored the human form, specifically the nude model in a studio setting. The artist adamantly states that his type of new realism stands alone and should not be categorized with Pop Art or Photorealism. Some have described his style as a painter's reaction against the new primacy of photography.

In this painting, one woman lies down with her head in profile; the other sits up, leaning on one arm and turning toward the viewer, but her eyes are closed. All of their physical flaws are evident, increasing the sense of painted reality. The two-dimensionality of the surface, emphasized by the cropped arm, feet, and head of the models, versus the illusionary three-dimensionality of their painted forms and that of the red pillow creates a visual tension.

Pearlstein is interested in exploring the formal aspects of the "landscape" of the human form and its surroundings, rather than the emotions or individual identities of his subjects. Often, he eliminates a model's head entirely from the composition or paints only part of his or her face. The eyes are always closed. Pearlstein includes every part of the setting in the painting, no matter how insignificant. All aspects are painted to a uniform level of finish. AMK

Philip Pearlstein
American, born 1924
oil on canvas
53.75 x 70 inches (136.53 x 177.8 cm)
Acquired with funds provided by the Humana
 Foundation Endowment for American Art
1994.051

© Philip Pearlstein, Courtesy Betty Cunningham Gallery, New York

© 2005 John Chamberlain/Artists Rights Society (ARS), New York

FUGUE FOR A TIN HORN, 1962

Indiana-born artist John Chamberlain is best known for his sculptures made from automobiles. In these early works, he cut, bent, crushed, and welded sections of auto bodies and strips of chrome trim to create multicolored, geometric sculptures. Although the Snite Museum's sculpture was created from flat, galvanized steel stock rather than from recycled automobile sheet metal, it looks like a two-tone version of the automobile sculptures, featuring black paint and bare silver steel. As in much contemporary art, the materials are common and the fabrication process is evident: there are paint scratches, distortions caused by folding the steel, and visible welds.

The word "fugue" in the title refers to a work of music in which a simple melodic theme is altered, repeated, and interwoven. Similarly, in this sculpture simple shapes are repeated, modified, and interconnected. The resulting object is purely abstract. It does not represent any specific thing, though it suggests many things from different angles: an architectural model, a mailbox, a heart-shaped candy box, a toy locomotive, even a homemade musical instrument. CRL

John Chamberlain
American, born 1929
painted and soldered galvanized steel
16.25 x 25 x 15 inches (41.28 x 63.5 x 35.1 cm)
Acquired with funds provided by the Walter R. Beardsley
 Endowment for Modern and Contemporary Art
1994.027

NATURAL FORM, 1969

This sculpture rises from a base that resembles a foothill or a rocky outcropping. Extending as if from a shoulder is a winglike form—a mix of geometric and featherlike shapes, such as those found on the wrought-iron African staffs the artist collects or the classic winged victory form that often inspires his sculptures. Richard Hunt makes no effort to conceal the material's elemental form, a chrome steel bumper featuring a bolt that once attached it to an automobile. The fabrication process is also apparent: welds are visible, the surface is iridescent where heated by a torch, and swirling patterns trace the action of a grinding wheel.

Commenting on the working and reworking of his fabrication process, Hunt described his art as "bringing into sculpture the Abstract Expressionist sensibility." Indeed, both the process and the content of his sculpture build upon the model of the Abstract Expressionists, who utilized process as a means to gain knowledge about themselves through the visualization of personal and cultural mythological archetypes—images that they realized through an aggressive, physical, improvisational process of art creation.

In these ways, Hunt's art melds the classic with the modern, Western with African, mythical with mundane, natural with industrial, found with fabricated, and black with white. CRL

Richard Hunt
American, born 1935
welded chrome steel
22.5 x 24.5 x 13 inches (57.15 x 62.23 x 33.02 cm)
Acquired with funds provided by the Humana
 Foundation Endowment for American Art
2002.048

Hunt's art melds the classic with the modern, Western with African, mythical with mundane, natural with industrial, found with fabricated, and black with white.

SOUVENIR, 1970

Jasper Johns
American, born 1930
color lithograph
30.75 x 22.25 inches (78.11 x 56.52 cm)
Acquired with purchase funds provided
 by Dr. M. L. Busch Purchase Fund
1974.081

On a visit to Tokyo, Jasper Johns saw a plate with a color portrait photograph baked on its center in a tourist souvenir shop. He had two plates made with his image in the center and the names of his favorite colors—red, yellow, and blue—stenciled on the rims. He then attached the plates and other three-dimensional objects to two painted canvases and entitled the compositions *Souvenir* and *Souvenir 2*.

This lithographic reproduction of one of the assemblages shows the plate standing on a ledge projecting from the lower-left corner of the painting. Behind the plate is a smaller, reversed, canvas-covered wooden stretcher frame that obscures three-quarters of the abstractly painted background. The word "souvenir" is handwritten on the bare canvas, under a stenciled number two. In the lithograph, the three-dimensional quality of the plate and reversed canvas contrasts with the loosely drawn, two-dimensional illustration of a flashlight pointed up at a bicycle's rearview mirror. Such mixtures of materials, spatial ambiguity, and enigmatic presentation of common objects are prevalent elements in the artist's oeuvre.

As a Neo-Dadaist, Johns expands the investigation of perception and semiotic relationships in the realm of familiar objects—especially flags, numbers, letters, and words. **AMK**

TWO CONICAL SEGMENTS GYRATORY GYRATORY II, 1979

South Bend native George Rickey added the elements of time and motion to his art. His kinetic sculptures are in motion around the world, activated by indoor air currents or powered outdoors by the whim of the wind. In their graceful movements, these hypnotic sculptures reveal the play of natural forces upon works of art that use physics to control the time and limits of their motion.

This piece's movements are unusually complex, as both cones rotate (often in different directions) and the entire sculpture "points" like a weathervane. On sunny days the piece casts an energetic shadow, and glints of sunlight reflect off its polished steel surface; in winter it catches snow.

Rickey inherited his mechanical aptitude from his father, a mechanical engineer, and his grandfather, a clockmaker. His artistic sources were Alexander Calder, the inventor of the mobile; the sculptor David Smith, who taught Rickey how to weld; and the Constructivists—in particular, Naum Gabo, who believed that works of art should reflect the laws of nature. CRL

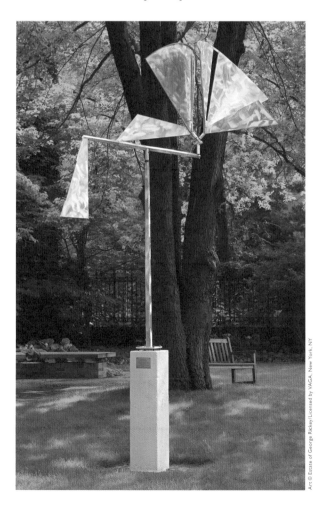

George W. Rickey
American, 1907–2002
123 x 124 inches (311.19 x 313.72 cm)
stainless steel
Acquired with funds provided by Mr. and
 Mrs. Al Nathe
1986.018

In their graceful movements, these hypnotic sculptures reveal the play of natural forces upon works of art that use physics to control the time and limits of their motion.

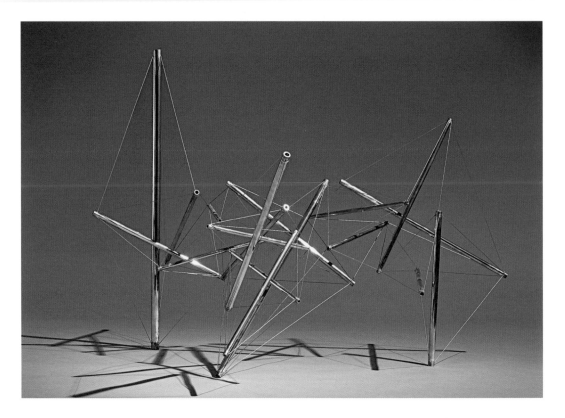

MOZART I, 1982

Kenneth Snelson studied painting and drawing at the Corcoran School of Art and the University of Oregon. In 1948 he enrolled at Black Mountain College in North Carolina, where his teacher, Joseph Albers, observed Snelson's facility for three-dimensional art and encouraged him in that direction. Snelson's latent interest in structure was reinforced by the influence of the architect Buckminster Fuller, who joined the Black Mountain College faculty later that summer. Fuller is known for his geodesic domes and other self-supporting structures.

Snelson's sculptures utilize metal tubes and steel cables to create forms shaped by balancing tension and compression. The pull of the steel cable is resisted by the push of the steel pipes, which do not touch each other and would tumble into a pile if the wires were cut. The finished products are lyrical, open-form works that suggest suspension bridges, intricate kite frames, and, for Snelson, music. He states, "The wires and metal tubes are my keyboard, on which I play my three dimensional spatial game. I have developed something like a musical scale." The Snite's sculpture, appropriately titled *Mozart I*, is a maquette for a larger sculpture of the same title and date in the collection of Stanford University. CRL

Kenneth Snelson
American, born 1927
brass and wire
34.75 x 50.5 x 49.5 inches (88.27 x 128.27 x 125.73 cm)
Gift of Mr. Thomas T. Solley
2004.030

LATENT EMISSIONS, 1998

African American artist Chakaia Booker crafts evocative sculptures from salvaged rubber—discarded tires, inner tubes, and hoses. In this example, Booker cut tires into elongated shapes like curving steel scythes or spear points, some sliced cleanly, others jagged and frayed. From certain angles, *Latent Emissions* looks like an erect animal, raised on its haunches and prickling with stiffened quills.

The sculpture resembles traditional African works known as "power figures," which are created by carving a wooden figure then ritually adding materials such as shells, beads, or nails to empower the sculpture. One particular type, called "nail fetishes" by Europeans and "Nkisi Nkonda" by their Congo makers, feature dog and human forms into which many nails are partially driven. The nailing process symbolizes the activation of the figures by metaphorically attaching the words of divorce settlements, criminal judgments, and other agreements. Guardians of the contracts, these sculptures stand with raised heads and bristling quill-like nails, prepared to attack anyone who dares break the terms.

Booker's sculpture is similarly poised for assault, ready to discharge the concealed properties suggested by its title. Literally, it emits the odor of rubber, a material associated with plantations, slavery, and colonialism. Figuratively, it releases African traditions into our world. CRL

Literally, it emits the odor of rubber, a material associated with plantations, slavery, and colonialism. Figuratively, it releases African traditions into our world.

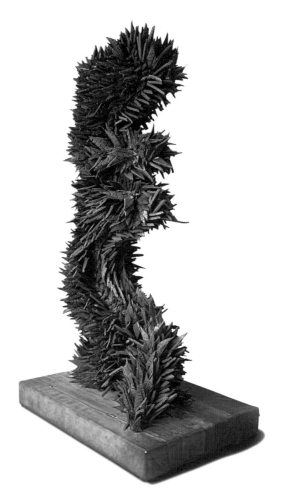

Chakaia Booker
American, born 1953
rubber tires and wood
72 x 45 x 32 inches (192.88 x 114.3 x 81.28 cm)
Acquired with funds provided by the Walter R. Beardsley Endowment for Modern and Contemporary Art
1998.028

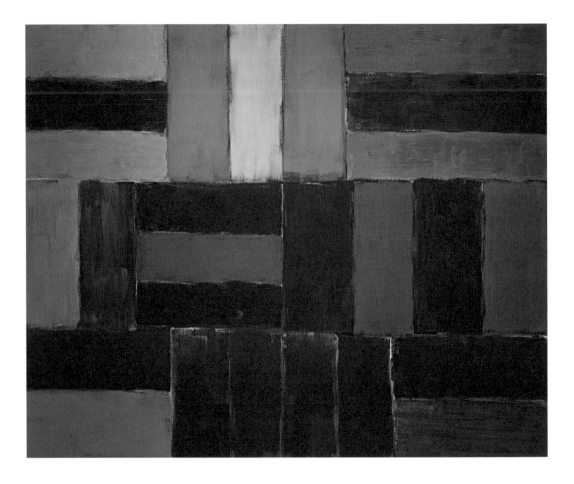

Color is applied in various bricklike configurations that must fit together in order to create a compact overall field—one that is not too perfect.

WALL OF LIGHT BLACK, 1998

The green and misty Irish landscape is practically a national symbol. Sean Scully, who was born in Dublin, is intrigued by the atmosphere of this island landscape, by the way light peeks in and out of perception, and how this quality might relate to the Irish people. The light has a peculiar and melancholic quality, what the late poet Robert Duncan called "a light wet with doubt." Indeed, Scully is not a painter of first light, when dawn brings the optimism of new beginnings. He gravitates instead toward dusk and late night, when doubt fuels the imagination.

While many artists seek to bring light out of dark, Scully seems intent on bringing darkness to light, as if he were revealing a deep inner secret. His *Wall of Light* paintings are not illustrative of a particular wall but are virtually analogous to the building of one. Color is applied in various bricklike configurations that must fit together in order to create a compact overall field—one that is not too perfect. Scully's blocks of color, at their best, have the naturalness of stones. MA

Sean Scully
American, born in Ireland, 1945
oil on linen
96.13 x 120.5 inches (244.16 x 306.07 cm)
Acquired with funds provided by the Humana
 Foundation Endowment for American Art
1999.027

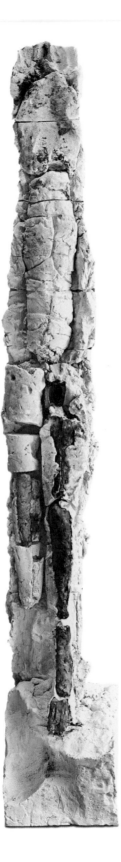

Courtesy the Artist and Franklin Parrasch Gallery

FIGURE COLUMN IX, 2001

Stephen De Staebler creates clay and bronze sculptures of the human figure that often juxtapose the frailty of individual lives against the remarkable resilience of mankind. Their form is rooted in ruins of classical sculpture, memorial stele, and architectural friezes; their style owes a debt to Auguste Rodin, Alberto Giacometti, and Henry Moore; and their fabrication process is influenced by the ceramic sculptor Peter Voulkos and by Abstract Expressionism.

Figure Column IX is a life-size, fractured representation of a human body—a leg, a second partial leg, an androgynous pelvis, a stomach, and a chest. The figure rises from a rocklike outcropping, suggesting humankind's dependence on, and tenuous relationship with, the natural world. It was formed lying on its back in a brick trough. The impressions of the bricks are visible within the clay and, when the sculpture is raised upright, form a horizontally striated pattern like those found on columns. Alternatively, they suggest geological strata, referencing evolution.

The sculpture was acquired to honor the victims of the September 11, 2001, terrorist attack on the World Trade Center in New York City. In memorializing the dead and assisting the bereaved in dealing with loss, it fulfills one of art's longest-standing functions. CRL

NOTRE DAME, 2001

Peter Voulkos created this piece during a two-week residency at Notre Dame in 2001. He first threw traditional ceramic forms, such as plates and bowls, on a potter's wheel, then took these vessels apart and reassembled them. In doing so, he challenged the traditional belief that ceramic objects should have a function, such as food storage or service, and that they should fulfill this function with highly decorated, refined forms.

Voulkos's interest in revealing the artist's labor is evident in the impressions left by his hands and fingertips. The sculpture also shows the chemical transformation that occurred during its firing in Notre Dame's *anagama* wood kiln. Ash carried by the draft of the fire landed on the surface, where it melted to form the glaze The greenish areas show where the ash rested most heavily, and the reddish areas indicate where ash did not settle.

Peter Voulkos
American, 1924–2002
wood-fired stoneware
56 x 32 inches (142.24 x 81.28 cm)
Acquired with funds provided by Mr.
 John C. Rudolf (Class of 1970)
2001.015

Stephen De Staebler (opposite page)
American, born 1933
fired clay
77 x 11.5 x 16 inches
 (194.81 x 29.1 x 40.48 cm)
Acquired with funds provided
 by the Humana Foundation
 Endowment for American Art
2002.028

Like Abstract Expressionist painters, for whom creating art was a process of self-exploration, Voulkos utilized an aggressive process to produce artworks. Some have suggested that his sculptures should be read as metaphors for the transformative events that all individuals undergo during their lifetime. Others see them as references to humans' primal needs: housing (caves or huts), food preparation (chimneys or ovens), and food storage (amphorae). CRL

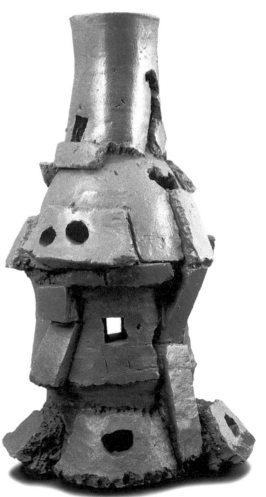

PHOTOGRAPHY

As the thirty photographs reproduced here suggest, the Snite Museum's photography collection is distinguished by both its quality and its quantity. Experts such as Lee Marks, Richard Pare, and Eugenia Parry have all praised the collection, while at the same time suggesting directions for future growth and improvement. More than five hundred photographers are represented by almost ten thousand examples of their images, some of which are unique.

Current areas of strength are early European photographs on paper, American western landscapes, documentary photography, and images from the American Civil War. Recently, the Museum has decided to expand its collection of photography from Latin America by systematically acquiring works from that region from the nineteenth century to the present.

The first photograph entered Notre Dame's collection in 1898. It was a small tintype of a Native American youth in the costume of a military cadet from a boarding school. It was collected not for the photograph but for the quality of the Iroquois beaded leather frame. More than fifty years later, the granddaughter of General William Tecumseh Sherman donated the general's personal collection of Civil War photographs that documented his campaign from Chattanooga to Atlanta and his march to the sea. The group included sixty-two prints by George Barnard, an official army photographer and one of the greatest landscape photographers of the period. Finally, in the 1970s, the Snite's director and a curator began systematically acquiring photographs, and the collection has been growing ever since.

The 1970s saw an explosion in the photography market, with both museums and private collectors acquiring images from a new network of galleries and private dealers. For what would seem incredibly low prices today, the Museum obtained photographs by such masters as Berenice Abbott, Ansel Adams, Diane Arbus, Richard Avedon, Brassaï, Henri Cartier-Bresson, Edward S. Curtis, Laura Gilpin, Lewis W. Hine, Joel Meyerowitz, Arnold Newman, August Sander, W. Eugene Smith, and Minor White. Donors contributed portfolios by Edouard Boubat, Manuel Alvarez Bravo, Larry Clark, Alvin Langdon Coburn, Robert Doisneau, Elliott Erwitt, Ralph Gibson, André Kertész, Aaron Siskind, and Garry Winogrand. One portfolio, *On the Road*, includes photographs by Robbert Flick, Mark Klett, and Joel Sternfeld.

A recent search of the Snite's photography database reveals the names of over one hundred donors, many of whom have made important and substantial contributions. Two families, however, became crucial in elevating the collection to a new level. The generosity of Janos Scholz, his wife Helen, their son Christopher and his family, and that of Fritz and Milly Kaeser deserves special mention.

Janos Scholz was a cellist who also collected prints and drawings. Eventually, his prints went to the Philadelphia Museum of Art, and the drawings went to the Metropolitan Museum of Art and the J. P. Morgan Library, both in New York. Still interested in collecting, Scholz began acquiring in a completely new field, nineteenth-century European photography on paper. A charter member of the Museum's advisory council, he let it be known that he was building his collection with the intention of donating it to Notre Dame. Packages of photographs began arriving in the late 1970s, and at a 1984 exhibition of sixty of his favorite photographs, Scholz publicly announced the gift of his entire collection. In 1994, one year after his death, the Scholz family presented the Museum with more than eight hundred photographs, knowing that his intention was for the collection to stay intact.

Scholz's collection includes work by the French photographers Antoine-Samuel Adam-Salomon, Eugène Atget, Edouard-Denis Baldus, Gustave Le Gray, Charles Marville, Nadar, Charles Nègre, Camille Silvy, Louis Vignes, and dozens of others. From Britain, there is a large group of prints and negatives by William Henry Fox Talbot, one of the co-inventors of photography. There are also photographs by Julia Margaret Cameron, Roger Fenton, and David Octavius Hill and Robert Adamson (who formed the partnership Hill and Adamson). Travel photographs include images by Felice and Antonio Beato, Giacomo Caneva, Charles Clifford, Juan Laurent, Robert Macpherson, Carlo Ponti, and Woodbury and Page. Many fine pictures are by unidentified photographers, and others are exceedingly rare, such as the only known prints of certain images by Camille Silvy and Hill and Adamson. One of the Talbot photographs was taken in November 1839, only months after he announced his discovery of the medium.

An exhibition of the Scholz collection highlights, accompanied by a catalog, opened at the Snite Museum in 2002. It then traveled to the Worcester Museum of Art in Massachusetts and the Arkansas State Center for the Arts in Little Rock.

Another charter member of the Museum's advisory council, Fritz Kaeser, and his wife, Milly, are the other preeminent donors to the photography collection. Fritz was a lifelong photographer who produced both commercial and personal work. He ran studios in Madison, Wisconsin; Aspen, Colorado; and Tucson, Arizona. Milly has been a dancer, teacher, sculptor, friend of the poor, and patron of the arts for over seventy years. Fritz and Milly both converted to Catholicism as adults and began searching for a place where they could combine their spirituality with their love of the arts. They found that place at Notre Dame.

After funding several Museum projects, such as the conversion of Ivan Meštrović's former sculpture studio into a gallery, Fritz turned his attention to the photography collection. In the 1980s he completed an extensive project, the reprinting of several hundred of his best negatives, some going back to the 1930s. He donated the resulting prints to the Snite Museum, knowing they would be preserved and appreciated. After Fritz's death in 1990, Milly worried that his negative files and prints might be dispersed after her death. She was pleased and grateful when the Museum accessed and catalogued her husband's archives, amounting to more than one thousand images.

In gratitude, Milly Kaeser began to support the Snite's photography program more actively, donating funds both for acquisitions and to support the work of the curator, who now holds the title "Fritz and Milly Kaeser Curator of Photography." A careful reading of the captions in the photography section of this book will suggest the quality of the numerous purchases she has funded.

These acquisitions have not been made at random; there is an overall plan of development. Since the Museum serves a university community, it is a teaching collection. Therefore, one goal has been to obtain photographs that are examples of the main styles and movements in the medium from its beginnings to the present. Another aim is to more widely represent the diversity of the world's photographers, seeking works of excellence from other countries and cultures. This is one impetus for the Snite's new interest in Latin American photography. Finally, Notre Dame is a Catholic university, and it is important that there are images that comment both literally and metaphorically on questions of faith and morals, on the struggle for redemption, on the nature of both grace and evil, and on social justice. These are lofty goals, but the Museum is working steadfastly and faithfully to achieve them. SRM

PORTRAIT OF NICOLAAS HENNEMAN, about April 1841

William Henry Fox Talbot
British, 1800–1877
calotype negative
2.25 x 1.75 inches (5.71 x 4.44 cm)
The Janos Scholz Collection of
　　Nineteenth-Century European
　　Photography
1985.074.020.A

When the discovery of photography was announced in 1839, the pragmatic Victorians immediately asked, "What is it good for?"

The earliest photographers must have felt they were involved in a kind of magic, but they were also concerned with making a profit. Since the invention of photography in 1839, almost all full-time photographers have produced pictures to sell to clients. After the sheer novelty of the medium wore off, it quickly became apparent that there was a huge demand by the public for portraits of themselves and their loved ones, and that they were willing to pay good money for them. But there was a problem: the time needed to take a photograph ranged from several minutes to an hour, too long for a person to sit perfectly still. The sitter invariably moved, resulting in a blurry image without the clarity and sharpness that the public demanded.

The inventor of photography on paper, William Henry Fox Talbot, made the negative image on paper illustrated here as part of the search for a shorter exposure time. Talbot had developed a process to capture an image projected onto a piece of sensitized paper in a camera. This portrait of his butler and assistant, Nicolaas Henneman, might have been done in thirty seconds to two minutes, just barely making commercial portraiture possible. A print made from a paper negative could never be really sharp, however, since the light was diffused when it passed through the paper fibers.

When the discovery of photography was announced in 1839, the pragmatic Victorians immediately asked, "What is it good for?"

PORTRAIT OF R. H. ALEXANDER,
1841/42

Henry Vines
British, active 1840s–1850s
daguerreotype
2.5 x 2 inches (6.35 x 5.08 cm)
Acquired with funds provided by
 Betty Gallagher and John Snider
2000.077.003

The second portrait is a daguerreotype, named after the inventor of that process, Louis-Jacques-Mandé Daguerre. Daguerreotypes, which were camera images imprinted on a silver-coated sheet of copper, could be incredibly sharp and clear. At first, they posed the same problem that Talbot's pictures originally had: very long exposure times ranging from ten minutes to several hours. By the time Mr. Alexander sat for this portrait in Bristol, England, the first commercial photographic studios had just been opened. With the introduction of a new type of camera and more sensitive plates, the exposure time was between three seconds and two minutes, depending on the brightness of the sunlight. More technical advances soon allowed bigger images and even shorter exposure times, and the daguerreotype became the overwhelming choice for portraits. Its dominance continued for more than a decade, until the process was rendered obsolete by glass negatives and albumen-coated paper, which yielded a sharp portrait at a much cheaper price.

Today, the paper print made from a camera negative is being replaced by the digital image, and the cycle of technological advancement continues. SRM

FOREST OF FONTAINEBLEAU, about 1853

One sunny day about 1853, Gustave Le Gray, a former painter, set up his large camera on a tripod along a rutted dirt road in the Forest of Fontainebleau, outside Paris. Using a process of his own invention, he produced a paper negative from which he printed this striking photograph. Le Gray deliberately chose to make the image somewhat diffuse and dreamlike, believing that the effect made the photograph more like a drawing, and thus more "artistic." The result resembles some of the landscapes of the Barbizon painters and anticipates the technique of the Impressionists.

Le Gray's forest view is a masterpiece of the genre. The warm golden tone of the photo-graph perfectly conveys the sunlight filtering through the leaves and dappling the trunks of the trees. The converging ruts of the path lead into the distant woods, inviting the viewer to enter the scene. Soft, cloudlike areas in the branches above are not technical mistakes but a record of the breeze that rustled the leaves during the long exposure, on a hot summer's day in France more than one hundred and fifty years ago. SRM

Gustave Le Gray
French, 1820–1882
salt print from a waxed-paper negative
10.1 x 14.5 inches (25.7 x 37 cm)
The Janos Scholz Collection of Nineteenth-
 Century European Photography
1984.012.030

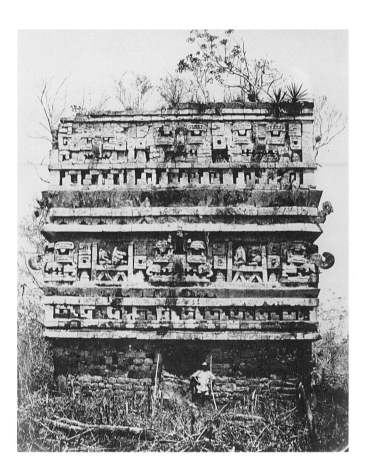

MAYA RUINS AT CHICHEN-ITZA, MEXICO, 1860

Désiré Charnay
French, 1828–1915
albumen silver print from
 wet-plate negative
16.25 x 13.25 inches
 (41.3 x 33.7 cm)
Gift of Milly Kaeser in
 honor of Fritz Kaeser
2000.046

Viewers of this photograph in the 1860s must have felt they were looking at something from an alien culture, as indeed they were. A building rises out of the jungle, recently freed from centuries of tropical vegetation and neglect. Long-nosed monsters with huge teeth jut out from the corners, and one glares directly at the viewer. These Maya sculptures are like nothing that had ever been created in Western art.

Désiré Charnay was a schoolteacher in New Orleans when he read reports of abandoned cities being discovered in the jungles of southern Mexico. Charnay quit his job, returned to France to learn photography, and began an expedition to Mexico. He photographed for two years, surviving bandits, rain, snakes, illness, and a civil war. He once woke to find himself and the walls of the ruin in which he was sleeping covered with large black insects that were sucking his blood. But he persisted.

His determination, as well as the successful sales of his photographs back in Europe, shows how important these exotic images were to the Victorians. For people who often lived their whole lives only a few miles from where they were born, such travel photographs entertained, educated, and astonished. SRM

THE FALLS OF TIVOLI, about 1858–60

It is hard to believe that the humble picture postcard is a direct descendant of this large, beautiful photograph. But they exist for the same reason: to serve as a souvenir of a journey. The common perception of the truthfulness of photography, combined with its affordability, made images such as this the perfect memento of the Grand Tour.

Practiced as early as the Elizabethan era, a tour of the monuments of Italy, and perhaps Greece, via France (as well as sometimes Egypt and the Holy Land) became a crucial educational experience for English gentlemen and artists in the eighteenth century. The technological and economic changes of the Victorian era enabled a greater number of people, including members of the middle class and Americans, to travel abroad and participate in this aristocratic rite of passage. The heart of the tour was Italy, which was rich in art and history and was also considered exotic, as its culture was often Mediterranean and always Roman Catholic.

Like their predecessors, these Victorian tourists wanted pictures of Italy and other locales to take home with them as souvenirs of their travels to mount in albums or hang on walls. Photography flourished as an inexpensive substitute for painting, and British photographers such as Robert Macpherson established themselves abroad to produce images for travelers.

A Scottish surgeon, Macpherson had originally moved to Italy for his health. He opened a studio there and became one of the finest photographers in the country. Like all great artists, he learned to work with both the strengths and weaknesses of his medium. He achieved extremely fine detail in his images by using large negatives that, instead of being enlarged, were printed by sunlight in direct contact with the photographic paper. His Victorian customers enjoyed letting their eyes roam over the surface of pictures such as this one, noting every rock, every leaf, the many streams of cascading water, and even the individual tiles on the roofs of the distant buildings.

The photographic process Macpherson used was not very sensitive to light, and the long exposures of the period made it nearly impossible to capture moving things, as they would blur in the print. Macpherson embraced this limitation and allowed it to transform the falls into soft, flowing shapes that seem to coat the cliffs with streams of liquid light. SRM

Robert Macpherson
British, 1811–1872
albumen silver print from wet-plate negative
16.6 x 12.25 inches (42.2 x 31.1 cm)
The Janos Scholz Collection of Nineteenth-
 Century European Photography
1979.122.001

PAINTER'S STUDY OF A NUN, about 1860s

Jean Nicolas Truchelut
French, active 1850s–1870s
albumen silver print from wet-plate
 negative
8 x 6 inches (20.3 x 15.2 cm)
The Janos Scholz Collection of
 Nineteenth-Century European
 Photography
1994.030.129

Photography has had a long and complicated relationship with the other arts, especially painting. Some nineteenth-century artists were resentful of the new medium, fearing that it would replace demand for their paintings, whereas others were quick to grasp its usefulness. Eugène Delacroix, for example, regretting that the invention had occurred so late in his life, took daguerreotype lessons, and both collected and commissioned photographs. He wrote in his journal that if photographs were used wisely, an artist could "raise himself to heights that we do not yet know."

The woman seen here is not a nun but a model dressed as one. She was photographed in a pose that an artist planned to incorporate into a painting. Since the image was not meant to be "real," studio props and posing stands were used openly to steady the model for the long exposure. The painter, probably François-Victor Jeannenet of Besançon, traced a grid to make it easier to transfer the image onto a larger canvas. Other photographs in this group suggest the painting may have been intended for a scene in a hospital, with a nursing sister offering water or medicine to a sick patient, in a kind and graceful gesture of healing. SRM

LU-LA LAKE ATOP LOOKOUT MOUNTAIN, CHATTANOOGA, 1866

George Barnard's photograph of Lu-La Lake on Lookout Mountain in Tennessee is not a typical Civil War photograph. There are no soldiers and no dead sprawled on the ground; in fact, there is no human presence. Because photography at that time was too slow to capture an actual battle, Barnard often photographed the aftermath, such as ruins, captured fortifications, and shattered trees. His images became quiet metaphors for the violence that had scarred the South.

Lu-La Lake, however, was not the site of a battle. Apparently, as Barnard explored the mountain in 1866, he could not resist the beauty of the scene. The rocks in the foreground appear to be close, but the transition to the lake and ridge receding in the distance is abrupt. Thus the image exists simultaneously in both two and three dimensions, giving the photograph a visual energy that contrasts with the serenity of the place.

A local Cherokee legend held that the waters of the lake had healing properties and warriors of different tribes could rest there without fear. After experiencing the bloodiest event in American history, Barnard must have seen a place where all could be healed as a symbol of what the country desperately needed. SRM

George Barnard
American, 1819–1902
albumen silver print from wet-plate negative
10 x 14 inches (25.4 x 36.56 cm)
Gift of the Friends of the Snite Museum of Art
2000.072

YOSEMITE CLIFF, AT SUMMIT OF FALLS, 1872

Eadweard Muybridge became famous in photographic history for successfully freezing the image of rapidly moving people and animals. Prior to his motion studies, Muybridge was already well known as a successful photographer. His mammoth glass wet-plate negatives and stunning, finely detailed prints proved that in addition to having a good eye, he was a master of photographic technique.

One of Muybridge's goals in this photograph was to communicate the vastness of Yosemite. On the right is a distant scene, with the valley and mountains fading until they disappear in the soft haze. In contrast, on the left is the sharply focused face of a rocky cliff, which seems to come right up to the viewer's feet. The point of view is not from the top of the cliff looking down, but rather from the face of the cliff looking out into space. This was a deliberate effect; newspaper accounts of Muybridge's expedition mentioned that he often had the camera and tripod (and himself, as camera operator) lowered by ropes to narrow ledges below the edge of the cliffs, so that the viewer would seem to be hovering in space. SRM

Eadweard Muybridge
British, 1830–1904
albumen silver print from wet-plate negative
17 x 21.5 inches (43.18 x 54.61 cm)
Gift of Milly Kaeser in honor of Fritz Kaeser
2001.048.001

HISTORIC SPANISH RECORD OF THE CONQUEST, SOUTH SIDE OF INSCRIPTION ROCK, NM, NO. 3, 1873

Its graphic simplicity gives this image a contemporary look, but the picture is also a product of its time, filled with meaning. The photographer, Timothy O'Sullivan, had photographed during the Civil War as a protégé of Mathew Brady and Alexander Gardner. After the war, Washington focused its interest on the still largely unexplored West, sending expeditions of soldiers, geologists, cartographers, botanists, and photographers to document its new territory.

Inscription Rock, now a national monument, had been inscribed by Native Americans for thousands of years. After the Spaniards conquered the indigenous tribes, they added the bluff to their empire. This particular inscription commemorates a Spanish expedition in 1726. One hundred years later, the cliff became the property of Mexico. Then, after the Mexican American War, it was ceded to the United States. Decades later, O'Sullivan arrived and made a photograph that asserts, "You are ours now, we own you, we measure you and file you in our final report." The Spanish inscription carved in stone has been made visible by cutting back the plant in front, and a yardstick has been placed underneath.

O'Sullivan's image has become a document of colonialism, imperialism, and manifest destiny. And, perhaps strangest of all, it has ended up in a museum, considered a work of art. SRM

Timothy O'Sullivan
American, born in Ireland, 1840–1882
albumen silver print from wet-plate negative
8 x 11 inches (20.32 x 27.94 cm)
Acquired with funds provided by Betty Gallagher and
 John Snider
1994.003.002

BAPTISM OF THE SHIVWITS INDIANS, March 1875

When this picture was taken near St. George, Utah, in March 1875, the Shivwits Indians were in a hungry, weakened condition, many of them dying from imported diseases such as measles and smallpox. A prophet named Antelope Jack had a revelation that the tribe should cooperate with its white neighbors, so their chief—called "Old Katoose" by the white settlers—agreed to lead the entire tribe into baptism in the Mormon Church. In the photograph, the elderly chief stands in the river, staring into the viewer's eyes.

The scene was captured by photographer Charles Savage. Savage was born in Southampton, England, in 1832 and was converted to Mormonism by missionaries. In 1857 he emigrated to New York, and in 1860 he moved on to Salt Lake City, where he operated a studio for the next forty years. In an article in the *Deseret News* in April 1875, Savage described the circumstances of making this photograph:

As we were leaving St. George for the desert, we saw a great gathering of Indians near a pool north of the city. We found on arriving there that Qui-tuss and 130 of his tribe, composing part of the Shebit nation, were about to be baptized. Their manner was as simple and childlike as could be. Bro. A. P. Hardy [standing on the right] acted as interpreter, and when he announced that they would engage in prayer, these swarthy and fierce denizens of the mountains knelt before our Eternal Father with

more earnestness of manner than some of their white brethren... animosities were buried, the past forgotten.

It may be asked, what good will it do the Indians? I answer that it means they must change their habits of life, they must wash themselves regularly, they must stop the use of paint on their faces, they must work and not let the ladies do it all, they must learn to live like their white brethren.... As evidence, I saw an Indian asking for work.... Others were hunting old clothes, that they might dress like their white brethren.

After the ceremony, two cattle were slaughtered and the meat distributed to the Indians. It is reported that for years afterward, the Shivwits regularly requested to be baptized again, so they could obtain more food and clothing.

Savage returned to Salt Lake City, where he made this albumen print from the glass negative. The negative was probably lost in the fire that destroyed his studio in 1883. Charles Savage was a charter member of the Mormon Tabernacle Choir, where he sang until his death in 1909. SRM

Charles Savage
American, born in England, 1832–1909
albumen silver print from wet-plate negative
7.75 x 9.63 inches (19.7 x 24.5 cm)
Acquired with funds provided by the Humana
 Foundation Endowment for American Art
2000.021

After the ceremony, two cattle were slaughtered and the meat was distributed to the Indians. It is reported that for years afterward, the Shivwits regularly requested to be baptized again, so they could obtain more food and clothing.

The lines and numbers Fraser inserted to identify parts of the brain may strike modern viewers as strangely numerical, ghostly thoughts still wandering around the dead man's brain.

PLATE 15 FROM "A GUIDE TO OPERATIONS ON THE BRAIN," 1890

The scientific use of photography began within the first year of the medium's discovery. A camera's ability to quickly record a large amount of detailed information corresponded perfectly with two of the nineteenth century's great obsessions: classifying and ordering. This picture of a human head was taken to train students at the Royal College of Surgeons in Dublin by Alec Fraser, the professor of anatomy. Fraser had developed a chemical treatment that hardened the inner organs of a cadaver, making it possible to saw off slices and reveal the interior structure.

Fraser's images, like Timothy O'Sullivan's western survey photographs, have proven over time to possess qualities that transcend their original use as documentation. Some of the pictures appeal to contemporary taste and are expressive of the photographer's personal vision. In this example, the lines and numbers Fraser inserted to identify parts of the brain may strike modern viewers as strangely numerical, ghostly thoughts still wandering around the dead man's brain. SRM

Alec Fraser, MD
Scottish, 1853–1909
autotype
13.5 x 10 inches (34.2 x 25.4 cm)
Gift of Milly Kaeser in honor of Fritz Kaeser
2004.008

SAINT-CLOUD, June 1926

Eugène Atget is one of the most admired photographers in the history of the medium. He came to photography after failed careers as a sailor, an actor, and a painter. He began documenting Paris and its environs in the late 1880s, and after almost forty years he had produced more than seven thousand glass negatives of plants, animals, street scenes, shop fronts, architectural details, and landscapes. Atget eked out a living selling prints to painters, designers, and government agencies. He shied away from being called an artist, apparently thinking of himself more as a craftsman.

Saint-Cloud was one of the few exposures Atget made in June 1926, the same month that his companion of thirty years, Valentine,

died. Atget would follow her a year later. In these late pictures, it often seems that he was less concerned with documentation than with exploring light and shadow and the passing of time. *Saint-Cloud* conveys the sensation of peering out from the darkness under a tree into the brightly lit park. It is unclear whether the viewer is moving forward into the light, falling back into the darkness, or balancing precariously on the edge between the two. SRM

Eugène Atget
French, 1857–1927
7 x 9 inches (17.78 x 22.86 cm)
gelatin silver printing-out-paper print
Gift of Milly Kaeser in honor of Fritz Kaeser
2002.020

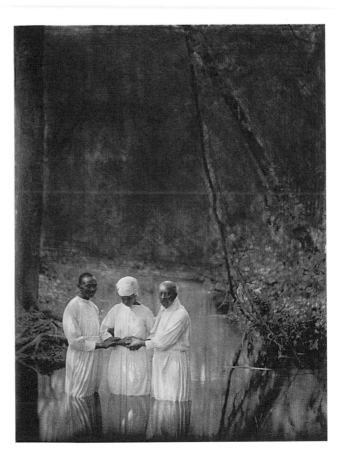

UNTITLED (BAPTISM IN THE SWAMP), 1929–33

From *Roll, Jordan, Roll*
Doris Ulmann
American, 1882–1934
photogravure
8.25 x 6.36 inches (30 x 16.2 cm)
Gift of Milly Kaeser in honor of
 Fritz Kaeser
2002.012.003

Doris Ulmann was a New York society photographer who worked from a darkroom in her Park Avenue apartment. She had a strong sense of social responsibility and decided to photograph American subcultures that were disappearing in the face of industrialization and urbanization. Ulmann photographed the Pennsylvania Amish, Louisiana Creoles, and Shakers and made trips into the Appalachian region in her chauffeur-driven Lincoln.

In the 1920s, Ulmann traveled to the South Carolina plantation of novelist Julia Peterkin to photograph the Gullah people. The Gullahs are descendants of slaves who had worked the rice and cotton fields near the coast. Ulmann was fascinated by them, and besides making many handsome portraits, she documented their work and the surrounding landscape. This beautiful photograph of a baptism is part of a series on Gullah religious rituals, published with Peterkin's text as the book *Roll, Jordan, Roll*.

Ulmann worked in the older pictorial style, which featured carefully posed subjects depicted in warm tones and soft focus. At the same time, she was driven by a more modern documentary sensibility, similar to that of her contemporaries Dorothea Lange and Walker Evans. Her work is a rare successful blending of the two different modes, balanced between romantic pictorialism and the social realism of the Depression. SRM

PARIS, CHILDREN PLAYING BY THE SEINE, 1931

When the Leica, a small handheld camera that used 35-millimeter film, was introduced in Europe in the 1920s, it caused a visual revolution. Photographers such as Ilse Bing, Henri Cartier-Bresson, and Robert Capa discovered they could now shoot quickly from any point of view. This development coincided with a more radical sense of design in graphics, and Bing's image is a fine example of this new way of seeing.

A vantage point above the scene allowed Bing to play with the shapes and patterns below. The boards of the gangplanks, the wooden pole, and the patterns of the cobblestones all run from lower left to upper right. The light pole and the railings shoot up toward the upper left, creating a counter force. Bing tilted the camera, making the river appear to be sliding off the left side, creating a sense of imbalance. Finally, the children running at a precarious angle up and down the embankment add to the tension. The result is not just another romantic Parisian image but a dynamic, modern-looking photograph that crackles with energy. SRM

Ilse Bing
American, born in Germany, 1899–1988
gelatin silver print
8.75 x 11 inches (22.22 x 26.95 cm)
Acquired with funds provided by Milly
 Kaeser in honor of Fritz Kaeser and
 the Walter R. Beardsley Endowment
 for Modern and Contemporary Art
2000.029

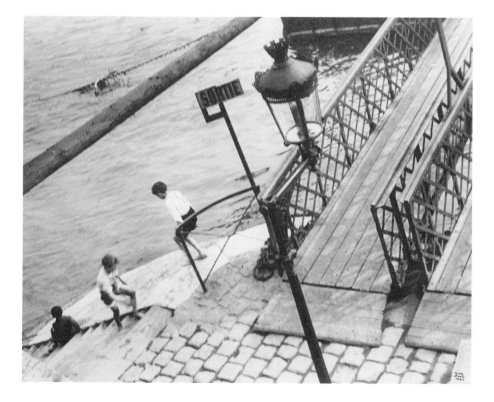

EL ENSUEÑO (THE DAYDREAM), 1931, printed 1974

Manuel Bravo was born in the heart of Mexico City, where the Catholic cathedral stands next to the remains of the huge temple of the Aztecs. All his life, he explored the meaning of *mexicanidad*, a personal and national identity that resulted from blending the history, customs, cultures, and geography of his country. Sometimes he photographed models, but more often he prowled the streets, searching for the miraculous in everyday life.

This image provokes a series of questions. Is the sitter in a dream state, her mind wandering? Is she as melancholy as she looks? She is surrounded by shadows, but a single beam of light shines down, brushes her hair, and comes to rest on her shoulder. Is the light about to move on, leaving her totally in the dark, or is it teasing her, pulling her out of the gloom?

The ancient peoples of Mesoamerica believed that when one dreams, the soul leaves the body to go on a journey. Sometimes the soul fails to return, so a search for a new one must begin. In a way, this describes the process by which Bravo and other artists after the Mexican Revolution sought to capture and define a new soul for their country. SRM

Is the light about to move on, leaving her totally in the dark, or is it teasing her, pulling her out of the gloom?

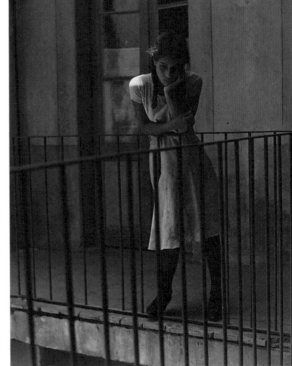

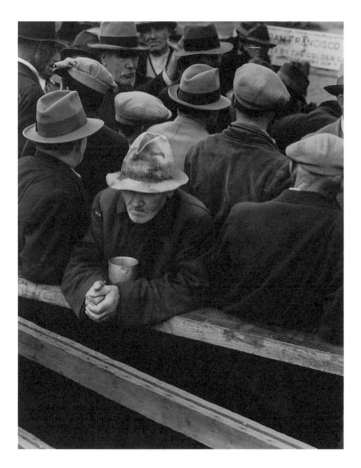

Dorothea Lange
American, 1895–1965
14 x 11 inches (35.56 x 27.94 cm)
gelatin silver print
Gift of Milly Kaeser in honor of
 Fritz Kaeser
2004.004

Manuel Alvarez Bravo (opposite page)
Mexican, 1902–2002
gelatin silver print
9.25 x 7 inches (23.5 x 17.78 cm)
Gift of Ms. Carol Lipis
1978.022.E

WHITE ANGEL BREADLINE, SAN FRANCISCO, 1933, printed 1950s

Dorothea Lange was a successful society photographer in San Francisco when the migrations of the Great Depression began. A curious and compassionate woman, she noticed the homeless and frightened men, women, and children who were pouring into the city looking for work. One day in 1933, she took her camera to the White Angel breadline, named by the men on the street after a wealthy woman who was using her own money to feed the hungry. Circling around the hunched figure of a small, grim man holding a tin cup, Lange made several exposures before finding the best angle. *White Angel Breadline* has become a classic image of America in the 1930s, a symbol of all the hungry, dejected victims of the Great Depression.

Lange tried to explain what it felt like to take a great picture:

> There are moments such as these when time stands still and all you do is hold your breath and hope it will wait for you. And you just hope you will have time enough to get it organized in a fraction of a second on that tiny piece of sensitive film... You know that you are not taking anything away from anyone: their privacy, their dignity, their wholeness.

SRM

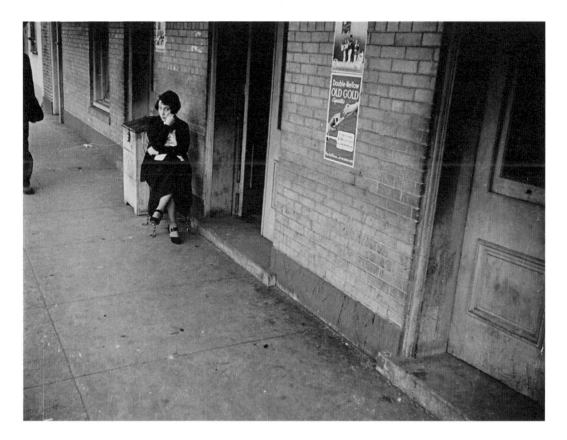

PROSTITUTE, NEW ORLEANS, LOUISIANA, 1936

Peter Sekaer was a brilliant commercial designer and a close friend of the photographer Walker Evans. They traveled together through the South, photographing side by side. It was previously assumed that Sekaer was learning from Evans, but now it is apparent that they were equals, learning from each other. Sekaer was one of the first Americans to experiment on the streets with the small new Leica 35-millimeter camera, and he made some great pictures.

In this photograph, the diagonals of the walls and sidewalk lead to the figure of the woman. Sekaer held his camera at eye level and took the picture at the exact moment she looked up and made eye contact. This makes the viewer feel that he or she is right there on the sidewalk, on a sunny day in New Orleans, approaching the wary woman and debating whether to walk by or stop and speak to her. SRM

Peter Sekaer
American, born in Denmark, 1901–1950
gelatin silver print
5.75 x 7.75 inches (14.5 x 19.5 cm)
Gift of Milly Kaeser in honor of Fritz Kaeser
2004.011.001

FLOYD BURROUGHS, SHARECROPPER, HALE COUNTY, ALABAMA,
1936, printed 1950s

Walker Evans
American, 1903–1975
gelatin silver print
9 x 7 inches (24.13 x 19.05 cm)
Gift of Milly Kaeser in honor of Fritz Kaeser
2000.044

Walker Evans was a complex man who strove to make photographs that looked simple. This portrait of George Gudger, who was given the pseudonym Floyd Burroughs to protect his privacy, was taken as part of a project commissioned in 1936 by *Fortune* magazine. Evans and the writer James Agee were called upon to produce an article on the living conditions of Depression-era southern tenant farmers and sharecroppers.

While Agee wrote, Evans photographed around Hale County, Alabama, mostly with a large view camera. His pictures often show the poverty of his subjects, but he was not making images for social reform. For Evans, the rural South was a place that had not been contaminated by the materialism and pretentiousness of urban American culture. Unlike the images of social documentary photographers such as Dorothea Lange, Evans's photographs were almost clinical and did not seem to have any social message at all. Here, the viewer is presented with the clear, sharp face of a tenant farmer but is not asked to feel any particular emotion toward him or endorse any specific social program.

Evans's photographs were widely admired by a new generation of photographers who saw them as documents that were in tune with the sharp, emotionless style of modernism. SRM

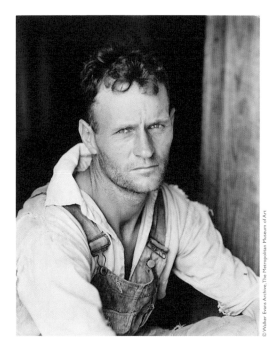

Here, the viewer is presented with the clear, sharp face of a tenant farmer but is not asked to feel any particular emotion toward him or endorse any specific social program.

The picture captured the fear and anxiety that families everywhere were feeling as war approached.

PVT. JOHN WINBURY OF THE CALIFORNIA NATIONAL GUARD SAYS GOODBYE TO HIS SON BEFORE HE LEAVES FOR HAWAII, 1940

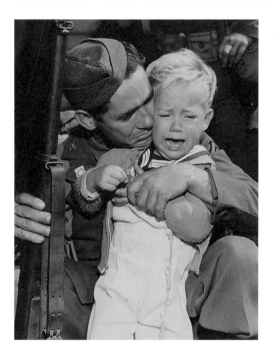

Robert Jakobsen
American, active 1940s–1950s
gelatin silver print
12.44 x 10.19 inches (31.6 x 25.9 cm)
Gift of Mr. Harold L. Cooke
1981.079

Robert Jakobsen was working as a photographer for the *Los Angeles Times* when he was sent down to the docks to get some shots of soldiers saying goodbye to their families. He was preparing to photograph a smiling couple, when he heard a child crying. Without thinking, he turned and snapped this picture. The editors of the *Times* realized it was special and immediately sent it over the wire to papers and magazines all over the country. The picture was an instant success, for it captured the fear and anxiety that families everywhere were feeling as war approached. It represents a scene that has been described for centuries in song and literature, going back at least to the *Iliad*.

Life magazine published the photograph in November 1940, greatly increasing its exposure. It was widely used as war propaganda in magazines and posters, and finally was circulated around the world as part of the hugely successful "Family of Man" exhibition and catalog.

This was the only important photograph Jakobsen ever took. Little is known about his life, not even his birth or death date. Private Winbury fought at the attack on Pearl Harbor, survived a number of battles in the Pacific theater, and eventually reunited with his son. SRM

W. Eugene Smith
American, 1918–1978
gelatin silver print
13 x 10 inches (33.02 x 25.4 cm)
Gift of Milly Kaeser in honor of
 Fritz Kaeser
2005.011

WOUNDED, DYING INFANT FOUND BY AMERICAN SOLDIER IN SAIPAN MOUNTAINS, 1944, printed 1977

W. Eugene Smith was a troubled man who often took great photographs. He entered Notre Dame on a photographic scholarship, but after failing two classes he left to look for work in New York. There, he slowly developed his reputation as a documentary photographer as World War II approached.

After Pearl Harbor, Smith tried desperately to get into the action, but various physical ailments held him up. Finally, he shipped out to the Pacific with his cameras, gramophone, and scores of jazz records. Before he was seriously wounded by shrapnel while covering his thirteenth island landing, he accumulated a remark-able body of work, photographs that conveyed the brutality of combat, as well as occasional moments of tenderness. He hated war and was not interested in glorifying it.

In this picture, Smith captured the scene of a medic retrieving the badly damaged body of an infant found under a rock. The soldier is helpless and can do nothing but wait for the child to die. His pose as he looks down at the body in his hands is an ancient one, recalling funeral monuments or perhaps a Pietà, a representation of Christ's body being handed down to his mother, who can only ponder and weep. SRM

MOUNT WILLIAMSON, SIERRA NEVADA, FROM MANZANAR, CALIFORNIA, 1944, printed 1970s

Ansel Adams made this photograph while driving home from the Manzanar War Relocation Camp. Manzanar had been built in a desolate part of Owens Valley, in eastern California, to house Japanese Americans who were forcibly interned during World War II. Adams produced a book of photographs, *Born Free and Equal*, focusing on the dignity of the detainees who had been imprisoned for years in the desert.

Although the photograph is a striking image of a rocky terrain, it is doubtful that beauty was the only thing on Adams's mind. Adams saw his photographs primarily as visual metaphors for the emotions and quasi-mystical feelings he had experienced while hiking alone in the High Sierra as a young man. These early epiphanies haunted him throughout his life, and photography was a way of communicating his sense of the divine in nature. If a picture was also beautiful, that was a testimony to his skill as a designer and a technician.

Adams was fascinated by the elegant rock gardens the Japanese Americans had constructed in Manzanar. Like these Zen rock gardens, his photographs were intended to be metaphors for the simultaneous complexity and unity of the universe. SRM

UNTITLED (CACTUS SPINES), 1950s

The Sonoran Desert is a vast place, and Fritz Kaeser was used to open spaces. Before establishing a studio in Tucson, Arizona, he had done most of his photographic work in and around Aspen, Colorado. His sharply focused, beautifully detailed photographs of the Rocky Mountains were sold to tourists, and he became nationally known as an accomplished ski photographer. The desert, however, was a completely new subject for him.

Fritz was a convert to Catholicism and had read widely on spirituality, especially the meditations of the Trappist contemplative Thomas Merton. He hiked in the desert with his camera for days at a time, focusing on smaller and smaller subjects: cacti, termite tracks on pieces of wood, torn scraps of linoleum, and blobs of slag from the abandoned smelters. He was fully aware of the nature of his quest, using photography to find spiritual illumination. When asked to explain these images, he often quoted a verse from William Blake:

To see a world in a Grain of Sand,
And a Heaven in a Wild Flower,
Hold Infinity in the palm of your hand,
And eternity in an hour.

SRM

Fritz Kaeser
American, 1910–1990
gelatin silver print
4.7 x 3.8 inches (11.9 x 9.6 cm)
Gift of Fritz Kaeser
AA1997.041.031.A

Ansel Adams (opposite page)
American, 1902–1984
gelatin silver print
15.55 x 18.5 inches (39.5 x 47 cm)
Mrs. Lorraine Gallagher Freimann
 Purchase Fund
1975.065

Heath began walking the streets with a camera, looking for images that resonated with his own dark childhood feelings, as well as his adult fears.

David Heath
Canadian, born 1931
gelatin silver print
14 x 11 inches (35.6 x 27.9 cm)
Acquired with funds provided
 by the Humana Foundation
 Endowment for American Art
1993.074.008

PORTRAIT OF A YOUTH, about 1957–60

David Heath's parents abandoned him when he was four years old, and he grew up in a series of foster homes and an orphanage as a ward of the state. One day he saw a photo essay in *Life* magazine about a troubled boy much like him. Heath realized he could use photography to make sense of his own life. He began walking the streets with a camera, looking for images that resonated with his own dark childhood feelings, as well as his adult fears. He accumulated hundreds of photographs and selected eighty-two prints to publish as *A Dialogue with Solitude* in 1965.

Heath was worried that some readers might see only the pain and darkness in the book, so he wrote in the preface:

What I have endeavored to convey in my work is not a sense of futility and despair, but an acceptance of life's tragic aspects. For out of acceptance of this truth: that the pleasures and joys of life are fleeting and rare, that life contains a larger measure of hurt and misery, suffering and despair—must come not the bitter frustration and anger of self pity, but love and concern for the human condition.

SRM

292

PARACELSUS, 1957

Frederick Sommer was a Surrealist, one of few American photographers to pursue that path. Over the years, he turned his camera on deteriorating books, broken glass, chicken parts, and pieces of junk found on walks through the Arizona desert. He experimented with completely new ways of making images, such as accumulating soot or paint on glass or plastic and using the result as a negative in his photographic enlarger.

At first glance, *Paracelsus* seems to portray the torso of a badly damaged sculpture. On closer look, it appears to depict a mass of metallic silver that has melted in places. Finally, after careful scrutiny, it becomes obvious that the beautiful swirls of silver cannot actually describe a three-dimensional object.

The original Paracelsus was a medieval Swiss alchemist whose goal was to find the elusive philosopher's stone, which supposedly could turn ordinary metal into gold or silver. To create this photograph, Sommer smeared an inch-long blob of pink polymer paint onto a small piece of plastic with his finger. When it dried, he placed the plastic in his enlarger and used it as a negative to print the image. Thus, like a modern-day alchemist, Sommer transformed an insignificant object into a silver print of great beauty. SRM

Frederick Sommer
American, born in Italy, 1905–1999
gelatin silver print
13.44 x 10 inches (34.13 x 22.56 cm)
Gift of Milly Kaeser in honor of Fritz Kaeser
2001.022

© Fredrick & Frances Sommer Foundation

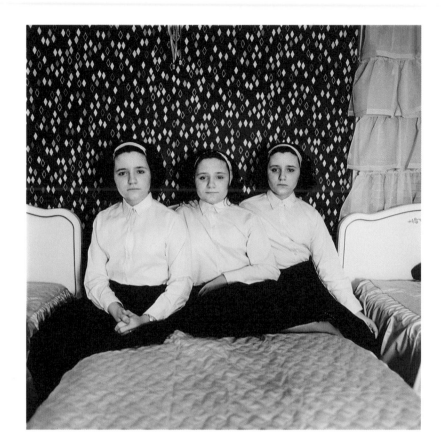

TRIPLETS IN THEIR BEDROOM, NJ, 1963, printed later by Neil Selkirk

Multiple births have fascinated humans for thousands of years. In some cultures, they were seen as a punishment or a bad omen, and the children were killed. In other societies' myths, twins performed great deeds, such as the founding of Rome by Romulus and Remus or the defeat of dark underworld forces by the Maya Hero Twins.

The triplets in Diane Arbus's photograph at first do not seem either frightening or mythic. What could be more normal than sisters sitting in their bedroom? Yet there is uneasiness below the surface. The identical beds are close together, creating a kind of display platform for the three identical girls. Hundreds of diamonds in the wallpaper, the folds of the curtain, and even the repetition of the soft patterns of the comforter reinforce the idea of replication.

Then it becomes apparent that the girls' skirts have been printed so darkly that they become one single form, from which the three torsos emerge. This illusion, that all three girls share the same body, recalls the Greek myth of the multiheaded Hydra. The middle girl's smile adds to the sense of enigma. SRM

Diane Arbus
American, 1923–1971
gelatin silver print
14.5 x 14.5 inches (36.83 x 36.83 cm)
Dr. M. L. Busch Purchase Fund
1977.090

I AM BLIND AND DEAF, 1963, printed before 1975

Photographers have always been attracted to the life of the streets, which are the busy theaters of our daily lives. Sometimes there is too much activity, and many techniques have been developed using both camera and darkroom to isolate an event from the clutter around it.

Garry Winogrand was one of the first street photographers to embrace all the contents of the frame, not just the most obvious ones. In this image, the viewer is immediately drawn to the two central figures, a stylishly dressed young woman gracefully depositing alms in a beggar's cup; the two are united by her arm but divided by the metal post. Winogrand, however, deliberately included other elements that make the picture more complicated and more interesting. A woman whose eyes are obscured by dark glasses looks angry, while another passerby seems wary and suspicious. Behind the beggar, two women approach, possibly curious about the photographer. Even the signs become part of the story: the phrase "No Cal" on the truck could perhaps be a comment on the woman's slim figure, and the sign on the wiggery, "Plain and Fancy," similarly invites reflection. SRM

Garry Winogrand
American, 1928–1984
gelatin silver print
8.7 x 13 inches (22.1 x 32.02 cm)
Mr. and Mrs. Harry Fein Purchase Fund
1975.072

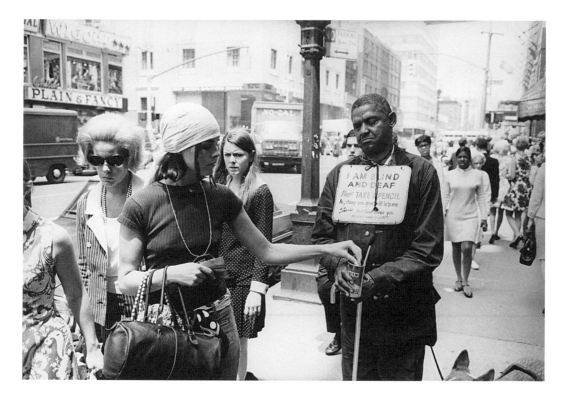

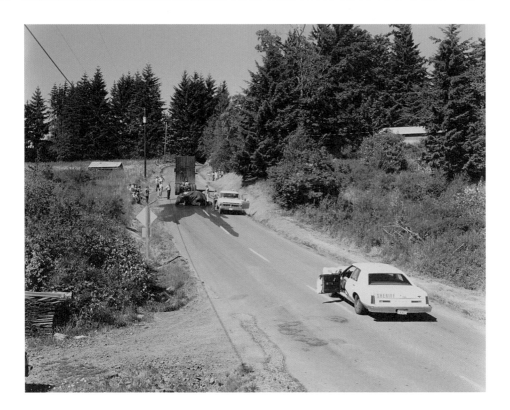

EXHAUSTED RENEGADE ELEPHANT, WOODLAND, WASHINGTON, 1979

The most eye-catching element of this scene is the elephant. Why is it there, lying on a rural road? The title suggests that it has escaped, possibly from a zoo or a circus. It could run no more and has collapsed in the road, where someone cools it with a hose as a small crowd watches.

If we had encountered this scene in real life, we might have slammed on the brakes, walked to the elephant, and taken a picture of the exhausted animal ourselves. Yet our photograph might not differ significantly from one we could have taken at any zoo or circus. Joel Sternfeld did something much shrewder. He stepped back with his camera and included the sheriff's car, a truck, a driveway, trees, sheds, and telephone poles: all the props of

a totally forgettable stretch of rural road. He instinctively understood that an elephant is not strange per se, but that one in this location certainly is.

Sternfeld belongs to a generation of color photographers who viewed the world with a kind of clinical detachment tinged with wonder, and often humor. Today, one school of photographers spends large amounts of time and money to create such scenes. Sternfeld finds them in real life. SRM

Joel Sternfeld
American, born 1944
ektacolor print
16 x 20 inches (40.64 x 50.8 cm)
Acquired with funds provided by the
 Walter R. Beardsley Endowment for
 Modern and Contemporary Art
1986.020.R

BRISTOL, VIRGINIA, 1996

There is an African legend about a wondrous place called the elephants' graveyard, where elephants supposedly went to die, leaving their bones and huge quantities of valuable ivory tusks. According to the legend, many expeditions tried to find the exact place, but none ever returned.

Mike Smith, who launches his own photographic expeditions into the hills and hollows near his home in eastern Tennessee, once stumbled across a lost automobile graveyard and returned with this photograph to tell the tale. The rounded car bodies somewhat resemble the bodies of elephants, and the various windows become empty eyes. The rusting steel

is slowly turning shades of brown and gray, blending with the muted colors of the winter trees and sky. The leaves have died and fallen to the ground, and the cars seem to be slowly sinking into the earth.

Smith's photographs are often reminders that signs and wonders exist all around us, in the most common places, if only we have eyes to see them. SRM

Mike Smith
American, born 1951
Type C color print
17 x 21 inches (43.18 x 53.34 cm)
Gift of Milly Kaeser in honor of Fritz Kaeser
2003.009

On the back of this photograph it states that Garringer was inmate 115224 in the prison at Angola, was born in 1962, and was incarcerated in 1990 to serve a life sentence.

Deborah Luster
American, born 1951
photographic emulsion on aluminum
5 x 4 inches (12.7 x 10.16 cm)
Gift of Milly Kaeser in honor of Fritz Kaeser
2004.031

DONALD GARRINGER, ANGOLA, LOUISIANA, 1999

Deborah Luster's mother was murdered by a hired killer. This experience may partly explain why Luster began a project in 1998 making hundreds of photographic portraits of inmates in three Louisiana prisons. On the reverse of each metal plate, she scratched the information the sitter volunteered to her. On the back of this photograph it states that Garringer was inmate 115224 in the prison at Angola, was born in 1962, and was incarcerated in 1990 to serve a life sentence. It is a cold, factual description of a man and his life.

The image itself is very different. A proud, handsome young man gazes into the camera, standing in the midst of a cotton field, ready to begin filling his sack with the white bolls surrounding him. The picture is confrontational, forcing us to make eye contact. The state may define the prisoner as a number, but the photograph shows him to be a real person.

Luster gave more than twenty-five thousand wallet-size pictures to the inmates, who mailed them to friends and loved ones. To Luster, this was the project's real goal: allowing the prisoners to make contact with the outside world, sometimes resulting in family visits for the first time in years, or ever. SRM

Maggie Taylor
American, born 1961
digital ink-jet print
8 x 8 inches (20.32 x 20.32 cm)
Gift of Milly Kaeser in honor of
 Fritz Kaeser
2005.013

GIRL WITH A BEE DRESS, 2004

This striking, mysterious girl is part of a revolution that has happened many times during the last 170 years—not a radical political shift, but a technological one.

Photography was the first true marriage of art and technology, and whenever the technology changed, the images changed. Daguerreotypes disappeared, replaced by albumen prints and bigger, faster wet-plate glass negatives, allowing new types of images to be captured. Dry plates, faster lenses, and flashguns freed photographers from tripods and portable darkrooms, resulting in access to new subject matter. The versatility of small 35-millimeter cameras opened up new views, producing different angles and exciting perspectives, indoors and out.

The rise of digital imagery, which is rendering film photography obsolete, has opened new ways of creating and manipulating images. As in previous revolutions, most photographers are still taking the same kinds of pictures they took before, only now they are using different equipment. Others, like Maggie Taylor, have realized they can create pictures that were too difficult, if not impossible, with the obsolete materials. Ironically, this picture, which relies on cutting-edge technology, is full of old-fashioned feelings like wonder, beauty, and nostalgia.

It will be fascinating to see where the medium goes from here. SRM

COLOPHON

This book was printed on Mohawk Options Crystal White 100 lb. text and 130 lb. cover. The typefaces used are Perpetua and Gill Sans.

Design: Sedlack Design Associates

Production Assistance: Ross Van Overberghe

Printing: Mossberg & Company Inc.